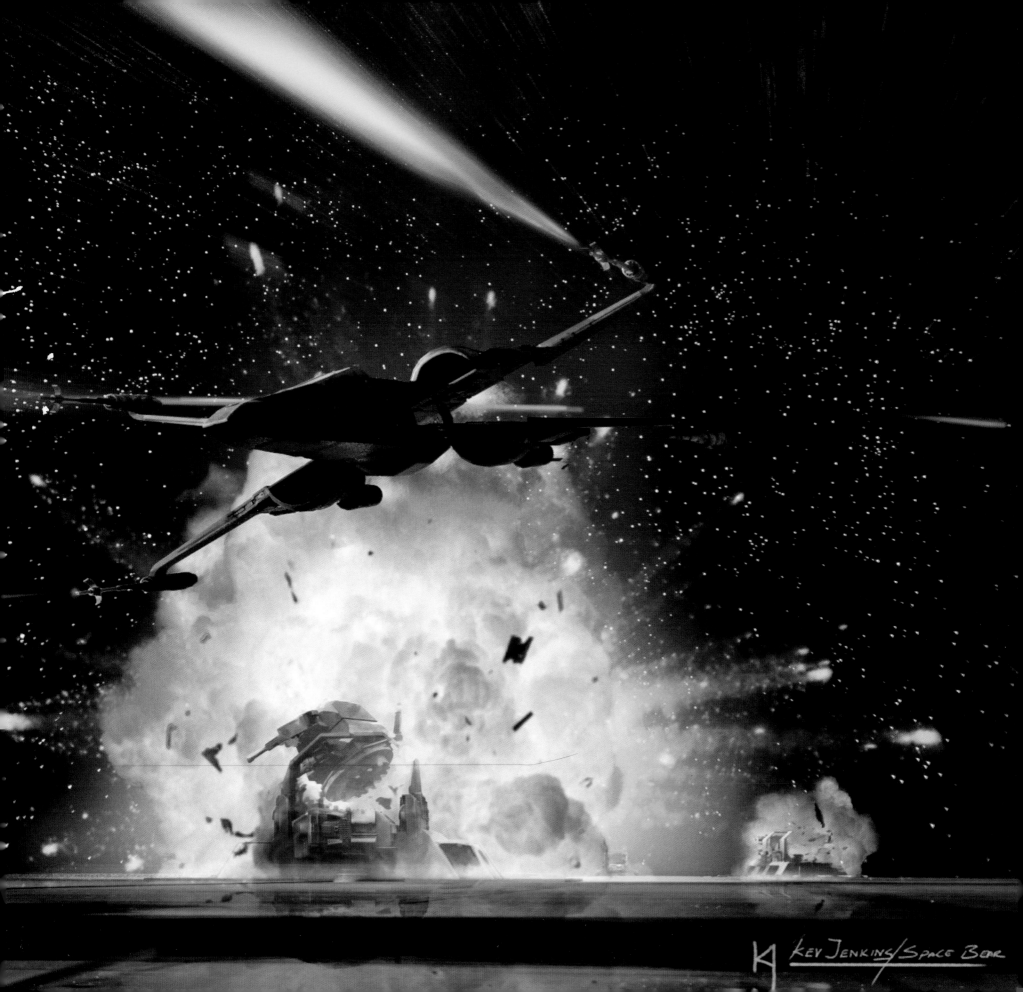

Kev Jenkins/Space Bear

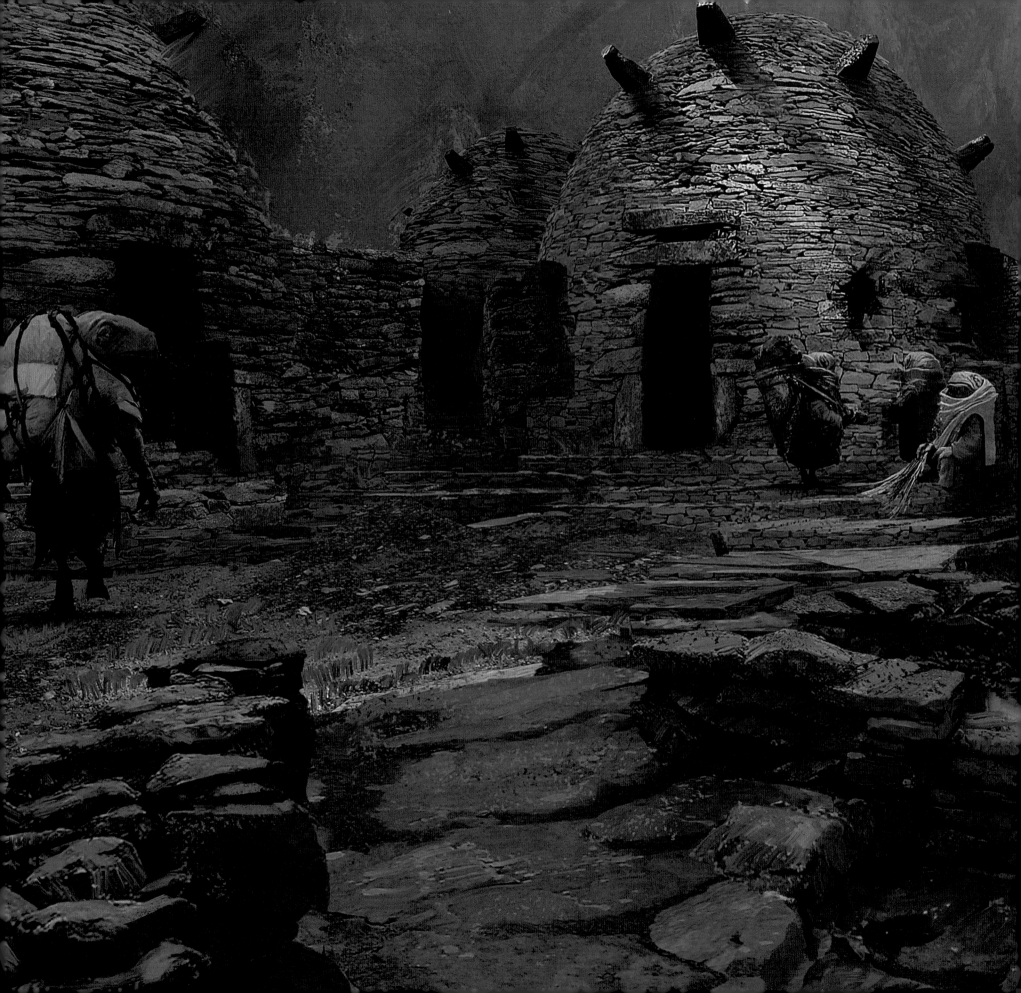

THE ART OF

STAR WARS

THE LAST JEDI

Written by PHIL SZOSTAK Foreword by RIAN JOHNSON

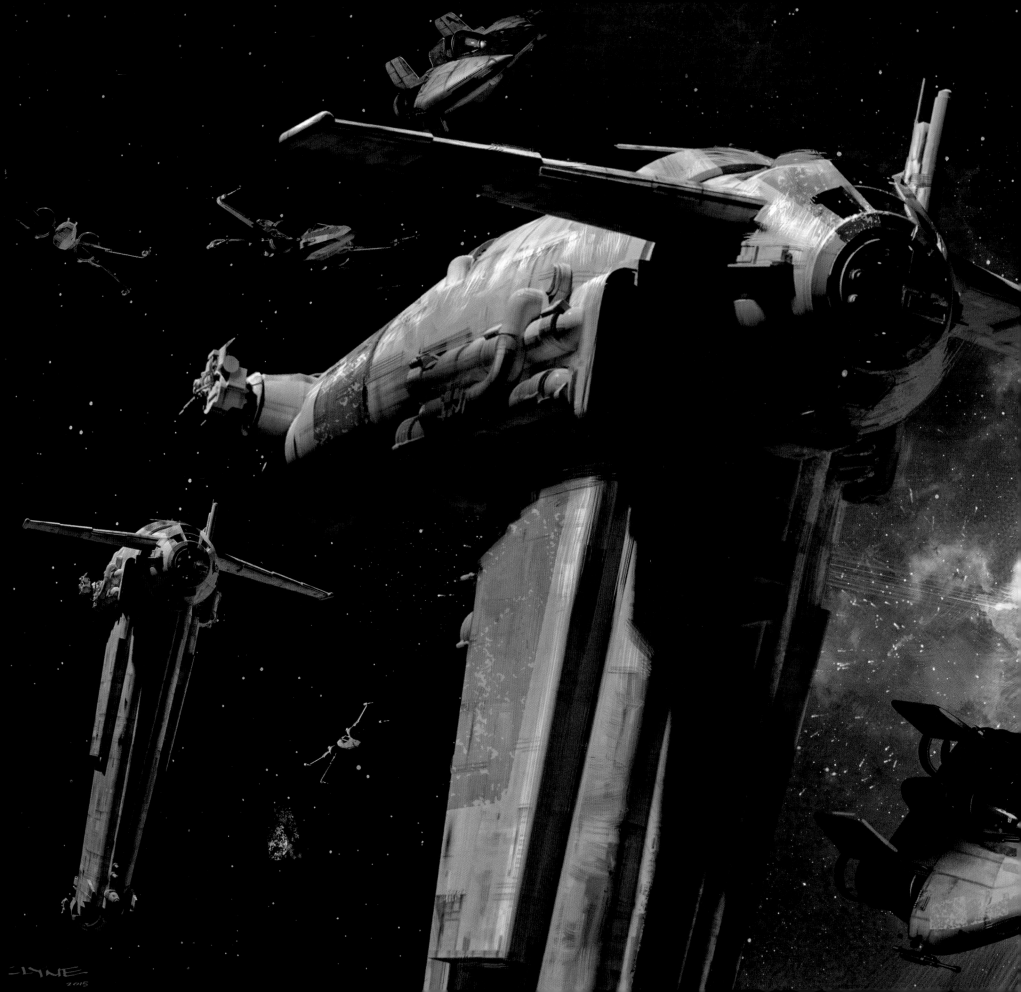

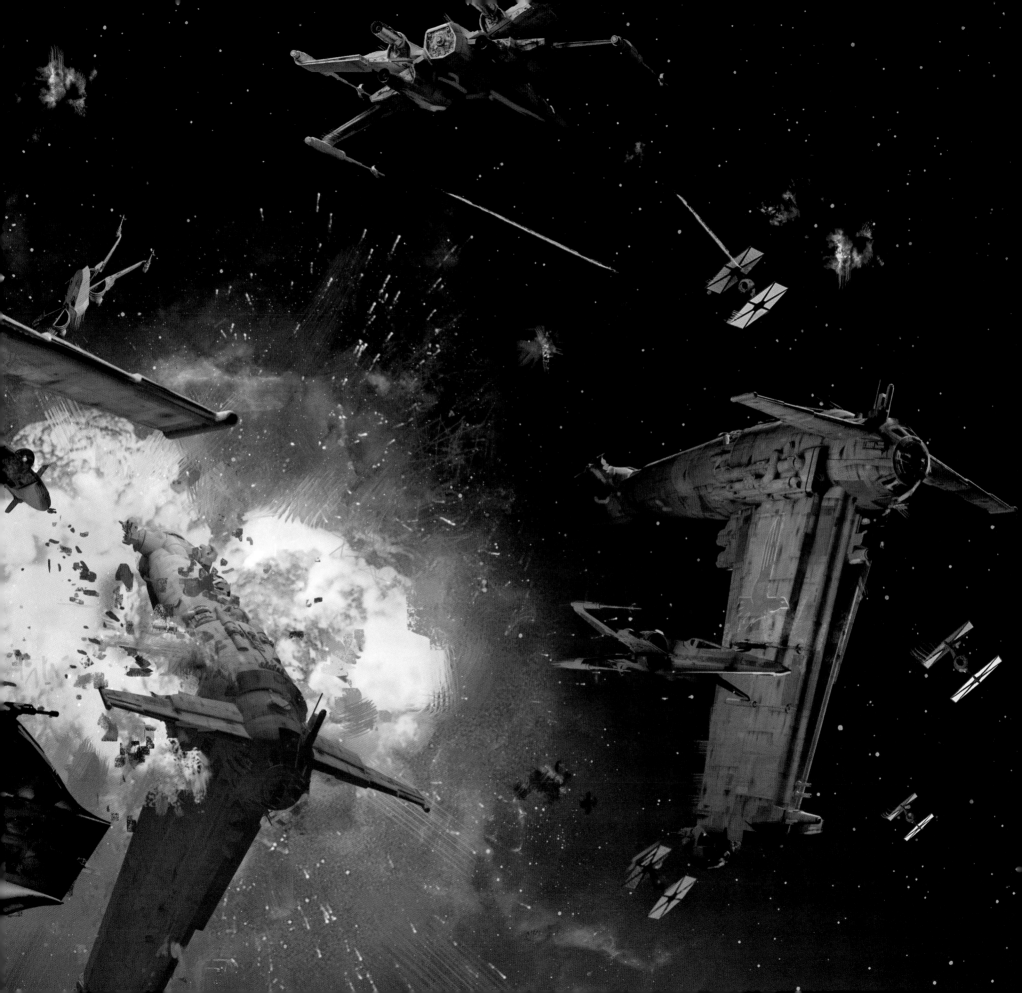

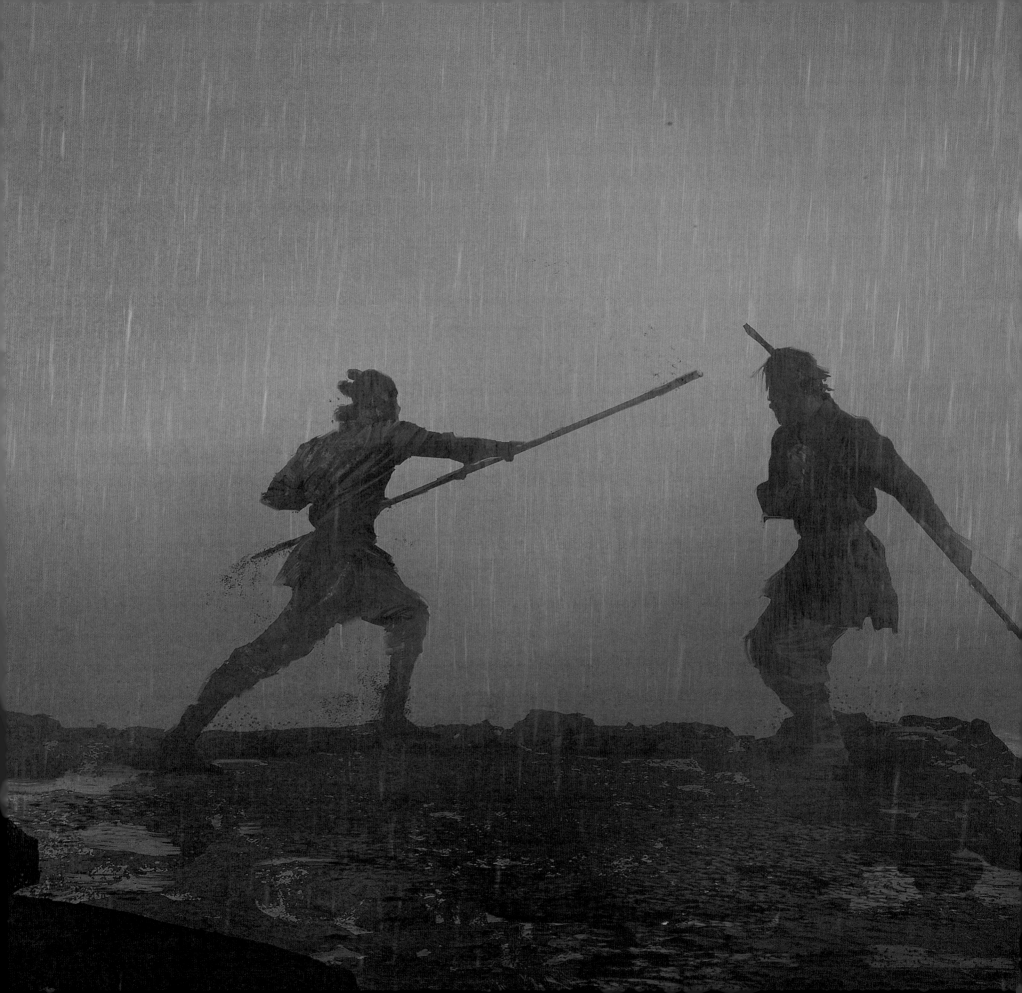

Contents

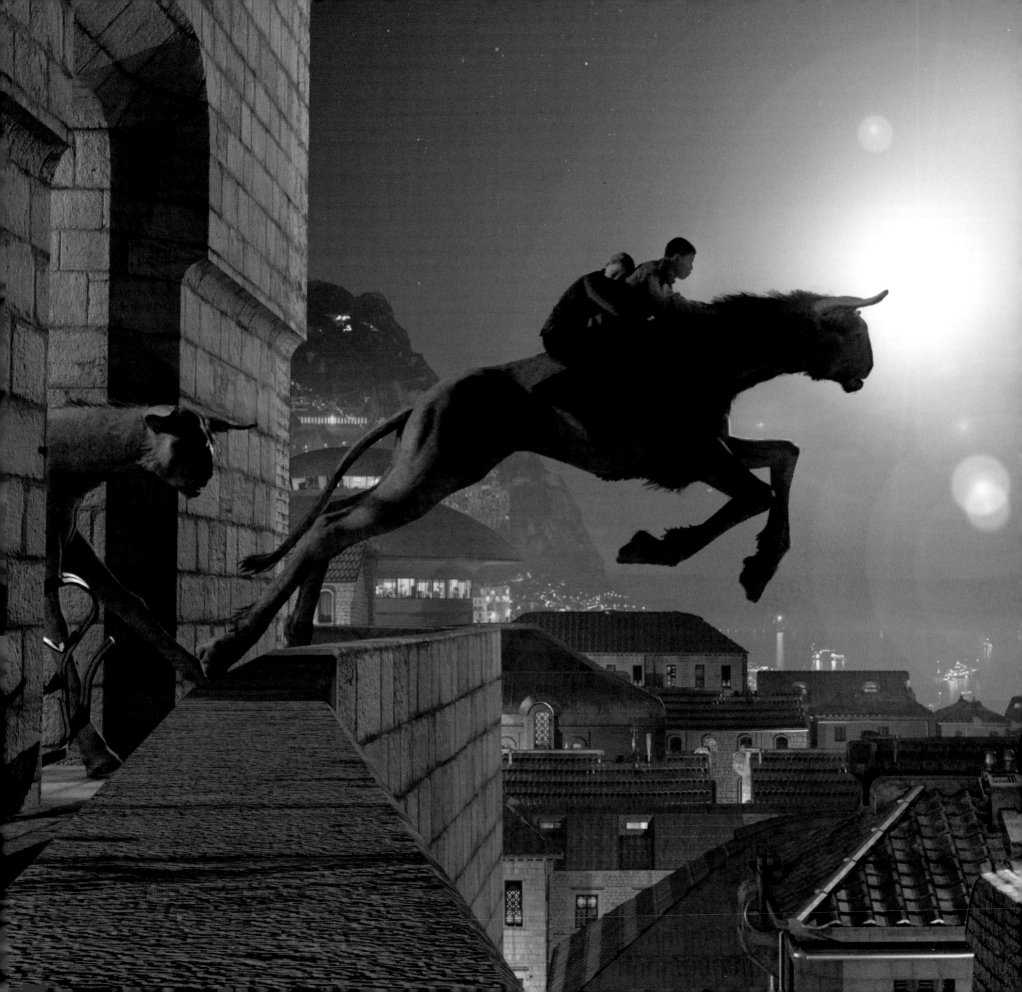

Foreword by Rian Johnson

Here's a party trick you can do. The next time you find yourself in the design offices of a *Star Wars* movie, lean over to the wealthiest looking person you can find, nudge them, and whisper, "*Psssst*, I bet I can grind this whole place to a halt for three hours." When you've got a bet secured, clear your throat and loudly ask to no one in particular, "So uh, what makes something look *Star Wars*-y?"

Pencils will drop. Opinions will be expressed about pill lights and coffin-shaped doors, gack lines and kitbashing, World War II and Flash Gordon, and then someone who worked on the prequels might say something about domes, and a chorus will rise in response and the game will be on. Check your watch, and in three hours collect your money. Congratulations, this book just paid for itself.

The only real answer (besides "Ralph McQuarrie") is that something feels *Star Wars*-y because it feels *Star Wars*-y. It's something elusive that everyone has their own instinct for, and when you find designers whose instinct lines up with yours, you latch on and don't let go. I was very lucky to work with several on this film, starting with our production designer, Rick "Ramblin'" Heinrichs. Rick created a space where everyone felt safe taking chances. Beyond that, everyone on the team was encouraged to make it personal.

That personal aspect was key, and the timing of our preproduction schedule helped. When we began the design work on *The Last Jedi*, J.J. was still at Pinewood Studios shooting *The Force Awakens*. The movie didn't belong to the world yet. Looking back, I'm very thankful for that. For that precious first year when we were visualizing our movie, we didn't have the cultural reaction to *The Force Awakens* to hold it up to, and our only compass was an interior one: How did we feel about these characters, what do we want to see them go through, what do we want to see in a new *Star Wars* movie, and what feels honest and real to us? All we could do was poll our own reactions and respond to that. It made the process intimate, and the creative decisions personal.

Flipping through this book, the scope and depth of work from our entire team of artists is almost overwhelming, and for me it's also a high-speed survey of four years of memories. From the earliest sketches of Luke's life on the island through a reimagining of *Star Wars* luxury and glamour in Canto Bight to the puzzle of how to approach another throne room all the way to the battle on Crait, I'm so proud of the creative efforts our whole team brought together—Michael Kaplan's costumes, Neil Scanlan's creatures, Ben Morris's ILM band of visual-effects wizards, Rick Heinrichs's sets, and the work of countless artists in the middle.

Speaking of those countless artists, as you peruse this book I encourage you take note of the designers behind the various pieces. As much as the look of the film represents a group effort, each design bears the personal stamp of a single person's imagination. The screenplay described the fathiers as alien but horse-like, gentle, and wise. What does the living embodiment of that actually look like? It was Aaron McBride who iterated a hundred versions before he cracked the code of the fathier's face. The walkers in the script were not special at all, and the new walker design came from Kevin Jenkins and I asking ourselves how we could possibly evolve what to us was one of the most iconic movie designs of all time. So Kevin spent some time staring at his office walls, mulled over the words "brutish" and "muscular," and then one day hit on the idea of a gorilla's profile. Every one of these sketches and paintings is the end point of one artist's struggle with a design challenge.

One last aspect of the design process that I'd like to hang a wreath on, mostly because it's hard to represent in a book of pictures, is the practical step of turning this amazing artwork into real, physical stuff. Watching Neal's creature designers take a concept drawing and translate it into a clay sculpture, I came to appreciate sculpting as its own process of design, capturing the nuance conveyed in a 2-D medium to a 3-D one. Neal claimed that more practical creatures were created for this film than for any other in motion picture history, and I'm not going to fact-check that, because I both can't believe it's true and I enjoy saying it. Similarly, taking set designs and translating them into real spaces is its own craft, and our talented set designers did that on a grand scale. We were fortunate enough to have the legendary Mark Harris, who worked in the art department on *The Empire Strikes Back*, tending to the wonderful bits of gack and panels and decals that give the sets that *Star Wars* feel. And finally, a loving shout-out to Chris Lowe, our supervising art director. We built an insane amount of sets, one hundred and sixty-seven, and shot them all in a hundred days shoot. It was Chris's job to figure out how to fit them all on our finite amount of Pinewood soundstages, which was a massively expensive game of Tetris. It sounds boring, but it is the reason that what you see in this book got on the screen.

But enough nuts and bolts and enough with the wordy introduction—this is an *Art Of* book after all, so let's look at some art. I hope you enjoy this peek into the process, and I hope that whatever "*Star Wars*-y" means to you, you'll find some of it here.

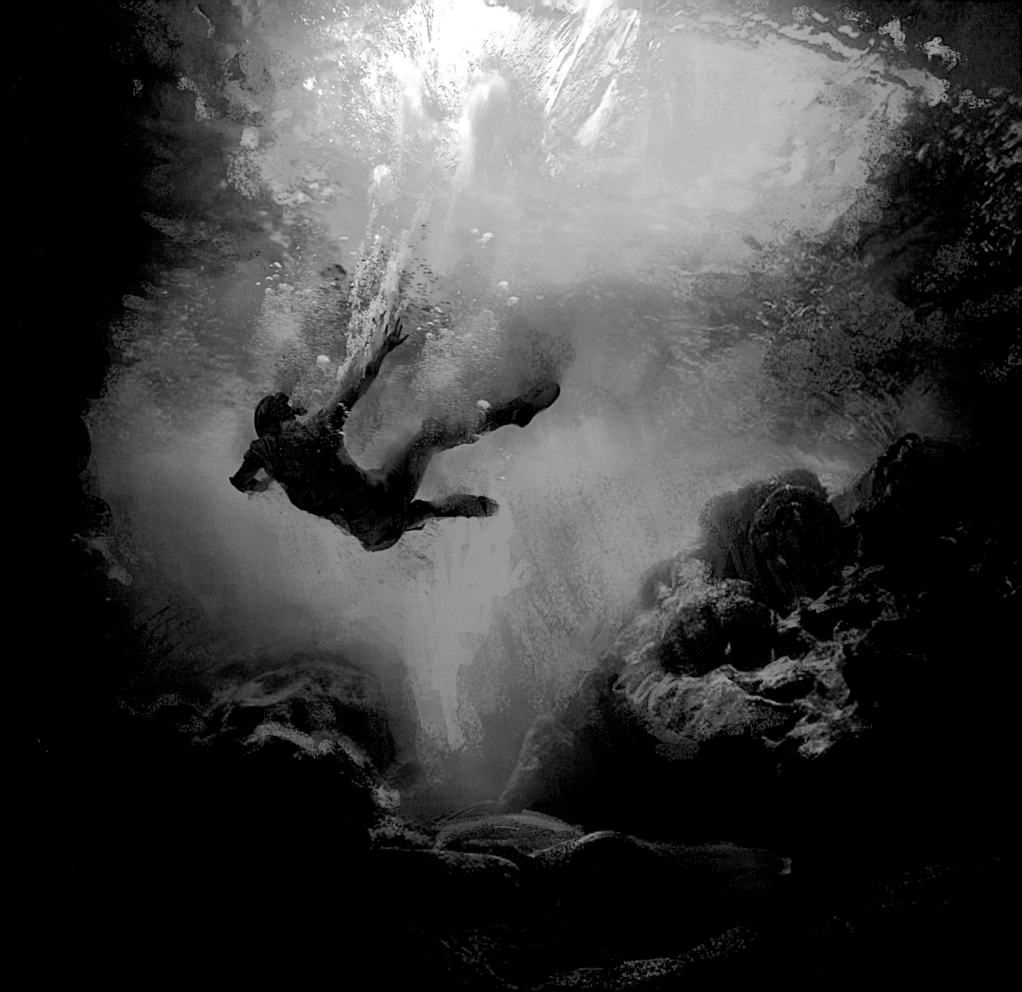

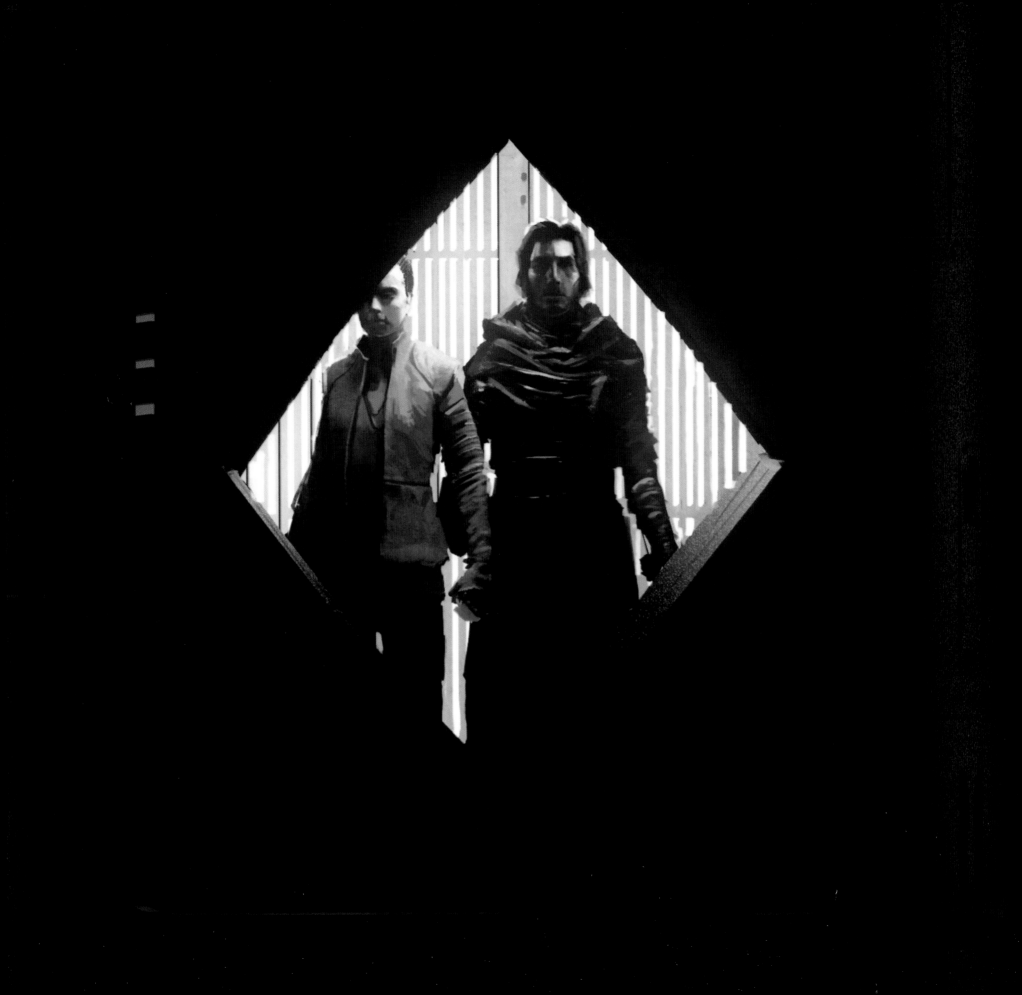

Introduction by Phil Szostak

"Who is Luke Skywalker?"

This question was first posed by *Star Wars: The Force Awakens* co–production designer Rick Carter in January 2012. Carter wasn't necessarily looking for answers; rather, he hoped this essential question would fire the imaginations of his collaborators during the earliest days of preproduction. "Maybe the mystery of the question is better than the answer," Carter said. "A question can keep fueling a project, like Christmas Eve forever, as opposed to an answer, which makes the question finite and thus limits the imagination."

An answer to this question was not offered within *The Force Awakens* itself. As cowriter Michael Arndt explained in a 2015 postscreening Q&A, "It just felt like every time Luke came in and entered the movie, he took it over. Suddenly you didn't care about your main character [Rey] anymore." Instead, *The Force Awakens* introduced more questions: Why has Luke abandoned his twin sister Leia Organa and best friend Han Solo in their most desperate hour? "I knew that Luke needed to have a reason that he actively thought being on the island was the right thing to do and was the best thing for everybody—including Leia, including his friends, including the entire galaxy," *The Last Jedi* screenwriter and director Rian Johnson recalled. "In his mind, this was an act of tremendous self-sacrifice, because all the universe wants is for him to come back and help."

Will Luke take possession of his father's lightsaber and return with Rey to aid the Resistance in their fight against the evil First Order? Or will Luke choose not to fight and let the will of the Force decide their fates? Pivotal events in Luke Skywalker's life, especially his encounter with Rey on Ahch-To, and the choices he made in response to them shape the answers we get to those questions, and indeed to the question, "Who is Luke Skywalker?" in *Star Wars: The Last Jedi*.

In *A New Hope*, Ben Kenobi warned his former apprentice Darth Vader, as they dueled aboard the Death Star, "If you strike me down, I shall become more powerful than you can possibly imagine." The popular interpretation of Kenobi's words is that he would return more powerfully in spirit form to guide Luke toward the redemption of his fallen father. But Rick Carter felt otherwise. Early in the development of *The Force Awakens*, he shared his belief that Kenobi, turning briefly to see that Luke was watching, consciously resolved to sacrifice himself, knowing that Luke would bear witness to his death. And that by bringing father and son together through that selfless act, Kenobi was hastening the end of Darth Vader and

therefore, the end of the Empire. So Kenobi trusts in the Force, choosing not to fight.

In *Return of the Jedi*, father and son square off one final time on board the second Death Star. A threat to his twin sister Leia sends Luke into a rage, raining blows down on Vader until he cleaves off the Dark Lord's hand. Looking down at his own cybernetic replacement hand, Luke has a flash of insight, seeing the dark path he is following his father down. Luke throws his newly constructed lightsaber (the design of which reflects Kenobi's) aside and chooses not to fight. "I am a Jedi, like my father before me." But this time it is Vader, or more accurately Anakin Skywalker, who, in bearing witness to his son's sacrifice, is inspired to dispatch the evil Emperor. Luke trusts in the Force, chooses not to fight and is victorious.

Prior to the start of *The Force Awakens*, Luke's nephew and Jedi apprentice Ben is seduced by Supreme Leader Snoke and the dark side of the Force. In an effort to bring Ben back, Han Solo confronts his son over the chasm of Starkiller Base's oscillator. Just like Kenobi and Luke, three decades earlier, Han chooses not to fight, and Rey, Finn, and his Wookiee copilot and companion Chewbacca bear witness to his sacrifice, hastening their confrontation with Kylo Ren at the conclusion of the film. By virtue of Han Solo's martyrdom, the Force acts through Rey and Kylo Ren is defeated.

As with all who are lured by the dark side of the Force, Ben's fall parallels Anakin Skywalker's fall in that it stems from a desire for order and control—the avoidance of loss. Throwing down your weapon, choosing not to fight, is an acknowledgment that we have no control, a surrendering to the Force. Is the movement of the Force one of letting go, of passivity, of peace?

According to Johnson, "It was a little nerve-wracking going into a *Star Wars* movie and have the big lesson—the one that Poe Dameron learns—be the value of running away, the value that heroism isn't brashness." Like Kenobi in *A New Hope*, Luke in *Return of the Jedi*, and Solo in *The Force Awakens*, the solution is sometimes surrender and sacrifice, not charging in recklessly. "That brashness is very much a young person's point of view. It would be disingenuous and wrong to have the only perspective that mattered in this movie be one of youth. We had to step forward into that part of adolescence where you start to glimpse the limits of the blue sky up above your teenage head," Johnson concluded. "Inevitably, another perspective on heroism had to enter into this movie because of the

Page 12
UNDERWATER SHOT 2
Engstrom

Page 13
KYLO RED ROOM 01
Clyne

◄ **THRONE ELEVATOR VERSION 04** Jenkins

legacy characters," said Johnson, "because of Leia, because of Luke and—especially considering what happened in *The Force Awakens*—because they're ultimately defined by loss."

If Joseph Campbell's "hero's journey" is a reflection of human-kind's journey beyond the innocence of childhood into the wider world of knowledge and responsibility, then what comes *after* the hero's journey, after "happily ever after"? What of the middle-aged hero, who now faces inevitable mortality and loss?

One of the great innovations of *The Force Awakens* was giving the faceless a face. Stormtroopers like Finn, previously perceived as merely cannon fodder, are shown to be flesh and blood, vulnerable human beings. We saw the formerly devil-may-care smuggler Han Solo's vulnerability and humanity: his struggles with getting older, facing his mortality, and dealing with the consequences of his choices. In *The Last Jedi*, we will get to know Luke as a person—that impatient kid on Tatooine kicking a clot of dirt—and see how everything he has experienced since then has damaged him on a real, human level. So, through the eyes of Rey, is the mythic Luke Skywalker revealed as just a man.

In spite of her youth, Rey is also ultimately defined by loss: abandonment by her family on the backwater planet of Jakku, forcing her to shoulder burdens well beyond her years. Rey's journey through *The Force Awakens* begins with a connection to a peculiar little droid in need, BB-8, who leads her to Finn, then Han Solo and Leia Organa. Through these companions and her growing relationship with the Force, Rey seeks to heal the hole in her heart through the connectedness that normally comes with family. That journey ends with the island and Luke, a man she once believed to be "just a myth." Rey's need for connection with Luke may not be entirely altruistic, for the greater good of the galaxy.

Will Rey reconcile the "myth" that she believes—and needs—Luke Skywalker the Jedi hero to be with Luke Skywalker the man? Like Kenobi and Luke before her, will Rey transcend the ceaseless war between Jedi and Sith, rebels and Imperials, good and evil, within us and without? Or will she stumble down the dark path of Anakin and Ben?

So who is Luke Skywalker? *The Last Jedi* finally provides us with an answer to Rick Carter's six-year-old question. It may not be the answer we seek, but it will be the truest one for our modern mythic hero. Instead of asking, "Who is Luke Skywalker?" perhaps we should be asking a larger question: "What makes a hero?" The answer to *that* question may ultimately be embodied by a self-described "no one" from Jakku.

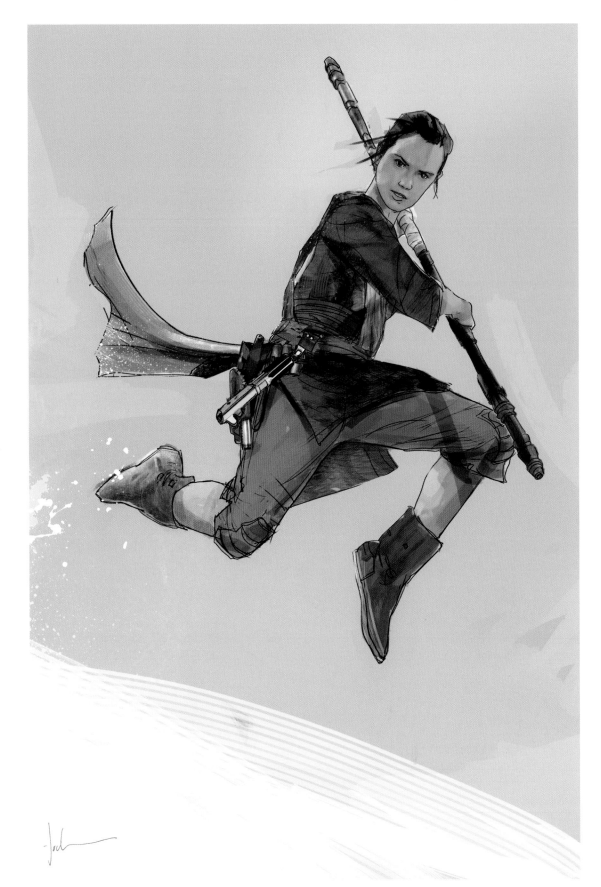

▲ **REY SABER HORIZONTAL** Jock

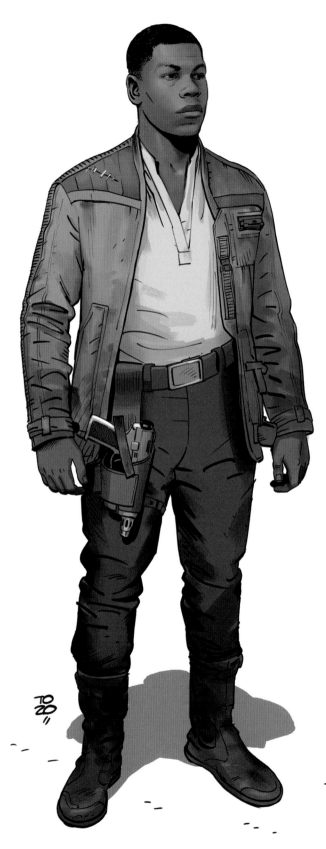

Who's Who

NICK AINSWORTH
Concept artist

DAVID ALLCOCK
Storyboard artist

CHRISTIAN ALZMANN
ILM (Industrial Light & Magic)
senior art director

MARTIN ASBURY
Storyboard artist

RAM BERGMAN
Producer

ANDREW BOOTH
Computer graphics
supervisor: BLIND LTD.

MAURO BORRELLI
Concept artist

ADAM BROCKBANK
Concept artist

TIM BROWNING
Concept artist

NEAL CALLOW
Art director

JAMES CARSON
Concept artist

RICK CARTER
*Star Wars: The Force
Awakens* co-production
designer

PAUL CATLING
Concept artist

PAUL CHANDLER
Concept artist

LELAND CHEE
Manager of the Holocron

TODD CHERNIAWSKY
Art director

DOUG CHIANG
Lucasfilm VP/executive
creative director

DEAN CLEGG
Art director

JAMES CLYNE
VFX art director

DAVID CROSSMAN
Costume supervisor

RODOLFO DAMAGGIO
Concept artist

JOHN DEXTER
Art director

GLYN DILLON
*Star Wars: The Force
Awakens* costume concept
artist

YANICK DUSSEAULT
ILM senior art director

SETH ENGSTROM
Concept artist

GREG FANGEAUX
VFX art director

**ROBERTO FERNÁNDEZ
CASTRO**
Concept artist

LUKE FISHER
Creature concept designer/
senior sculptor

KIM FREDERIKSEN
Senior 3-D concept artist

JULIAN GAUTHIER
Concept artist

LAURA GRANT
Key graphic designer

LUIS GUGGENBERGER
Concept artist

MARK HARRIS
Senior art director

KIRI HART
Lucasfilm senior vice
president of development

RICK HEINRICHS
Production designer

PABLO HIDALGO
Lucasfilm creative executive

JASON HORLEY
VFX art director

MICHAEL JACKSON
Storyboard artist

KEVIN JENKINS
VFX art director

RIAN JOHNSON
Writer/director

JAIME JONES
Concept artist

JOCK (MARK SIMPSON)
Costume concept artist

ROBERT JOSE
Senior modeller

MICHAEL KAPLAN
Costume designer

KATHLEEN KENNEDY
Producer
Lucasfilm president

CHRIS KITISAKKUL
Graphic designer

TANI KUNITAKE
Concept artist

KARL LINDBERG
ILM senior concept artist

CHRIS LOWE
Supervising art director

GEORGE LUCAS
Star Wars creator

JAKE LUNT DAVIES
Creature concept designer

IVAN MANZELLA
Creature concept designer
Senior sculptor

AARON McBRIDE
ILM senior art director

IAIN McCAIG
*Star Wars: The Force
Awakens* concept artist

JASON McGATLIN
Executive producer
Lucasfilm senior vice
president of physical
production

RALPH McQUARRIE
Original trilogy concept artist

BEN MORRIS
ILM London VFX supervisor

TIM NAPPER
Creature concept designer

BRETT NORTHCUTT
ILM senior concept artist

MARTIN REZARD
Creature concept designer
Senior sculptor

RAYNE ROBERTS
Lucasfilm creative executive

TIMOTHY RODRIGUEZ
Concept artist

CHRIS ROSEWARNE
Concept artist

ROBERT ROWLEY
Costume concept artist

LEE SANDALES
Set decorator

MATTHEW SAVAGE
Prop concept designer

NEAL SCANLAN
Creature and droid effects
creative supervisor

DANIEL SIMON
Concept artist

HENRIK SVENSSON
Creature paint finish designer

JUSTIN SWEET
Concept artist

DAN SWEETMAN
Storyboard artist

KURT VAN DER BASCH
Storyboard artist

OLIVER VAN DER VIJVER
Art director, action vehicles

CHRIS WESTON
Costume concept artist

JAMIE WILKINSON
Prop master

SAM WILLIAMS
Costume modeler

TONČI ZONJIĆ
Costume concept artist

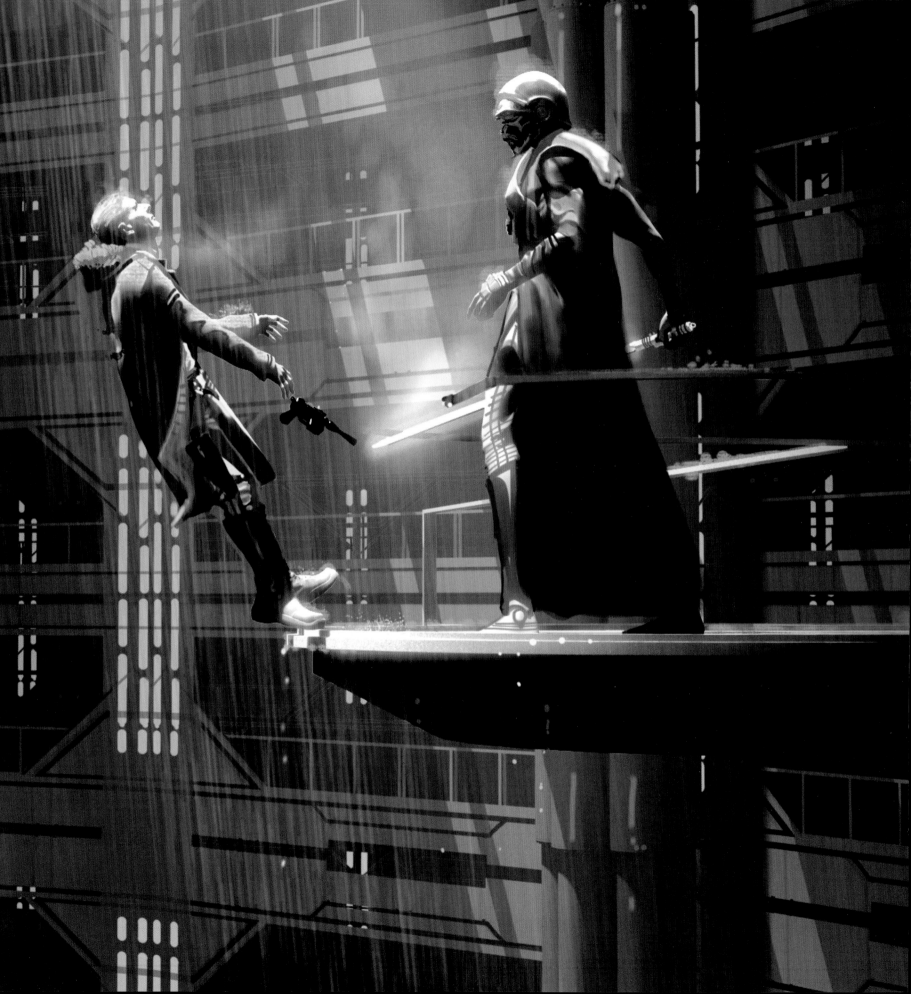

The Death of Han Solo and Rebirth of the Jedi

To help preserve the filmgoing experience of The Force Awakens *for Star Wars fans around the globe, concept art depicting an older Luke Skywalker, the Jedi temple, the training of Rey (initially called "Kira" in early development), and the death of Han Solo was not included in* The Art of Star Wars: The Force Awakens. *It is revealed here for the first time.*

In December 2012, co–production designer Rick Carter (*Jurassic Park, Forrest Gump, Avatar*) and Lucasfilm VP/executive creative director Doug Chiang (*The Polar Express, War of the Worlds* [2005], *Rogue One: A Star Wars Story*) assembled a small but world-class team of "Visualists," concept artists and veteran Lucasfilm creatives who, alongside screenwriter Michael Arndt (*Little Miss Sunshine, Toy Story 3*), director J.J. Abrams (*Mission Impossible III, Star Trek* [2009], *Super 8*), and Lucasfilm development executive Kiri Hart and her Story Group, were tasked with dreaming the continuation of the Skywalker saga into being. But on January 9, 2013, one week prior to the very first meeting of the Visualists, Chiang, inspired by a few informal brainstorming sessions with Carter, painted portraits of an aged Luke Skywalker. Speaking in May 2013, Chiang recalled, "I did these four paintings of Luke. I just pulled some current-day images of Mark Hamill and repainted them. That became the jumping-off point for discussions on how we could bring back the old cast and what we could do with them."

Recounting the current version of *The Force Awakens*'s backstory, Chiang continued, "After *Return of the Jedi*, when the Empire fell, Luke went through a period of turmoil. He decides to reform the Jedi, Luke being the last. So he creates his own Jedi academy and recruits people." One of Luke's pupils was the character then known as the "Jedi Killer." "Ultimately he turns against Luke. There's a big fight, and the Jedi Killer is wounded and cast aside. There's this big through-line of the Jedi Killer wanting revenge on Luke. And that's partly why he takes on this persona of Darth Vader: to haunt Luke."

Soon the remaining Visualist designers, including Erik Tiemens, Kurt Kaufman, Christian Alzmann, Yanick Dusseault, Iain McCaig, and, working remotely from Los Angeles, James Clyne, followed in Chiang's footsteps in preparation for a January 16 meeting with *Star Wars* creator George Lucas (*THX-1138, American Graffiti*)

at Skywalker Ranch. Among the pieces presented at the ranch's Main House were additional portraits of Luke, the temple where he dwelled in exile, and the training of a young disciple Kira, later renamed Rey.

"At this point in the story, thirty years after the fall of the Empire, Luke has gone to a dark place," Chiang said. "He always had this potential dark side within him, being that his father was Darth Vader. So he is really struggling with that. He ended up secluding himself in this Jedi temple on a new planet, and he's just there meditating, reassessing his whole life. Gradually, over the arc of the movie, he rediscovers his vitality and comes back to himself." But as the film evolved, Arndt realized that Luke Skywalker would better serve the needs of the story as the person that everyone seeks but does not find until *The Force Awakens*'s final scene. The plot points of an ancient temple and Rey's training there would be temporarily shelved. Additionally, Han Solo, now reintroduced at the start of the second act of the film, would have more time to shine. For the first time in a *Star Wars* story, Han would fill the mythological archetype of the mentor for Rey, as Obi-Wan Kenobi did for Luke in *A New Hope*. *The Force Awakens* would also be a victory lap, of sorts, for both the character and for Harrison Ford, the actor who first portrayed him thirty-eight years prior.

In late summer 2013, the Visualists were let in on two secrets that would not be revealed to the rest of the world for another year and a half: that the beloved Han Solo would meet his end in *The Force Awakens*, dispatched by the malevolent Jedi Killer—and that the Jedi Killer would be Han and Leia Organa's son. "This was big," Christian Alzmann said in September of 2013. "We found out that, at essentially the same running time in *A New Hope* when Obi-Wan gets killed, Han will get killed by the Jedi Killer—by his son! That's super-Biblical stuff, heavy stuff! I had a feeling that Harrison would love it; he's wanted Han to die for a while. The biggest problem we had was that we waited thirty years, and we never saw Han, Luke, and Leia get back together. I wanted to see everyone in the *Millennium Falcon* cockpit, and then you can kill Han, if you had to. But that won't happen, as far as we know." The impact of Han Solo's death would reverberate through the two remaining films in the *Star Wars* sequel trilogy.

◄ **FALL VERSION 01** "We knew it was going to happen at this Imperial station—like a Death Star, but on an ice planet. I was thinking of rain and steam because the gun had just been fired and melted the snow outside. It's very operatic. The Jedi Killer got close to Han and did a stiletto move where he had the lightsaber off, put it to Han's chest, and turned it on. Since it's an ice planet, I put Han in a duster with a furry hood." **Christian Alzmann**

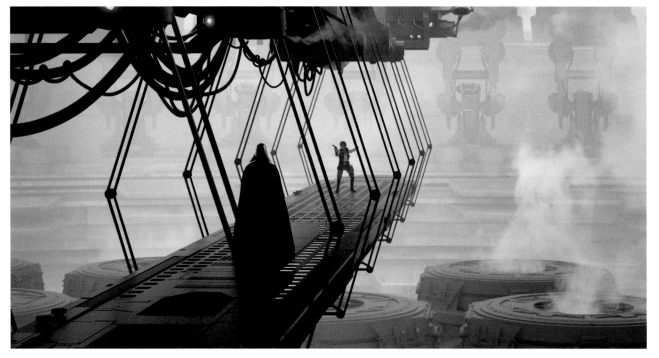

▲ **CATWALK 1.1** Yanick Dusseault

▼ **JEDI KILLER THREE QUARTERS VERSION 01** Glyn Dillon

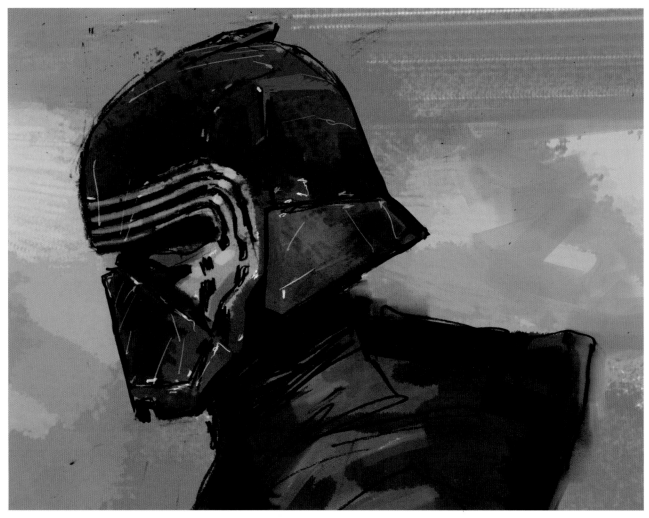

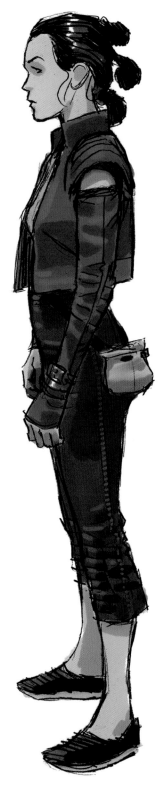

▲ **KIRA END VERSION 02** Dillon

Costume concept artist Glyn Dillon initially designed Rey's second outfit to be a more direct homage to her fallen father figure, including a short blue jacket and red piping down the side of her trousers.

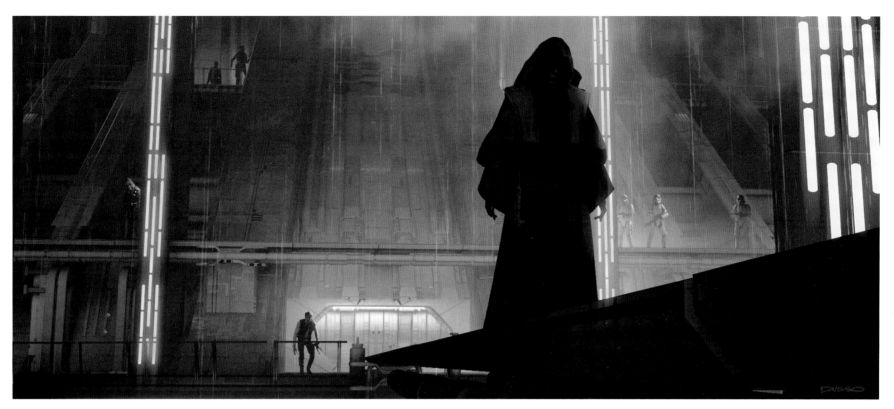

▲ **SILO HANGAR WALL 02** Dusseault

▲ **CORE FIGHT 1.1** "The brief from [*The Force Awakens* co–production designers] Darren Gilford and Rick
Carter was to include pill lights and shapes from the classic Star Destroyer bridge. We had a bunch of
Jakku graveyard pieces modeled, and they're absolutely everywhere. This was about the moment—a very
dramatic, iconic moment. If your illustration isn't iconic, you know it's not good enough." **Dusseault**

TEMPLE VERSION 11 Brett Northcutt ▼ **JEDI TEMPLE** Dusseault

The Last Jedi in Exile

"My earliest memory is my dad putting me in the car to go see *Star Wars*," recalls *The Last Jedi*'s writer and director, Rian Johnson (*Brick, The Brothers Bloom, Looper*). "I was really, really young—probably *way* too young. And my earliest creative play was with *Star Wars* toys. So I was creating stories in this world when I was a kid—play being maybe the more important part of it."

As a child of the late seventies and early eighties, the *Star Wars* films themselves were not accessible to Johnson or any fan outside of the movie theater. *A New Hope* was not released on the Video Home System (VHS) and Betamax home video formats until 1982, a full five years after its initial theatrical run, and years would pass before the film was released at an affordable price. Rental through neighborhood video stores was the primary means of distribution at the time. "I remember when we got the VHS for *Star Wars* from the video store," Johnson said. "We had our friends over, and we would watch it for twelve hours straight, over and over, until we had to give it back. There'd be like a three-month waiting list to get it."

Those limitations had an unexpected effect on early *Star Wars* devotees. Johnson remembers, "I had the records. I had the storybooks. I had the holiday album. I had anything I could get that had to do with *Star Wars*. But the one thing we didn't have was the movie. Largely, it was talking with your friends about the movie, pooling information and memories of it. And so it was a very strange and very mythological experience of *Star Wars*. It mythologized the films in a very powerful way because, like God's absence, the actual object of your worship was not there! [*Laughs*] So you and your friends end up studying the sacred texts and philosophizing about it. I hadn't really thought of it that way before, but that might be part of the reason why, in a way that can be hard to explain, *Star Wars* feels like such a powerful myth of our childhoods. Maybe it's because we couldn't see the actual movies. [*Laughs*]"

Like most *Star Wars* fans of that era, Johnson was familiar with the work of concept artists Ralph McQuarrie and Joe Johnston, who defined the look of *Star Wars* ever after, even if he didn't yet know

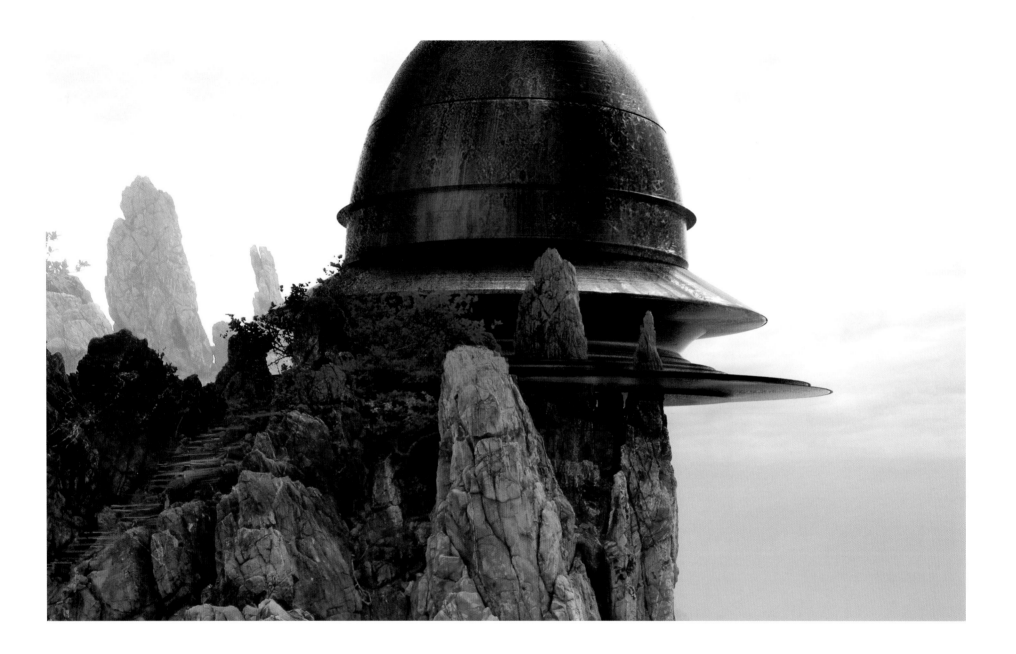

them by name or own *The Art of Star Wars* books. "When I was a kid, I would see those paintings," Johnson says. "And they would add to the mythological feeling, since they kind of look like *Star Wars* but kind of don't. So there are more layers to this notion that this thing is bigger than just two hours of film." Johnson did, however, make a later and significant connection with *Industrial Light & Magic: The Art of Special Effects* by Thomas G. Smith, published by Ballantine Books in 1986. "As a teenager, that was the tome that I would pore through. That book was amazing because it showed not only the *Star Wars* movies, but also everything up through *Starman*. It broke down the process, in a vague but significant way, of how all of these effects were done. That, for me, was the most important book about *Star Wars* that I had growing up."

Three-plus decades later, following the release of *Looper* and the sale of Lucasfilm and the *Star Wars* franchise to the Walt Disney Company, Rian Johnson had a general meeting with Kathleen Kennedy, newly appointed president of Lucasfilm. Then, another meeting with Kennedy was called. "It was very out of the blue. They called me in for what I thought was another general meeting. It ended up being them feeling out my interest in directing *The Last Jedi*. Only then did I realize what the meeting was [*laughs*]. It was shocking. It was amazing. And it was also something that I took a step back from and gave some real thought to, for a lot of different reasons," Johnson recalls. "Ultimately, I just couldn't imagine anything making me happier than doing this. And I thought, 'Well, that's what I should listen to.'"

▲ **TEMPLE 04** "This was a very early take on Luke's temple, way back when there was still no director. This artwork was shown to George Lucas in a presentation. Doug came back and said, 'Congratulations, James. You got a George "Fabulouso" stamp.'" **Clyne**

"After working with George on the prequels for seven years, I knew in some ways how to anticipate what forms he would like—which is really good, because he still likes those forms. So for the Jedi temple, he loved that bell shape. It's reminiscent of some of the imagery that [original *Star Wars* trilogy concept artist] Ralph McQuarrie painted way back." **Chiang**

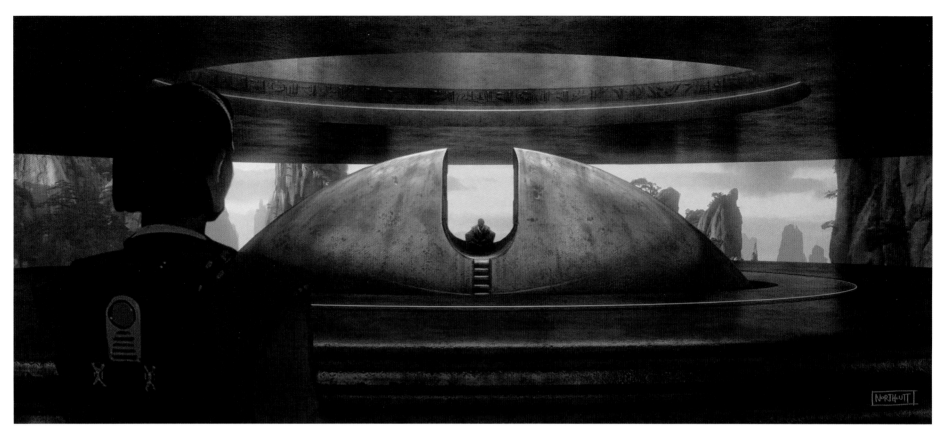

▲ **TEMPLE INTERIOR 01** Northcutt

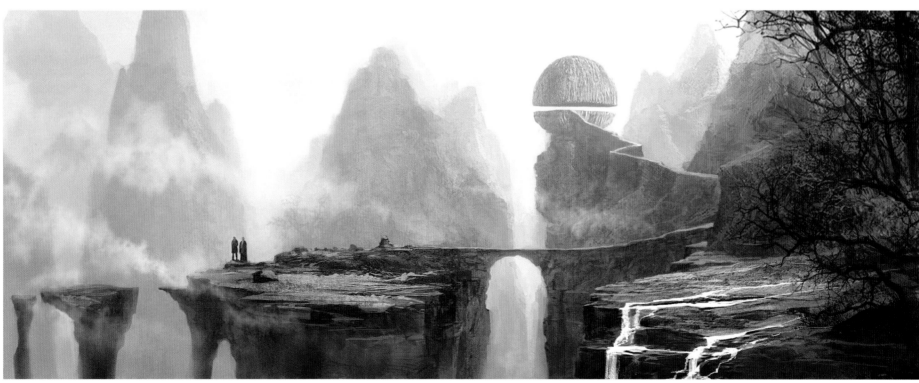

▲ **TEMPLE 4A** "I was going with a really eclectic mix of architecture and mysticism. I thought, 'Let's design things that hint at the power of Luke.' Weird stuff. So I had the idea of floating rock domes, little things that are very *Star Wars*." **Chiang**

▲ **LUKE A** Chiang

▲ **LUKE VERSION 03** Iain McCaig

▲ **LUKE 03** Alzmann

▲ **KEYFRAME 001** McCaig

Rick Carter brought in a stack of random stills from Japanese filmmaker Akira Kurosawa–directed films such as *Rashômon* and *The Hidden Fortress*—huge influences on George Lucas as a filmmaker generally and on *Star Wars* specifically—to the first Visualist meeting on January 9, 2013. As a creative exercise, Carter handed that stack to Kiri Hart and asked her to select several that told the story of *The Force Awakens* in whatever way she thought best. The five chosen images were eventually painted by the concept artists to depict Kira's/Rey's journey through her training with Luke Skywalker.

▲ **KIRA TRAINING** Karl Lindberg

▼ **KIRA VICTORY** Lindberg

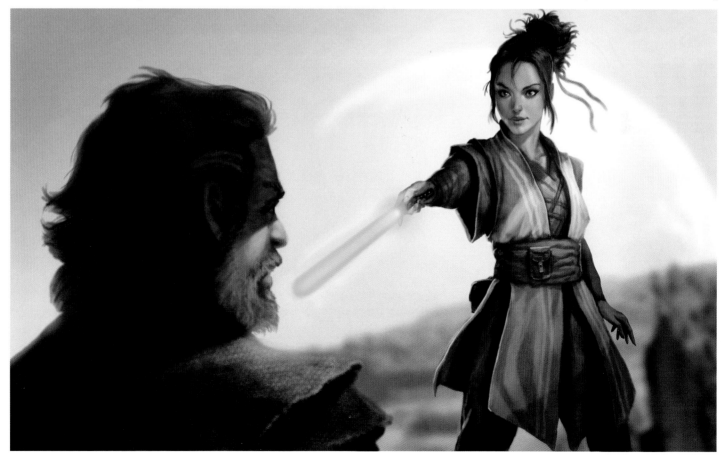

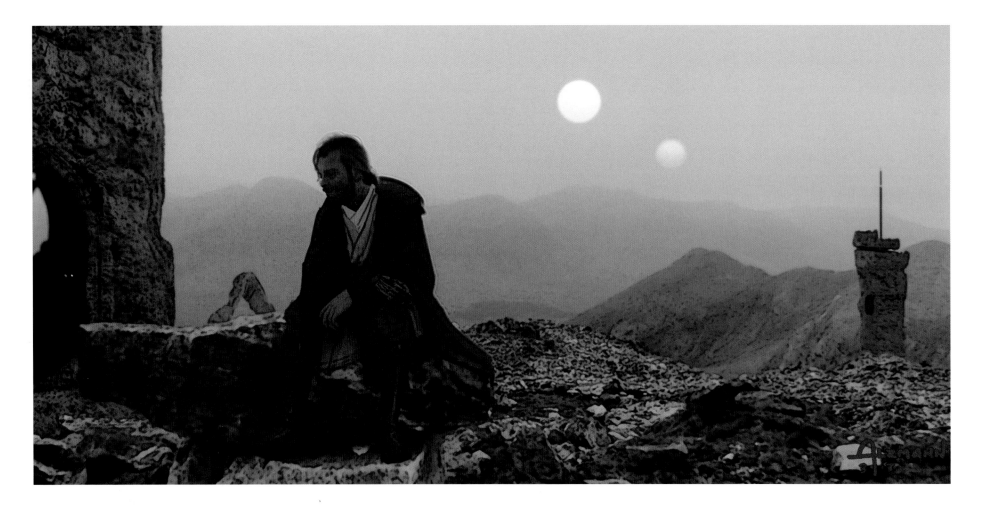

▲ **LUKE SUN MOMENT 02** "My first project was Luke Skywalker, who was inspired by Marlon Brando's character in *Apocalypse Now*, Colonel Kurtz. Luke was always on another planet. And Kira's—the female heroine of the story [later renamed Rey]—journey was to find her master and begin her training. She has to discover who Luke Skywalker is, what the Force is, and then, by the end of the film, meet him if not begin their training together." **Alzmann**

"There are lots of versions of down-and-out Luke. Rick Carter has us working almost in a dream state. 'Let's do the two suns: it doesn't necessarily have to be Tatooine.' He wants the vibe to be *Star Wars*. I believe that was something he specifically asked for. 'Put the two suns in this,' even though I was thinking it was another planet." **Alzmann**

◄ **LUKE SITH GHOST 01** "We've seen dead Jedi come back as blue ghosts. Maybe Sith can come back. And maybe there's some all-powerful mastermind Sith that's controlling whatever the dark side is. We did talk a lot about how the final battle frontier for Jedi might be in the spirit realm. So you have to have a bad-guy ghost." **Alzmann**

▶ **SUN DUO 01** McCaig

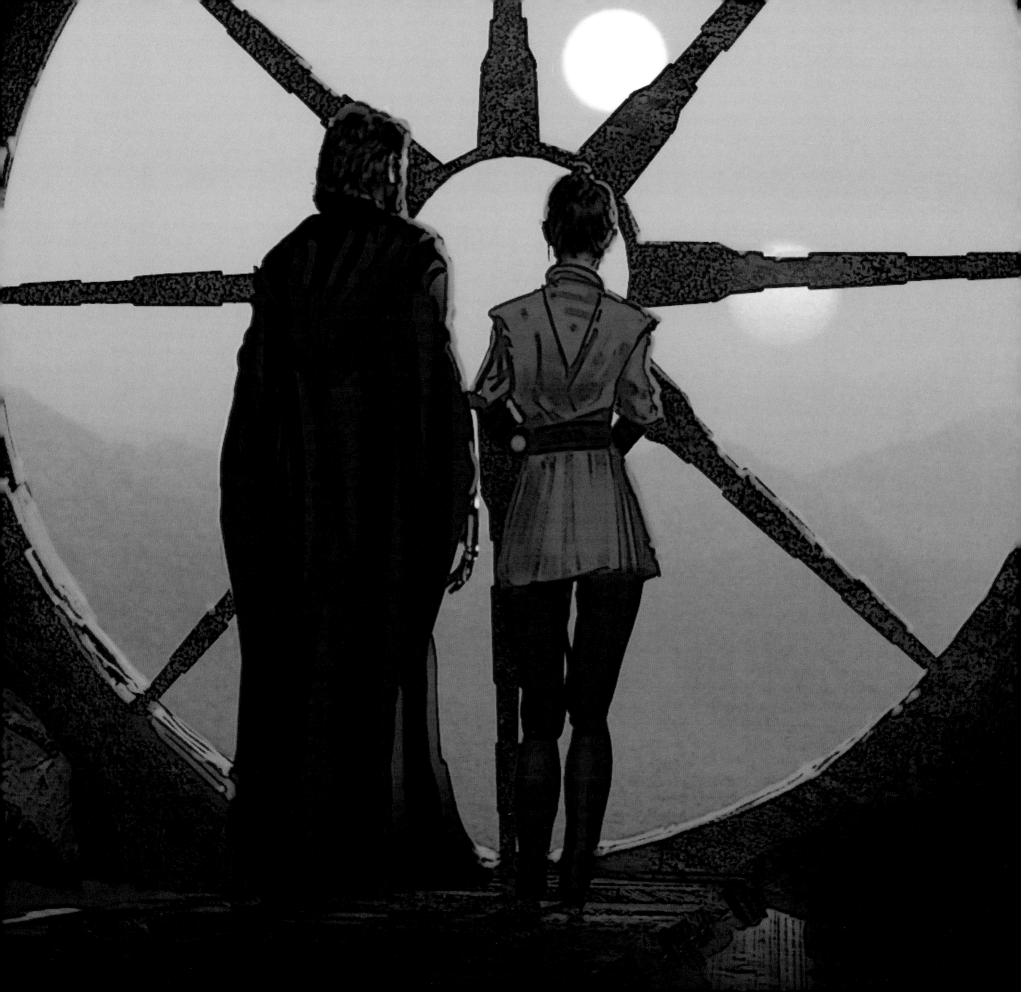

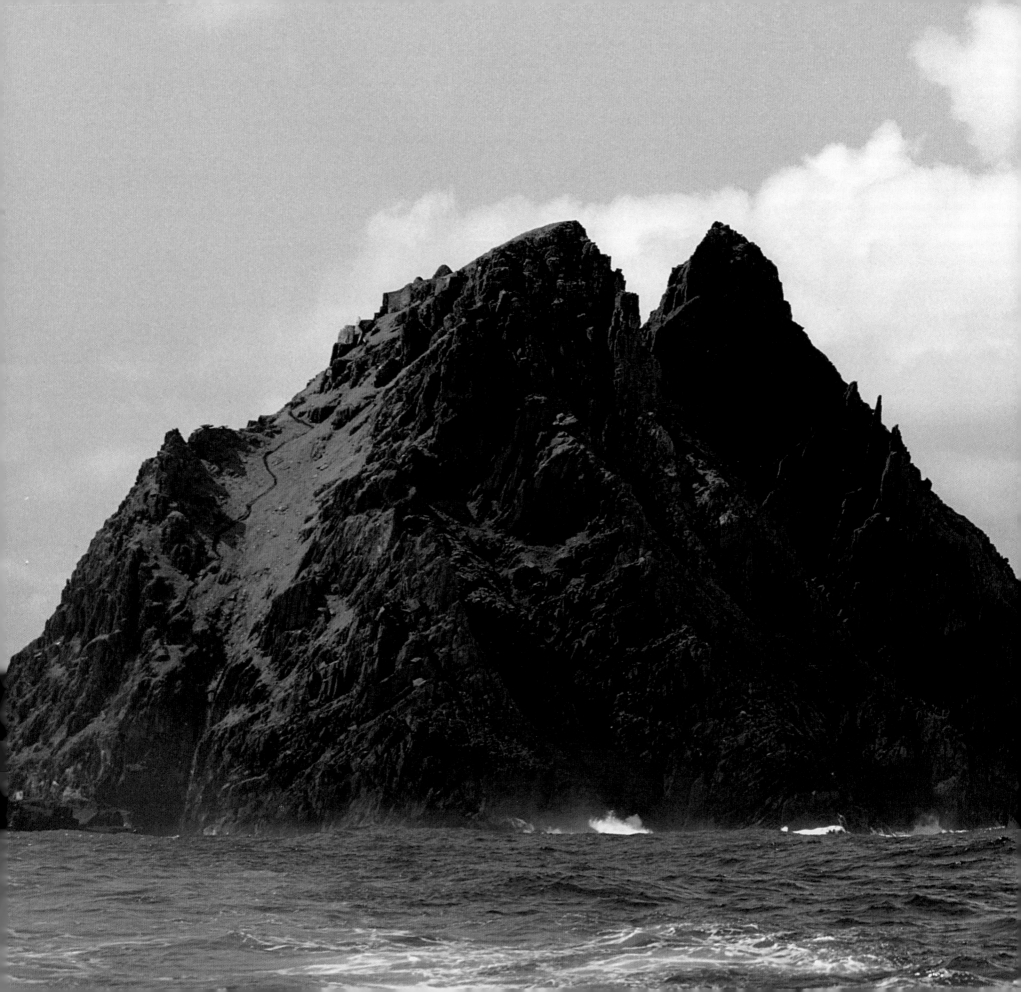

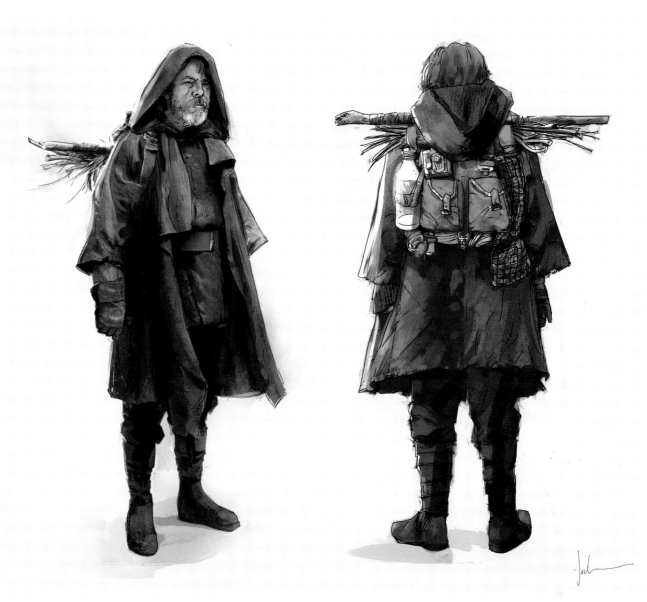

▲ **WORK WEAR FINAL** Jock

"Rian knew that Luke had a lot of daily chores to do. He was not this rebel any longer; he was living his life on this island. So we did something more utilitarian, something that felt a little bit less like Luke Skywalker and more like a *Star Wars* hermit. Long ceremonial robes, with all those stairs on Skellig Michael, would be impossible. So it had to be something more maneuverable and with protection against the elements because it was going to be raining a lot. So waterproof ponchos but still a hood, because we wanted to keep it in that same Jedi vernacular. Fabric-wise it was oilskins and canvas, utilitarian, British." **Michael Kaplan**

◄ **REY ARRIVES AT ISLAND** Rick Heinrichs

EARLY ISLAND PITCH ART

In July 2014, Kevin Jenkins, visual effects (VFX) art director for Industrial Light & Magic London, was still tackling, alongside VFX art director James Clyne, the Starkiller Base battle sequence for *The Force Awakens*. Jenkins heard that Rian Johnson had been hired to direct *The Last Jedi*, and he wished to secure a role on the upcoming film and, more importantly, open up a dialogue with Johnson. "I thought the best way to do it was not to just draw some pictures, but to explain how I think through art and how that could inspire ideas for the film," Jenkins recalls. "All I knew of *The Last Jedi* was that Rian was on the show and they're on the island. I knew nothing else. So I just wanted to fill in those gaps with some art." Accompanying Jenkins's ten pieces of pitch art was a document explaining each idea in detail.

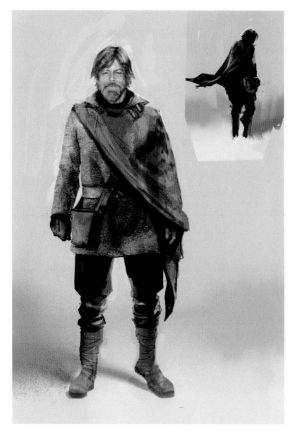

▲ **LUKE 1B4** Jock

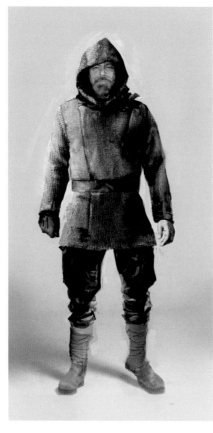

▲ **LUKE OUTER WEAR A** Jock

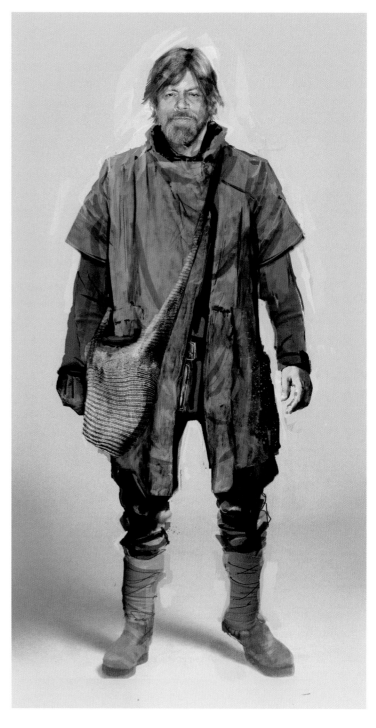

▲ **LUKE 8D** Jock

▲ **LUKE BACKPACK** Matthew Savage

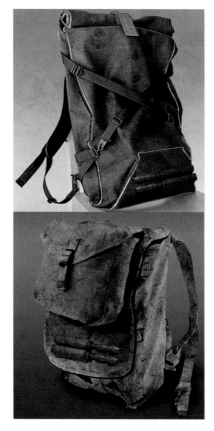

▲ **LUKE BACKPACK VERSION 02** Savage

"Luke's work outfit was one of the first things that we tackled. During the preshoot on Skellig Michael, we just used the costume from *The Force Awakens*. So it gave us quite a bit of time to work out his look. Jock did most of the Luke drawings. Then we made different texture samples to show Rian. If he were wearing a leather poncho, it would go through our aging and dyeing process. And then Tim Shanahan, our key textile artist, would add textures to it or prints on top. So then you'd show the whole lot to Rian and see what he responded to. There's oilskin. There's leather. There's a big, chunky knit, which is then printed over. There are strong heavy cottons. All of these things start out as quite innocuous fabrics that go through our dyeing and aging department. They add more magic to them so the fabrics don't look so worldly." Crossman

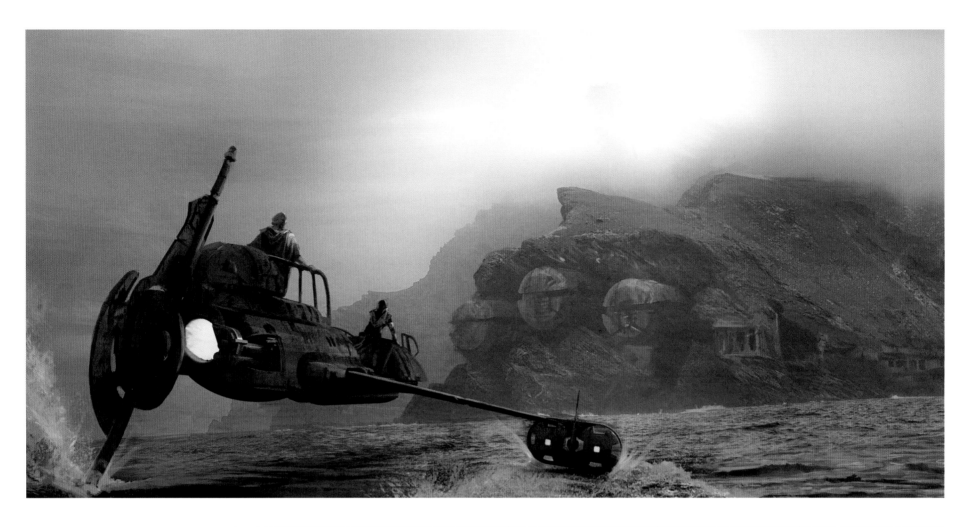

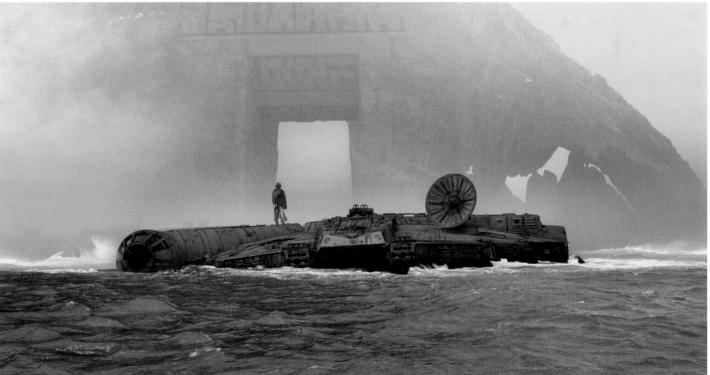

▲ **SKIFF JOURNEY VERSION 01** "Luke has resorted to a simpler life. His only serious technology is an old skiff. He takes Rey around the island whilst on a fishing trip, which reveals the old Jedi temple ruins carved into the base of the island." **Jenkins**

▶ **FALCON IN WATER** "Rey takes the *Falcon* and discovers ruins. Maybe the early Jedi were spread out extensively across the islands. Not being able to land on the rocky island, she chooses to ditch the *Falcon* and swim through the portal. I thought it would be cool to see the *Falcon* deliberately ditched in the sea as a landing." **Jenkins**

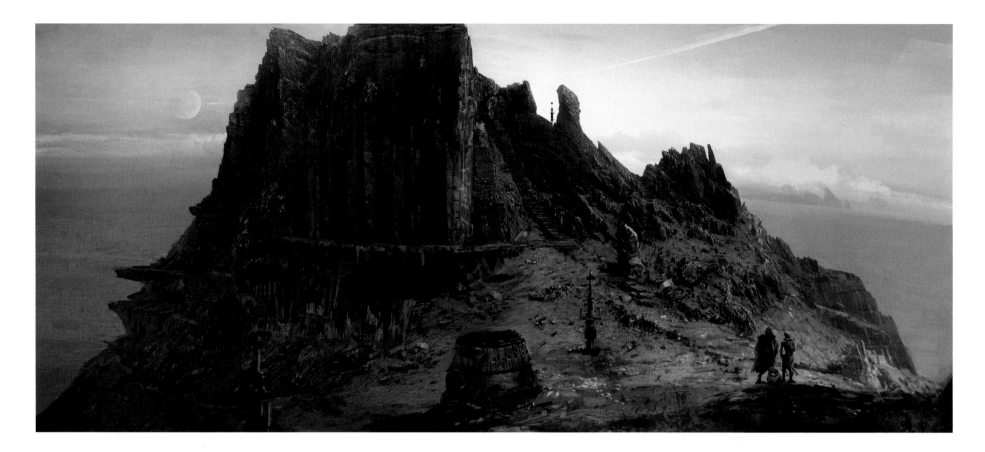

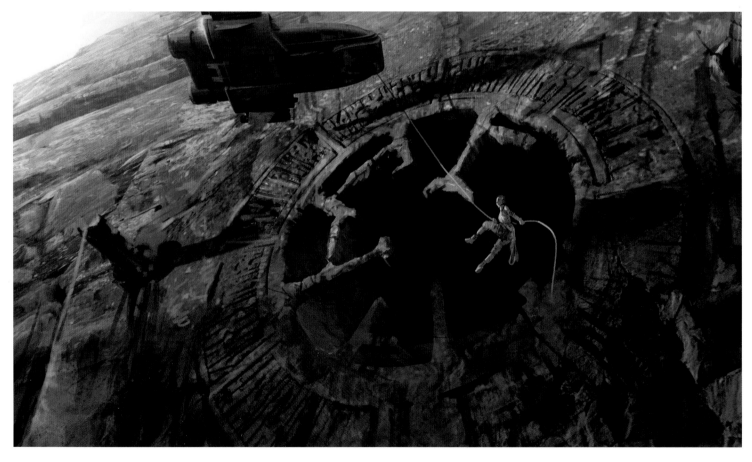

▲ **ISLAND RUINS VERSION 01** Jenkins

◄ **CLIMBING VERSION 01** "The entrance to the ruin bears a resemblance to the window seen behind the Emperor's throne in *Return of the Jedi*. This indicates how the early symbology of the Jedi may have been used over time, representing both the dark and the light side. Possibly, when this first temple existed, there was no light or dark side of the Force. I was looking for ways to tie in designs from the original trilogy and link them with some history." Jenkins

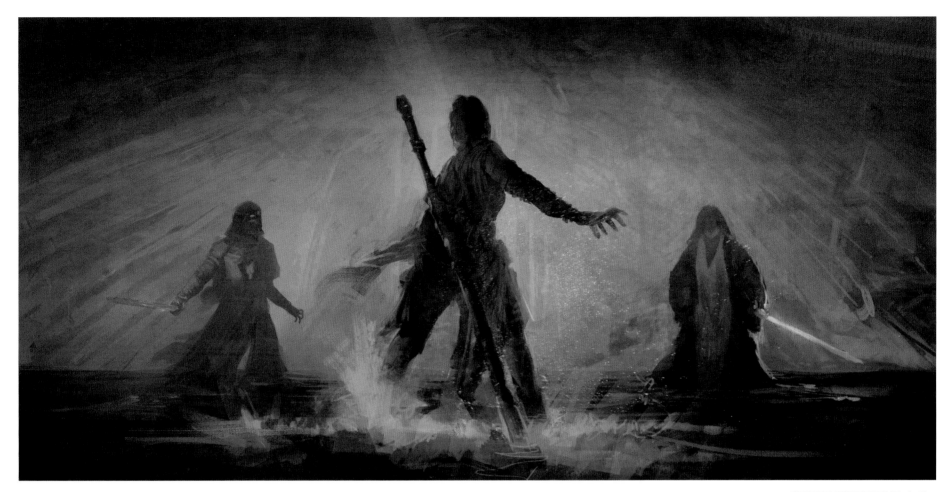

▲ **CONFRONTATION VERSION 01** Jenkins

▼ **NIGHT ASSAULT VERSION 01** Jenkins

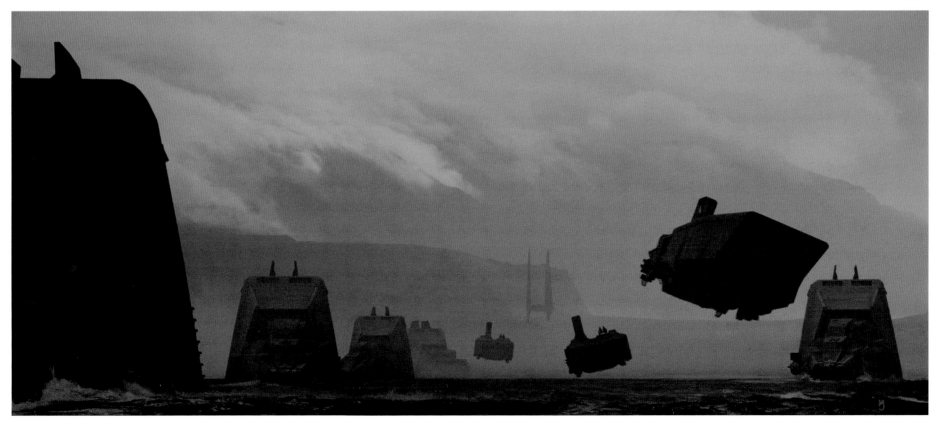

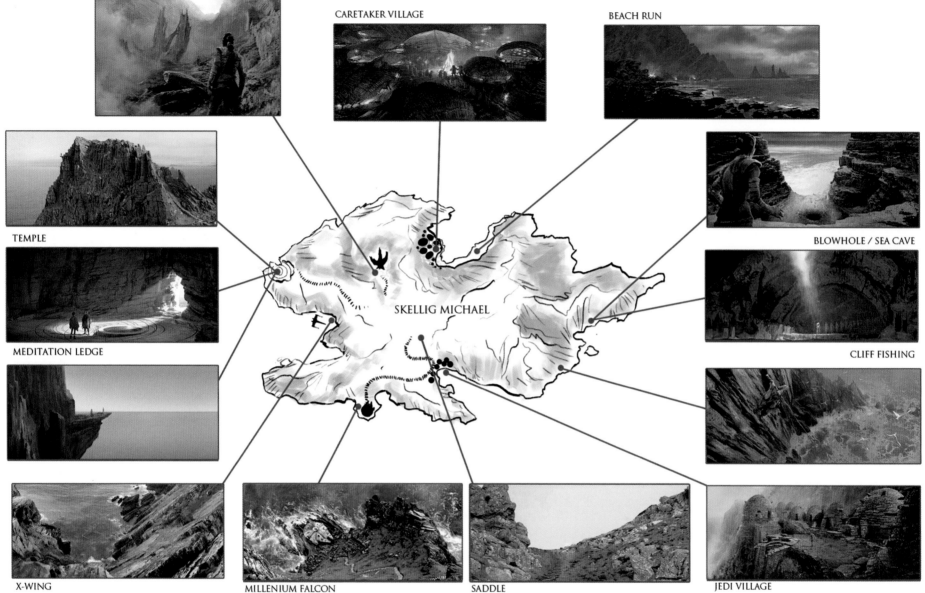

TREE

CARETAKER VILLAGE

BEACH RUN

TEMPLE

MEDITATION LEDGE

SKELLIG MICHAEL

BLOWHOLE / SEA CAVE

CLIFF FISHING

X-WING

MILLENIUM FALCON

SADDLE

JEDI VILLAGE

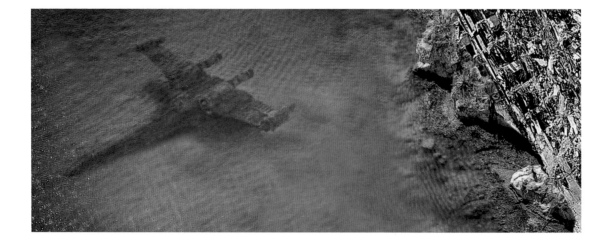

▲ **TEMPLE ISLAND OVERVIEW** David Allcock plus various

◄ **SUNK X-WING 03** Chiang

In February 2013, Doug Chiang painted Luke Skywalker's X-wing starfighter sunk beneath a tropical turquoise sea for *The Force Awakens*'s development. The idea would finally bear fruit in July 2014, when Kevin Jenkins returned to the concept in early pitch art. "I wanted to tell a slightly different story: As Rey finds Luke on the island, maybe she stumbles into these caves and upon the X-wing, rather than seeing it from a distance," Jenkins says. In 2014, he wrote, "Rey explores the island, trying to understand Luke's self-imposed exile from the universe. She comes across a cave, sunk at high tide within the base of the island. Here she discovers Luke's scuttled T-65 X-wing, rusted and rotting away in the water. It was set alight before it sank. It shows Luke's commitment to his exile, as he destroyed his only means of leaving the planet." In the end, Rian Johnson chose designs more similar to Chiang's initial painting of the sunken starfighter just off the coast of the island.

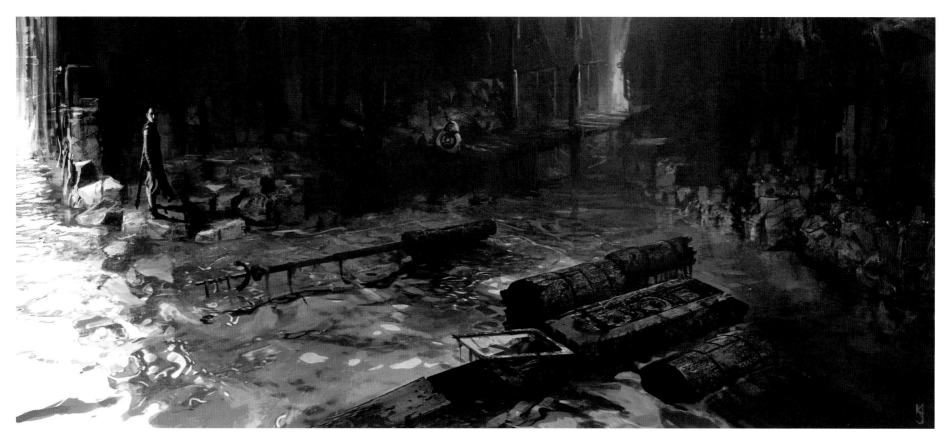

▲ **SCUTTLED VERSION 01** Jenkins

▼ **X-WING UNDERWATER VERSION 07** Engstrom

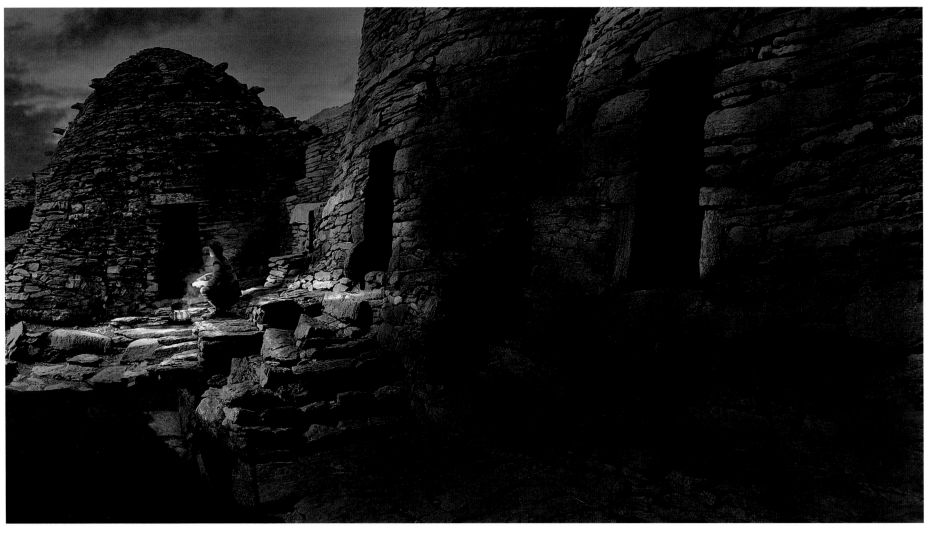

▲ **EVENING VERSION 01** Engstrom

▼ **VILLAGE 02** Dean Clegg and Robert Jose

▼ **LUKE'S WING DOOR FINAL** Nick Ainsworth

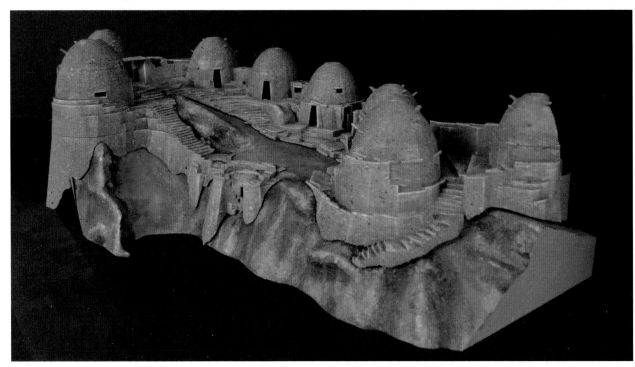

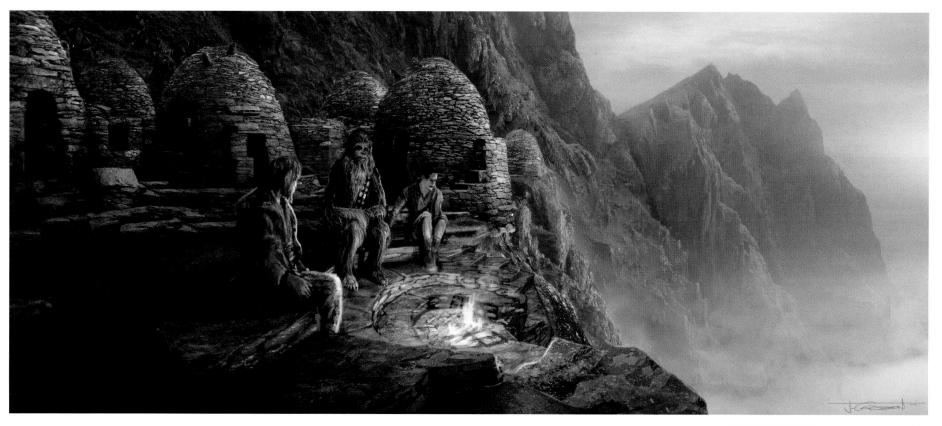

IT TAKES A VILLAGE

As early as the end of 2014, Rick Heinrichs (*Fargo, Pirates of the Caribbean: Dead Man's Chest, Captain America: The First Avenger*) identified the three toughest challenges he would face as production designer of *The Last Jedi*, which he began tackling immediately. The first was the fathier racing creatures on Canto Bight, knowing that their scale and look would impact the environments around them. The second was Rian Johnson's edict that the production shoot as little green screen photography, and as much on location or on set, as possible. And the third was how to shoot for Skellig Michael, the island off the southwestern tip of Ireland where the final scene of *The Force Awakens* was filmed, without having access to the island itself (outside of a short preshoot on September 15 and 16, 2015). "Not being able to shoot at Skellig was a challenge," Heinrichs said. "But we were pretty close to Skellig, on the west coast of Ireland. So the character of the stone—the look and feel—was close enough. We assembled Ahch-To from a lot of disparate elements, going all the way to the northern end of Ireland."

Rian Johnson recalls, "We had this crazy notion, which ended up paying huge dividends, of actually building the village set on a cliffside in Ireland. So you get the real elements, the real interactive light and the scenery. An obvious answer to the problem would have been putting a green screen around the village and comping all of that in. But I watch those scenes in the finished film and there are lighting conditions and interactive things happening that I'm not talented enough to have imagined or asked for on a soundstage."

"That came out of the location scouts we did very early on in 2015," Heinrichs says. "There were a lot of amazing cliffs along the coast of Ireland. But if it doesn't wrap around on itself, so you can actually see the cliffs, then it doesn't make any sense to use them for the village. The location we ended up using was the one particular place that had this incredibly dramatic cliff and ocean that wrapped around. There was nothing else like it."

But a further complication added to the complexity of the Jedi village shoots: scripted scenes set at night, in the rain. "The very specific logistical problem is not just that it would be uncomfortable, but also that you have to hang big lighting structures and rain rigs from cranes up above the set," Johnson said. "And the wind out there on the cliffs doesn't let you do that. So it's technically impossible. We went back and forth and ultimately said, 'Look, we have to do it twice: build it once on set to do our night stuff, and then pack it up and ship it to Ireland for all the day stuff.' So we did. That was a challenge." The Jedi village night and rain scenes were shot on April 6, 7, and 8, 2016, on the North Lot at Pinewood Studios, Buckinghamshire, England. The set was then packed up and shipped to Sybil Head on the Dingle Peninsula of Ireland for additional location shooting on May 18 through May 24, 2016.

CARETAKERS

"Personality-wise, I wanted the Caretakers to feel like nuns—to feel disapproving," Rian Johnson remembers. "But I didn't say, 'Make them fish people.' That's just the direction they ended up going in." Returning creature effects creative supervisor Neal Scanlan (*Babe*, *The Golden Compass*, *Prometheus*) recalls, "Rick Heinrichs had several early designs for Caretakers, which were rather goblin-like or *Lord of the Rings*–like in their initial sort of feeling. Skellig Island is a puffin island. So there was a parallel concept development: What the Caretaker looks like would also be true for their fellow island-native porgs. There has to be some feeling that, from an evolutionary perspective, the same DNA is in there. And the thinking was the Caretakers should have a more aquatic or fish-like quality to them."

Scanlan continues, "One particular Caretaker is the matron; she's in charge, and she clearly has a problem with Rey being on the island. Rey's intruding in this private world, and in this private relationship that they have with Luke. That was the idea: to try to always make you feel that the Caretakers love him. As we did with *Rogue One* and a little with *The Force Awakens*, we always try and find a real-world example of somebody we can all identify with— 'Yeah, to me, Matron is Margaret Rutherford'—and get that quality into it. You didn't really mess with Margaret. She had a certain sense of being in control all the time. But she's also very lovely, and you want to cuddle up with her."

▶ **PUFFIN 22B** "I did try and give the males a bit more bulk in the shoulders and a slightly rougher, craggier edge to the face, perhaps less fluid than the females. I wanted to experiment with the idea that perhaps they weren't such a primitive society. The script told us that the male group visited the island every month, so I began thinking that perhaps they went out on extended, weeks-long hunting trips or worked far offshore on some kind of drilling rig, hence the inclusion of hard hats and goggles, and heavy duty harpoon guns and power tools." **Jake Lunt Davies**

▲ **PUFFIN GIRLS** Justin Sweet

▲ **PUFFIN 04** Luke Fisher

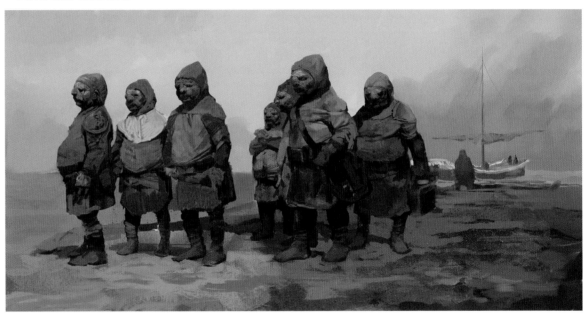

▲ **PUFFINS IN PROGRESS** Sweet

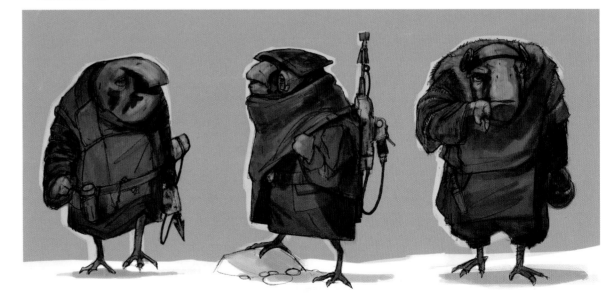

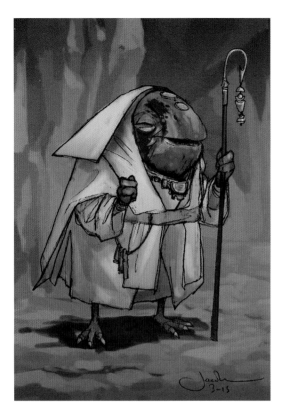

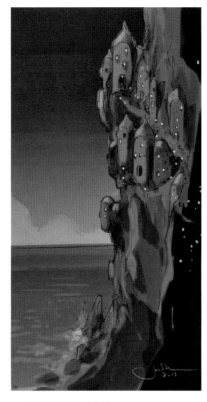

▲ **PUFFIN 17** Lunt Davies

▲ **PUFFIN 18** Lunt Davies

▲ **PUFFIN 13** "I started by sketching ideas that played with the silhouette of a puffin's head and beak, and then mixed in shapes, forms, and skin textures of aquatic mammals like seals, whales, and manatees. The color-flashes around the eyes and nose are pigmented skin markings that mimic a puffin's beak coloration. I saw them living primitively as a hunter-gatherer tribe, like the Inuit/Eskimo, using the available materials for all their needs: seals, whales, and fish providing their meat, furs, and textiles, bones for weapons, etcetera. I hinted at a possible religious reason for their group with the Matron's staff, using fish symbols or reinterpreting the shepherd's crook as a barbed fish hook." **Lunt Davies**

▶ **PUFFIN 23C** Lunt Davies

"We started with a generic male or a generic female, and then found the Matron from what we learned during iteration. So, for instance, if one was male and he was a real seafarer, he might have a barnacle on his face, and his face would be weathered and leather-like. If she was somebody who was going about her business washing clothes, she would have a content, in-her-own-world, rather calm karma about her." **Neal Scanlan**

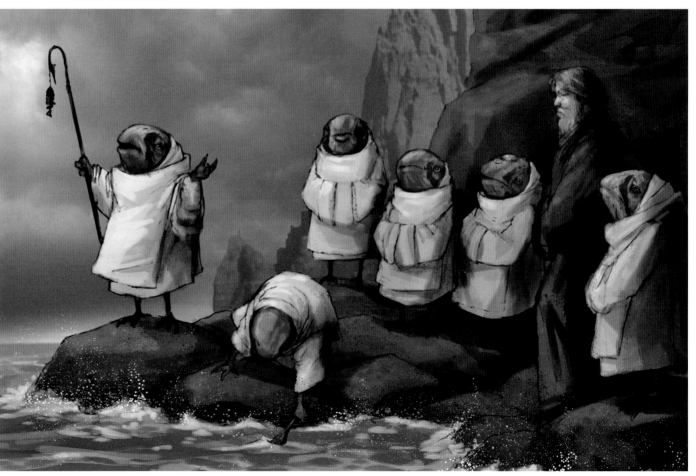

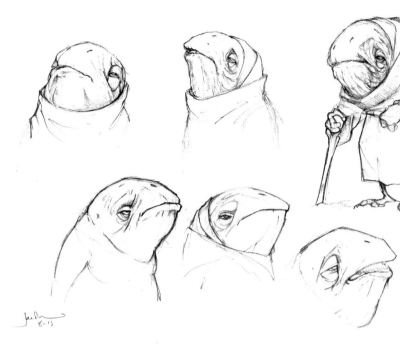

▲ **CARETAKER POSES 30** Lunt Davies

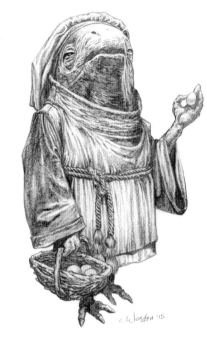

▲ **FEMALE CARETAKER 01** Chris Weston

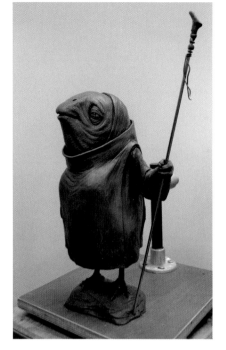

▲ **CARETAKER MAQUETTE** Martin Rezard

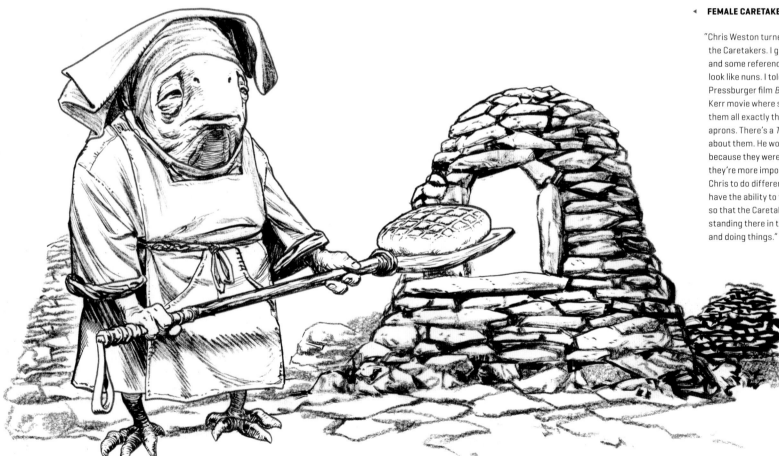

◄ **FEMALE CARETAKER 12** Weston

"Chris Weston turned out to be brilliant at doing the Caretakers. I gave him some rough sketches and some reference material; I wanted them to look like nuns. I told him about the Powell and Pressburger film *Black Narcissus*, a Deborah Kerr movie where she plays a nun. I didn't want them all exactly the same. I wanted different aprons. There's a *The Sound of Music* feeling about them. He worked on the females first because they were whom you see first and they're more important in the story. I asked Chris to do different activities, so Rian would have the ability to think about that and choose—so that the Caretakers would not just be standing there in the background, but engaged and doing things." **Michael Kaplan**

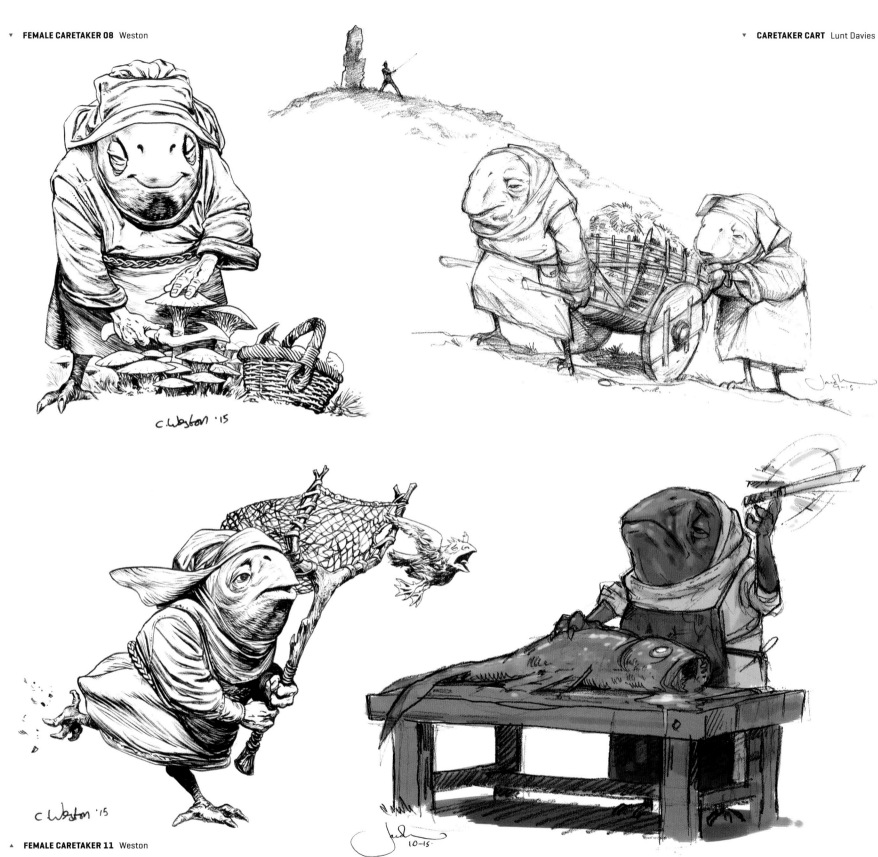

c.Weston '15

c.Weston '15

▲ **FEMALE CARETAKER 11** Weston

"Chris Weston did a sketch where one was chasing a bird
with a butterfly net. When I saw that, I was like, 'Oh, that's
it. That's what we're going for.'" *Johnson*

▲ **CARETAKER SUSHI** Lunt Davies

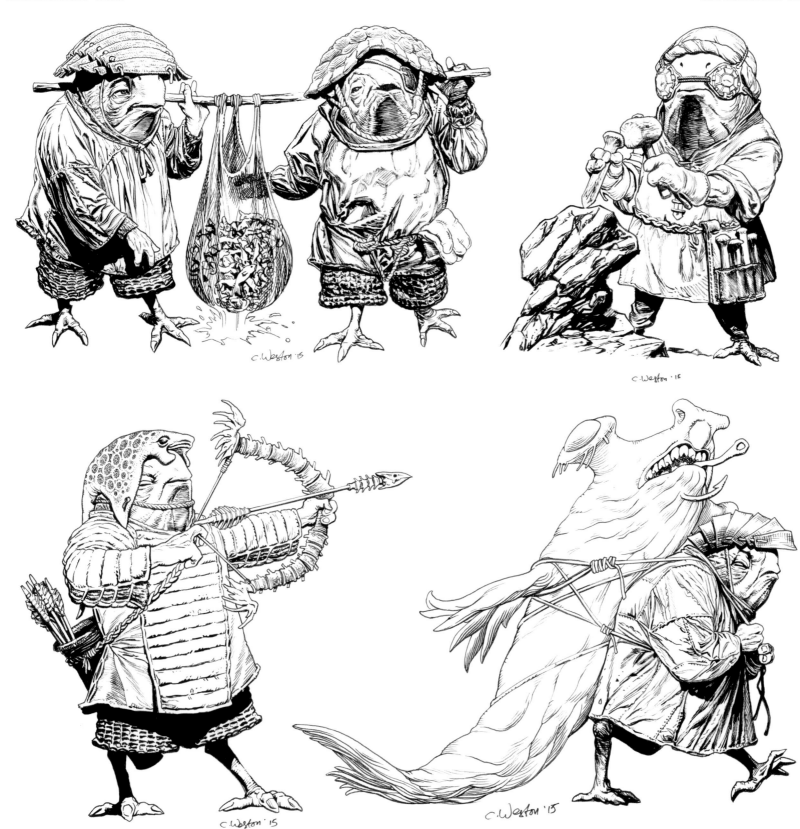

▼ **MALE CARETAKER 13** Weston

▲ **MALE CARETAKER 07** Weston

▶ **COLOR CARETAKER** Weston

"There was a dedicated workroom solely doing Caretaker costumes for a few months—piecing together various textures. And then our costume props department made the specialty stuff, like bones or fish heads or shells, which was added to everything. So it was quite a long, detailed process for the Caretakers. It started out at thirty Caretaker costumes and then it dropped slightly, into the twenties." **Crossman**

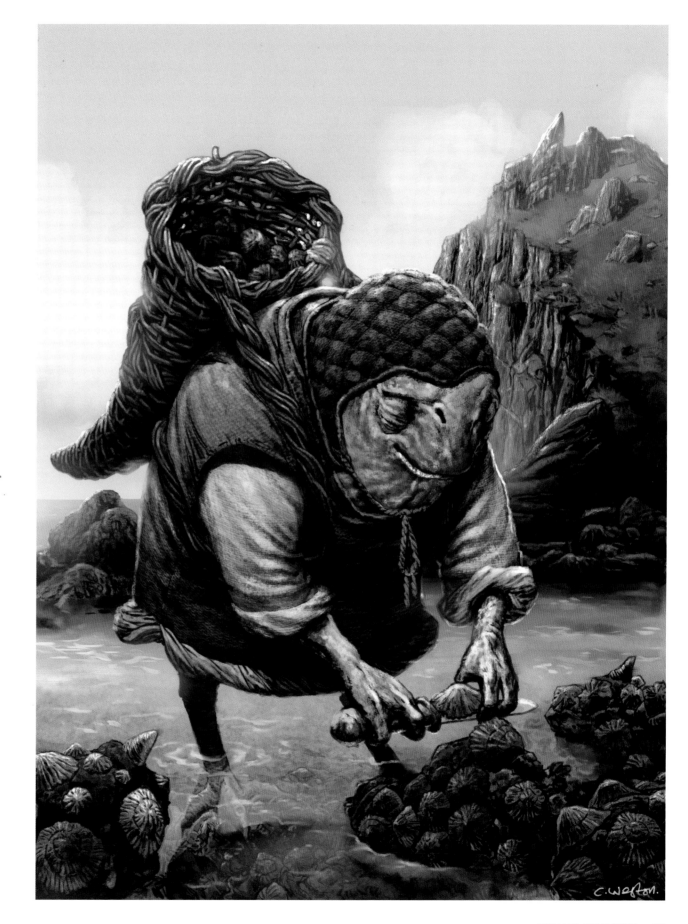

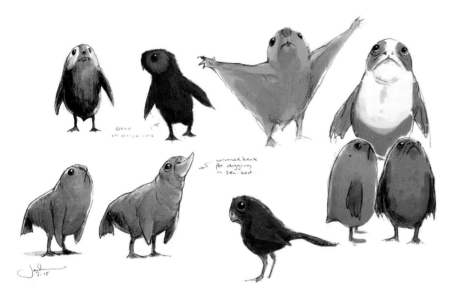

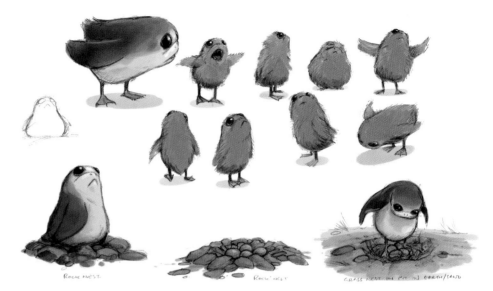

▲ **PORG CHICKS 01** Lunt Davies

▲ **PORGS 03** Lunt Davies

"All of the puffins were on Skellig Michael when we went for the preshoot in September. I forget who exactly had the idea, but you get the sense that all of these things evolved from the same creature. [Laughs] So, with the porgs, I knew I wanted something puffin-like." Johnson

"After we'd explored ideas that drew from birds, bats, flying squirrels, and aquatic creatures such as seals, otters, and beavers, the sketch which caught Rian's eye was this one [bottom right]. By and large it carried on right through to become the porgs. The influences for the design were a seal combined with a pug dog. At this stage they had seal-like fur, flippers for wings, and webbed feet. They were flightless and would be more at home underwater, like penguins." Lunt Davies

▸ **PORG BEACH ROAST 03** "With Chewie's porg, there was consideration to give it different markings, even as far as mirroring Chewie's coloration. But we felt this didn't seem right or make much sense. The only concession was to give the porg a blue iris to the edge of the eye instead of the usual brown." Lunt Davies

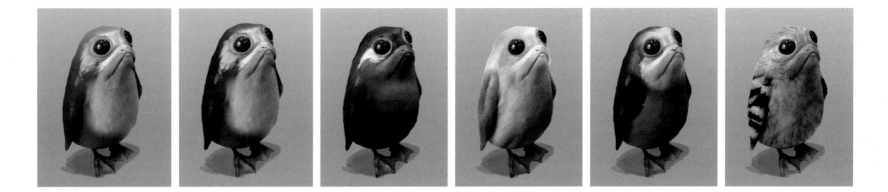

▲ **PORG COLOR TESTS** Lunt Davies

"Simplification is really important with nearly every design in *Star Wars*. We kept coming back to saying, 'It doesn't really matter what the detail is. What's the outline? What's our little porg? If a child wants to draw a porg, how easy is it to draw so that you instantly know it's a porg?' That pushed it to two eyes and a little head on a stubby body with little legs." Neal Scanlan

"We eventually got the color options down to nine, which were painted up on foam versions by creature paint finish designer Henrik Svensson. It came down to a choice between brown and white with orange flash and one onto which I'd transposed the markings of my dog Jess. It was agreed that the brown, white, and orange was the stronger look because, as ever with *Star Wars*, being able to distill a design to its bare essence and still have it recognizable is the ideal." Lunt Davies

"All in all, we made about fifteen porgs for specific moments. From a methodical perspective, they all came from the same generic mold: Each skin was designed to fit the same mechanism, and the mechanism was designed to be modular. So we could kit out a porg per its requirements for the film. They are a kit of parts that allows us creative freedom to say, 'Oh, this one has to scream. Oh, this one has to splat against a window.' Different needs, and the differences *for* those needs are subtle: the lines of the eyes, a slight downturn to the mouth, a slightly puffier nose, or slightly more scrunchiness." Scanlan

▼ **PORG SEAT RIPPER** Lunt Davies

▲ **PORGS LIGHTSABER 08** Lunt Davies

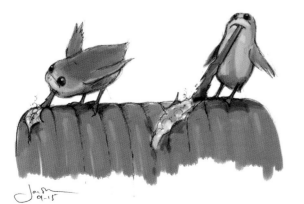

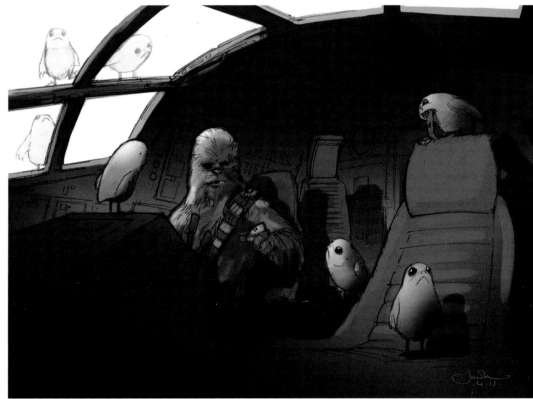

▼ **PORGS COCKPIT 02** Lunt Davies

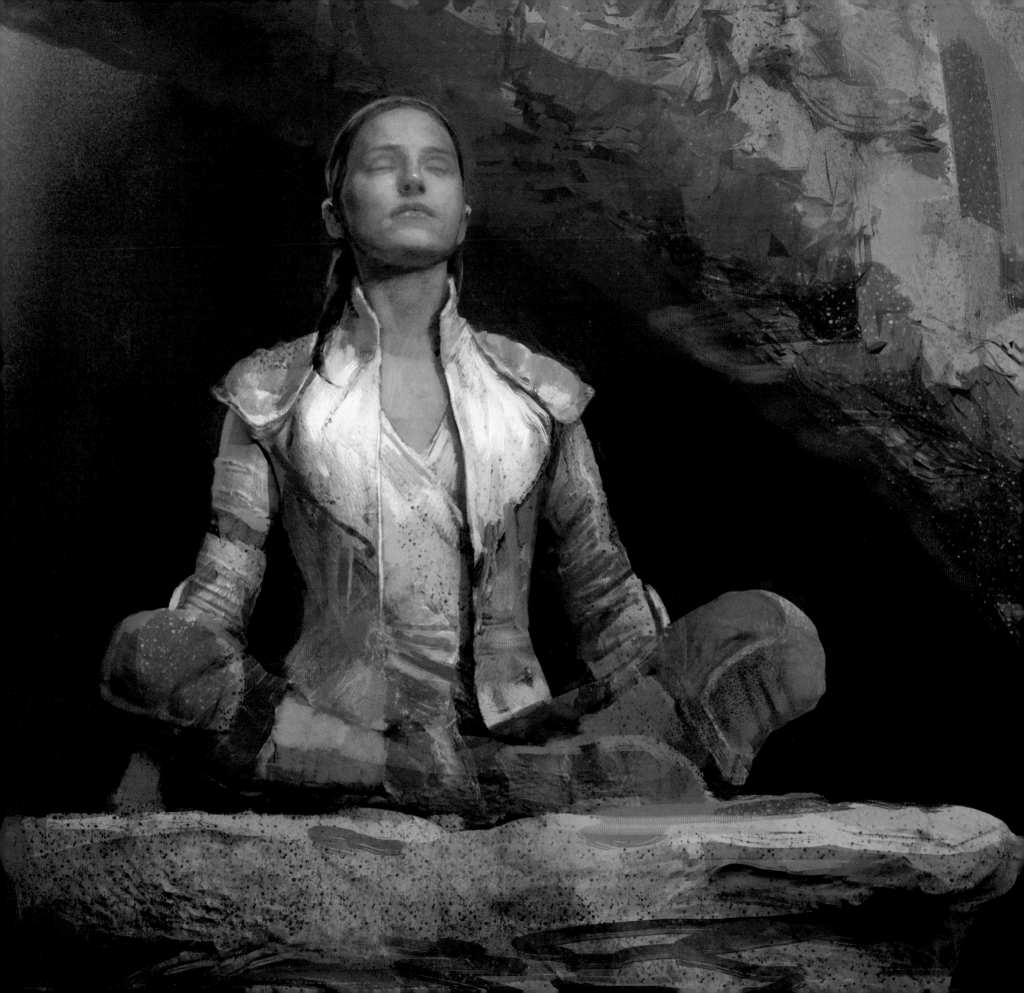

Rey and the Jedi Steps

Just as *The Force Awakens* co–production designer Rick Carter had done with director J.J. Abrams a year earlier, he invited Rian Johnson to his home in Malibu, California, for a weeklong series of story sessions. "The very first thing that I did was have lunch with [*The Force Awakens*'s co-screenwriter] Larry Kasdan. But the very next thing I did was go out to Rick Carter's house," Johnson remembers. "And we had four or five all-day sessions where we'd go down, take a long walk on the beach, and just talk, not even brainstorming story stuff or even *Star Wars* specifically, just really thematic, general stuff. I think I might have mentioned this embryonic visual idea I had of the mirror cave and the multiple versions of Rey. But I didn't know where it fit. He got very excited about that.

"The real value of it for me was the fact that the first step in this potentially scary process was walking on the beach with Rick and having the wackiest, hippy-dippy conversations possible— just letting our imaginations roam, with no sense of practicality at all. It wasn't like just walking with a buddy of mine and saying, 'Wouldn't this or that be great?' This was Rick Carter, who was at the heart of this machine I was about to enter. And this is what *he's* all about? This is going to be okay. [*Laughs*] It was beyond reassuring."

Rick Carter realized very early in the development of *The Force Awakens* that much of the power and resonance of *Star Wars* stems from its innate connections to the life of its creator, George Lucas. So his conversations with both Abrams and Johnson were an attempt to elicit those qualities for their respective films. "The conversations went deep. That's what it was all about," says Johnson. "And at the very start of the process, Rick gave permission to make it personal, which is essential. It was really important to me. My fear coming into it was that the process would be the opposite."

A few short weeks later, Rian Johnson and his long-time producing partner Ram Bergman (*Brick, Looper, Don Jon*) were invited to tour the Lucas Museum of Narrative Art's *Star Wars* prop, costume, and art collection at Skywalker Ranch in Marin County, California. "I got a couple of days in the Skywalker Ranch archives, with the white gloves on, just going through everything." Johnson said. "That was amazing—so incredible and so useful. It put my head in exactly the right space from the get-go."

Johnson continues, "One of the first times I was at Skywalker Ranch, I was hanging out at the Main House library. And there was this book called *Vertical Warfare*, written back during the Second World War, which details the argument for why bombers are the way to go—the efficiency and effectiveness of bombers." *Vertical Warfare* would be one of the earliest narrative seeds planted in Johnson's mind, later inspiring the Resistance bombing-run sequence that kicks off *The Last Jedi*.

One month after Johnson and Bergman's first trip to Skywalker Ranch and following a year and a half development period, principal photography on *The Force Awakens* finally began in Abu Dhabi on May 16, 2014. A week later, Gareth Edwards (*Monsters, Godzilla* [2014]) was officially announced as the director of *Rogue One: A Star Wars Story*, with Edwards's first official day on the job starting at Lucasfilm in San Francisco, California, on May 27.

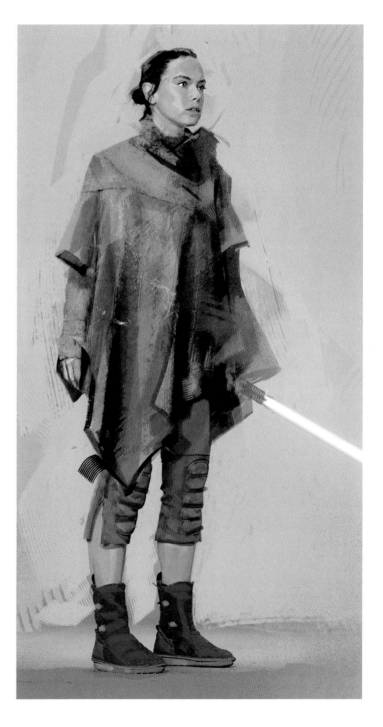

◄ **REY MEDITATE** Sweet

"I wanted to give Rey more color. I knew she wasn't in the desert anymore, so I took her away from desert tones—the creams and beiges, like *Lawrence of Arabia*—and put her in something a little bit more appropriate for this island. So she has a parka, more in the colors of this movie as opposed to the desert. She's in the look she travels in from *The Force Awakens* for a great deal of the movie, but then I thought it was time for a change. And it was the right time to do it." **Kaplan**

▶ **REY OUTER WEAR N3** Jock

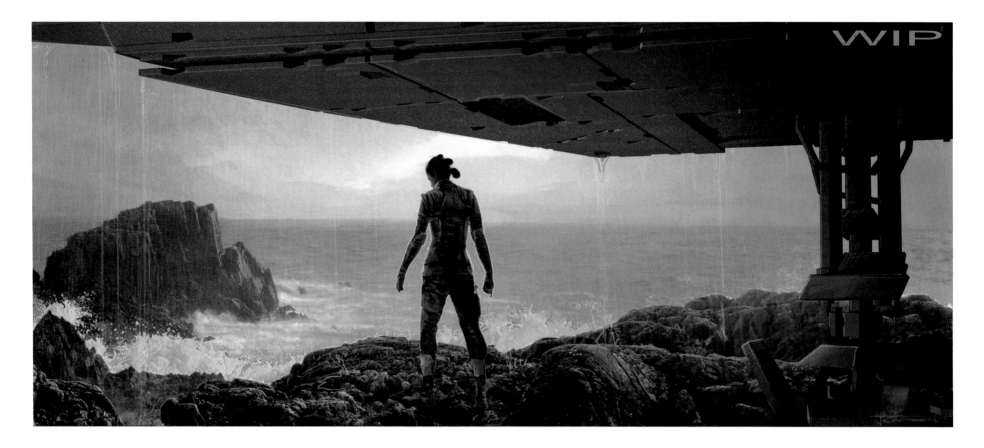

WIP

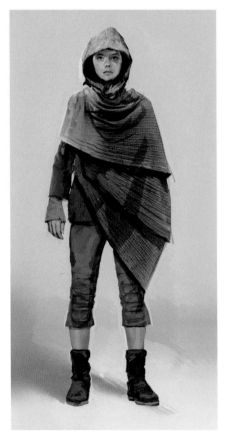

▲ **REY OUTER WEAR H2** Jock

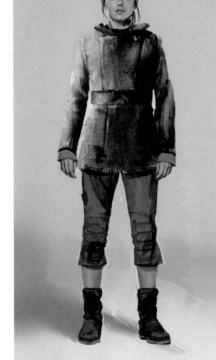

▲ **REY OUTER WEAR J** Jock

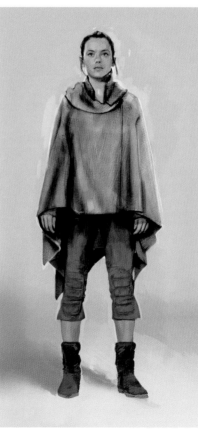

▲ **REY OUTER WEAR K3B** Jock

▲ **UNDERCARRIAGE CLOSE VERSION 05** Carson

"We shot this pretty much in-camera at Malin Head [on the Inishowen Peninsula of Ireland]. The reverse angle, looking back at Rey, was in Longcross in Surrey, England. Hopefully that will all cut together." **Heinrichs**

▲ **HANGING GOLD DICE VERSION 01** Laura Grant

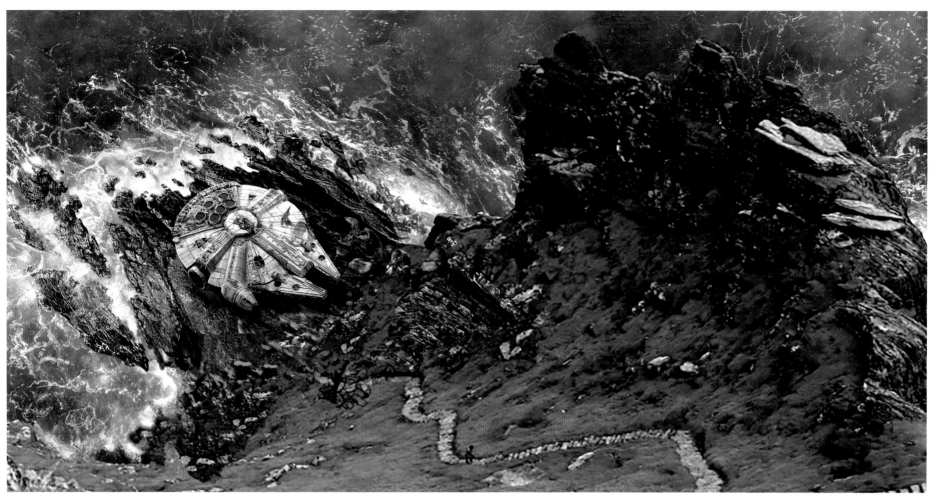

▲ **FALCON LANDING PAD VERSION 03** Jenkins and Carson

▼ **LUKE SNEAKING VERSION 03** Carson

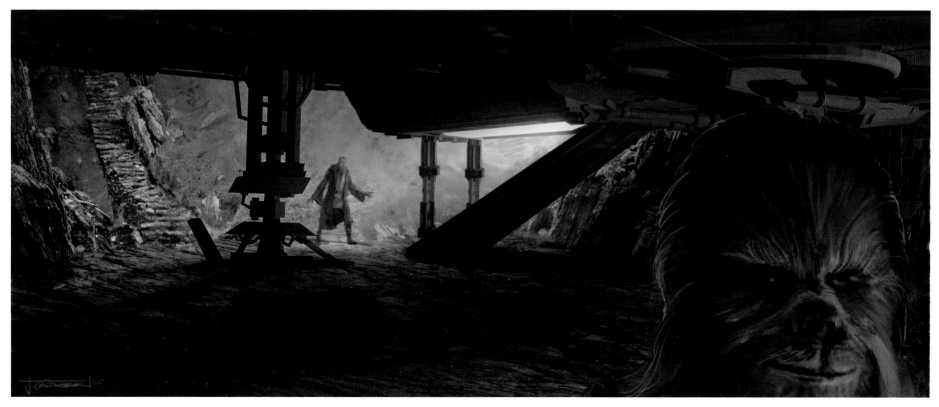

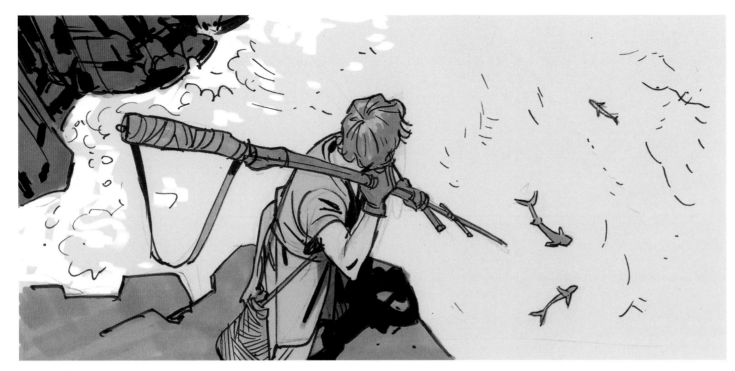

▲ **CLIFF FISHING VERSION 02B** Damaggio

▲ **CLIFF FISHING VERSION 02B** Damaggio

▲ **JUMP VERSION 01** Damaggio

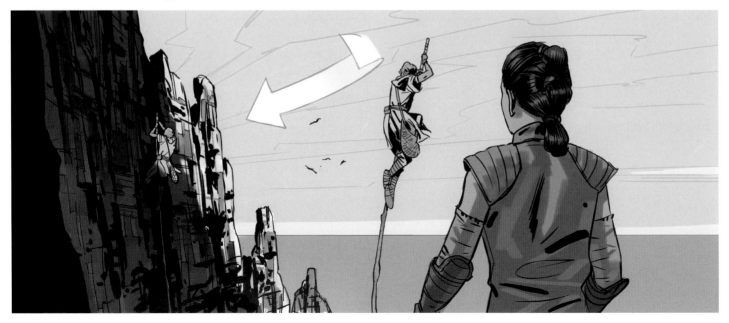

◄ **CLIFF** Damaggio

The fishing sequence was filmed in Brow Head, the southernmost point of mainland Ireland, on May 17, 2016, with Luke Skywalker stuntman Florian Robin suspended hundreds of feet above the surf by an elaborate set of wires and scaffolding. "Honestly, I was always very skeptical about whether that was worth all of the energy it took to make happen on location," Heinrichs wonders. "The proof is going to be in the experience that we have of the real place."

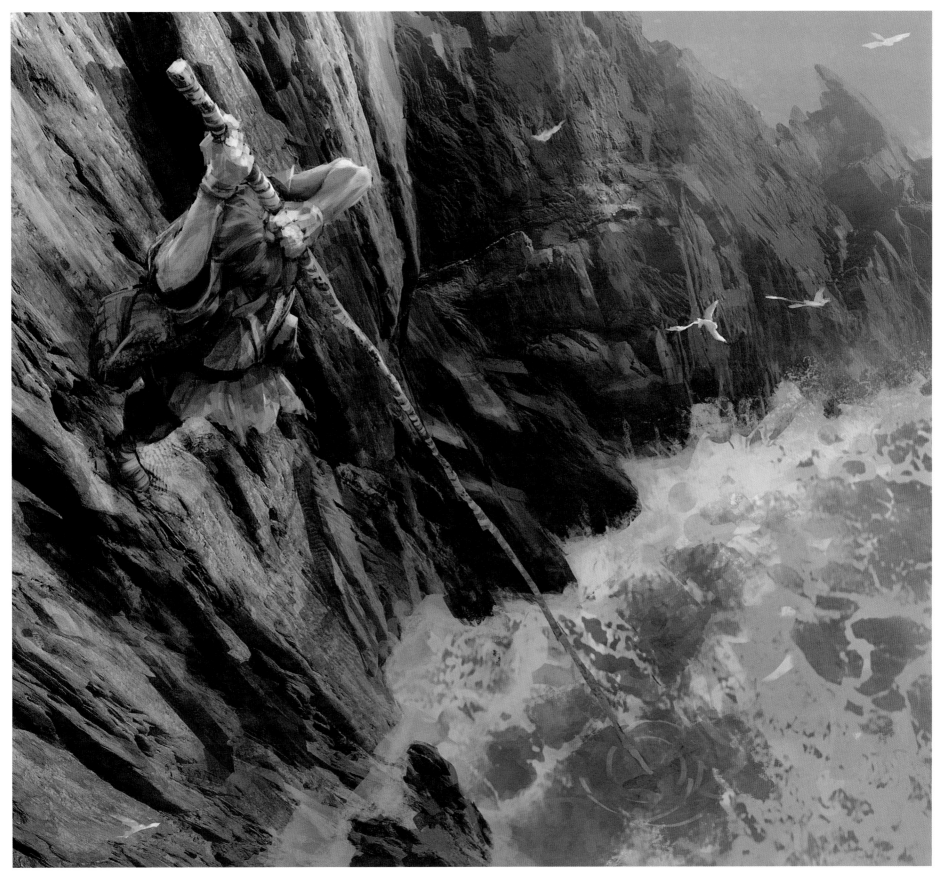

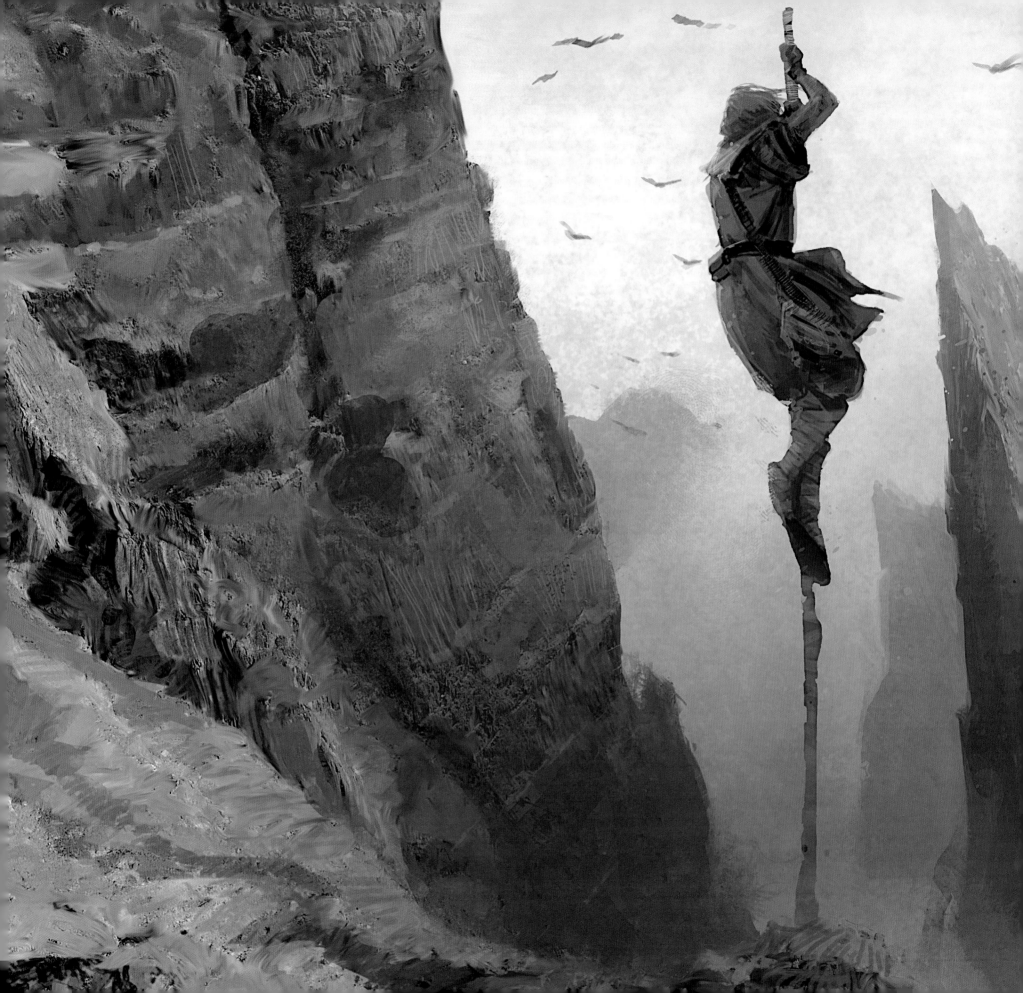

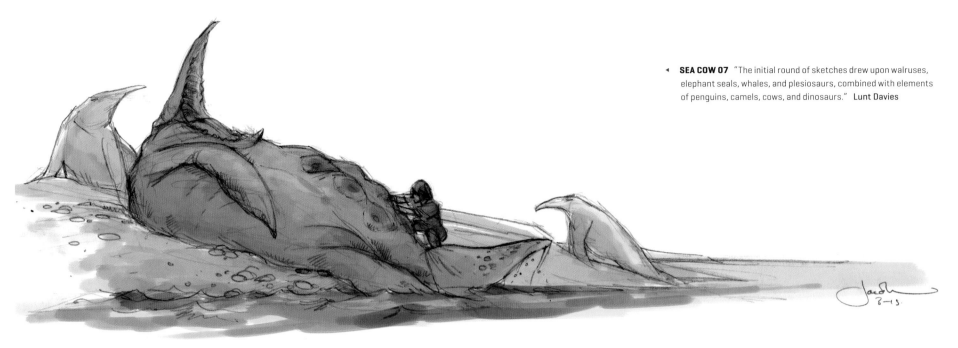

◀ **SEA COW 07** "The initial round of sketches drew upon walruses, elephant seals, whales, and plesiosaurs, combined with elements of penguins, camels, cows, and dinosaurs." Lunt Davies

▶ **SEA COW 02** Lunt Davies

"To be honest, we started with the sea cow's udders because we knew that's what the shot was. We looked at cow's udders, since this is essentially an animal that's being milked. So start with the udders and work outwards. A little backstory to help the design was that they clearly come to this rock to sunbathe and relax, and they do as seals or sea lions would do, basking. Seals have an amazing attitude. The way they lounge around and clearly look to be laughing at you. 'This is what you call life.' So that brought with it the pose, the physical space that this sea cow needed to occupy." Scanlan

▲ **SEA COW 05** Lunt Davies

▲ **SEA COW MOUTH 04C** Lunt Davies

▲ **SEA COW PAINTOVER EYES 02** Lunt Davies

▲ **SEA COW 06** "Rian liked the drooping, dopey face in these sketches, but he wanted to give it a different pose. He suggested it was sitting up, leaning against the rocks, looking slouchy and relaxed like a guy slobbing in his La-Z-Boy with a beer." Lunt Davies

▶ **SEA COW 15** Lunt Davies

▼ **SEA COW BEACH VERSION 04** Tim Browning

▲ **ISLAND LIBRARY VERSION 03** "Rick said there was a library on the island, giving nothing really more than that. So I just went off the vibe of what existed there. Rick felt like this design fit in the world, but it just didn't serve the story needs. The stone steps were just broad-stroke, going off of Skellig. But yeah, you can almost imagine it being in the same location as the final library. As far as I know, other than what Kevin was doing, this was one of the first island locations that we started to revisit." Clyne

▲ **LIBRARY VERSION 06** Damaggio

▲ **TREE SIDE 2** Damaggio

▲ **TREE 1D** Mauro Borrelli

▸ **TABLE 3** Damaggio

"The Jedi tree was going to be on location at one point, and we fought heavily for it to be on location. We drone-scouted Iceland and did a model of the hillside we were going to put the tree on. But there were a number of concerns our construction manager was having. It was becoming fall, and before things got too frozen up there, he had to install a plate in the ground for this thing; April was when we would return and actually construct the tree. Bridges to the location were getting washed out because it's such a natural environment, and Iceland was going to cost us a lot of money to send the main unit to. It was becoming too much the tail wagging the dog, and ultimately, it just didn't make sense. At the very last minute, we were able to pivot to another idea, and we ended up having to build it here, at Longcross. I actually do love that aspect of what we do. The process itself shakes everything out and hopefully you end up with the smart way of doing things." Heinrichs

▾ **TREE CLOSE-UP VERSION 03** Engstrom

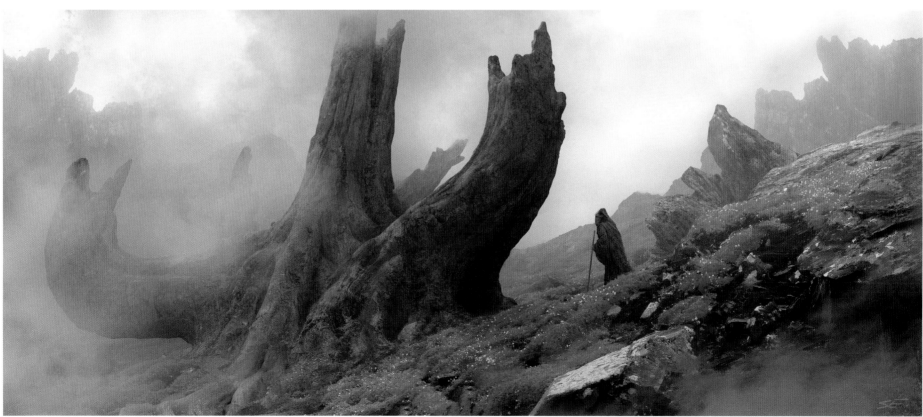

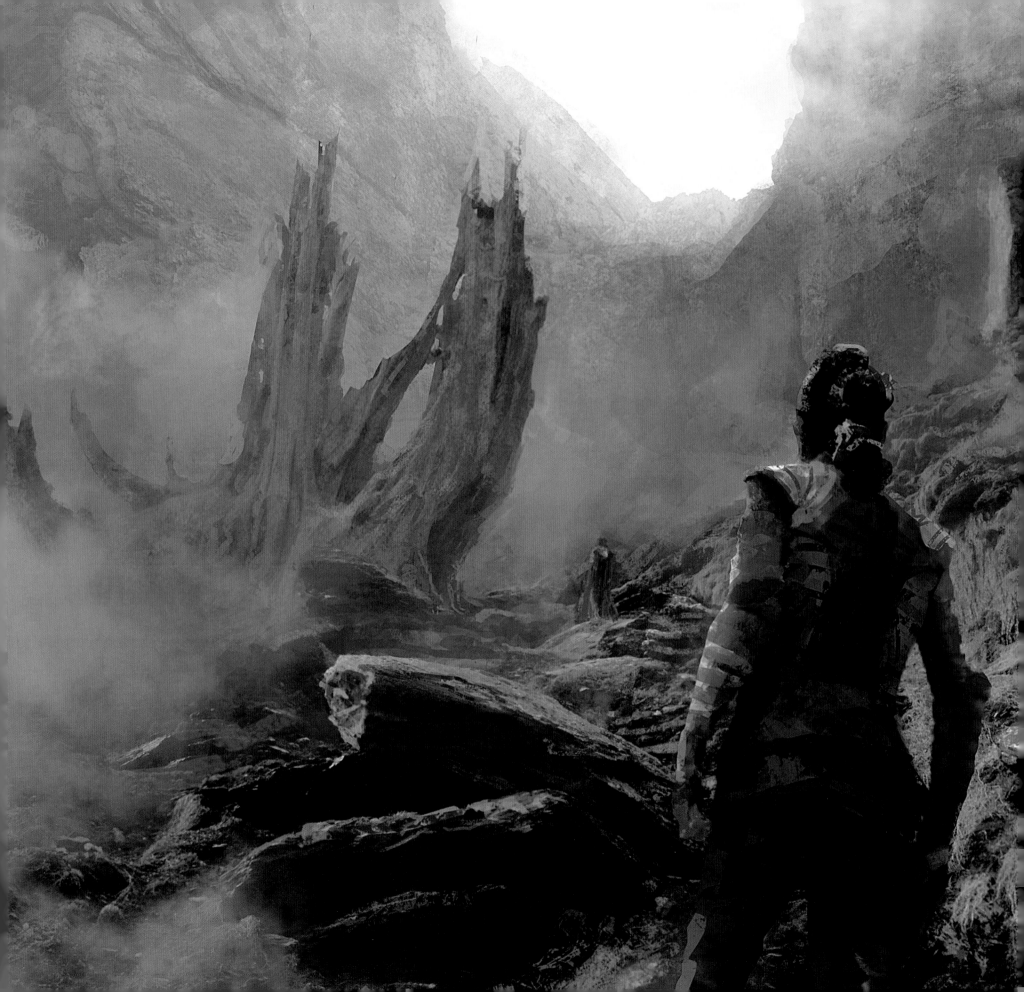

◄ **TREE LIBRARY EXTERIOR 3** Engstrom

▲ **TREE INTERIOR ENTRANCE VERSION 03** Engstrom

▲ **LIBRARY SECTION** Damaggio

▲ **LIBRARY INTERIOR VERSION 03** Damaggio

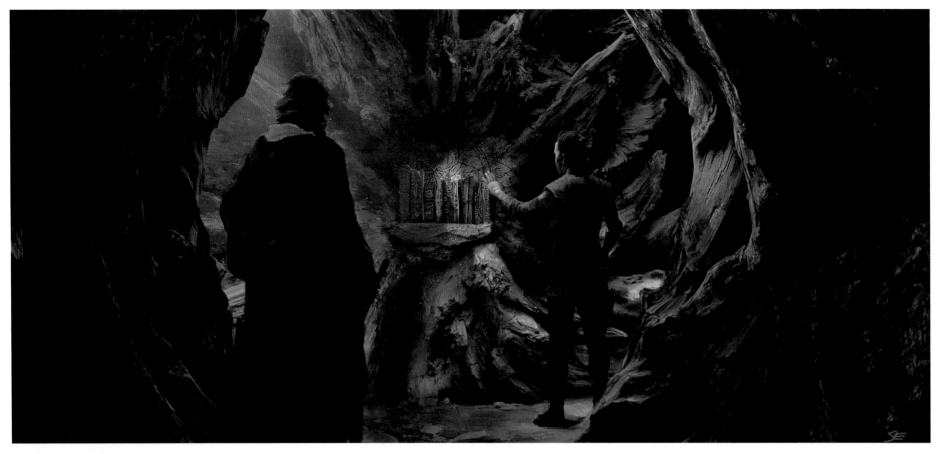

▲ **NEW BOOKS VERSION 04** Engstrom

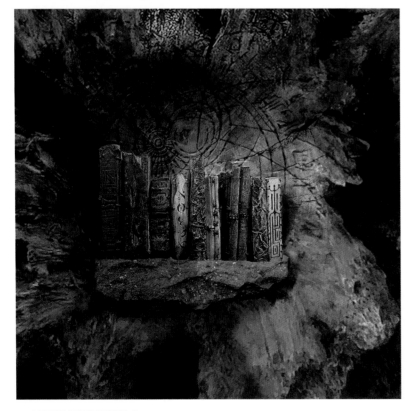

▲ **BOOK NOOK VERSION 6C** Engstrom

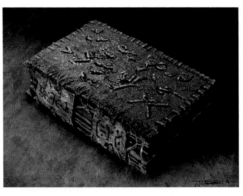

▲ **JEDI BOOK VERSION 01** Carson

▲ **JEDI BOOK VERSION 04** Carson

▲ **JEDI BOOK VERSION 06** Carson

▲ **JEDI BOOK VERSION 07** Carson

▲ **JEDI BOOK PAGES VERSION 01** Chris Kitisakkul

Toward the end of December 2014, production designer Rick Heinrichs reached out to Pablo Hidalgo and Leland Chee, creative executives in the Lucasfilm Story Group, to ask for ancient symbols related to the Jedi that had appeared elsewhere in the *Star Wars* canon. The six-page PDF that Hidalgo and Chee shared would inform the shape of the library tree; the Jedi text covers and individual page designs; the temple's celestial carving; and the reflecting pool mosaic. Heinrichs pondered, "Is it okay to use the rebel icon symbol if you do it obliquely, hopefully not hitting it on the head too hard? It's hard to know exactly how subtle you can be with this stuff.

It's an unfolding universe, and we want the audience to recognize it and be comfortable in it—for it to feel familiar—but also to create something new that they haven't seen before. Hopefully it's not taking them into *Battlestar Galactica* or *Star Trek* or something like that. We were constantly checking ourselves on that, and checking with you, Pablo, and Leland occasionally. Some of the designs were really scraping against the central iconic imagery of the Jedi, that sect and everything—deep lore territory, where angels fear to tread. But we had to go there. I think what we've ended up with does feel very organic to the series. That's our hope, anyway." **Heinrichs**

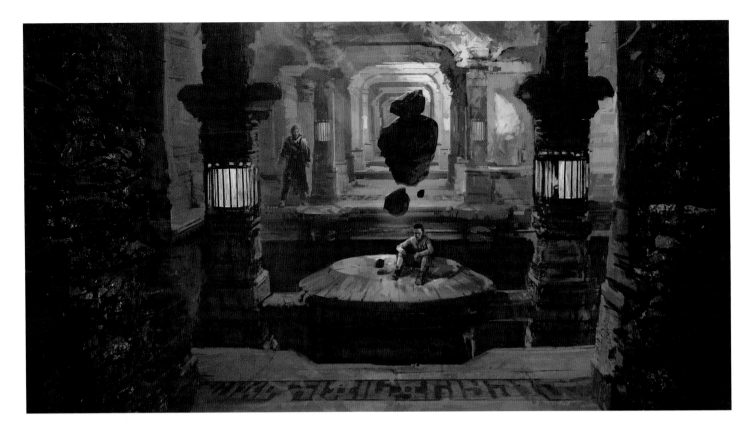

"Rey, under Luke's instructions, trains in an early-era underground Jedi temple. The frustration in her pose indicates that she is not happy with the training or that she is frustrated by her progress. She's manipulating the energy around her by levitating rocks and other debris, mirroring the training in *Empire*. The architecture is inspired by early Hindu patterns, which I used for their repetitive nature and carved motifs, and which appear frequently in McQuarrie's work. The stonework at the entrance is similar to the monasteries on Skellig, indicating that after the temple was abandoned, a more primitive or advanced culture continued building, but not for Jedi purposes." **Jenkins**

▼ **POOL TREE SYMBOL VERSION 02**
Engstrom and Heinrichs

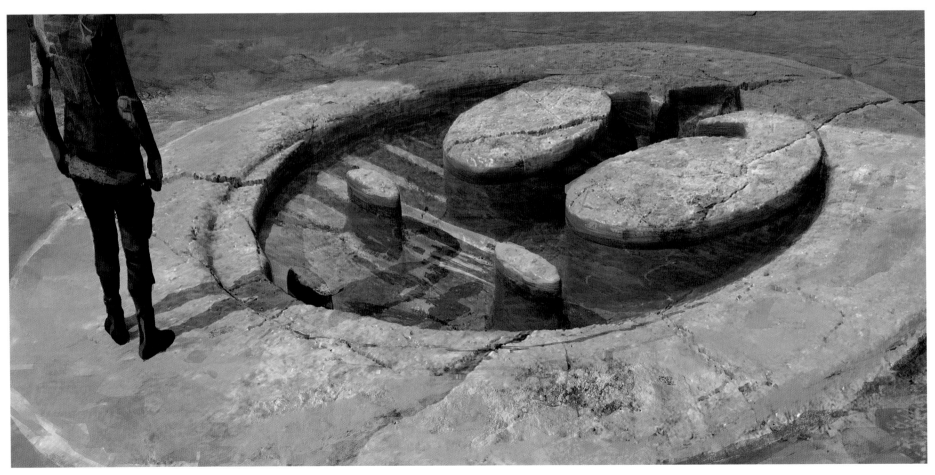

▲ **POOL ROCK JEDI VERSION 04** Engstrom

Seth Engstrom's Jedi Temple designs were inspired by Taoist symbology of the yin and yang (dark and light shapes within each other, representing both the balance of dualities and that the schism between them is merely perceptual). Both George Lucas and *The Empire Strikes Back* director Irvin Kershner were influenced by Asian philosophical and religious traditions, particularly Zen Buddhism, for Lucas's early conception and Kershner's later development of the Force, principally outlined within Yoda's teachings in *Empire*. "This is a symbol of the first Jedi, or 'Jedi Prime'," Engstrom explained in March 2016. "The center, yellowish rocks represent the energy of a lightsaber, splitting off into two directions: the dark and the light side of the Force. The black rocks symbolize the energy of the Force—everything in between, binding the universe together."

▼ **POOL ROCK JEDI VERSION 06** "The rocks on either side are faceless because they have not chosen yet which face the viewer is to become." **Engstrom**

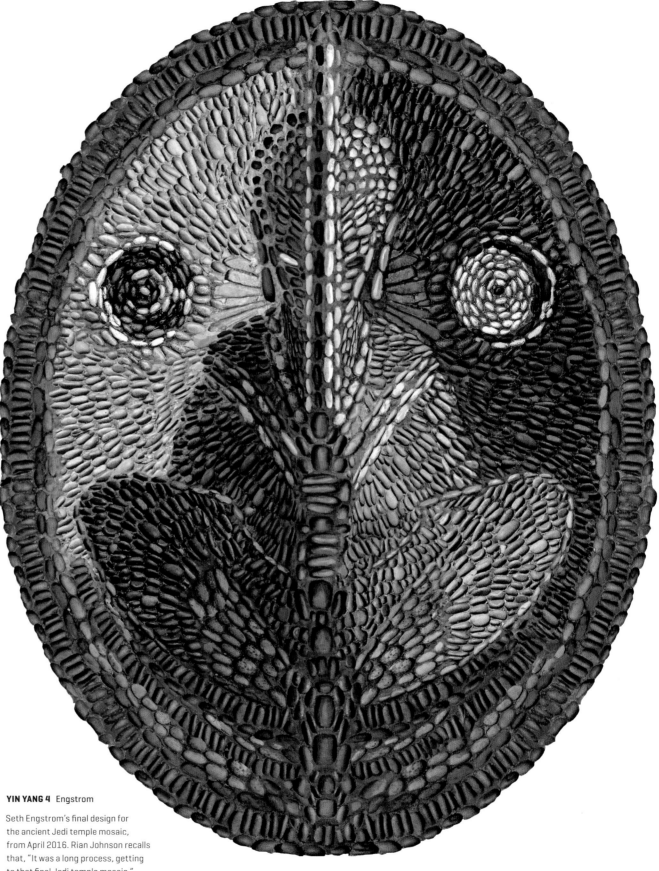

▶ **YIN YANG 4** Engstrom

Seth Engstrom's final design for the ancient Jedi temple mosaic, from April 2016. Rian Johnson recalls that, "It was a long process, getting to that final Jedi temple mosaic."

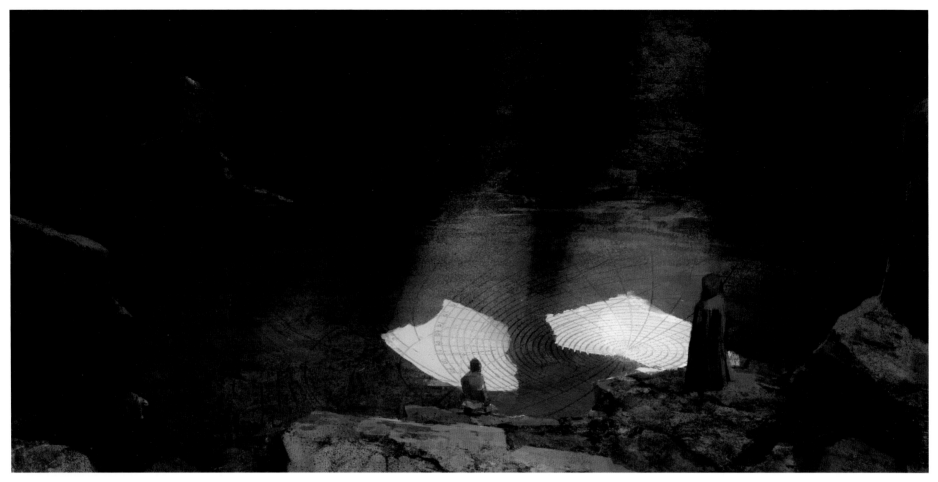

▲ **TEMPLE INTERIOR** Sweet

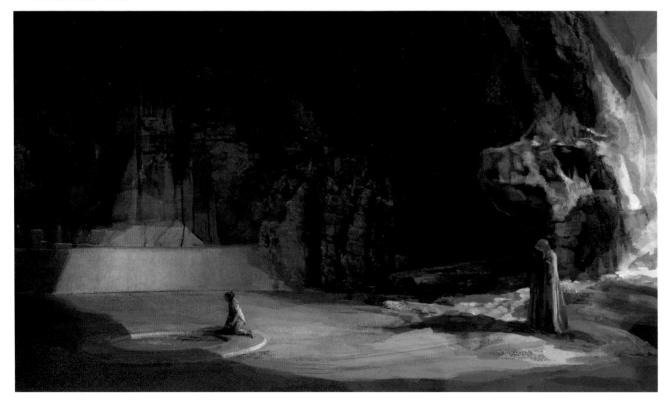

▼ **TEMPLE POOL GRAPHIC VERSION 04** Adam Brockbank

◄ **TEMPLE POOL** Sweet

"It's an interior space that's meant to feel holy—a place to commune, to sit. We did scribe the celestial carving into it. I had these ideas that there would be a light from the sun shining through, interacting with the carving. But that fell by the wayside as it became more about getting out to the ledge and for the scene to happen out there." **Heinrichs**

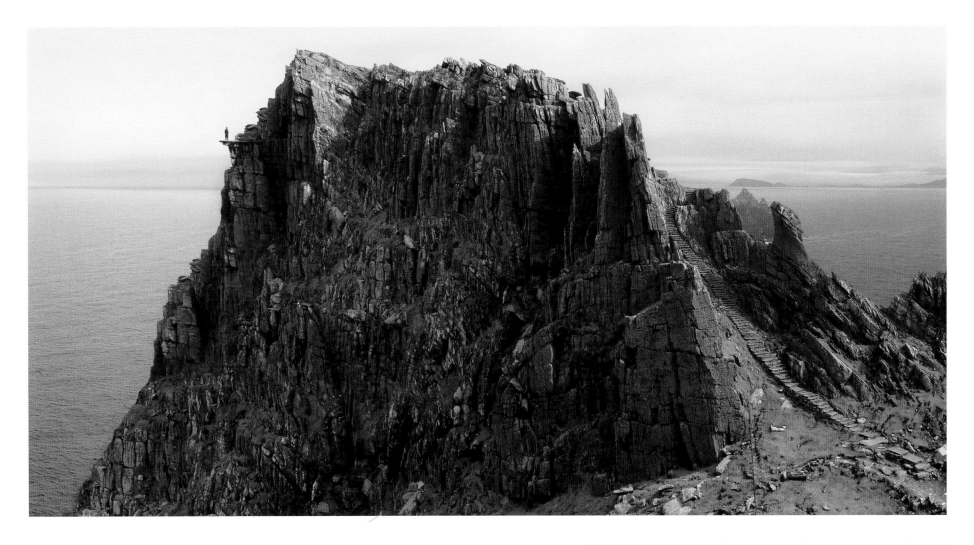

▲ **STAIRS BETWEEN HUT AND TEMPLE VERSION 01** Damaggio

▶ **TEMPLE POINT VERSION 03** Sweet

"We're not going to be building a temple exterior, per se. We're using the architecture of Skellig. Only the meditation ledge is a practical set." Heinrichs

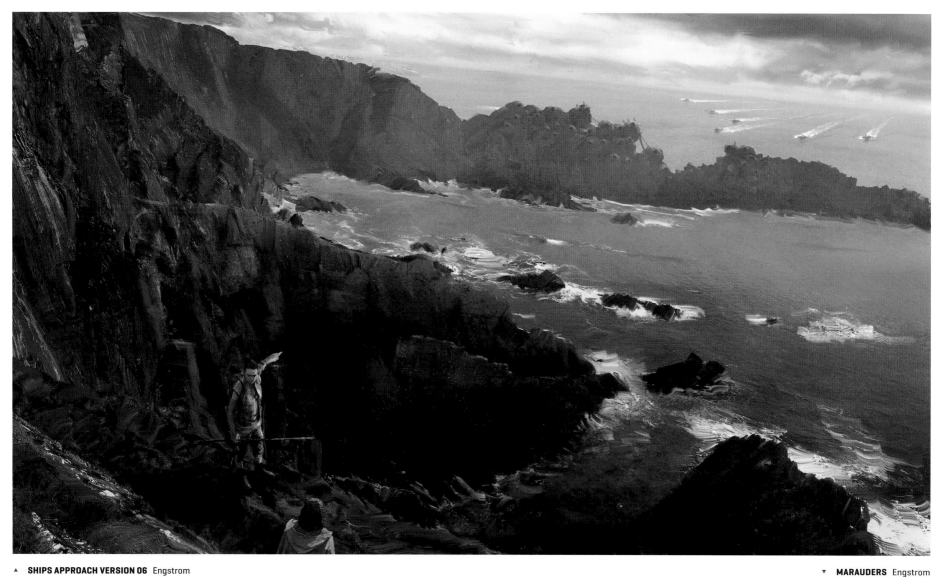

▲ **SHIPS APPROACH VERSION 06** Engstrom

▼ **MARAUDERS** Engstrom

◄ **CARETAKER VILLAGE VERSION 02** Engstrom

Shots of Rey running with lightsaber in hand were filmed with actress Daisy Ridley on the coast beneath the Malin Head cliffs in County Donegal at dusk on May 13, 2016, early in the two-week Ireland location shoot. The location was not far from where the partial *Millennium Falcon* exterior set was erected for the following day's shoot of Rey taking shelter underneath the freighter's edge, looking out over crashing ocean waves. The cliffs of Malin Head also served as Luke Skywalker's footpath approaching the library tree, shot on May 15, 2016, cutting to the tree filmed at Longcross Film Studios more than a month prior, on April 1 and 4.

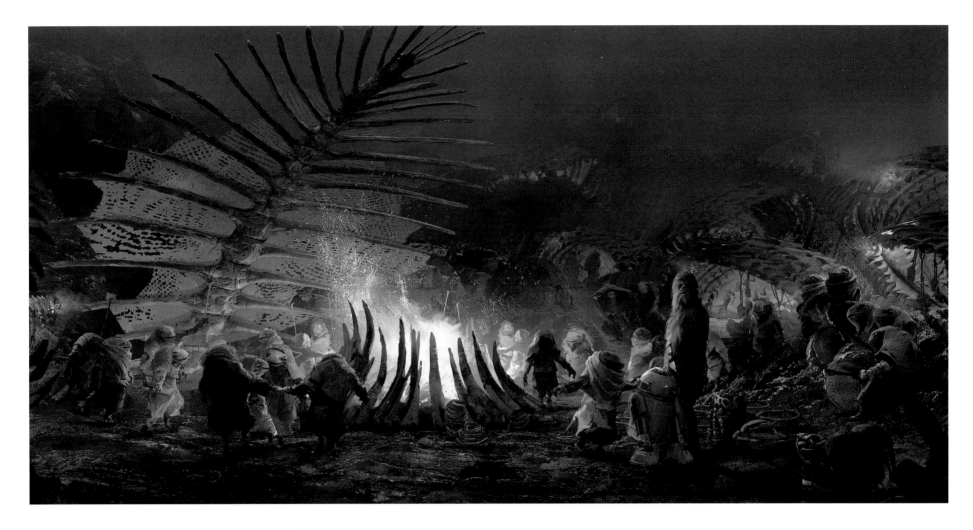

▲ **SPIKY FIRE TOTEM 4** Engstrom

▶ **CARETAKER VILLAGE LANAI** Engstrom

"When Rey shows up, the first and foremost thing is she needs a mentor. In looking at this grand plan from ten miles up in the air, Luke is missing the thing right in front of his nose. Here's somebody who needs you, who needs your help. If you think you are throwing away the past, you are fooling yourself. The only way to go forward is to embrace the past, figure out what is good and what is not good about it. But it's never going to not be a part of who we all are. And that includes Rey, who grew up hearing the legends about the Jedi. So the notion of, 'Nope, toss this all away and find something new,' is not really a valid choice, I think.

"Ultimately, Luke's exile and his justifications for it are all covering over his guilt over Kylo. The big gloss that he's putting over the whole thing is: 'The Force does not belong to the Jedi. This ongoing dynamic between the Jedi and the Sith just keeps renewing itself and just keeps feeding the fire. It's time for this old religion to die so that the truth about God can rise from elsewhere—basically, so that a more worthy god can rise. It's really hard, and it's going to cause a lot of pain, but that's what has to happen. So I'm going to do the hardest thing I've ever done, what I couldn't do in *Empire*, and not answer the call of my friends so that the Jedi Order dies and something new has to rise and pull the light up.'" Johnson

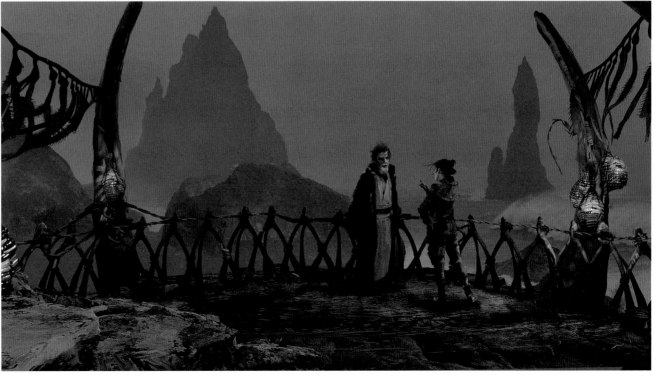

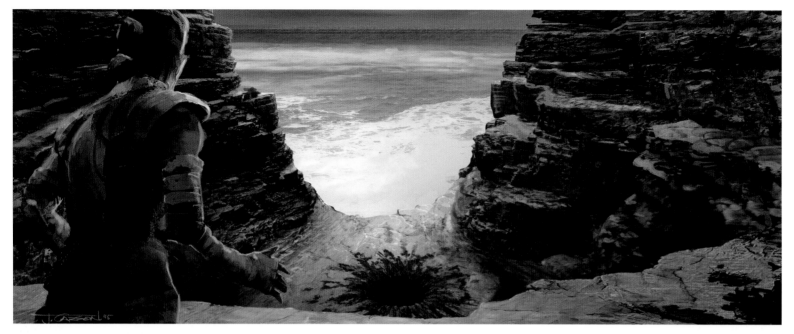

▲ **FLATLANDS BLOW HOLE VERSION 02** Carson and Engstrom

▼ **FALLING VERSION 06** Carson

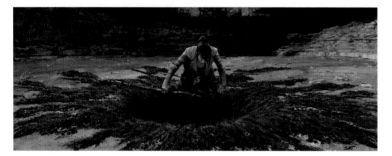

▲ **REY KNEELING 2** Engstrom

▼ **UNDERWATER 2B** Sweet

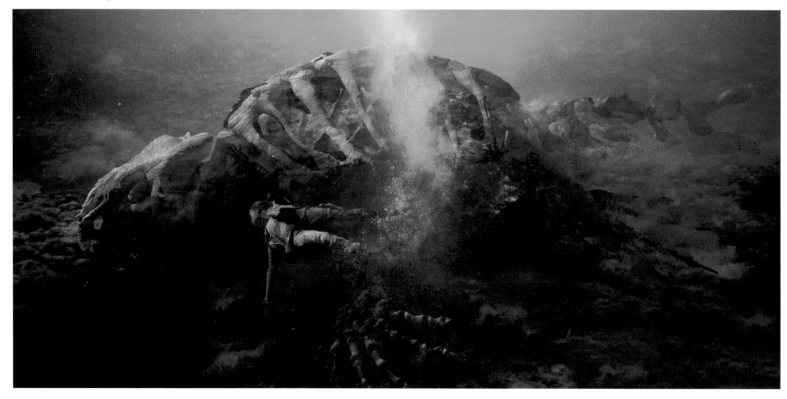

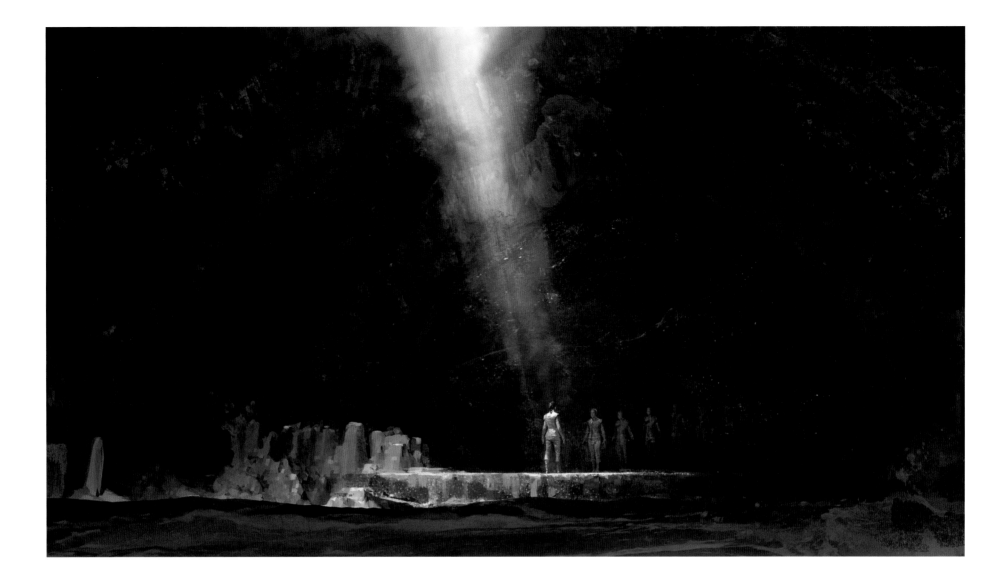

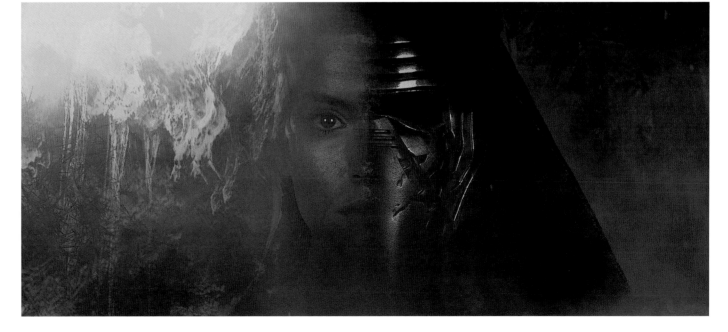

▲ **MIRROR CAVE WIDE 2** Sweet

▶ **KYLO KIRA FORCE MASH 01** "The first thing I talked about with Rian was the mirror cave. These concepts were still vibing off of the Rick Carter 'guided imagery,' 'let's talk about place and tone and where we are, going forward' principles. What are Rey's conflicts? This image reflects a little bit of the Kylo/Rey Force connections, as well as the duality of light and dark, good and evil. Some of these were being pulled from what I knew of *The Force Awakens*, but also little glints of information from Rian and mirroring the cave in *Empire*." Clyne

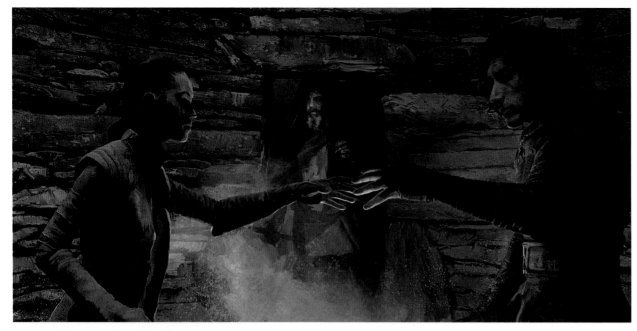

▲ **REY HUT BLAST** "Luke blowing apart the hut worked out amazingly. It's all in-camera! There is a difference in what you get with Mark Hamill standing there and the rocks really going by him and not feeling like it's a visual effect. What ILM does is always mind-blowing to me. When you combine what they can do with in-camera work so that they are matching stuff that the actors are really in, I think that just ups everybody's game." Heinrichs

▼ **LUKE DESTROYS REY'S HUT** Engstrom

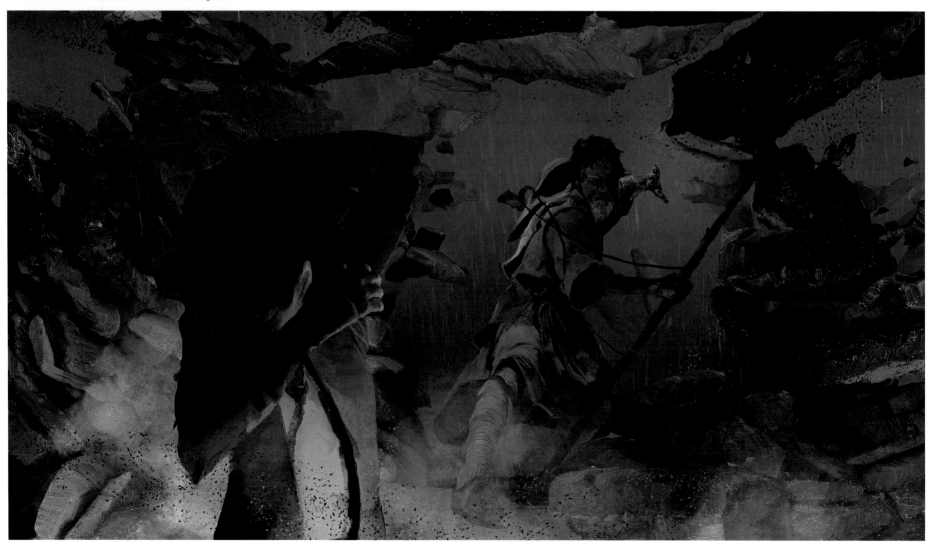

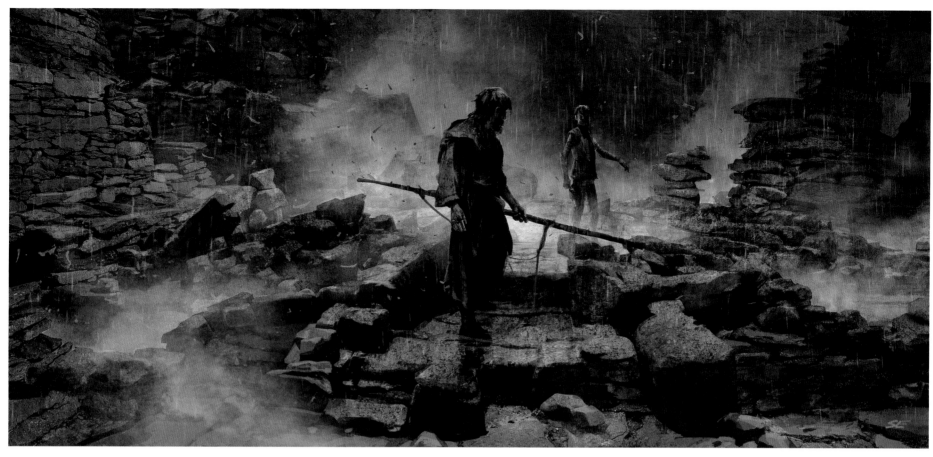

▲ **DESTROYED HUT VERSION 03** Engstrom

▼ **TEMPLE ISLAND FALCON ARRIVAL VERSION 02** Engstrom

▶▶ **LUKE WATCHING FALCON LEAVE VERSION 04** Engstrom

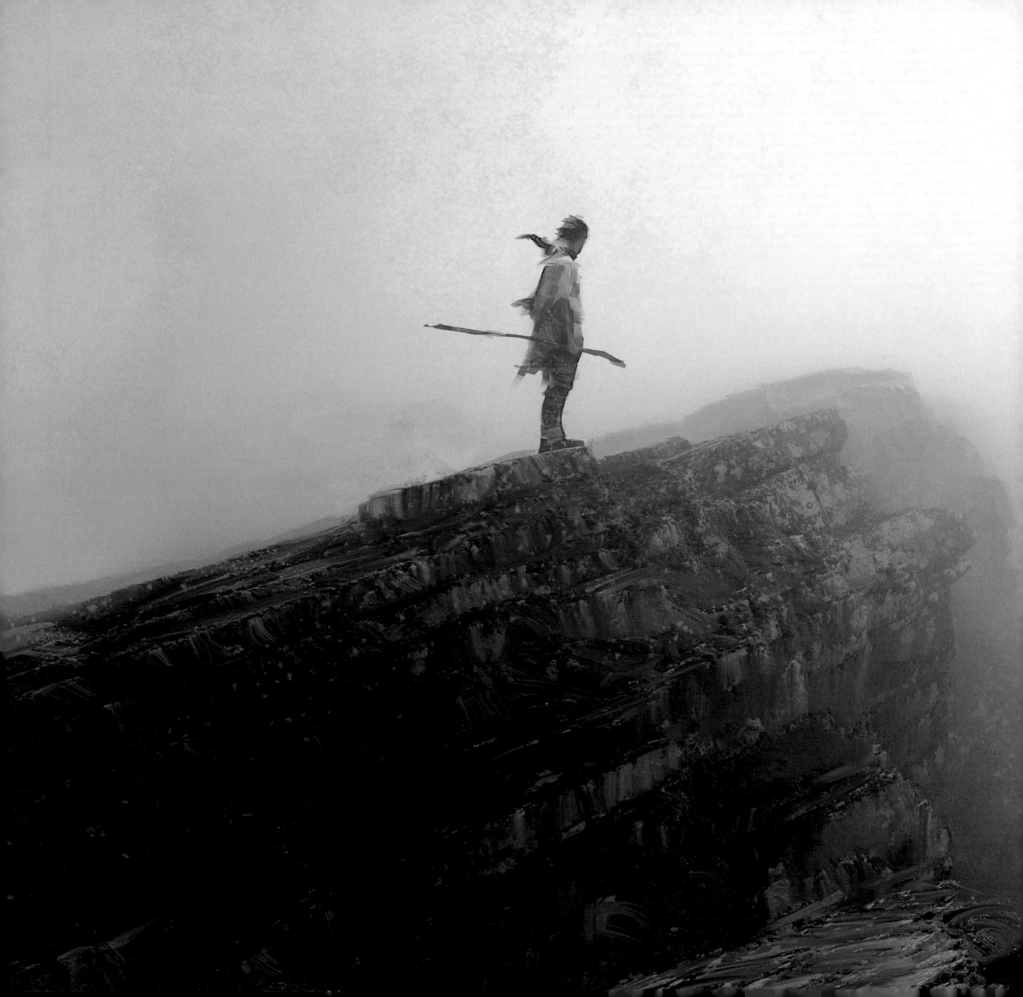

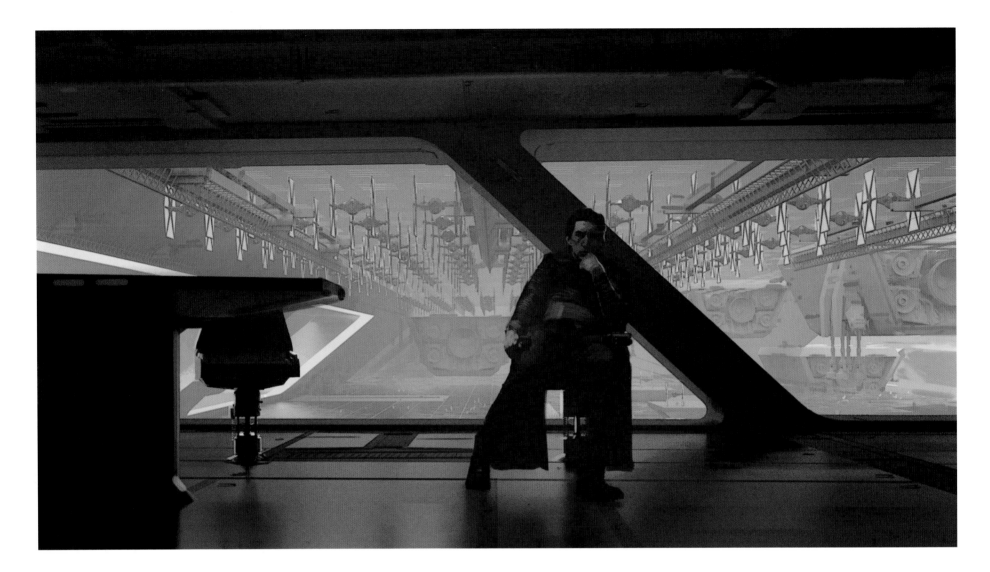

Battle Scars

By the start of summer 2014, Rian Johnson was fully engaged in the writing process for *The Last Jedi*. "This is my first studio movie and my first experience doing anything approaching this kind of scale and scope—both in terms of the film itself and in terms of the process: the amount of people and the amount of money involved. So I didn't know what to expect," Johnson remembers. "But this was one of the most pleasurable writing experiences that I've had, for some odd reason. That pressure never actually came into play, and I found I was able to very naturally sync into this world— to play in it and feel it out. It felt fun. Writing never feels fun. It was very unusual. This was not the typical self-doubt and torture. This was a bizarrely pleasurable writing experience."

"'What's the story here that I care about?' I started by writing down each of the main characters' names. I didn't start with set pieces. I didn't start with plot stuff. I just started with the character names and said, 'What do I know about them? What do I love

about them? What is the hardest thing that each of them could be challenged with in this next movie?' I did that for each character and worked forward from there. It presented this real clarity going forward. I hoped that foundation would then allow me to form the fun stuff, like set pieces, the big stuff around an essential thread of character. In reality, for me, the character stuff is the fun stuff and the big stuff [*laughs*]."

Johnson continues, "A big bedrock thing for me was, 'What do you keep from the past and what do you not? What is the value of the myths you grew up with? What is the value of throwing those away and doing something new and fresh?' For me, that's most prominently illustrated in the movie in the Rey and Kylo relationship: her trying to reconnect with the past and him trying to throw it all away. Ultimately, my allegiance has come down with Rey. But it's not that simple, and I think it's a very shaded and interesting thing. Yoda expresses some of Kylo's same sentiments. There's also a

▲ **HANGAR OBSERVATION VERSION 2D** Clyne

"I was sitting in a chair in the art department," recalls ILM art director James Clyne. "And Rian was trying to explain how he wanted Kylo to sit. I'm like, 'Alright, just take a photo.' With his iPhone, he composed the shot." In the end, the scene, as shot at Pinewood Studios on March 11, 2016, had Kylo Ren standing by the window overlooking the First Order hangar.

sin in venerating the past so much that you're enslaved to it. For me, it's not just a meta thing of talking about *Star Wars*—how much do you copy what came before versus throwing it away. It's very much a huge thing in life that I've spent a lot of time thinking about. It felt very germane, something very interesting and prudent to explore right now."

On the heels of Rian Johnson's official first day with Lucasfilm, on July 2, 2014, *The Force Awakens* concept artist and Industrial Light & Magic art director James Clyne started working a day here and there on *The Last Jedi*. Johnson's first assignment for Clyne was early visualizations of the mirror cave, an idea he had initially discussed with Rick Carter during their March story sessions.

A series of screenings were scheduled throughout July 2014, with each movie hand-picked by Johnson either to represent some tone or aspect of *The Last Jedi* he was hoping to evoke or simply to share a beloved film. Attendees of the screening series included Kiri Hart's Story Group, members of the unofficial Lucasfilm "brain trust"—such as Lucasfilm Animation's Dave Filoni, ILM chief creative officer John Knoll, ILM executive director Dennis Muren, and Lucasfilm VP/executive creative director Doug Chiang—and *Star Wars* Visualists of the ILM art department, including James Clyne, Ryan Church, and Christian Alzmann. The first of the series was Hideo Gosha's *Three Outlaw Samurai*, screened at Lucasfilm's Premiere Theater on July 9.

At the time, Johnson remarked that any 1960s samurai film of the Akira Kurosawa or Masaki Kobayashi ilk would have sufficed, but *Three Outlaw Samurai* was less likely to have been seen repeatedly by the well-versed attendees. The following three days saw Mikhail Kalatozov's devastating 1960 drama *Letter Never Sent*; *Twelve O'Clock High*, a 1949 World War II film featuring Gregory Peck; and the cinematic prisoners-of-war classic *The Bridge on the River Kwai*, starring Alec Guinness twenty years prior to his role as Obi-Wan Kenobi in *Star Wars*. The series resumed on July 14 with *Gunga Din*, a 1939 adventure picture that heavily influenced Lucasfilm's *Indiana Jones and the Temple of Doom*. The final two films were screened at Skywalker Ranch: Alfred Hitchcock's *To Catch a Thief* on July 23, and *Sahara*, starring Humphrey Bogart, on August 1.

"One of the most influential films from those screenings was *Twelve O'Clock High*," remembers Johnson. "In *Star Wars*, you have dogfights. You have a submarine feel on board some of the ships. But you've never really had the feeling of a bombing run, which was such a huge part of aerial warfare in World War II."

James Clyne recollects, "I just wanted to know what inspires Rian and what *Star Wars* means to him. What better way than for him to come up and show movies he's inspired by? Funny enough, the only one that I made it to was *Twelve O'Clock High*. And serendipitously, the one thing that I spent the most time on was developing this bomber."

"Maybe that's another part of the reason why the writing process was so pleasurable: there was such support at Lucasfilm with the Story Group—with Kiri Hart and with Rayne Roberts and with Pablo, Leland Chee, and everybody," says Johnson. "There was a real sense of love and support. And there has been from the very start. I'm sure that contributed. That screening series was great."

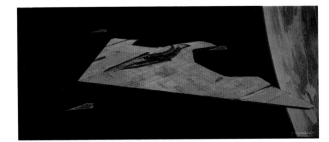

▲ **SUPER DESTROYER VERSION 02** Jenkins

▲ **SUPER DESTROYER VERSION 04** Jenkins

▲ **SUPER DESTROYER VERSION 07** "Snoke's Mega Destroyer, *Supremacy*, came pretty quick. We sat down and talked about a big Star Destroyer, and Rian said, 'What about a big flying wing? That might be cool.' And I did only about six or seven shapes. He chose one, and then I worked up a painting that ended up in the moviescape [the collection of concept art that spans the entire film, chronologically] for the whole journey. It's a big flying city. Vader's *Executor* is a simply a headquarters, but Snoke doesn't have a planet, so he lives on the ship." Jenkins

◄ **SUPER DESTROYER VERSION 03** Jenkins

▼ **STAR DESTROYER HANGARS 04** "Very early on, I thought it would be cool to have Star Destroyer docking bays on the front or sides of the Mega Destroyer. But Rian said, 'No, it's getting too busy. That's not *Star Wars*' or 'We don't need that.' He was right: It comes back to that simplicity of design. We just kept returning to a huge flying wing." Jenkins

▼ **MEGA STAR DESTROYER** Heinrichs

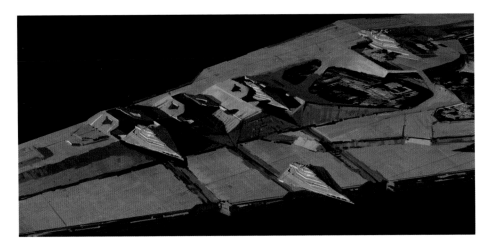

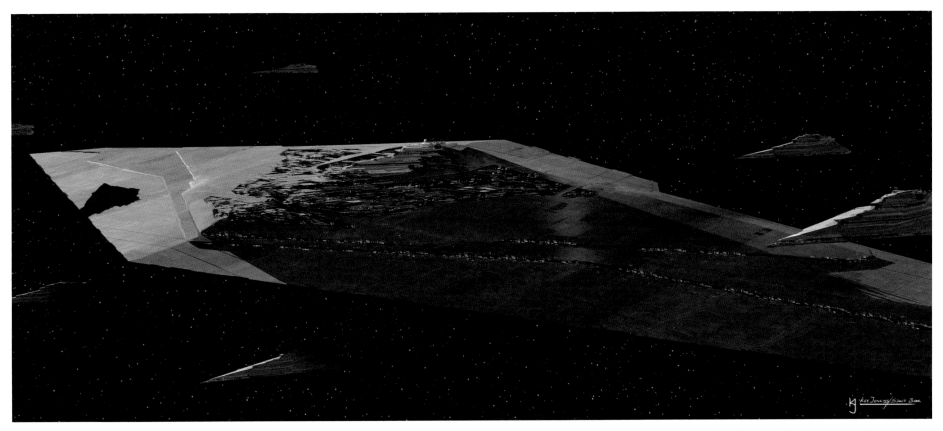

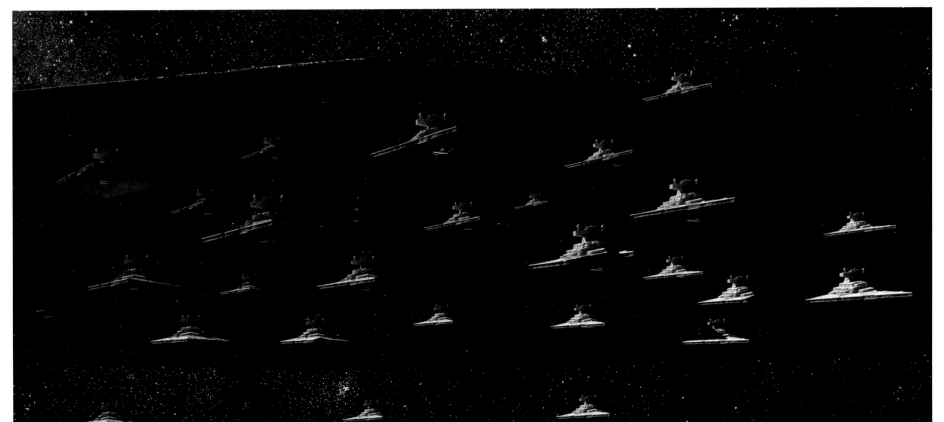

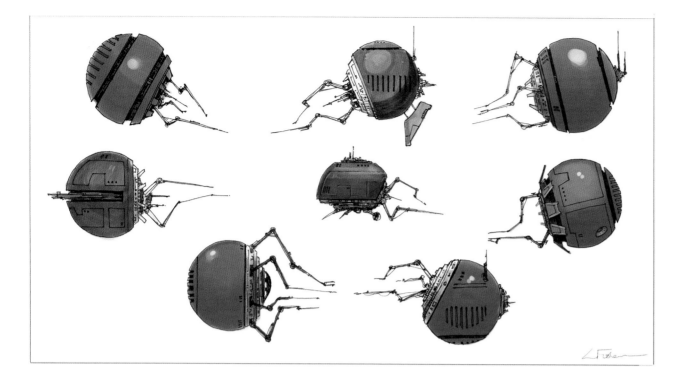

▲ **MED DROID FINAL** Fisher

"The idea is that this droid is insect-like, with these horrible, almost fly-like legs. The way the legs were jointed and the speed at which the joints were moving, almost like a sewing machine, gave it a great presence. So you try to think of things that people have phobias about and making those your design roots. Obviously, it has the Imperial aesthetic. But we're trying to come at it the other way, starting with a personality. You start from, 'What's evil? What's heinous? What's threatening?'" **Scanlan**

◄ **MED DROID 02** Fisher

▼ **MED BAY INTERIOR VERSION 04** Fernández Castro

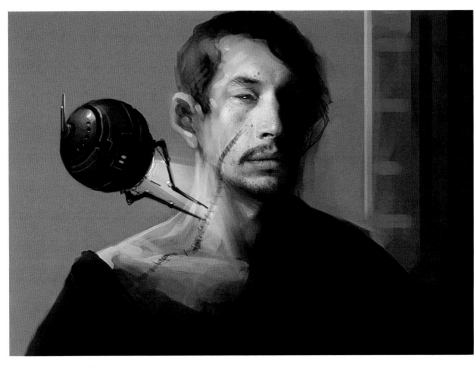

▲ **KYLO AND MED DROID** Fisher

▲ **KYLO DRESSING VERSION 01** Brockbank

▲ **KYLO DRESSING VERSION 05** Brockbank

▸ **KYLO REN WITH CAPE VERSION 07** Zonjić

"That was the big design choice with Kylo: losing the mask. It was a little terrifying because, by the time we were making the movie, the first film had come out and every kid was wearing Kylo Ren masks on Halloween. It was the symbol of the movie on packaging. And I love the helmet. But the whole premise of this film is that you're getting inside this guy a little bit more. More than that, Rey is seeing there's more to him than she thought. And Adam Driver is one of my favorite actors working today. The notion of getting the mask off of him so we don't have to deal with it and can look into his eyes seemed really important. The rest of his costume is a slight variation on what was in *The Force Awakens*." **Johnson**

"A new stitch-quilted tunic was made. We kept the sleeves the same, to retain some of his *Force Awakens* look. Obviously, Adam wanted to move and fight comfortably, and we always tried to make arrangements so he could do so. The cape has more of an aggressive, power-garment feel. A cape, especially a heavy black cape, will always give you a certain amount of gravitas." **David Crossman**

"I didn't want Kylo to look like a new character. Rian did want him to lose the helmet and to become a lit-tle bit . . . I wouldn't say more *casual*, but he wanted a change. The cape is a bit softer. It doesn't have that big neckpiece. It's beautifully patchworked in small pieces of leather. So there is some wonderful detail to it. But it's pretty subtle." **Kaplan**

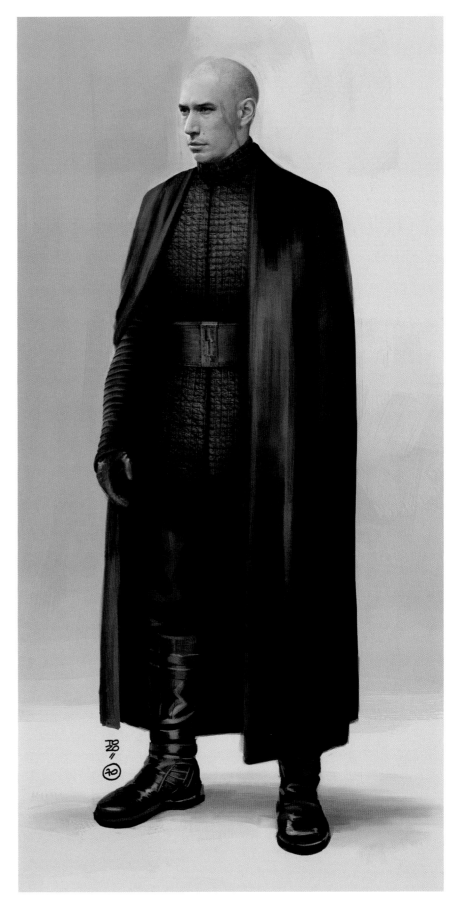

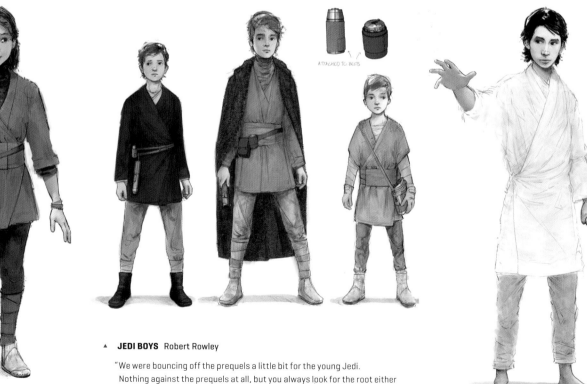

JEDI GIRL 1 Rowley

JEDI BOYS Robert Rowley

"We were bouncing off the prequels a little bit for the young Jedi.
Nothing against the prequels at all, but you always look for the root either
in *Star Wars* or *Empire*. So you look at Alec Guinness and those fabrics.
We mirrored a lot of those fabrics in the young Jedi." Crossman

ATTACHED TO BELTS

▲ **KYLO'S BED CHAMBER VERSION 15**
Brockbank

"The three flashbacks were a late addi-
tion—one of the last things that went into
the script before we started shooting.
It's similar to *Rashômon*, but the actual
story motivation was that I wanted some
harder kick to Rey's turn: 'You didn't tell
me this.' I wanted some harder line that
was crossed—a more defined thing that
we could actually see—between Luke and
Kylo. I didn't want to do a big flashback.
So one flashback that you repeat three
times but that's just one moment seemed
more right. Ultimately, the only one who
lies is Luke, in the very first flashback,
where he omits the fact that he had a
lightsaber in his hand. Kylo is basically
telling the truth about his perception of
that moment." Johnson

◀ **KYLO YOUNG FINAL** Rowley

"'What should Kylo look like? What kind of
Jedi?' In the end, Rian said, 'Oh, no, no—
he's in bed. He can just wear a nightshirt.'
[*Laughs*] And Adam Driver was happy, so
that was good." Crossman

▶ **DOJO EXTERIOR VERSION 05** Brockbank

▲ **INTERIOR WITH FLIGHT CONTROLS VERSION 01** Fernández Castro and Oliver van der Vijver ▼ **KYLO WATCHES CRUISER ATTACK VERSION 05** Jenkins ▼ **TARGET STORY** Booth and BLIND LTD.

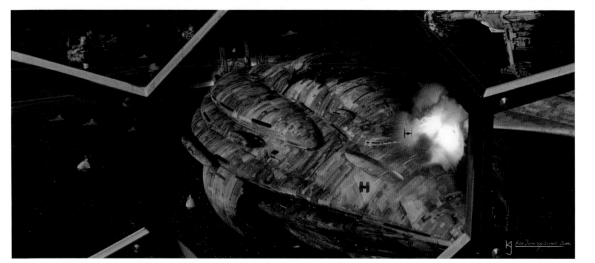

KYLO FIGHTER 01 "Kylo just had his command ship, *The Finalizer*, in *The Force Awakens*, with no sense of him being a pilot. Initially, Rian was like, 'Give Kylo something totally his own, that you understand is his own ride—unique and cool.' I might have taken the unique part of it too far. The idea was that it came from the same car company. But it was their super-car version. Ford has their GT40 supercar, but they also have Escorts. So this is the GT40 of the line, the expensive model. On *The Force Awakens*, we played with a thousand different versions of TIE fighters. So how do you make it your own? This has got a B-wing feel, always trying to play with asymmetry." Clyne

KYLO FIGHTER 02 "In this one, you can see a bit of a progression. Rian was like, 'Well, this is cool, but try something a little more symmetrical, a little more reminiscent of a TIE fighter.' It really came down to taking that ball and turning it into not a sphere but something more faceted, more angular." Clyne

KYLO FIGHTER SIDE VERSION 08 "The wings are stretched really long. Rian loved this idea of projecting those front mandibles out. And we charted different sizes: short, medium, long, super-long. He went with the super-long ones [*laughs*]." Clyne

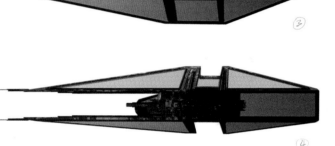

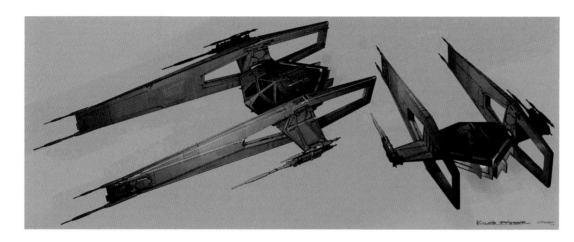

KYLO FIGHTER 10 "The resemblance to the front of Kylo's shuttle is not by mistake. Don't try to create from whole cloth. Use what's already been done. Pay service to it and embrace it. I think his shuttle's great. So it would make sense that his fighter would have some kind of the same DNA in it, which I think in the final design it still does." Clyne

KYLO FIGHTER VERSION 17A "This shows a faceted rather than round face. My favorite part is these two windows that act as eyes. They don't have a mullion in the glass; it just bends around." Clyne

"This was a great example of kitbashing [a model-making technique in which the artist pulls pieces from commercial model kits in the creation of something new]. I would take preexisting models of the TIE interceptor, Vader's TIE fighter, and even a bit of the classic TIE fighter and start to kitbash. Once we started discussing it, and Rian said something like, 'This should really be a next-generation TIE fighter that fits into the whole family.' We got into that realm and were off to the races." Clyne

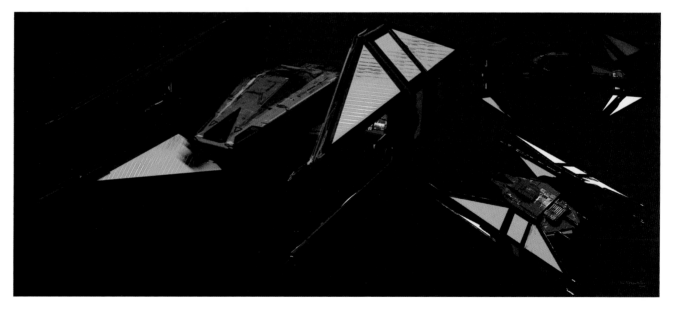

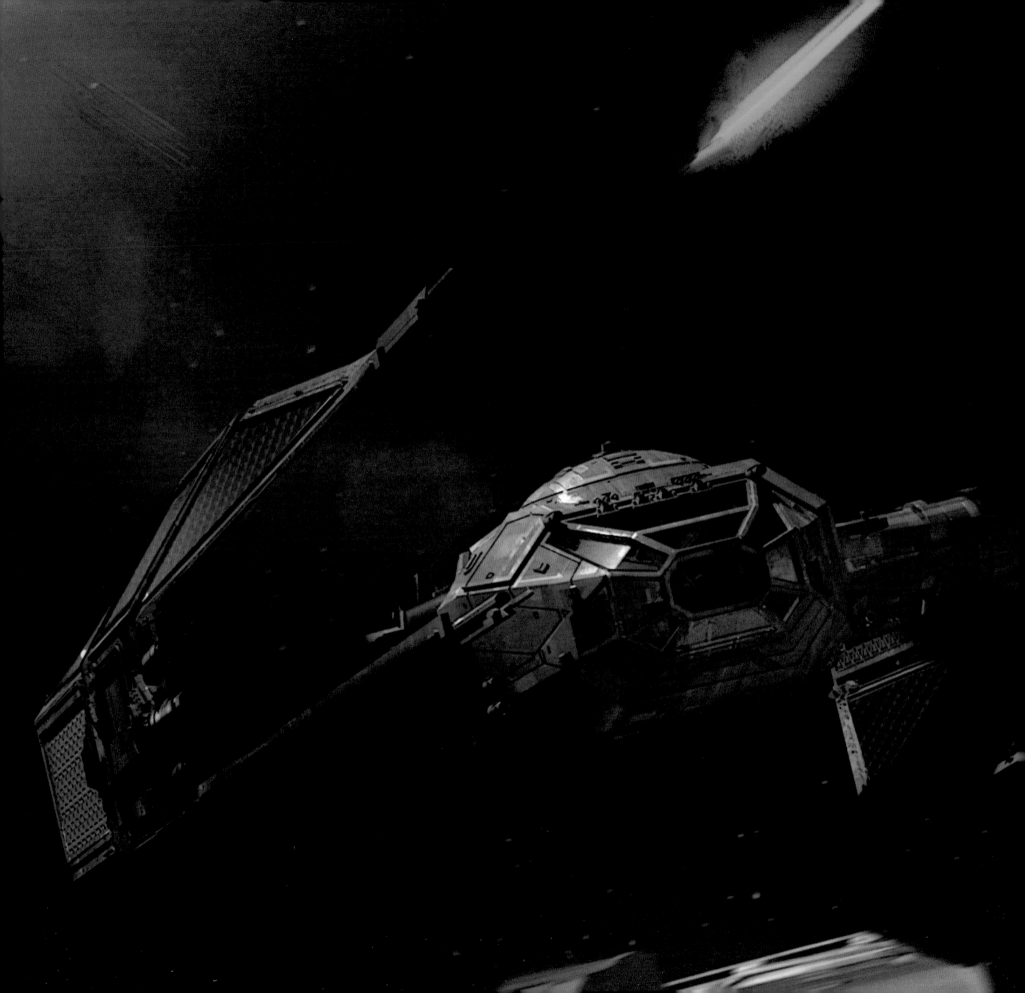

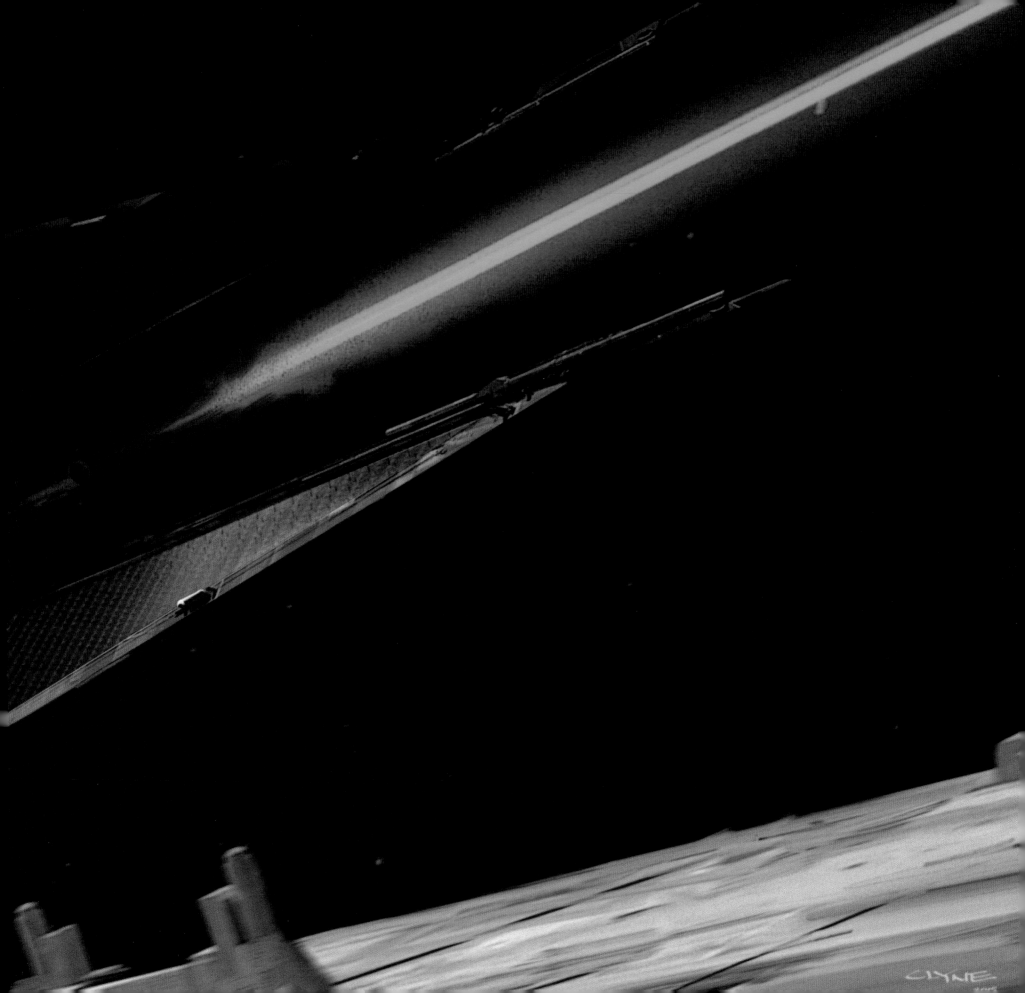

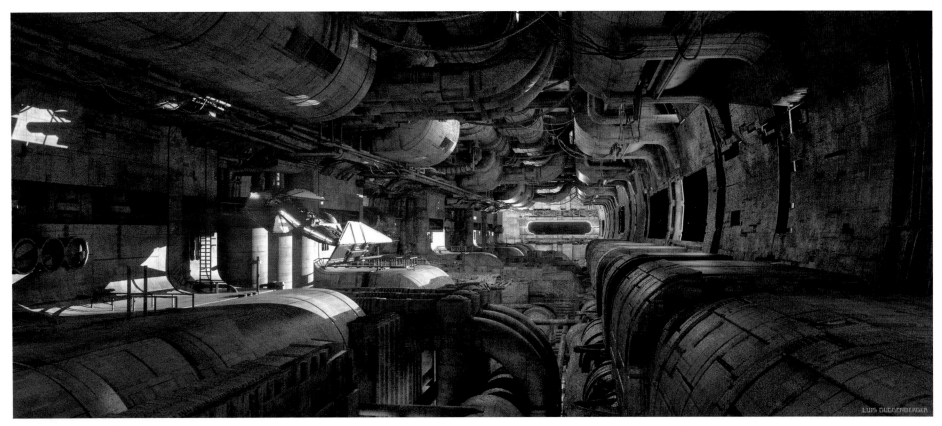

▲ **RESISTANCE CRUISER VERSION 45** Guggenberger

▼ **MEGA DESTROYER SCHEMATIC IDLE** Andrew Booth and BLIND LTD.

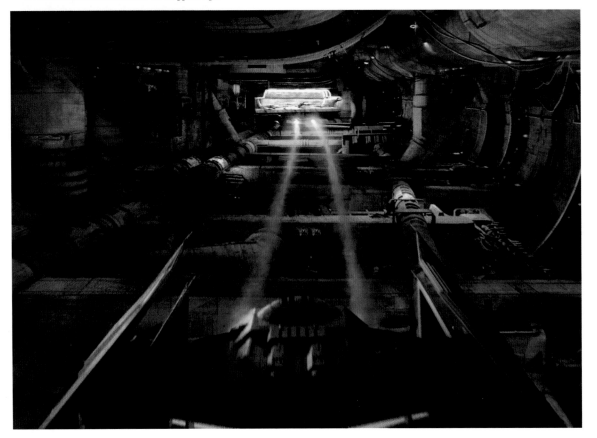

▲ **RESISTANCE CRUISER VERSION 140** Guggenberger

▲ **FLEET CHECK A IDLE** Booth and BLIND LTD.

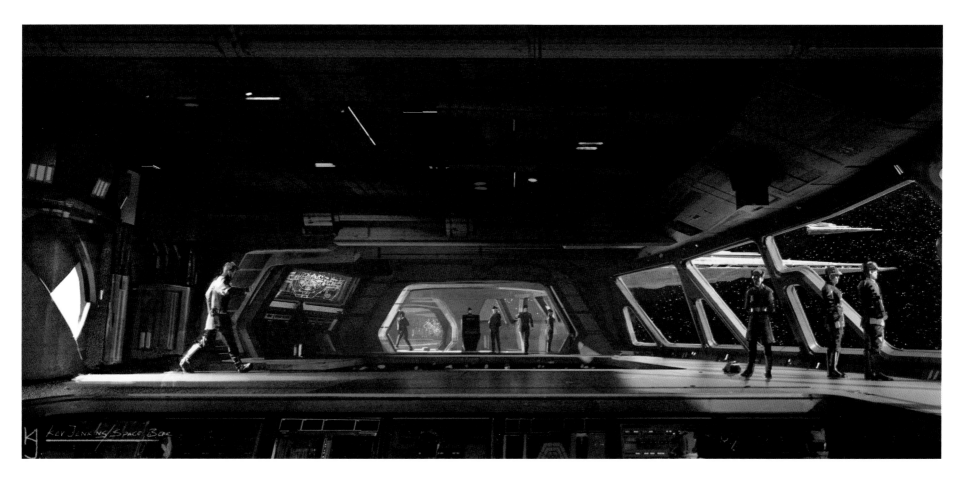

MEGA BRIDGE HUX VERSION 01

"All of the bridges in *The Empire Strikes Back* were thin and squat and submarine-like. And I thought, 'Well, you're on this very long, wide ship. It could be interesting to have the bridge snake away to the left and right, wherever you look.' We built sets to shots. When I was designing it, I remember the conversation, 'We can actually flip this, film it both ways, and mirror the set.' We only built half of the set, but you get both sides. Knowing what specific shots you need is what allows you to build that way. There are a lot of filmmaking tricks in this one." **Jenkins**

MEGA BRIDGE HUX VERSION 02

"This first image of the bridge got a really positive response from Rian. The shape in the window mullion mirrors Kylo's mask. But the rest of them are big, top-to-floor big mullions. Those images went straight to senior art director Mark Harris, and they built the set from that model." **Jenkins**

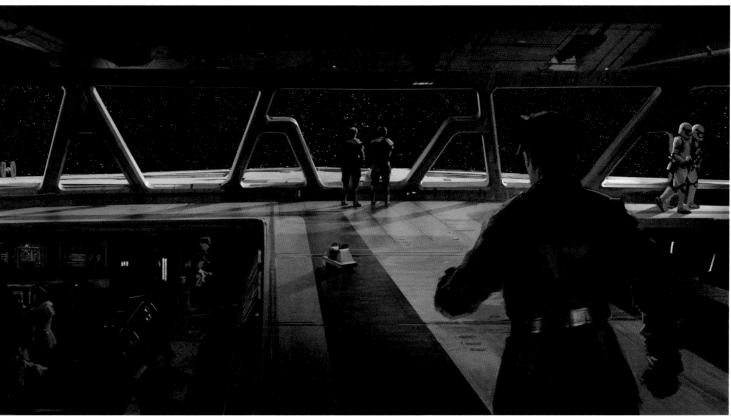

The Man Behind the Curtain

In the midst of his *The Last Jedi* screening series, Rian Johnson was invited to join Lucasfilm's informal "Intellectual Property Development Group" (IPDG) for the film, to help work out a specific filmmaking problem: how to visualize the Force connection between Rey and Kylo Ren that threads its way throughout the story. IPDG members attending the meeting included the Story Group's Kiri Hart and Pablo Hidalgo, ILMxLab VFX supervisor John Gaeta, Doug Chiang, Dave Filoni, John Knoll, senior vice president of physical production Jason McGatlin, head of franchise creative and asset management Brian Miller, Dennis Muren, and Skywalker Sound audio designer Gary Rydstrom.

"I remember coming into it with the notion of 'The purpose here is just to create intimacy,'" Johnson says. "'How minimal can we go? And what is the simplest way of clearing everything out, so it's just like you and me having a conversation in a room?'" The answer arrived at by Johnson and the brain trust was simply to intercut between Ridley and Driver as if the actors were in the same room. "The idea of it being pure cinematic language—just intercutting and doing nothing else to it—that solution saw through all the way to the finished product. I think it works."

By August 2014, the basic story of *The Last Jedi* was in a solid enough place that Johnson began sharing his vision with potential collaborators, including Kevin Jenkins and final candidates for the production designer position (the production designer on a film leads the entire art department, taking creative feedback from the director on concept and production art and, with his team, translates that feedback into practical, buildable sets, environments, and vehicles, supplemented by props, set dressing, computer graphics, special effects, costumed characters, and costumed creatures from those respective departments). The leading candidate for production designer of *The Last Jedi* was Rick Heinrichs (*Fargo, Pirates of the Caribbean: Dead Man's Chest, Captain America: The First Avenger*).

"I had never worked with Rian before," says Heinrichs. "I got the call in late summer, through my agent, that Ram and Rian were interested in talking to me. That was it. And I was like, 'Well, I don't know. Am I interested?' I didn't really know what was going on with *Star Wars* at the time." The first trailer for *The Force Awakens* was not released for another three months, in late November 2014. "I told my kids about it and my son—he's almost twenty-one now—was like, 'Oh, you're going to do that.' It got cemented when I met with Rian and Ram in a coffee shop. Rian gave me a ten-minute pitch, and that pitch was the movie that we shot."

"I only met with a handful of designers," Johnson recalls. "Rick Heinrichs was one of them, and I really loved him and gravitated toward him. I think Rick Carter did suggest Rick Heinrichs, because I know they have a history going back. And I know Carter was very up on the idea of Rick doing it."

Thinking back to that afternoon, Heinrichs says, "So many things were fully fleshed out in Rian's mind, in terms of who the characters were and what their function was. That was amazing to me. I'm used to our more normal process of the write and the rewrite. In this case, it was the pitch and the write. And that script came all the way through with very minor changes along the way. From Rian's head onto the page."

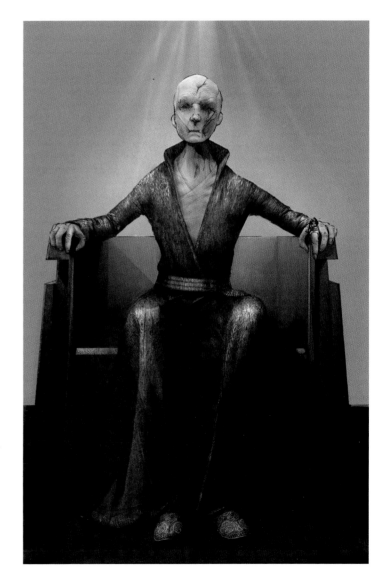

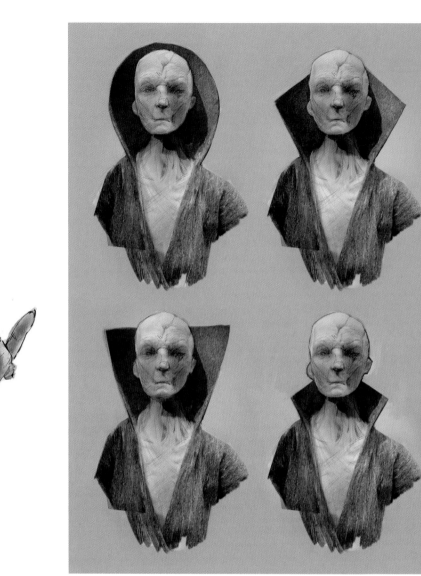

▲ **SNOKE MOLD SKETCH** Rowley

▲ **SNOKE SIDE** Rowley

"I sprung the idea of Snoke in gold on Rian. Because we're in a room that's predominantly red and black, and because Snoke's skin is very off-white, I thought that we wanted something a little bit more powerful. And we have these red Praetorian Guards, and then we have these purple attendants. So rather than do more red or purple, I just thought, 'There's no gold in the room. That would look beautiful.'" **Kaplan**

"Snoke in gold was all Michael. He came up with it after we had designed the throne room. He was like, 'What about gold?' And I flipped out. 'Yes, gold! That's awesome!'" **Johnson**

"Andy Serkis was wearing the physical costume while doing the motion-capture [the technical process in which an actor's performance is captured and, at a later date, mapped onto a digital character] just for the feel of it. There was also a very tall person who would be seated there for eye lines, and he's wearing the actual robe that would be Snoke's size. I think it's important for them to know, specifically on film, what it's going to look like so that the mocap matches that." **Kaplan**

◄ **SNOKE RING** Rowley

▲ **SNOKE SHOES** Rowley

"I think the slipper line is gone from the film, but Snoke definitely mentioned them at one point. Ian Jones, our props maker, handmade him some gold, embroidered slippers. The reference guide we were using in the shots had huge feet. Ian, who is very clever, just made them from scratch." **Crossman**

PROPERTY OF HAN SOLO

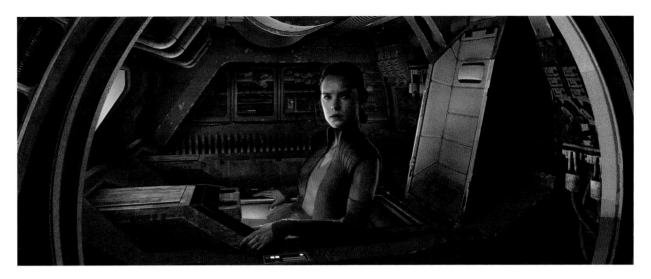

▲ **CLYNE-ESE 01B** "Rian really wanted to make it clear that this came from the *Falcon*; he wanted 'Property of Han Solo' written across it. I was flying back the following day and Rian was like, 'On your flight back, you need to sit down and come up with a new language.' So on the plane, I looked at preexisting languages from Thailand, from the Middle East. I put that reference away, started to do some scribbling, and eventually came up with three different versions. Rian chose this one and wrote a response email in it. And I had to translate it like an old fifties decoder ring [*laughs*]. I had no idea what it said!

"But it said, 'Beautiful!!' and that made my day. He specifically wanted something that was more like calligraphy, more like cursive, as opposed to something like a font. There was some discussion that it could be Corellian." Clyne

▼ **BEAUTIFUL!!** Johnson

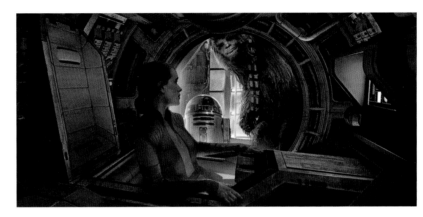

▲ **ESCAPE POD VERSION 08** Brockbank

◄ **ESCAPE POD VERSION 07** Brockbank

"This is a new little set that we had to do for Rey in the escape pod. We hid the ladder behind, because we didn't want to say exactly where we were, so people didn't get too crazy about it [*laughs*]." Heinrichs

▼ **ESCAPE POD VERSION 05** Brockbank

▲ **COFFIN PICKUP VERSION 02** Clyne

▲ **NEO STAR DESTROYER COFFIN 01** "When Rian talked about coffins, it would mostly be in context of size and shape—something coffin-like that would be a single-person escape pod. Rey would lie supine, on her back. A door would open up and reveal her. I guess being stuck in this escape pod is better than being blown up. So there was a lot of talk about it looking coffin-like, but also making sure that it felt like it was a part of the *Falcon* itself. The color palate, the aging and paneling, had to feel very *Falcon*-like." Clyne

◄ **COFFIN ESCAPE POD VERSION 02** Jenkins and Heinrichs

"In C. S. Lewis's *Perelandra*, the main character travels across space to Venus in a coffin. For some reason, that image really stuck with me. And so I kept pushing James to make it more like a coffin. He kept throwing me spaceships—'Nope, make it more like a coffin.' There was something kind of cool about it feeling like that, with her flying to the final confrontation. Something about it felt really right." Johnson

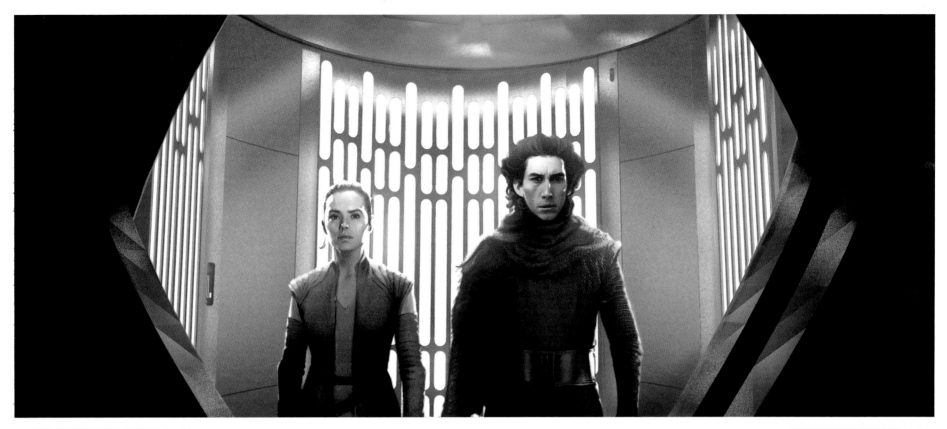

▲ **ELEVATOR REVISED VERSION 02F** Brockbank

▼ **THRONE ROOM VERSION 06** Jenkins

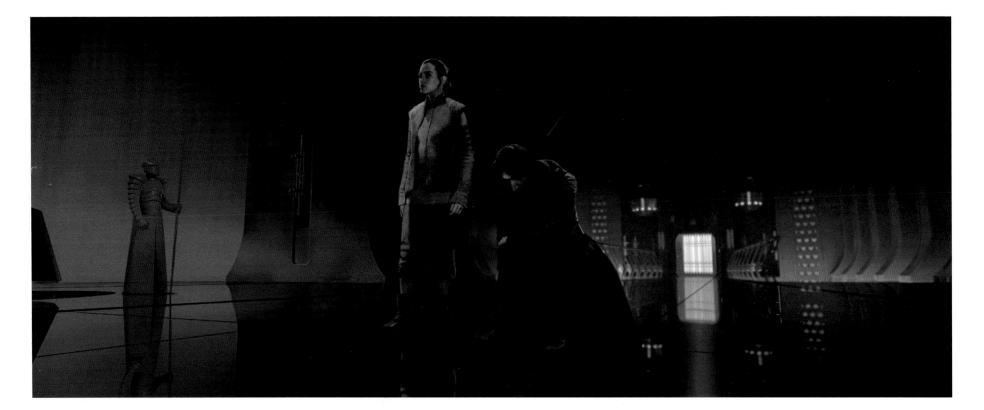

▲ **THRONE ROOM SKETCH** Jenkins

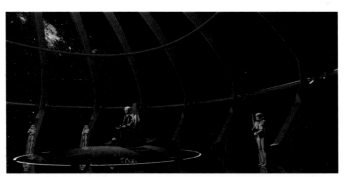

▲ **SNOKE THRONE INTERIOR VERSION 55** Damaggio

"We approached the throne room by thinking about Snoke's character. He's physically weak, so he uses theatricality. And that's where *The Wizard of Oz* element came in. To some extent, he's consciously creating a purposefully dramatic space, as opposed to the Emperor's throne room, which was utilitarian. My notion was, 'Let's give Snoke theatricality that then burns away and reveals the structure behind.' So I had had the notion of red curtains. We had a very tough time with that, because it was hard to not make it look like big red drapes hung up everywhere. The late [director, screenwriter, and playwright] Anthony Minghella had done this beautiful production of *Madame Butterfly*, with one set piece with this vibrant red and a reflective floor. Why don't we see if we can just go with an abstract space, like a James Turrell installation [the contemporary American artist whose work is primarily concerned with light, color, and space], where you almost don't know what you're looking at? It's just abstract red—very simple. And it's only when it catches fire that you realize, 'Oh it's this physical thing now burning away.' And the Wizard's curtain is drawn back." **Johnson**

◄ **SNOKE THRONE ROOM VERSION 01** Jenkins

"I think the most important inspiration for the throne room is a Ralph McQuarrie drawing of Darth Vader in hell. Obviously, this is a metaphorical hell. And we've taken the essential organic characteristics of Ralph's image and refined it into a much more polished and ceremonial space—more *Wizard of Oz*." **Heinrichs**

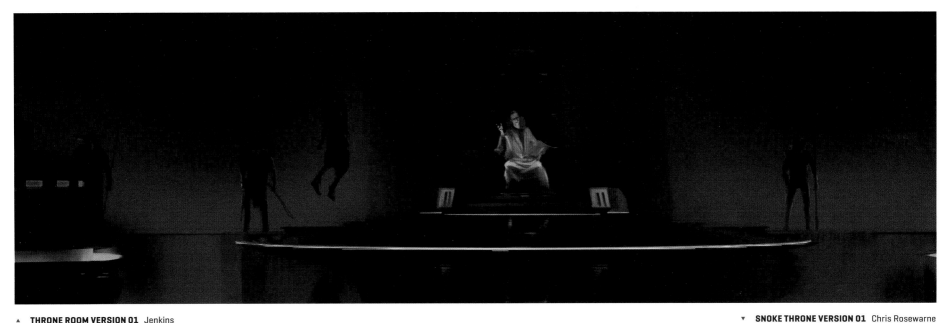

▲ **THRONE ROOM VERSION 01** Jenkins

▼ **SNOKE THRONE VERSION 01** Chris Rosewarne

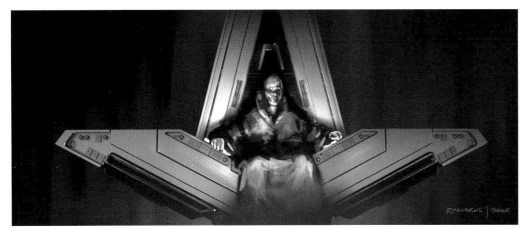

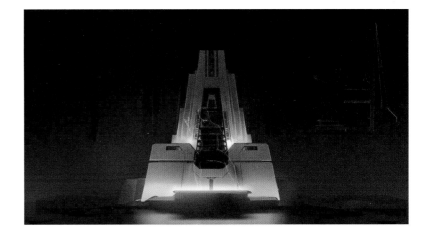

▲ **SNOKE THRONE VERSION 03** Rosewarne

"I thought, 'How do you reinvent the throne room from *Jedi*?' And Rian said, 'I don't want to reinvent the throne room from *Jedi* because it's already been done.' He always used the words 'organic' and 'theatrical.' Early on, the one thing that stuck was the heavy red with a colonnade of banners. It is part of the *Ran*/Kurosawa thing—the samurai influence. It's a colonnade leading you to a dais and a chair. Rian didn't mention *Twin Peaks*'s Black Lodge—the red room—but we all did in an art department meeting." Jenkins

▶ **THRONE VIEWS VERSION 01** Jenkins

▶▶ **THRONE VIEWS VERSION 03** Jenkins

"The influence for the throne is purely from a Ralph McQuarrie concept painting for *Return of the Jedi*. It shows the Emperor's throne among the lava underneath Coruscant, where Palpatine was to have a lair. If you look at that Ralph throne . . . I thought I'd keep it simple, basic, and why not give Ralph another nod? Why reinvent the wheel?" Jenkins

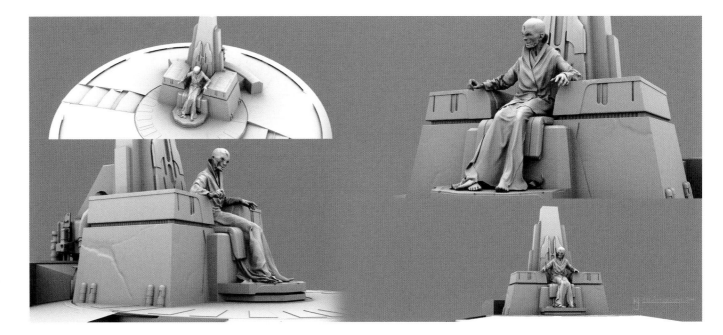

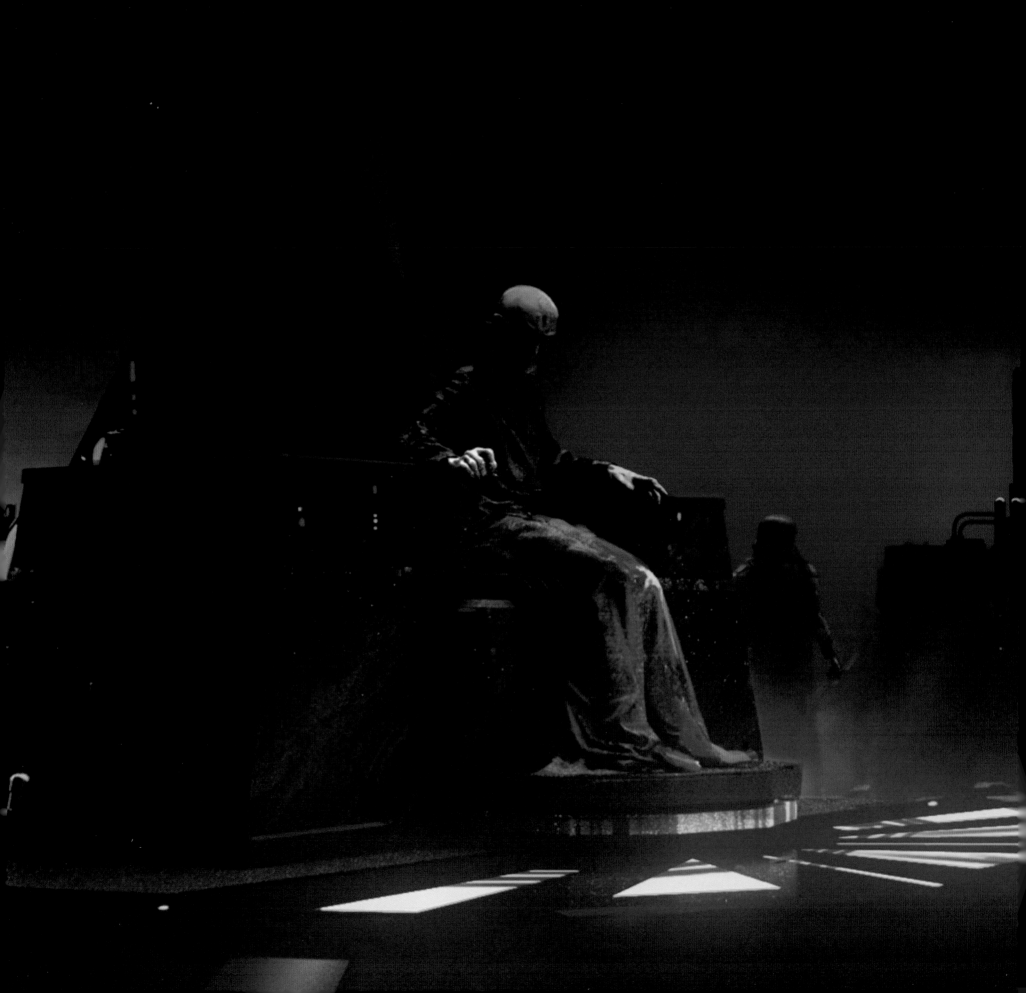

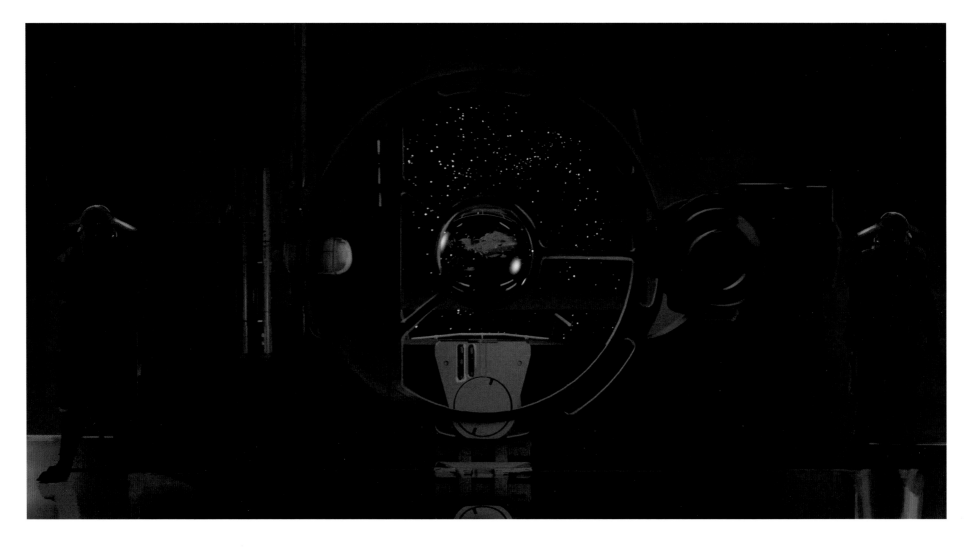

▲ **OCULUS VERSION 01** "I made the model of the throne, the oculus, and the dais. And Mark Harris, a brilliant art director who was an assistant on *The Empire Strikes Back*, translated them exactly. It's like when you look at Ralph and Joe's work on the other films—it was translated so literally at times." **Jenkins**

▲ **PRAETORIAN VERSION 03** Jenkins

▲ **FIRST ORDER OCULUS VERSION 01** Rosewarne

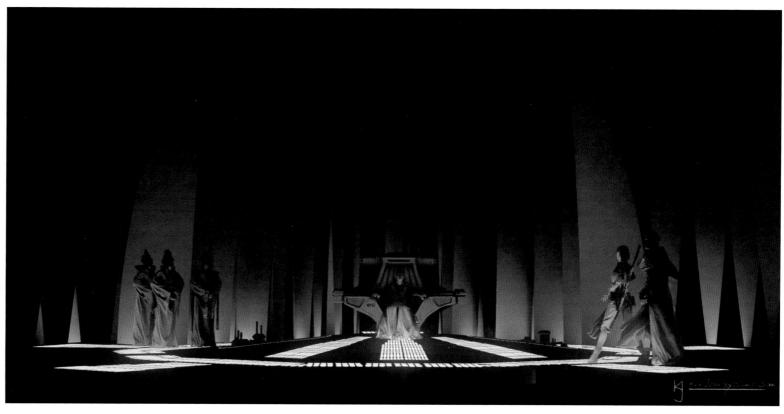

▼ **ALIEN 012** Ivan Manzella

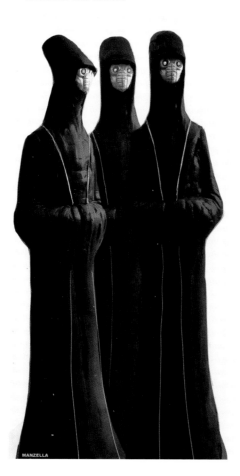

▲ **THRONE ORGANIC VERSION 01** Jenkins

◄ **GUARD** Rowley

▼ **GUARDS CLOSE** Rowley

"Snoke's aides were an Ivan Manzella design from *The Force Awakens*, quite close to being used. They were also quite close to being used in *Rogue One*. But no one seemed to find the place for them. And then suddenly, 'Bang!' It was Michael Kaplan that really drove the costume and their final look, more than anything—even the color of their faces. They were tailored toward that sort of servile, quiet, almost religious-type feel." **Scanlan**

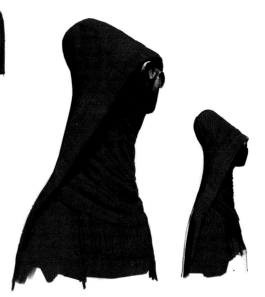

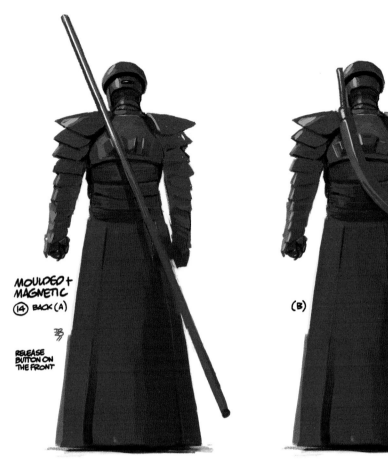

MOULDED +
MAGNETIC

⑭ BACK (A)

RELEASE
BUTTON ON
THE FRONT

(B)

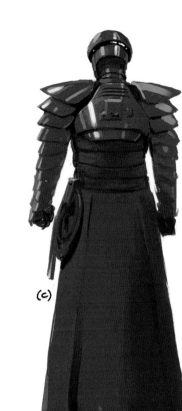

(C)

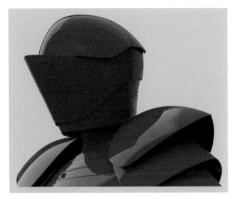

▲ **JOUSTER CLOSE-UP** Sam Williams

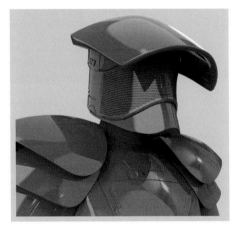

▲ **BACK VIEW PRAETORIAN GUARDS VERSION 01** Zonjić

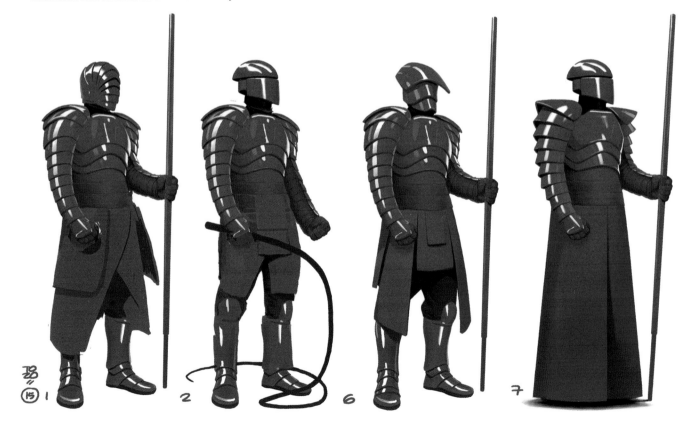

⑮ 1

2

6

7

▲ **FLAT CAP CLOSE-UP** Williams

◄ **PRAETORIANS REPAINTED REVISION 1B** Zonjić

"The Emperor's Royal Guards are some of my favorite designed characters in the original films. But they're very ceremonial; I want these guys to be samurai, to be very much based on where their name comes from—the Praetorian Guards. They're there to defend the Emperor. And they need to look like they can move. When they were able to fabricate the suits so the stuntmen could actually move in them, I knew we were onto something really exciting." **Johnson**

"I did a mood board with knights, samurai, fashion, and those original red guards from *Jedi*. I also looked at 1970s muscle cars, with their vents. I wanted this fire-truck-red lacquer feeling." **Kaplan**

"The armor goes hard and soft, with different types of polyurethane and various materials; there are certain areas of it that are soft so they can bend. They were put together very delicately with tough elastic, which allows movement." **Crossman**

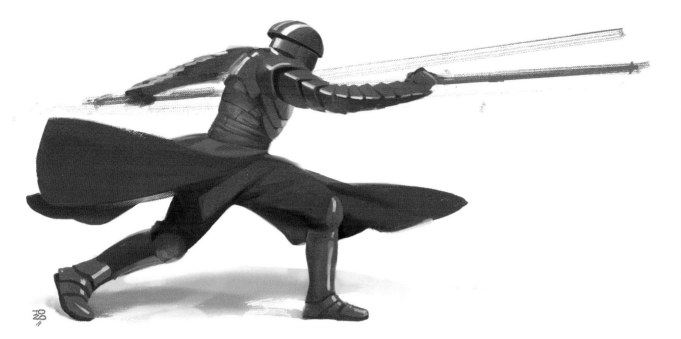

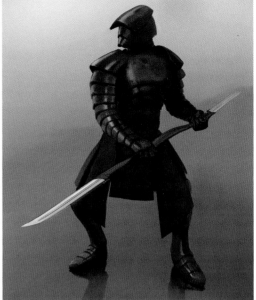

▲ **PRAETORIAN WEAPON STAFF VERSION 12** Catling

▲ **ACTION PRAETORIAN GUARDS VERSION 01** Zonjić

"The idea was to go back to that samurai vibe of the long skirts with the openings. We made a heavy red wool that would really hang, that had enough weight that they would look great when they were stationary." **Crossman**

"I also wanted it to look like they couldn't see out of the helmets. So we did tiny little saw lines. When you do that, you can see out perfectly well from the inside, but from the outside it looks solid, especially at a distance." **Kaplan**

▲ **PRAETORIAN GUARD WEAPON VERSION 19** Savage

▼ **PRAETORIAN GUARD WEAPON VERSION 53A** Savage

▼ **PRAETORIAN GUARD WEAPON VERSION 54B** "We tried to design melee weapons that could fight light-sabers, but were not actually lightsabers themselves. A key scene Rian asked us to reference was the dojo fight in *Crouching Tiger, Hidden Dragon*. So there was certainly a Chinese influence in there. But whenever the design veered too earthly and terrestrial, we introduced blade shapes similar to the *Return of the Jedi* skiff-guard weapons, with that very *Star Wars*-y silhouette." **Savage**

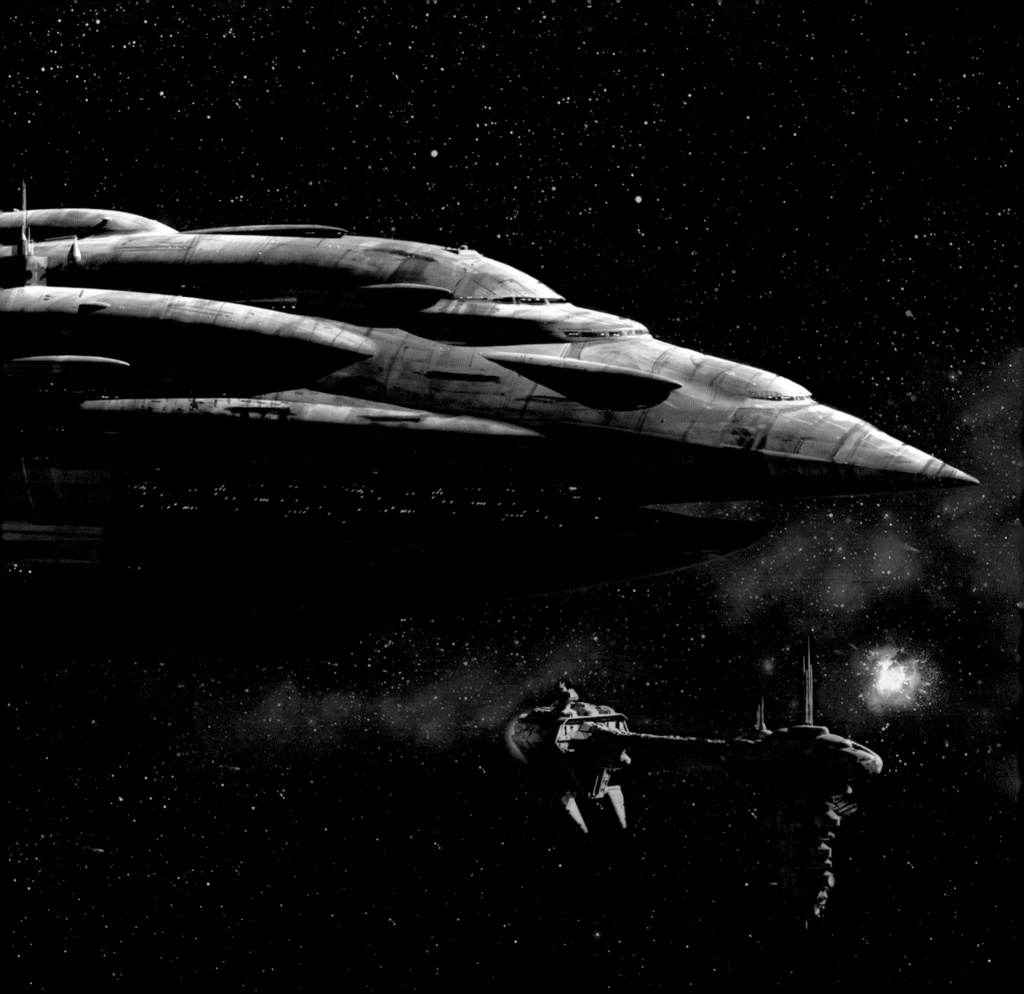

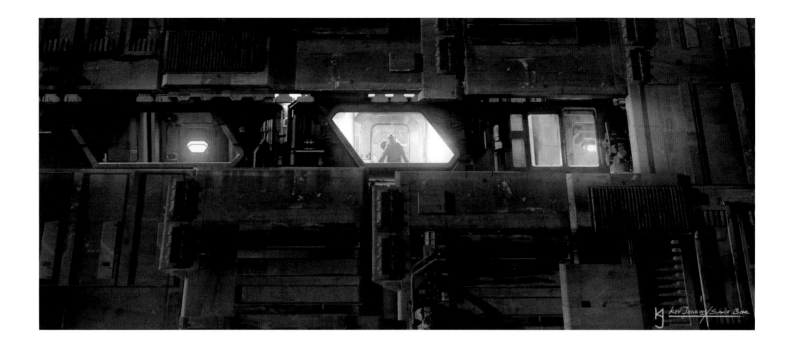

Finn Awakens

Prior to his official start date as *The Last Jedi*'s production designer on October 6, Rick Heinrichs traveled to the San Francisco Bay Area for a series of September meetings at Lucasfilm, including three days at George Lucas's *Star Wars* archive at Skywalker Ranch. On September 10 and 16, Heinrichs and I surveyed the prop, costume, and art collection covering both the original and prequel trilogies. We were joined on September 12 by Pablo Hidalgo for a deep dive into the concept art of Ralph McQuarrie and Joe Johnston, the latter with whom Heinrichs had collaborated on *Captain America: The First Avenger.*

"Real Ralph McQuarrie, Joe Johnston, and Nilo Rodis-Jamero drawings! Going through all of that was amazing, as well as having the opportunity to go over to the library. It's one of the rare visual research libraries," Heinrichs recalled. "Just being able to spend time in a place like that, with the help of research librarian Jo Donaldson, and getting a great steeping in the original films was fantastic." Heinrichs, Hidalgo, and I slowly examined and discussed every concept sketch and production painting in the archive one by one, primarily focusing on work from *A New Hope* and *The Empire Strikes Back*. We even dipped into the darker corners of *Star Wars* ephemera, like McQuarrie's work utilized on 1978's infamous *Star Wars Holiday Special.*

Heinrichs also reviewed documentation that I originally compiled in early 2013, and which was shared with Rick Carter and *The Force Awakens* Visualists, that detailed George Lucas's sense of the *Star Wars* visual aesthetic circa 1975—in particular an interview Lucas gave to advertising publicity supervisor Charles Lippincott. Heinrichs recalls, "All of that background on George's design philosophy was key: 'Let's not make the props too noticeable. Let's not make

the sets stand out.' It's not that he's anti-art, because—my God—he had Ralph McQuarrie and Joe Johnston and all of these amazing artists working on it. It really was an aesthetic of, 'Let's keep things moving along. Let's make it about the characters and the story.' Rian really gets it. He doesn't dwell on things. Designs are there to support what's going on. Just as George would chew through the scenery, Rian was likewise going for it. It makes you want to look at the movie again, too. I love that fact. You're not stuck in any one place for so long that you're tired of it and need to move on."

"I'm not an artist or a visual designer the way that Kevin or James or Rick are," Johnson says. "So anytime I have specific design ideas, it's entirely because of its function in the story. That's what I'm always trying to focus toward and push toward with every single element. Design-wise, it will get to where it needs to be when it's serving its function in the story as efficiently as possible. Serving the needs of the story is nothing revelatory. That's what you're always trying to do with design, I think."

In the midst of his visits to Skywalker Ranch, Heinrichs also attended several meetings at Lucasfilm's San Francisco campus. On September 11, Rick Carter walked Rick Heinrichs and his Visualists through the latest *The Force Awakens* moviescape and officially handed *The Last Jedi* off to Heinrichs. By that point in *The Force Awakens*'s production, the ILM-based art department had wrapped and principal photography at Pinewood Studios had resumed following the three-week break necessitated by Harrison Ford's on-set injury. Heinrichs also met one on one with Doug Chiang and James Clyne that same day.

◄ **RESISTANCE FLEET VERSION 01**
Jenkins and Heinrichs

▲ **FINN IMPROMPTU MED ROOM** Jenkins

"We had to do one of Finn's bacta suits relatively quickly for one shot, where John has woken up and he's wandering the corridors confused. The main shot at the beginning of the movie was filmed much later on." Crossman

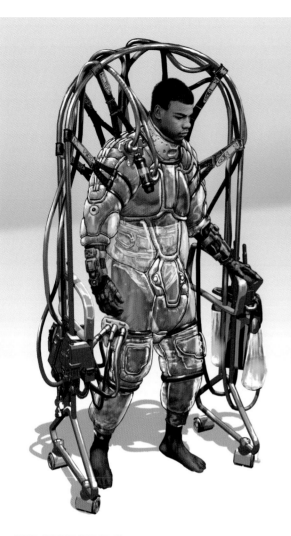

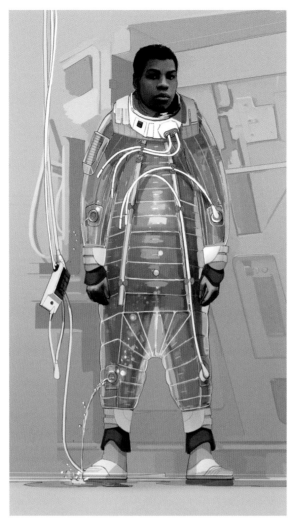

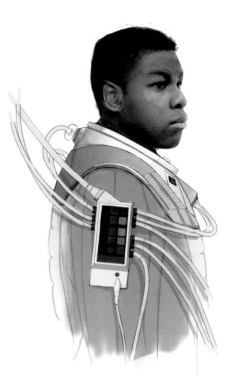

"The original reference, when Michael and I were talking about the bacta suit, was a big puffy 'onesie.' It was obviously healing John and taking care of him—a nurturing thing. So we tried to put as much pressure as possible on those pouches so it looked like it was pushing, if that makes sense." Crossman

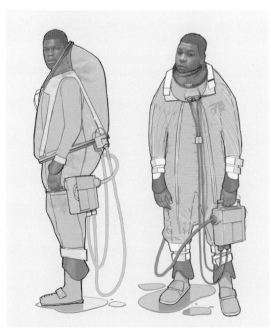

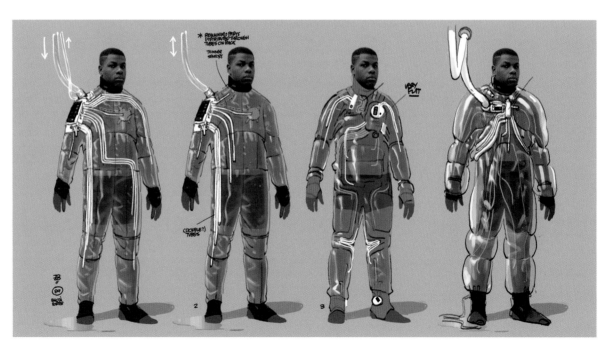

CONTINUOUS...

CAM

CONTINUOUS...

CAM

CONTINUOUS...

CAM

CONTINUOUS...

CONTINUOUS...

▲ **ACT 1 BOMBING RUN VERSION 03** Allcock and Michael Jackson

▶ **GURNEY VERSION 21** Catling

"Essentially, we got a sandwich-cutting laser machine. They use them in food factories and industrial packaging, like airbags. It's like a laser sewing machine. Pierre Bohanna's department had to experiment on each pouch. First we filled them with water, but the liquid was too fast-moving. Then we added silicone so the liquid wouldn't move so violently. They 3-D printed these very clever valves which connected the bags. You could fill each bag or you could fill the whole suit up. We made suit after suit, a fresh one for each time we were doing a sequence. You can refill it, but the suit would get so sticky, it was almost unusable." **Crossman**

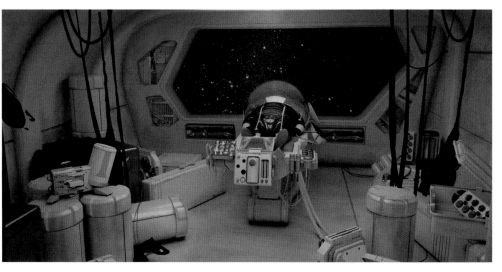

▲ **GURNEY VERSION 23** Catling

▲ **CONSOLE A IDLE** Booth and BLIND LTD.

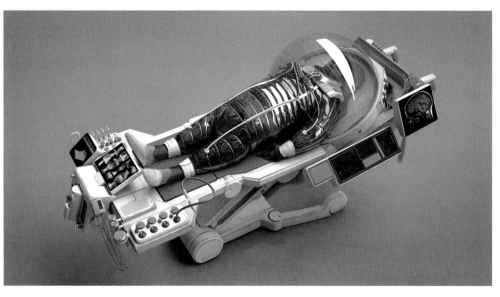

▲ **RESISTANCE CRUISER VERSION 04** Jenkins

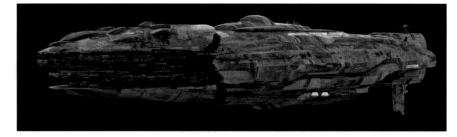

▲ **RESISTANCE CRUISER VERSION 05** Jenkins

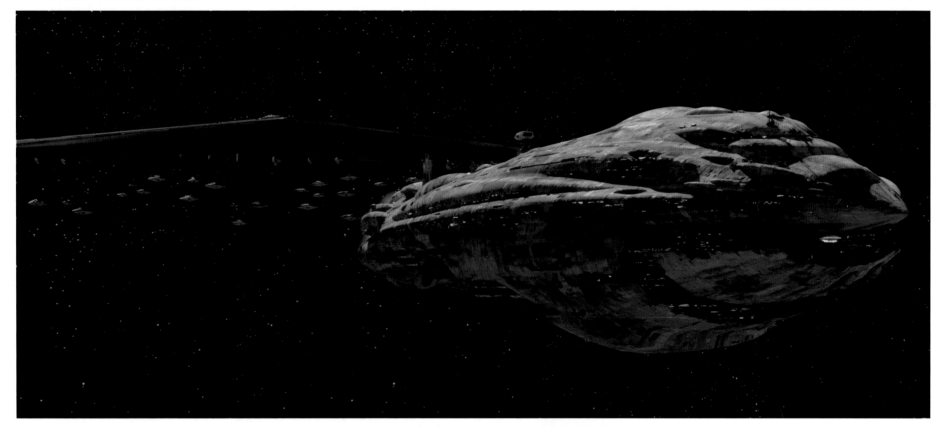

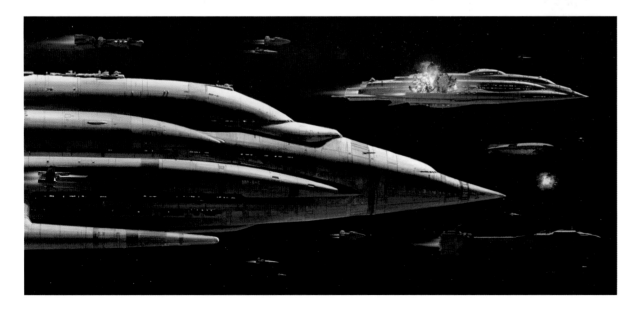

▲ **RESISTANCE CRUISER VERSION 01** "Rick and Rian were talking about Ralph's painting of the Mon Calamari ships from *Return of the Jedi*, which had a rocket ship–feel to them, with noses and everything. I did about six side-on images of the Resistance flagship. And the one he went for had the McQuarrie-type rocket ship nose. Resistance stuff is messy. It's a kit of parts, much more than the ordered, Brutalist Imperial stuff." Jenkins

◄ **REBEL FLEET VERSION 02** Damaggio

In early drafts of the script for *The Last Jedi*, the Resistance fleet consisted of six "battleships and frigates," which were picked off, one by one, by the pursuing First Order fleet. The Rodolfo Damaggio painting seen here is based on original trilogy concept artist Ralph McQuarrie's portfolio illustration of the Rebel fleet. Over time, Johnson consolidated the Resistance fleet down to the four ships we start with in the final film.

"I think that was a good decision. It's more distilled. We still have that beat of the Resistance abandoning the medical frigate. Leia's cruiser was inspired by the ones in *Jedi*, but not one to one. The same goes for the medical frigate and blockade runner—they're updated but clearly recognizable. There's been an evolution after thirty years." Heinrichs

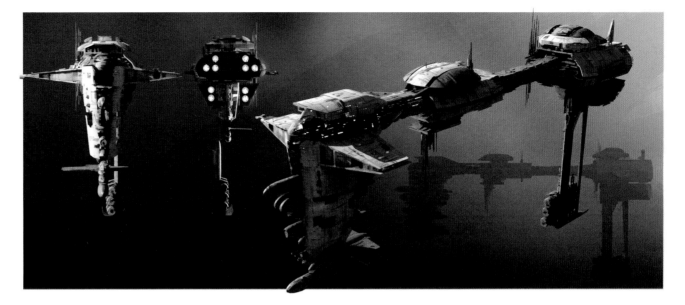

▲ **FLEET SKETCHES** Jenkins

▲ **MEDICAL FRIGATE VERSION 01** "The original medical frigate was designed around an outboard motor. And this is taking that a step further. Let's get some of the design influence from the bomber in there. Maybe the same company that made the bomber made the front of the medical frigate? Maybe medical frigates in *Star Wars* have submarine torpedoes hanging off them? It's an iterative process, thinking that these companies have moved forward. You'll recognize something of the old ships in them rather than a completely new, wacky shape." **Jenkins**

▼ **FRIGATE VERSION 04** "Rather than reinvent the wheel, I look at this as the difference between World War II/Korea and the sixties/the Cold War. Designs should be iterative. You don't come up with completely new things. It's like following a McDonnell Douglas plane all the way through its history. When you look at Saab or Dassault planes, they kind of look the same. What's another ship that that same company made? This is a heavier blunter blockade-runner. Rian liked the catapult nose. It's a wider, fatter, squatter—literally a blockade-runner, rather than a ship running away. You feel it can actually plow into things." **Jenkins**

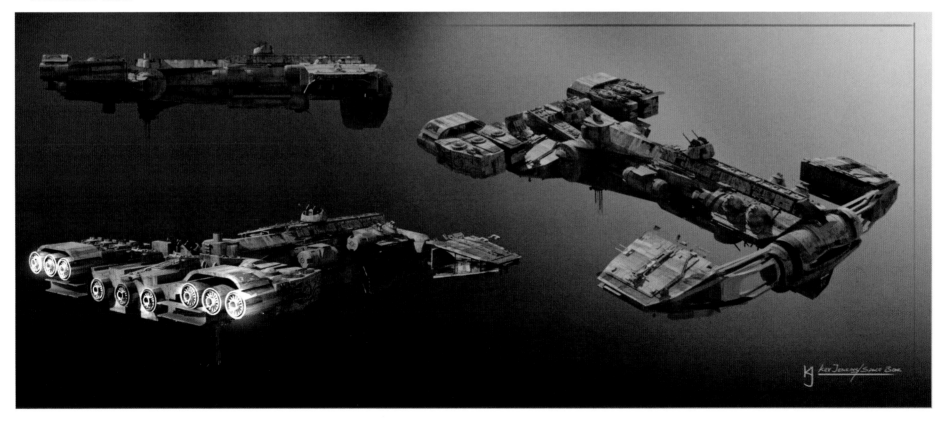

A Rose in Bloom

As concept artists James Clyne and Kevin Jenkins wrapped full-time work on *The Force Awakens* in mid-October 2014, after a nearly two-year run for Clyne (Jenkins would continue to iterate on Starkiller Base designs for ILM VFX supervisor Roger Guyett's postproduction unit for another month), Rodolfo Damaggio started his own two-year run as concept artist on *The Last Jedi* on October 20. Ultimately, Damaggio would touch nearly every design, most notably Canto Bight exterior environments, as well as the Resistance command and temporary bridge sets.

Meanwhile, production designer Rick Heinrichs visited the final standing sets for *The Force Awakens* at Pinewood Studios from November 2 through 12, with principal photography on the film wrapping on November 6 with Rey's "Forceback" vision sequence. By November 12, the art department for *The Last Jedi*, by then code-named "Space Bear," had officially moved into a small nondescript office on West Olive Avenue in Burbank, California, not far from the legendary Warner Bros. Studio Facilities and Walt Disney Studios lots and, more importantly, not far from Los Angeles–based director Rian Johnson, producer Ram Bergman, and Heinrichs. Preproduction had officially begun.

"Using the technology that we have now, we came up with this idea of the 'war room' with monitors and conference links to everybody," recalls Heinrichs. "So we set up a Friday afternoon meeting, once a week, for as long as we could, linking with London, San Francisco, and Burbank. We would go through the week's work, and Rian was able to review it and make his insightful and incisive comments.

"From those frequent meetings and Rian's frequent immersion in what we were doing, we were able to really get a good sense early on of what it was he was going for and what was developing. There was no easy ramp up to it, knowing that I was going to need to move to London in April or May and set up shop with the group that was actually going to be building all of this. I realized, 'We've just got to run at it as hard as we can.' All of that had a huge impact on how we were able to successfully translate the designs. As a raw list of sets, it was daunting to look at. But, as with anything else, the more you break it down into its parts, what's the look, how it is going to function for the shooting, what do we really need out of it, exploring what's on location, the easier it was to digest," says Heinrichs.

James Clyne joined *The Last Jedi*'s art department on November 3, working remotely from Lucasfilm in San Francisco. "My first massive influence into design for film was *The Empire Strikes Back Sketchbook*. As a child, seeing that it starts with just a sketch is so visceral—there's such a connection to it. These guys aren't doing some magical thing on a computer. They sat down and really worked it out in their heads."

"It comes down to problem solving," Clyne continues "It's nothing more than that. And it's one problem at a time. With *Star Wars*, George Lucas built an equation. We are just trying to crack that equation, understand it a little more: what worked, what didn't work. George was a magician. It's all smoke and mirrors. It looks so simple but it's one of the hardest things to hit."

Kevin Jenkins soon followed suit, joining the art department on November 10, working remotely from ILM's offices in the Soho neighborhood of London. "I would be enamored to know what Ralph McQuarrie was thinking," Jenkins says. "I can see references to the Korean War. I can see references to *Flash Gordon, Buck Rogers,* and even *Forbidden Planet,* because I found window mullions from *The Empire Strikes Back* in *Forbidden Planet.* I'm just trying to think the same way, having a rational reason for design choices. *Star Wars* is not about doing cool stuff. Everything needs to be there for a reason, naturally."

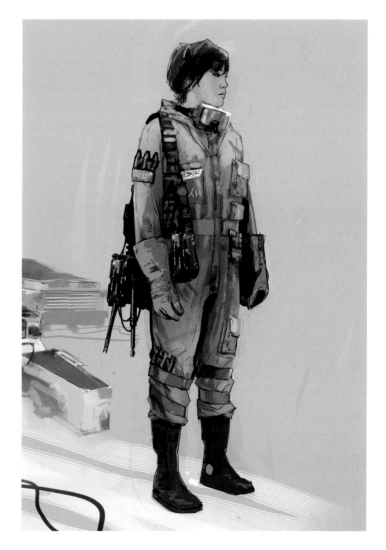

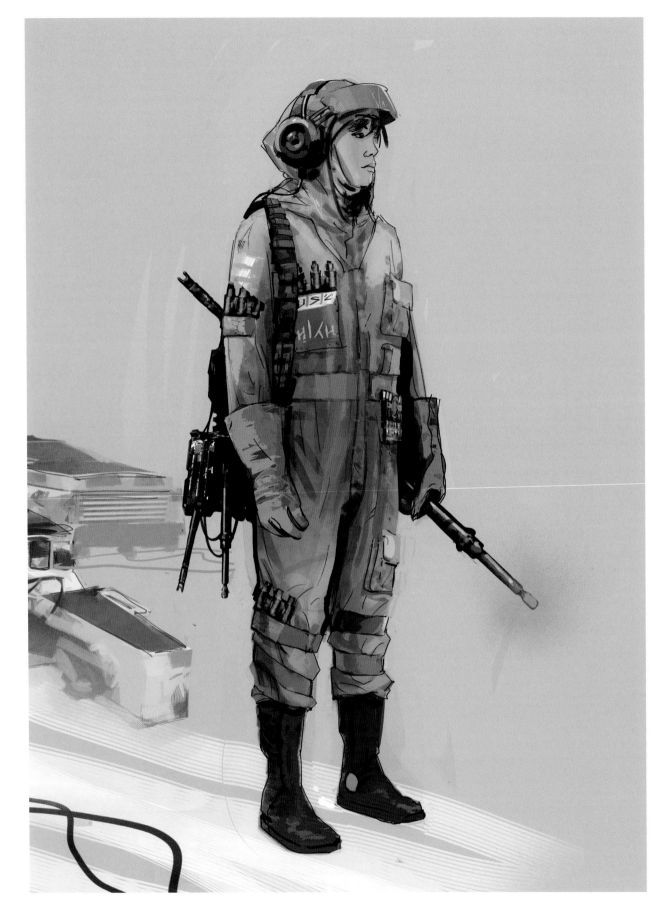

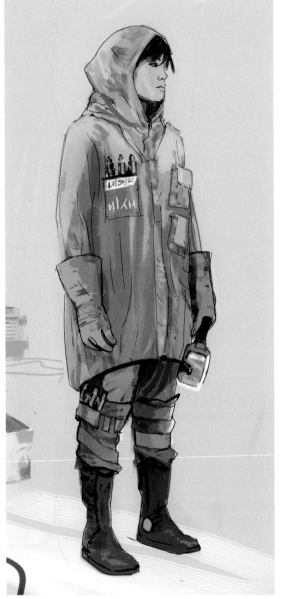

▲ **ROSE GROUND CREW A7** Jock

◄ **ROSE GROUND CREW A72B** Jock

"When we were figuring out Rose's outfit, we didn't even know who the actress was. But we knew it was going to be a basic coverall. Rian wanted it to be pretty shapeless, something that a man or woman could wear. But it's in her character: She's not someone that has to look good for work. Rose is a no-nonsense character. She just plugs along and she's spunky. So it does work. They decided to keep her in that outfit throughout the whole Canto Bight situation." **Kaplan**

"Rose has a modified Resistance ground crew outfit from *The Force Awakens*. For *The Last Jedi*, we went with the all-in-one suit. And we mixed the two looks for different roles among the ground crew. The original color of the ground crew—that acidy green—works well. So Rose went into that. The nice thing about a jumpsuit is you can put lots of detail on it. You can add big graphics to it. It ages nicely." **Crossman**

▲ **PENDANT VERSION 01** Savage

▶ **PENDANT VERSION 10** Savage

▼ **ROSE PENDANT VERSION 01** "The initial brief, as per the script, was to design a two-part pendant that would be split between Rose and her sister. Story-wise, that developed into two identical pendants—one for each sister—but the 'yin and yang' aspect led the design. Set decorator Richard Roberts suggested some Celtic reference that influenced one design, which quickly became Rian's favorite, and that design stuck." **Savage**

▲ **ROSE RING VERSION 02** Savage

▼ **LEIA CHAMBER VERSION 01** Catling

PCAT 010

▲ **LEIA CHAMBER VERSION 69** Catling

"This was one of the first things we shot, actually. We had this idea of a round shape with these bays off of it and a window. And as we got into it, I remembered in *Empire* there was this area of the *Millennium Falcon* with Luke in it that had this feel—inset bunks with a skylight nearby. I always loved the shapes that *Empire* production designer Norman Reynolds had put into it. So we wanted to riff a bit on that and yet keep it in our world, as well." Heinrichs

◄ **LEIA CHAMBER VERSION 10** Catling

"We recolored See-Threepio this time because we asked Rian, 'Which Threepio do you prefer?' He liked *The Empire Strikes Back* one. So we went back to that warmer gold Threepio. He's a bit cleaner and back to a more classic look. And we put a little wax on the final plates so he's not overly chrome-y. Anthony Daniels can now get the suit on in eight minutes. It originally took an hour and a half; it used to take a half an hour just to get the helmet on. It's a much happier experience for Anthony, I think. He's in and out of it so quickly." Crossman

▲ **LUKE IN MEDICAL BAY (PRODUCTION ILLUSTRATION FOR** *THE EMPIRE STRIKES BACK*) Ralph McQuarrie

▲ **LEIA CHAMBER VERSION 66** Catling

▲ **MEDICAL DROID FRONT PAINT** Zonjić

▲ **LEIA CHAMBER VERSION 21** Catling

B

PCAT 045

▲ **LEIA CHAMBER VERSION 45** Catling

▲ **LEIA MEDICAL HEAD** Rowley

"Leia's medical outfit is kind of her hospital gown. It still has a drape to it. There's a beautiful, slight pattern on it, which you'll be able to see in the film depending upon the lighting." **Kaplan**

▼ **LEIA CONSOLE FINAL** Ainsworth

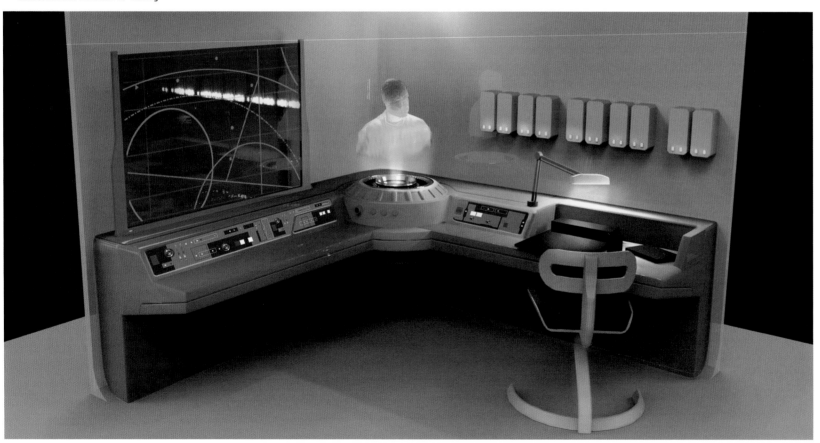

▲ **MINI RESISTANCE TRANSPORT VERSION 01** "I remember having a chat when we originally pitched that Resistance transport to J.J. Abrams on *The Force Awakens*—that it could be modular. But we left it at that. When Ram said, 'I just need a really small ship to do this and this,' I said, 'How about the Resistance transport?' Obviously, you see *Star Wars* ships carry over in the first three films from one to another. So we were trying to think of something that could dribble into *The Last Jedi*. I said, 'What if we rip the whole body and gun bit off the end?' They didn't need the rest of it, so they took the engine bit and flew that down to Canto. Rian said, 'Yeah, that's cool,' and that's what it was. It's one of those *Star Wars* sets where what's inside is much bigger than what can fit in the outside." **Jenkins**

▶ **MINI RESISTANCE SHUTTLE VERSION 01** Jenkins

▼ **MINI RESISTANCE SHUTTLE VERSION 02** Jenkins

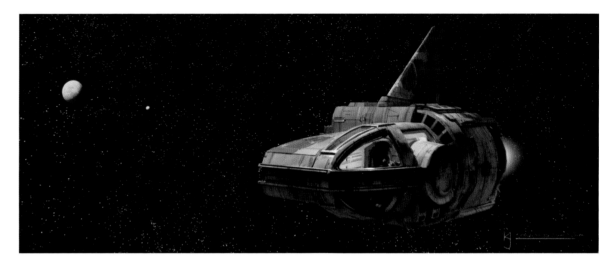

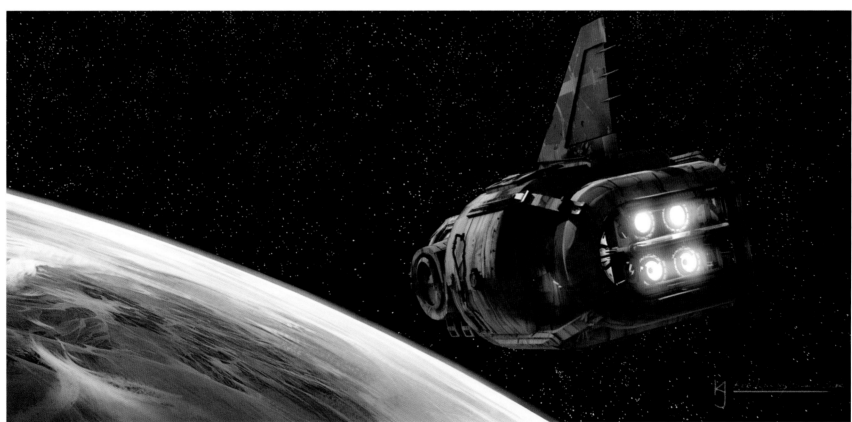

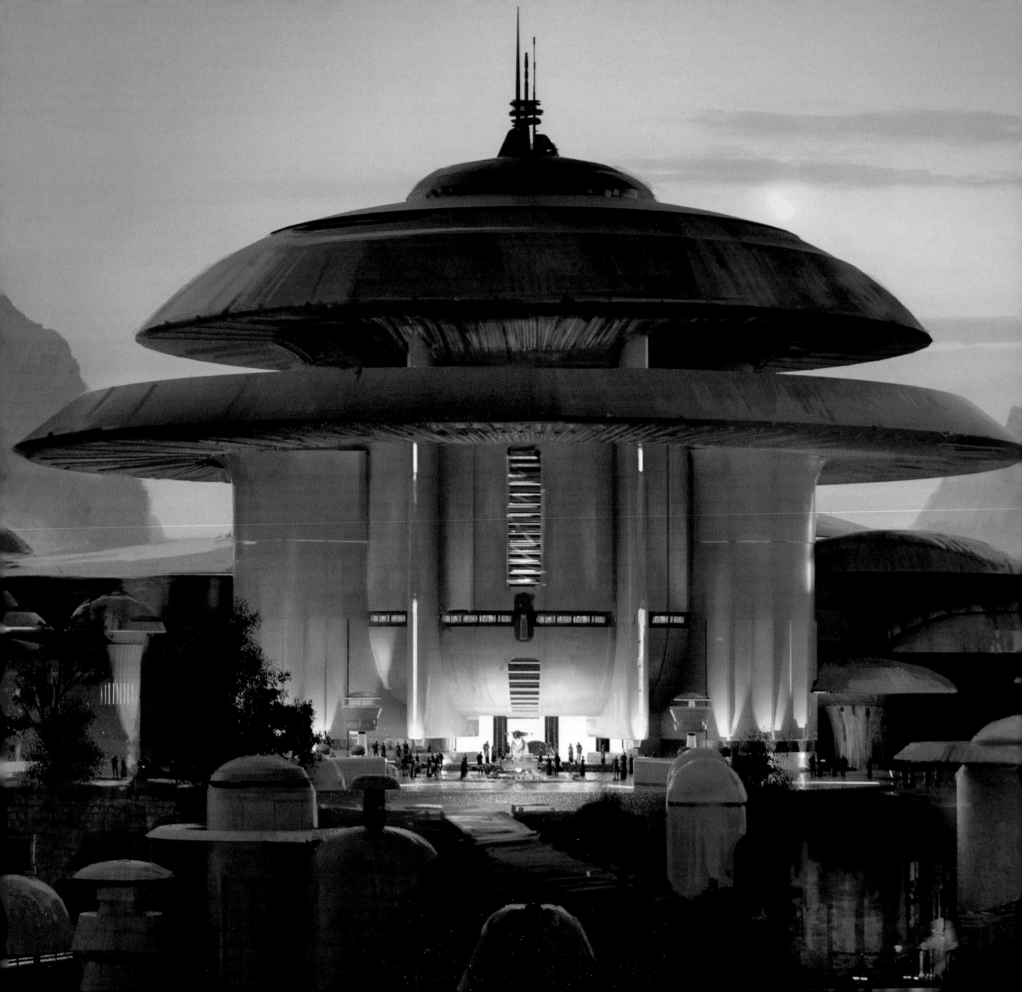

To Catch a Codebreaker

By the end of November 2014, art director John Dexter, concept artist Tani Kunitake, and production assistant Chris Arnold, creator of the "Space Bear" production logo of a panda bear wearing an astronaut helmet, had joined production designer Rick Heinrichs, concept artist Rodolfo Damaggio, and coordinator Andrea Carter at the Burbank-based *The Last Jedi* art department, while James Clyne and Kevin Jenkins continued their design work remotely.

That month, concept artwork focused on preliminary designs of a more fleshed-out temple island on Ahch-To and the earliest ideas for a new Resistance base hidden in a mine on a salt flat planet. Clyne also pitched the idea of reviving the Mono Lake–inspired environment developed in the earliest months of *The Force Awakens*. (Mono Lake is a uniquely alkaline soda lake in Northern California with beautiful, naturally occurring tufa limestone towers.) "Mono Lake was discussed for Jakku in *The Force Awakens*," Clyne says. "Never throw anything out."

Ultimately, Rian's salt flat concept for the Resistance base won out. "But there was no discussion of the base being abandoned, so I would always throw in ships and X-wings," continues Clyne. "Maybe it's built upon preexisting architecture. I was riffing off of Hoth from *Empire*—Echo Base, and the base being tucked into something. At which point it evolved from just a slit in a ground plane to more of a bunker idea with some fortifications. At this point, we were talking about locales like Death Valley as a theme." World War I–style battle trenches dotted with cannons surrounding the base were also first illustrated in November, with Clyne relocating fortifications from either the top of or cliffs surrounding the base, down into a channel circling its perimeter. "It's really the conceit of kitbashing again," says Clyne.

Prior to the 2014 holiday break between Christmas Day and New Year's Day, concept artists Daniel Simon, Justin Sweet, and Jaime Jones were enlisted in the ever-growing *Last Jedi* effort in Burbank. Damaggio tackled Jedi temple and library tree designs on the island, while Jones and Kunitake focused on Canto Bight's landscape and casino interiors, respectively. Even at this early stage, the library tree was already subtly shaped like the Rebel Alliance phoenix or "Starbird" logo. The Jedi temple was a more open, dome-like cave. And the Canto Bight's seaside layout, inspired by Monte Carlo's contiguous alpine and coastal geography, was locking into place.

On the vehicle-design front, Simon worked on the very earliest designs for DJ's stolen "sleek ship." And Jenkins's conception of Supreme Leader Snoke's mobile command center, the Mega Destroyer *Supremacy*, was iterated on and approved by director Johnson over a period of just one week. James Clyne continued his development of the Resistance base, which now included a shield-shaped door on the exterior and a circular, interior starfighter hangar space with a low, slit opening—not unlike the Yavin 4 rebel base in *A New Hope*. "Doug Chiang saw that interior and said, 'Let's be careful that it doesn't tread too much on Yavin for *Rogue One*,' which it did. They built a bit of physical set looking right out the door, so you had sunlight coming right through. That was a good note from Doug," says Clyne.

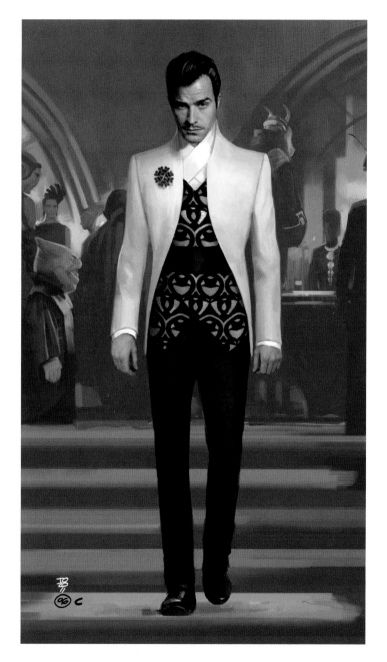

◄ **CASINO ESTABLISHER VERSION 04** "I did the main entrance, the main exterior, and a couple of wide shots of what the city was like for the casino. I think it pulled everybody into being more *Star Wars* and a bit less classical and almost earthly. Fundamentally, I split the roof of the casino into hanging buttresses." **Jenkins**

► **MASTER CODEBREAKER VERSION 05** Zonjić

"*To Catch a Thief*, another one of the films we watched at Lucasfilm, was a big reference for the whole feel of the world of Cantonica and the Master Codebreaker—the devil-may-care romance." **Johnson**

"It was a mystery. Who will the Master Codebreaker be? Justin Theroux came just the day before shooting. So our tailor, Lewis Westing, made him a bespoke suit very quickly. He basically worked most of the night making a lovely white tux for him." **Crossman**

▲ **PARTY YACHT VERSION 02** Greg Fangeaux

◄ **PARTY YACHT EXTERIOR** Fernández Castro

The party yacht that sails off the edge of
Canto Bight's sea was filmed on the sun-
deck of an actual yacht in the Adriatic Sea
near Dubrovnik, Croatia at dusk on March
10, 2016, for wide establishing shots of
the ship, and March 15 for closer shots
on the deck. The chartered *Sea Star* is a
forty-five-meter-long luxury ship docked
in Dubrovnik. Production crews utilized
the two lower decks of the vessel to house
equipment and dress and prepare the
actors for their scenes.

▲ **CASINO ALIEN 11** Lunt Davies

"For most of the Canto Bight aliens, the thought was, 'How far can we push this?' That's tough, because that automatically takes you into H. R. Giger territory, which is not *Star Wars*. They had to be grotesque, but with an element of beauty to all of them. That was the balance we were trying to strike." **Johnson**

▶ **YACHT VERSION 01** Brockbank

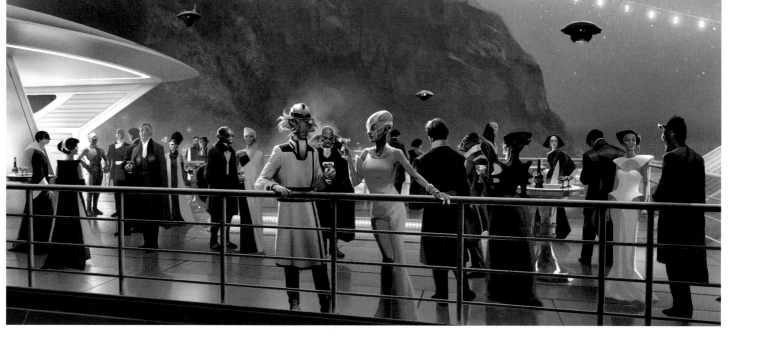

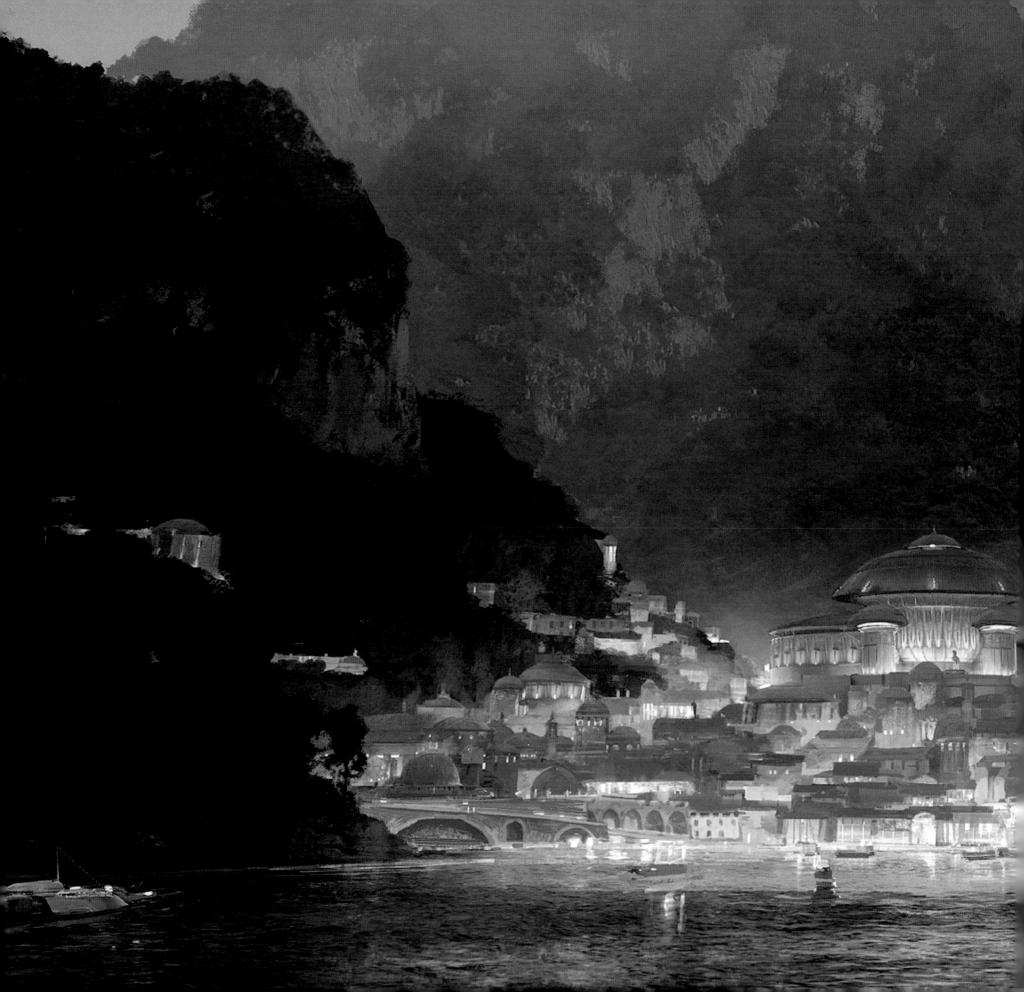

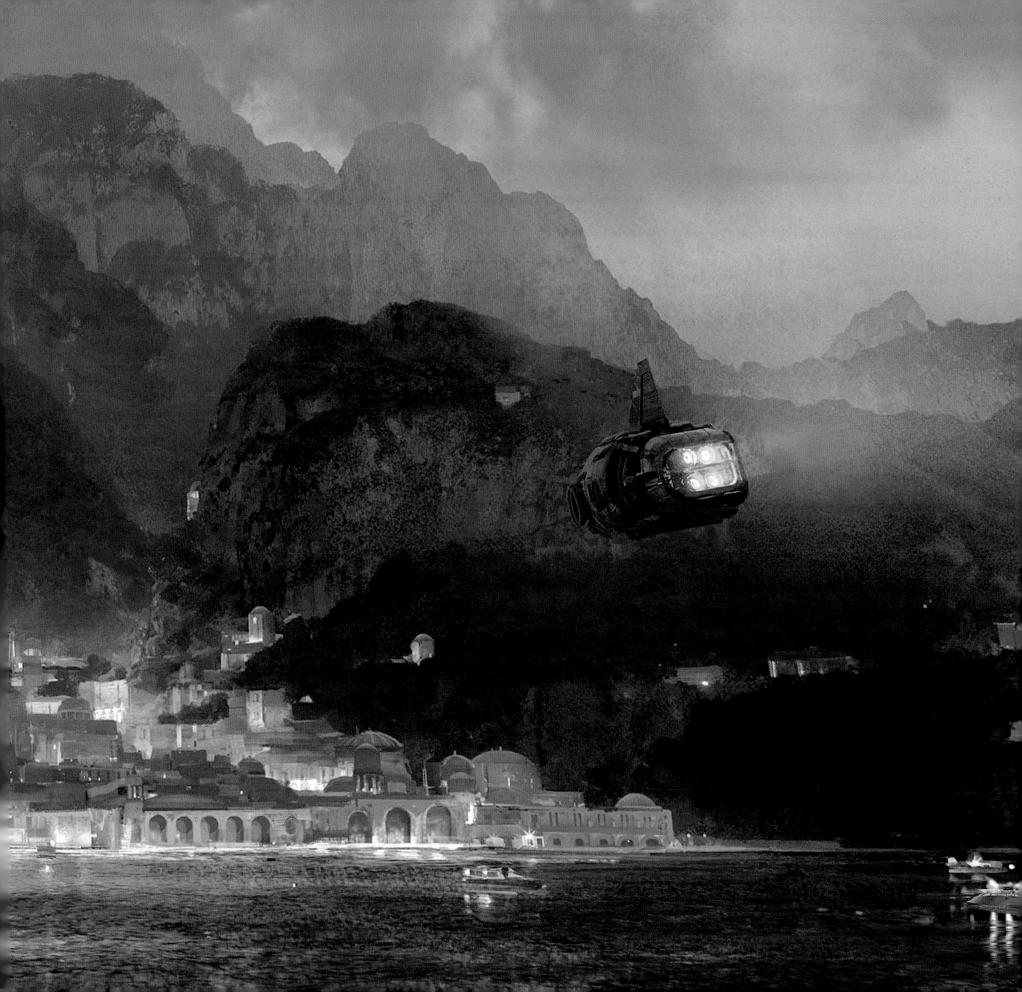

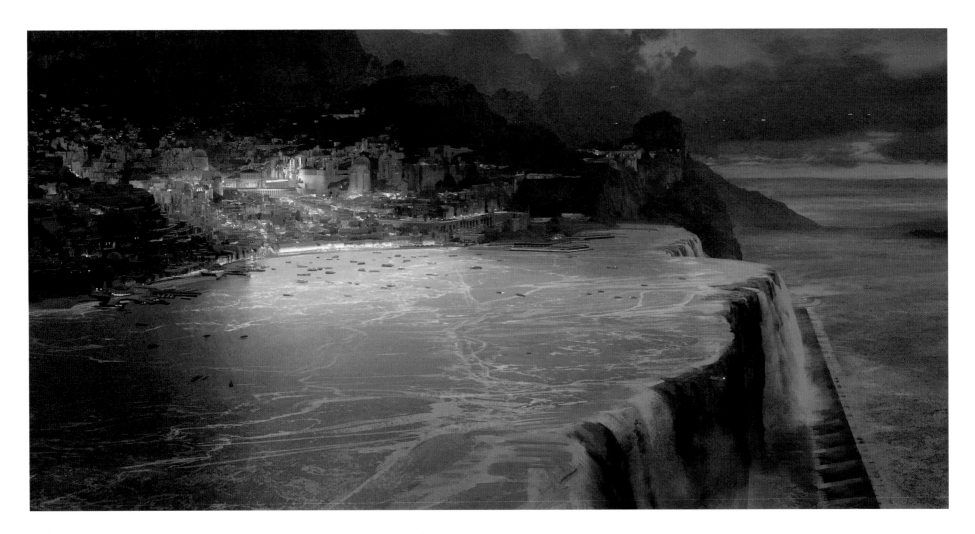

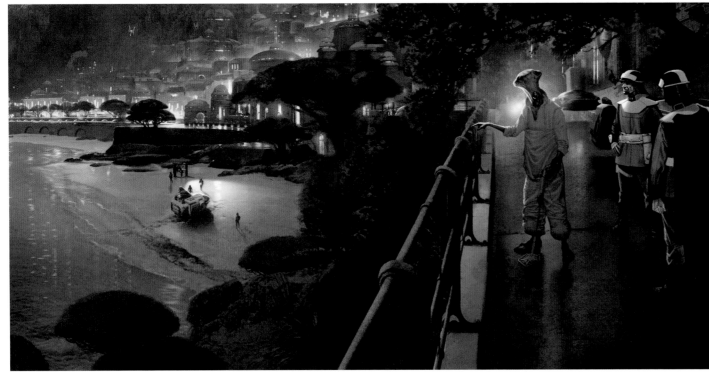

▲ **DESERT AT NIGHT** Jones

◄ **BEACH SHUTTLE VERSION 02** Brockbank

"There are certain designs that you just identify with more than other designs. And Ello Asty, one of the Abednedo aliens in *The Force Awakens*, is one of those designs. The idea was to expand upon with what we did on *The Force Awakens*—color, pattern, complexion, and color-of-eyes variations. The costume always plays a very important role. The Abednedo that we see in the casino, for instance? His costume makes him appear of that place and very different. We put one in a flying suit, and he looks like a serious fighter pilot. We put one in an easier, lounge-y, beach-y costume, and he becomes a much cooler dude. One would hope that we see more of them in the future." Scanlan

▶ **CASINO VALET VERSION 02** Jones

"The casino needed to feel that it was a rendered shape. Trying to figure out how to conform that aesthetic to the cut-and-dressed stone look of Dubrovnik was a bit of a challenge. Cities are not snapshots where everything was built at the same exact moment of time and of exactly the same materials. We came up with a concept of older and newer areas of the city. It feels layered in a way that we haven't seen in a *Star Wars* film. Going back to Lucas's own words and instincts from the beginning, you want to feel like it's always been there, that a team of artists didn't sit down and design it. And you're shooting it in a casual way, not like, 'Hey, look at me. This is the most amazing thing you've never seen before.' It wants to feel familiar, that there's a history to it, but you're here to watch the characters, not to gape at my beautiful sets [*laughs*]." Heinrichs

▼ **CASINO ESTABLISHING VERSION 02** "There were beautiful paintings that Rick and the art department were developing. But fairly late in the game, Lucasfilm president Kathy Kennedy came in a said, 'This just doesn't look like *Star Wars* to me.' It felt maybe too Monte Carlo and not enough *Star Wars*. So everybody jumped back in. I pulled a Ralph McQuarrie sketch from 1980 for Jabba's Palace, putting that McQuarrie dome on top of a bit of rock. I imagined that they carved the top of this hill off and had the city snake up the side of it, but I still focused in on the structure, which Rian really responded to. At the same time, Kevin started to do some sketches. This was the first initial spark, showing that McQuarrie sketch. 'Well, if it doesn't feel like *Star Wars*, then just give them *Star Wars*.'" Clyne

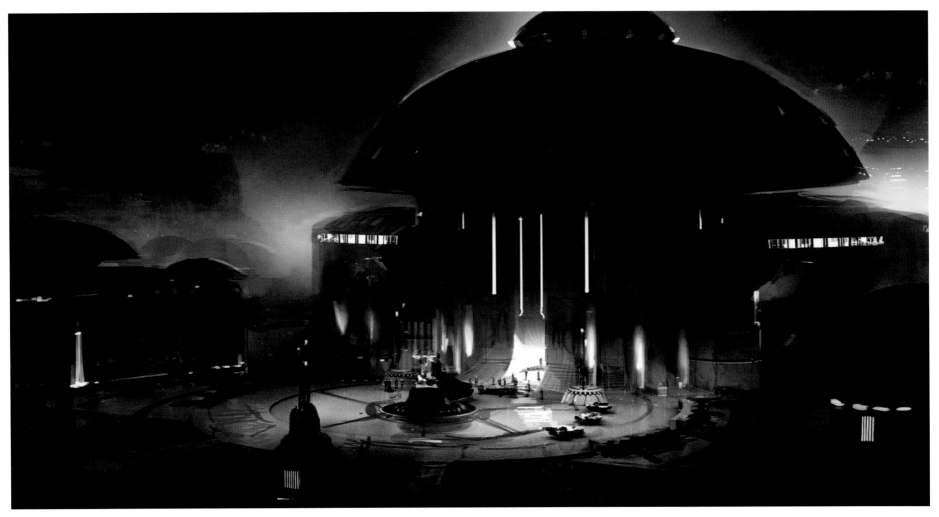

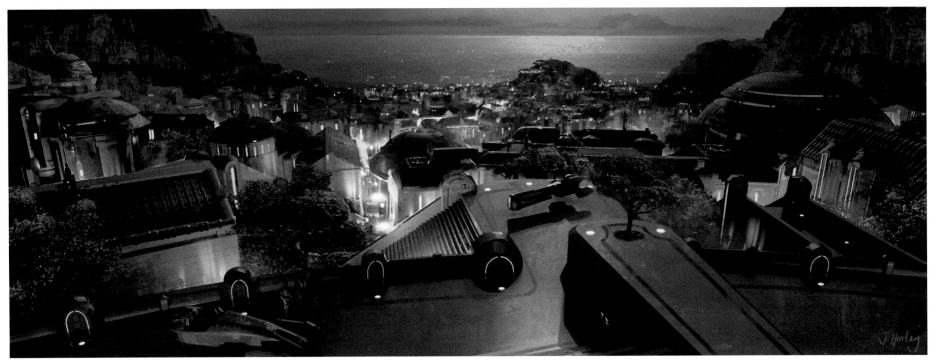

▲ **KING 12** Manzella

▼ **CASINO ALIENS 49** Lunt Davies

▲ **PEARL GENERAL 05** Tim Napper

"Rian said that this casino wasn't a place where the skullduggery and the lowlives of the *Star Wars* world would meet. This is where you went if you had inherited money, made money, or were in the process of becoming very rich, to go and enjoy yourself amongst your own. And the patrons would be wearing black-and-white suits, which was a rather frightening idea. But apart from that, it was a completely open forum. We laid maybe three hundred designs all out on boards in the workshop and invited Rian for his first shortlisting. That's the X factor for art, isn't it? He walked down, very freely, putting on Post-it notes—same as we did with J.J. on *The Force Awakens*. Four to six weeks later, it got to what we called D-Day. I think we ended up making forty-something characters, and he chose thirty-five in that one session. Had any of us bet on which ones he was going to choose, we all would have lost." Scanlan

▲ **KING 19** Lunt Davies

▲ **MALE SCREAMER 01** Napper

▲ **DAYTONA VERSION 39** Fernández Castro

"As we were doing the casino exterior, we realized that these speeders were helping us a lot, making us believe we are on this other world. That combination of technology with the architecture . . . I think it is going to work." **Heinrichs**

▲ **CARABO GRAPHICS** Booth and BLIND LTD.

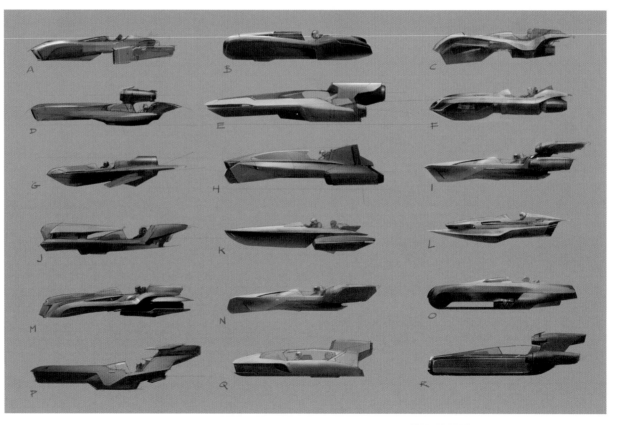

▲ **SPEEDER OPTIONS VERSION 02** Fernández Castro

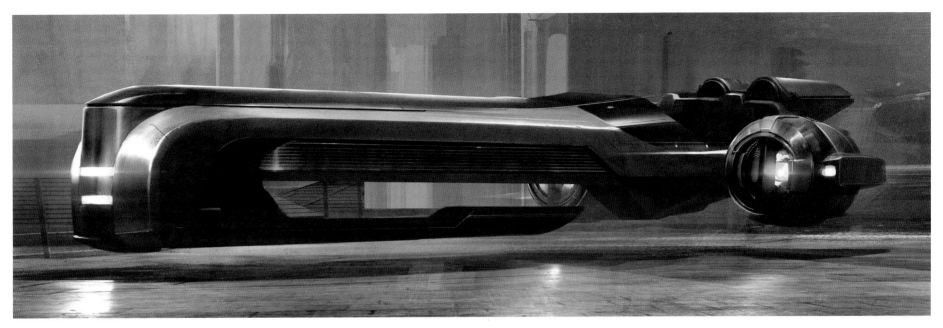

▲ **ROYAL COUPE VERSION 37** Fernández Castro

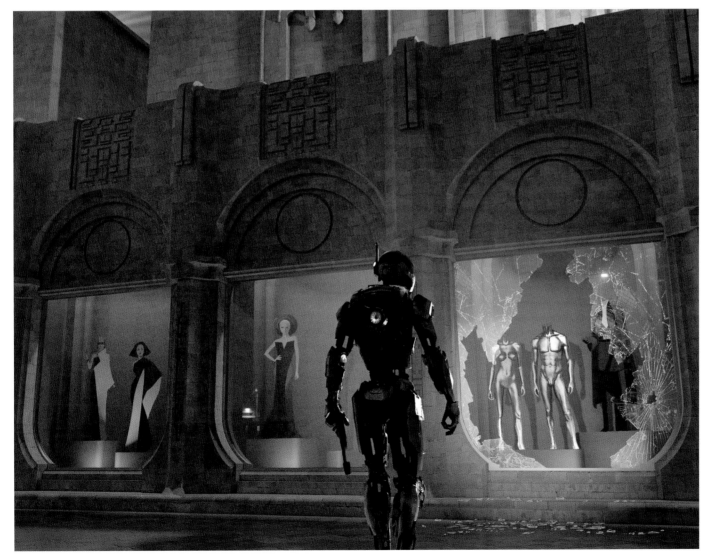

◄ **FORMAL SHOP VERSION 02** Damaggio

Costume designer Michael Kaplan recalls, "There was supposed to be a scene where Rose and Finn broke into a shop window when they got to Canto Bight. She put on a gown and he put on a futuristic tuxedo. So that was going to be a reveal for Rose, going from this frumpy-dumpy coverall to a beautiful gown, which never happened." In early drafts of *The Last Jedi*'s script, Finn was also to receive lots of ego-inflating attention upon entering the casino, only to realize that he had his tuxedo on backwards. Ultimately, the sequence was cut, with Finn and Rose instead sticking out like sore thumbs in their Resistance gear, and being arrested before they can meet with the Master Codebreaker.

▼ **BACKWARDS SUIT VERSION 01** Zonjić

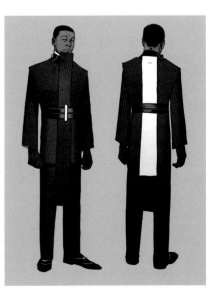

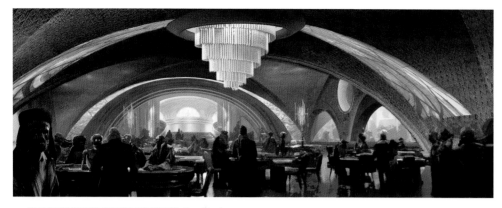

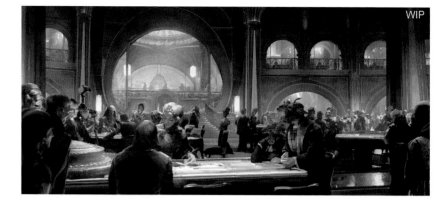

WIP

▲ **CANTO BIGHT SKETCHES VERSION 01E** Brockbank

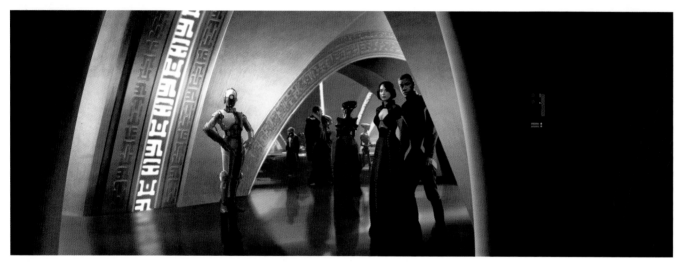

▲ **GAMING HALL FLOOR VERSION 03** Jones

▼ **GAMING HALL FLOOR ENTRANCE** Fernández Castro and Heinrichs

"This was a fabulous set to walk onto on the day. All of Neal's work and all of the props and set dressing was amazing. That was on 007 Stage [the massive permanent soundstage at Pinewood that was originally built in 1976 to house the *Liparus* supertanker set for *The Spy Who Loved Me*], and we filled it. We wanted it to have scale. And we worked closely with [ILM London VFX supervisor] Ben Morris about what they were doing: what should be green-screen, what shouldn't be green-screen, what was going to allow Rian to shoot as if he was in a real place and get that look and feel across. But when you need scale, you need scale. It has to look opulent. It has to look over the top. If you tried to squeeze this scene into a set the size of the cantina, it wouldn't have worked." **Heinrichs**

▲ **CABARET REVAMP ENTRANCE VERSION 01** Brockbank and Heinrichs

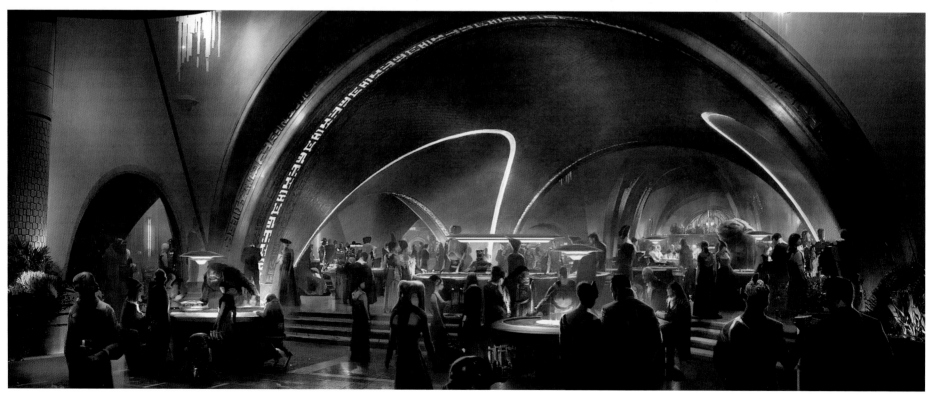

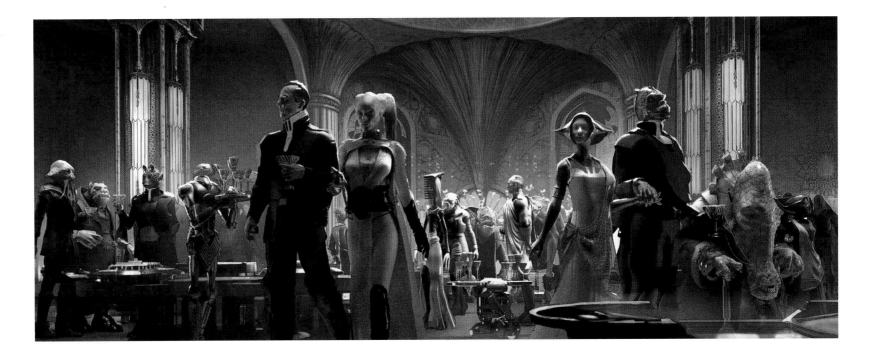

INTERIOR CASINO ENTRANCE VERSION 12
Borrelli and Aaron McBride

"I did an early pass at casino patrons where there was a lot of variety to their species and their attire, like the aliens of Jabba's court or Mos Eisley. Rian was inspired by a painting by Jean-Georges Béraud, *The Casino at Monte Carlo (Rien ne va plus!)*, 1890. He wanted clean, simple lines of black-and-white dress in a warm, golden room, with the variety being in their species. He said, 'Think of their dress like a black tie affair. . . . What would be the *Star Wars* version of the Academy Awards' red carpet?' I looked a lot at Ralph McQuarrie's design sketches of the citizens of Bespin, the clean lines and art deco motifs, as that felt like the most affluent place we see in the original trilogy." **McBride**

BB-8 SLOT MACHINE VERSION 01 Savage

SLOT MACHINE BALL VERSION 02 Rosewarne

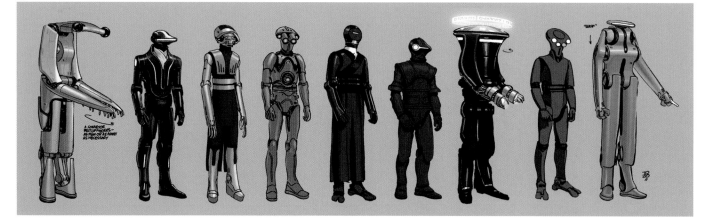

▲ **CASINO DROID IDEAS** Zonjić

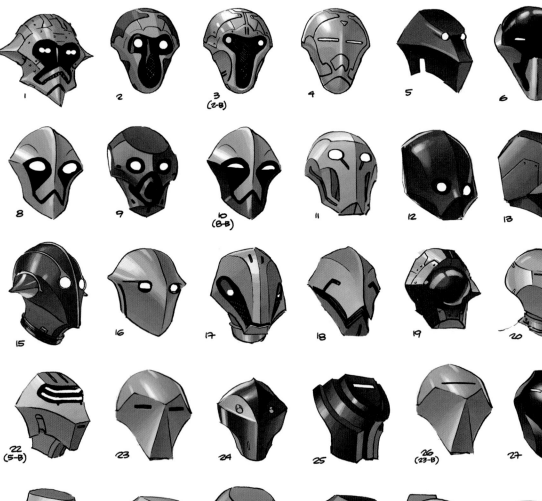

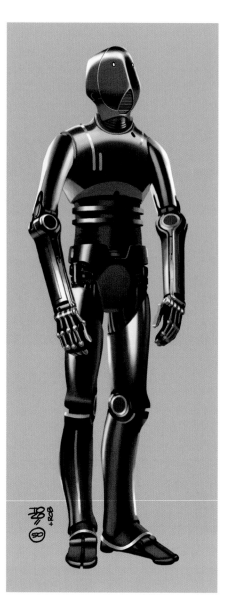

▲ **CASINO DROID REVISION 3** Zonjić

"There were a lot of versions of the waiter droid. People were mostly happy with the body. And Pierre Bohanna developed this new paneled leg that would come apart when the leg moved, so it's very clever. But the face always leads everything. It's blank but supposed to have a slight air of superiority. Once it had that face, Rian was happy. We made a see-through mask so you didn't have to look through the eyepieces anymore. It's a paint treatment onto a clear plastic, so your vision's very good, which Anthony Daniels liked. He was coaching the droids on set." Crossman

◄ **DROID HEADS** Zonjić

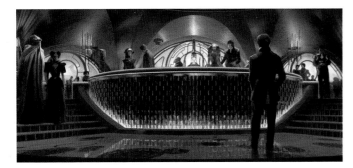

▲ **CASINO BAR VERSION 01D** Brockbank

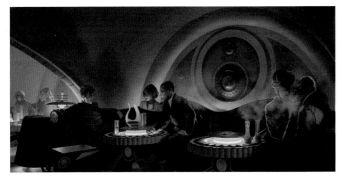

▲ **CABARET VERSION 04A** Brockbank

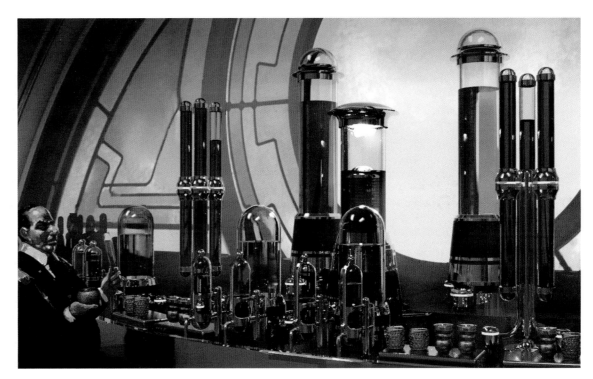

▲ **CASINO BAR VERSION 01** Rosewarne

▼ **CASINO BAR VERSION 05D** Brockbank

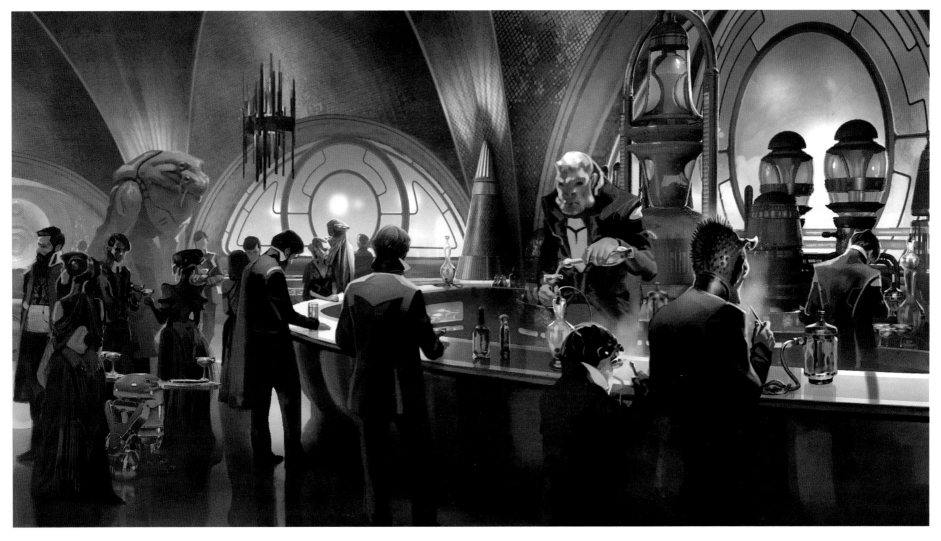

▲ **CASINO ALIENS 02** Lunt Davies

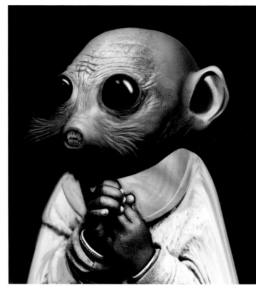

▲ **KING 56** Manzella

▲ **CASINO ALIENS 37A** Lunt Davies

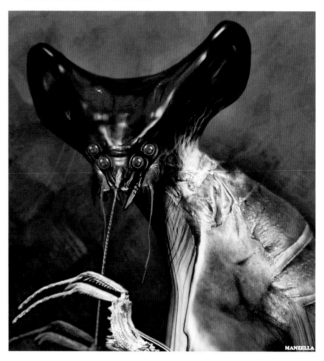

▲ **KING 11** Manzella

In early drafts of the script, the Master Codebreaker chats with Finn and Rose in the casino's cabaret, revealing that he has been casing an insectoid warlord, known as "the Butcher of Brix," for over a year. The Codebreaker intends to steal "the blood jewels that finance his murderous regime." "The warlord had two very beautiful ladies by his side, all the time," Neal Scanlan says. "He's fully animatronic; there's no performer in him. Super-slime dripping from his mouth, caught in a glass very delicately by a lady."

◄ **KING 35** Manzella

▲ **KINGS 30AB** Rowley and Manzella

▲ **KING 02 COLOR** "Having previously worked with performer Derek Campbell on *Rogue One*, I really wanted to create a creature that fully exploited his body shape. Derek is a double below-the-knee amputee and had been a droid in *Rogue One* with extra-long legs using custom prosthetic limbs. For KO02, I really wanted to push and accentuate that. So I looked at him having these really long and thin lower legs clad in riding boots that gave no room for regular performer's feet and pushed his height to over eight feet." Lunt Davies

▲ **KING 09** Manzella

"The purple lady is all sculpted, with an animatronic head. There are several characters that we approached like that. Their shapes lend themselves to being on wheels, so the performers inside can then concentrate on their upper sections. Gustav Hoegen, creature effects supervising animatronic designer, mechanized the features to give her that air of real life. We sculpted her with that feeling that she can court any man she wants. The extras played brilliantly off of her. There's one man in particular, with a very James Bond look about him, who would spend a lot of time caressing her shoulder or holding her hand or leaning forward. And it just adds to the magic." Scanlan

▲ **CROUPIER** Lunt Davies

"The little rod that operates the croupier's chip shovel was motorized from under the table. He has little motorized legs. So there was a performance happening under the table and a remote-control head, designed very much to be within the Muppet or hand-puppet realm. He had that charisma, that perfect English gent charm about him, which is what makes the character funny. You have all these extras around the table and Dave Chapman, who performs and vocalizes him, standing off to the side going 'House wins, thank you very much.' No one's acknowledging Dave's presence. They're all watching the croupier [*laughs*]. Madness, absolute madness." Scanlan

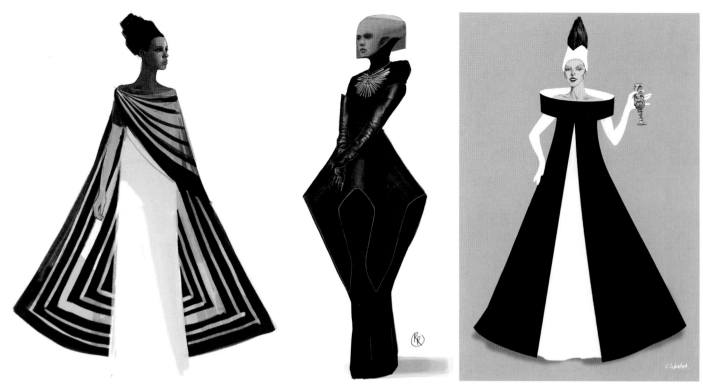

▲ **TRIANGLE CAPE 3** Rowley ▲ **KING 28** Rowley and Fisher ▲ **SCOOP NECK COLLAR WOMAN** Weston

▲ **MORE SUITS** Zonjić

▲ **SPIRAL GLOVE** Rowley

▲ **WHITE BLACK GLOVE** Rowley

"Formal-wear in *Star Wars* was a huge, tricky thing, but something that Kaplan and his team did an amazing job with. I told him, 'I don't want it to look wacky and ceremonial. I want it to look as if Armani were living on a different planet and designed this stuff.' So it can't be ornamental and goofy. It's got to be legitimately sleek and cool-looking." Johnson

"I put together mood boards of people from different periods who were famous for their eccentric beauty or their extreme height. It was all black and white, striking. When I read about the casino, I thought, 'This is going to be a challenge. How do I translate what feels on the page like a James Bond movie into a world that is fathomable and acceptable to people who love *Star Wars*?'

"It helped that everything was being made here. We had not only sewing rooms, but a millinery department and a jewelry department—which we've never had on *Star Wars* before. Vast amounts of jewelry and headpieces and tiaras and belts and gloves. So it was almost like MGM in the thirties; It was kind of crazy but wonderful." Kaplan

"We had to do fifty creatures and a crowd of just over three hundred. The men you can kind of get away with slightly more of a tuxedo look. So we created four styles of tuxedo, plus we made some special versions for special characters. You vary all the fabrics and the facings, and then, when you fit them on different characters, you start to get that variety.

"With the women, it's far more complicated: You can't just make hundreds of one dress. I've never had so many workrooms in a studio in my career. Each room would make around thirty to forty individual dresses. Some of the dresses we sent out to various fashion factories to make short runs: eight of one dress, half a dozen of another. Or they'd make capes. Rian didn't want to use too much pattern. He preferred things either graphic or one color or two-tone. Nothing too complicated, nothing too fussy." Crossman

CASINO ALIENS 07 Lunt Davies

"One of the things I've noticed when designing creatures and aliens is that, disregarding the context of costume and body shape, there is a default assumption to read a design as male. This issue extends back to the early days of comics and animation, where the hero characters were generally male and the subsequently introduced female characters were defined with the addition of staple tropes: eyelashes, lipstick, hair. It's always been a goal to create a female character design that exudes femininity without relying on those symbols to define that." **Lunt Davies**

"The girls that played them were models. And they played them with the same luster as if they were walking down a catwalk, which I though was amazing because these weren't puppeteers or performers. They were such good sports. They got into those suits, and they put those heads on. And they sweated and suffered like everybody else did. But they did bring an element of sexuality to *Star Wars* that we had not yet seen." **Scanlan**

▲ **COLE DRESS** Rowley

"For model/actress Lily Cole, Jo Van Schuppen, a specialist couture cutter, made her this beautiful dress, done very quickly but very skillfully." **Crossman**

▶ **COAT SKETCH** Rowley

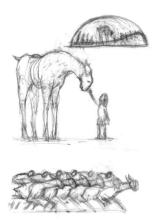

▲ **FATHIER RACE SKETCH** Heinrichs

◄ **WINDOW TRACK VIEW VERSION 02**
Brockbank

"The stained-glass windows were a struggle to figure out. One of the nice things about having all of this time to refine things with Rian is that we simplified the racetrack and the patrons in the stands to a glimpse of something that we will reveal more of later. One of Rian's geniuses, since he's writing it as well as directing it, is to go in and come up with story solutions that get you from A to B." **Heinrichs**

▼ **CASINO GRANDSTAND VERSION 03**
Brockbank

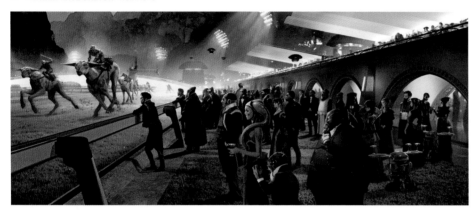

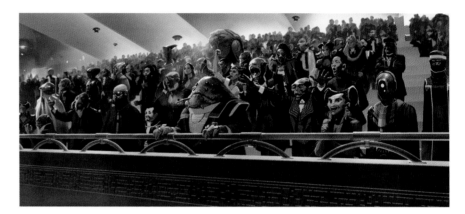

▲ **CASINO GRANDSTAND VERSION 01** Brockbank

▼ **RACE TRACK VERSION 09** Jones

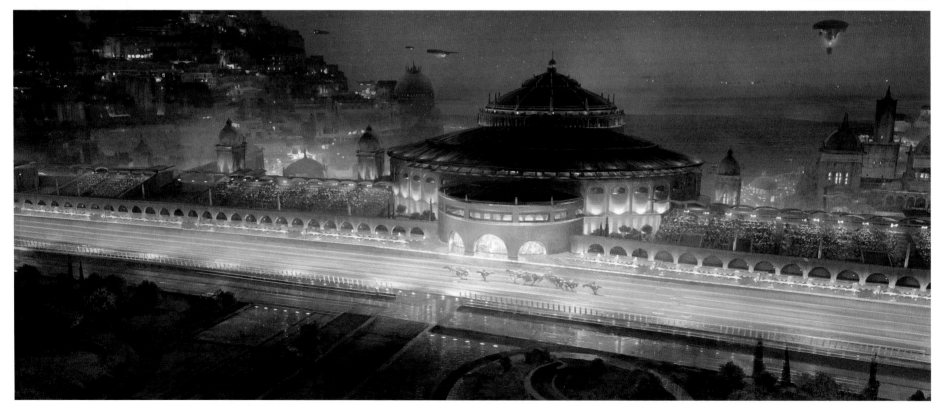

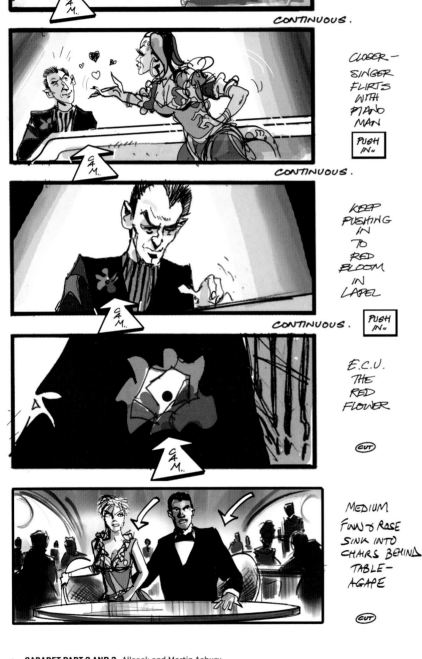

ON STAGE, SINGER & PIANO-MAN

PUSH IN"

CONTINUOUS.

CLOSER — SINGER FLIRTS WITH PIANO MAN

PUSH IN"

CONTINUOUS.

KEEP PUSHING IN TO RED BLOOM IN LAPEL

CONTINUOUS.

PUSH IN"

E.C.U. THE RED FLOWER

CUT

MEDIUM FINN & ROSE SINK INTO CHAIRS BEHIND TABLE — AGAPE

CUT

▲ **CABARET PART 2 AND 3** Allcock and Martin Asbury

The Master Codebreaker's original introduction was to take place in the casino's cabaret room, where an "alien lady sings a torch song" as the Codebreaker accompanies her on keyboards, crooning along. Rose and Finn spot his "red plon bloom," following the Codebreaker to a private booth for a chat about "the Butcher of Brix," whom the Codebreaker is on a caper to steal from. The group then departs the casino via a service entrance.

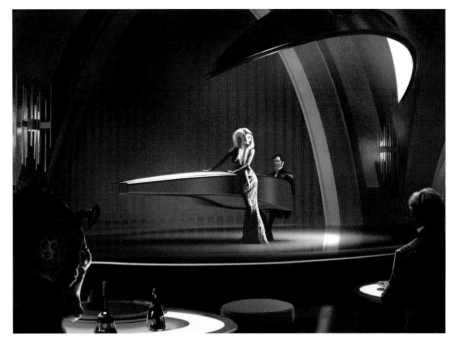

▲ **CABARET REVAMP VERSION 04B** Brockbank

▲ **MASTER CODEBREAKER BROOCH** Weston

C.Weston.

▼ **PIANO KEY LAYOUT** Kitisakkul

▲ **POWER MAMBA 08** Napper

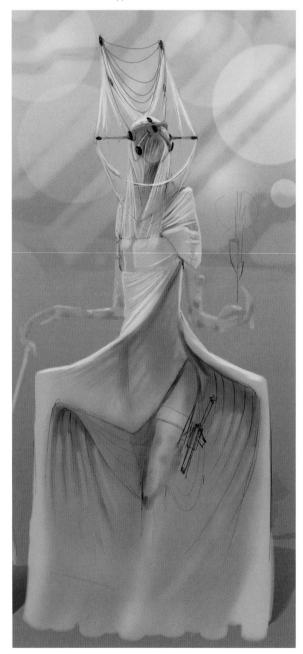

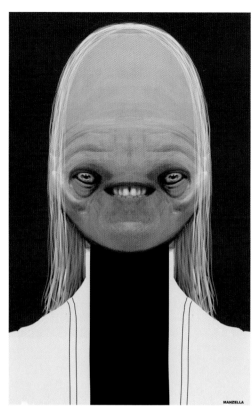

▲ **KING 21** Manzella

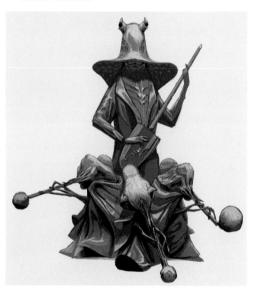

▲ **BAND NEW 02** Napper

"The band is very bizarre—another crazy abstract design
by[creature concept designer] Tim Napper. The principle
is that as their brains deflate, they come out of the end of
the instrument. So they're not playing their instruments,
they're physically within them. Again, it seemed like a fun
visual, and you have a physical way of selling the music.
When Rian chose a Tim design, it was like, 'Wow, okay.
Now I've got to make sense of this.'" Scanlan

◄ **FLATISH 01** Napper

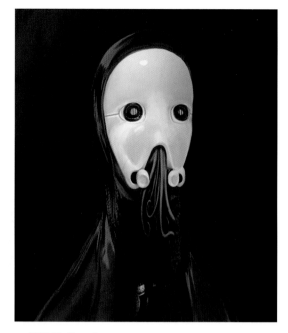

▲ **KING 29** Manzella

▲ **KING 21** Manzella

"Michael Kaplan's team pulled the proportions back to the
original drawing by the cut and the design of the costume.
It's subtly brilliant. His ability to have that sympathy with
creatures makes him quite unique. It's one thing to dress the
human body, but it's another to dress one of an alien nature
that doesn't conform to human proportions. And to still be
able to make it feel like, 'He's a sharp dressed guy, isn't he?
He's got his spats on, his walking stick, and his tails. He abso-
lutely looks like he's just come from Savile Row, kitted out for
a night in Monte Carlo.'" Scanlan

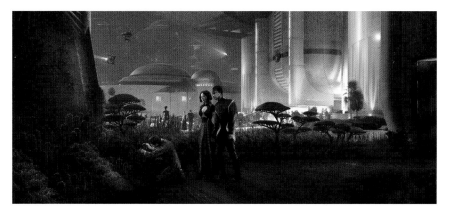

▲ **CASINO SIDE VERSION 12** Borrelli

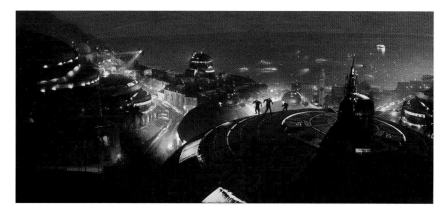

▲ **CASINO ROOF** Borrelli

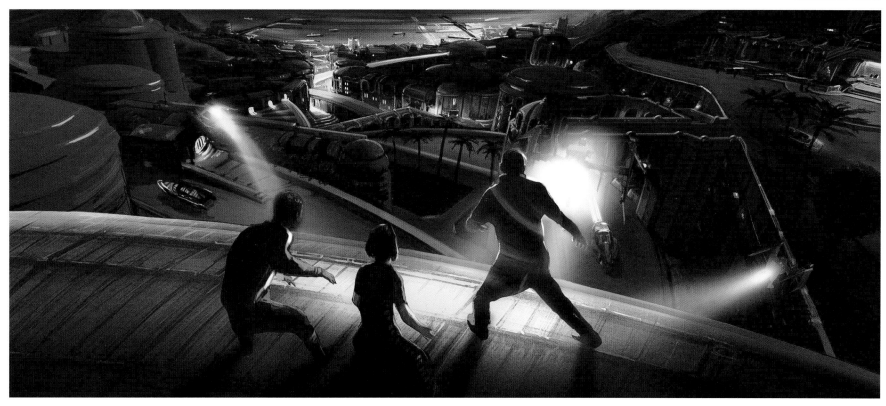

▲ **ROOF VERSION 13** Borrelli

▼ **PRISON SHIP** Tani Kunitake and Heinrichs

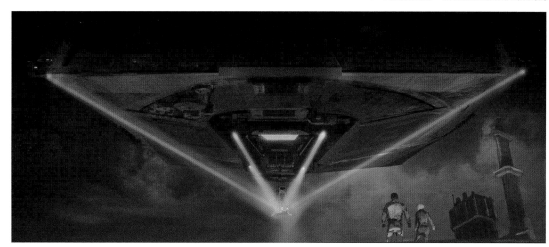

The original Master Codebreaker sequence continued with Finn, Rose, and the cat burglar departing the casino to recover a "stashed knapsack" stuffed with the "tools of thievery." Finn and Rose unwittingly along for the ride, the group climbs onto the casino rooftop with the intent of breaking into a wealthy warlord's room, only to be spotted by a "darkened surveillance droid." A dozen police vehicles—spotlights and sirens blaring—appear, as a "taser beam" from a huge prison ship physically abducts the Codebreaker. Finn and Rose are arrested and taken to the Canto Bight casino drunk tank/jail.

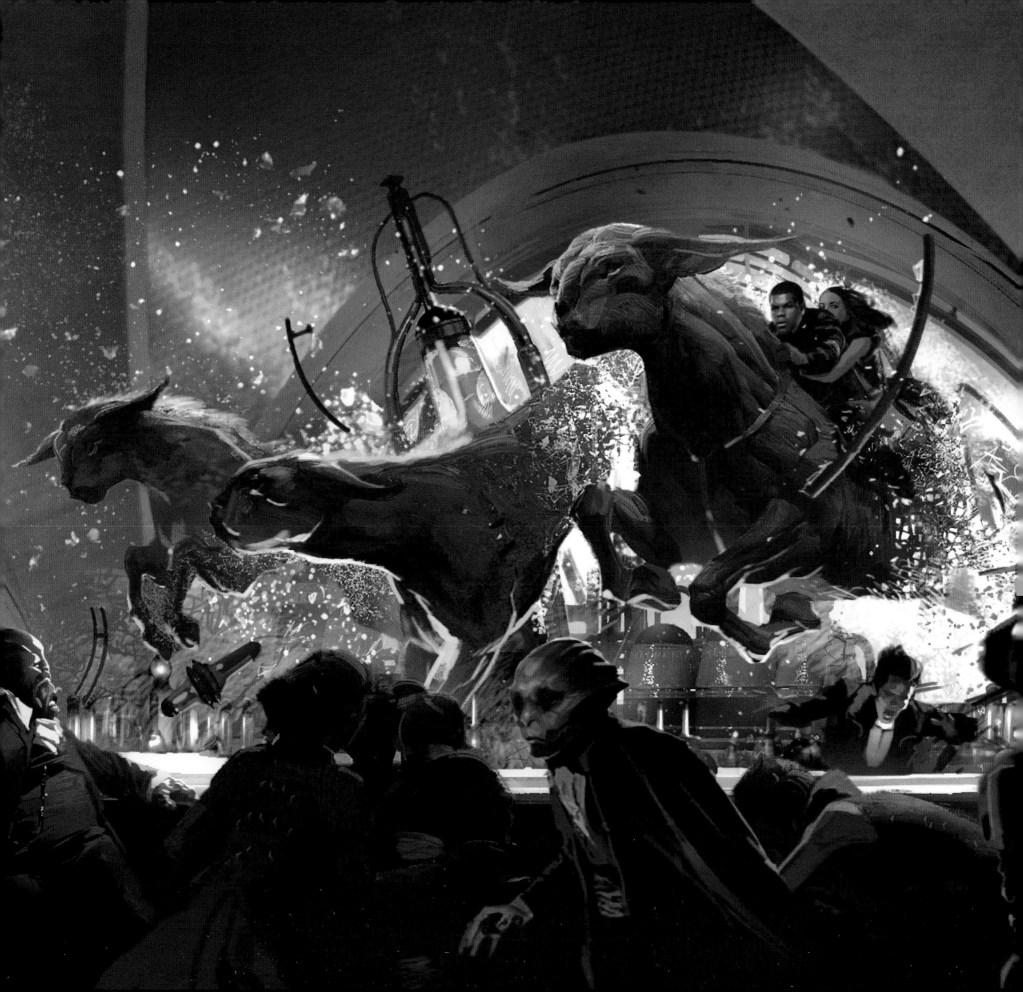

Don't Join

With Neal Scanlan's creature team having just started on Gareth Edwards's *Rogue One: A Star Wars Story* and therefore still at least half a year away from fully transitioning onto *The Last Jedi*, Rick Heinrichs recruited ILM art director and concept artist Aaron McBride to buoy Kunitake and Sweet's efforts in creation of the fathier, at the time described as a "horse-hound" by Rian Johnson. "I knew that Aaron McBride was fantastic to work with from my *Pirates of the Caribbean* experience," Heinrichs remembers. "And Neal was busy with these other *Star Wars* movies. So we had to attack the fathier head-on and figure out, with ILM, what the character of its run was going to be. Is it equine? Is it canine? Is it some kind of combination of the two? That was an intense period, in the winter and spring of 2015, of trying to nail the look, feel, and scale with Aaron and everybody who was working on it."

Rick Carter, co–production designer for *The Force Awakens*, briefly returned to the *Star Wars* art department on January 15 for a *The Last Jedi* moviescape presentation in the Space Bear Burbank offices, with all of the concept artists and several Lucasfilm luminaries in attendance. By that point, *The Force Awakens* had wrapped a month prior, simultaneous to the first official turnover of shots to Industrial Light & Magic for postproduction visual effects work.

Regular weekly art reviews with Rian Johnson, his producing partner Ram Bergman, and *The Last Jedi* art department officially began in February, with concept artists Seth Engstrom and Mauro Borrelli, storyboard artist Dan Sweetman, and art director Todd Cherniawsky joining the team on February 25, March 9, March 11, and March 18, respectively.

During the early months of 2015 in Burbank, Rodolfo Damaggio continued his exploration of the library tree, transitioning on to illustrations of Luke Skywalker's cliff fishing and the fathier stables, with Engstrom finishing off the library interior and exterior in March. Justin Sweet did the very first explorations of both the male and female Caretakers and the crystal fox, soon joined by Jake Lunt Davies at the Pinewood-based creature department, who would also get an early jump on the sea cow. By the end of March, Sweet locked in the final look of the Jedi temple, including the meditation ledge. Jaime Jones resumed his work on the casino exteriors and interiors, supplemented by Borrelli in April. Tani Kunitake designed the Canto Bight police speeder and early fathier chase environments. And Daniel Simon painted some of the earliest concepts for the ski speeder, DJ's stolen sleek ship, and First Order "ox-tow" walker, with Clyne, Jenkins, and Kunitake contributing designs as well.

At Lucasfilm's San Francisco offices, James Clyne resumed his work on the rebel mine base, joined the effort to define Canto Bight's architecture, finalized the basic look of the Resistance bomber, and kicked off the process on the Resistance transport vehicles alongside Jenkins. In London, Kevin Jenkins contributed to the aforementioned vehicles before shifting over to early Snoke throne room. "We had some amazing artists working on *The Last Jedi*: Kevin and James, the guys I had down in LA," Heinrichs says. "Tani, Rodolfo, and Seth, I had worked with in the past. Jaime and Justin I had never worked with before."

On March 4, 2015, Rian Johnson submitted the very first rough draft of *The Last Jedi*'s script. A week later, on March 12, chairman and chief executive officer of the Walt Disney Company Bob Iger announced long-rumored Rian Johnson as the director of the film—along with the title and star, Felicity Jones, of *Rogue One: A Star Wars Story*—at a Disney shareholders meeting at the Palace of Fine Arts, directly across Richardson Avenue from the Lucas Digital Arts Center, San Francisco home of Lucasfilm. *Star Wars: The Last Jedi* was then slated for release on May 26, 2017, in a little more than two years.

◄ **CASINO BAR VERSION 08** Brockbank

► **DJ IDEA J** Jock

"Especially today, when we're bombarded by so much information and so many points of view, it's so easy to say there are no good guys and there are no bad guys. Everything is just shades of gray. It's seductive, because there is some truth to it. But using that as an excuse to live selfishly is something that we all struggle against, day to day. Through DJ, Finn finds that nobody's purely perfect or purely evil, but that there are still things worth fighting for. There are things that are right and there are things that are wrong. This is not an *entirely* post-truth world [*laughs*]. There are truths that are worth standing up for.

"Every single choice Finn makes in *The Force Awakens* is a personal one, and this is what's so endearing about him. It's the opposite of what Luke's doing in *The Last Jedi*. Finn is never acting for a cause. He's always acting to help or protect someone right in front of him who he cares about, which is a really important part of his character." **Johnson**

ᚦᛟᚾᛏ
ᛃᛟᛁᚾ

▲ **DON'T JOIN** Williams

The name DJ—or "Don't Join"—was inspired by a disturbing but powerful 1978 promotional poster for English punk/new wave band Elvis Costello and the Attractions' third album *Armed Forces*, depicting Costello holding a Sterling submachine gun in his mouth with the slogan "Don't Join!" set in block letters above the photograph. "I always loved that phrase," said Johnson.

▶ **DJ OUTER WEAR** Jock

"The DJ costume came about from hearing, at our first session, what Benicio del Toro felt like his needs were going to be. When he came back weeks later, we had put together a mock-up costume for him. Every time he was looking for something, like a pocket, there was a pocket there. He said, 'It's working really well. What if I start out and I'm not wearing the shoes?' When he leaves the jailhouse, they're on a shelf, so he just puts them around his neck. We see a shot of his feet, so I said it would be really cool if he has holes in his socks, his toes poking out. We added lots of things that he could use: jewelry and gloves and this amazing collar that he could hide in." Kaplan

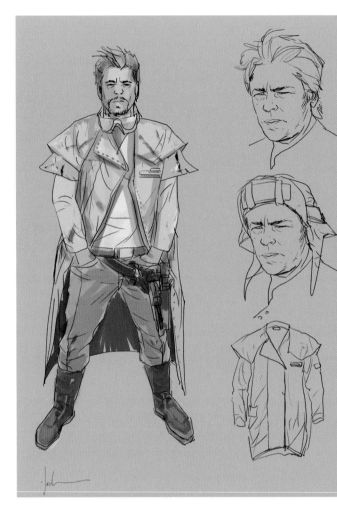

▲ **CASINO DJ WHITE VERSION 04** Weston

"For a time, there was a choice as to whether DJ was going to be established in the casino or the jail, and thus whether he should be in a disheveled *Star Wars* tux or be his own character, with his own look, from the beginning. The jail look was probably better, because it contrasts more with his disguise as an Imperial officer." Crossman

▶ **DJ IDEA B** Jock

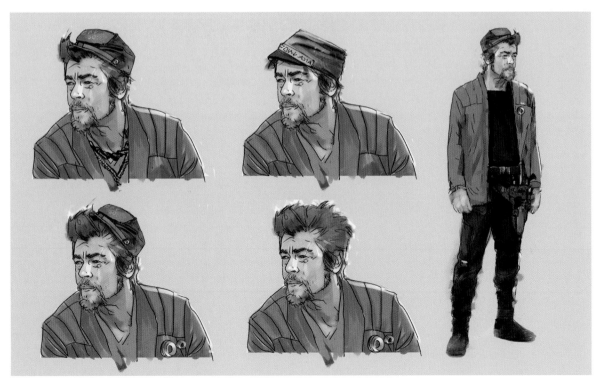

CELL LIGHTING VERSION 53 Paul Chandler

"Since this jail is part of the casino, I wanted it to look and feel like it, too, and use the curves. I wanted it to be high security. But it's not a dungeon, by any means. It's a drunk-tank for the casino. Rian wanted to see some of the patrons that were on the yacht in jail." **Heinrichs**

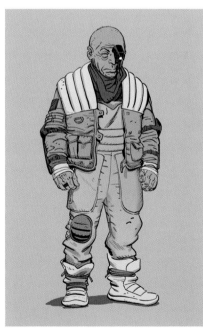

▲ **JAIL BIRD 03** Zonjić

▲ **JAIL BIRD 02** Zonjić

✱ POCKETS ON THE *INSIDE* OF COAT TOO

▲ **CELL LIGHTING VERSION 27** Chandler ▼ **CELL DOOR LOCK 03** Borrelli

▲ **CANTO BIGHT COP VERSION 03** Weston

▼ **CANTO POLICE FLAT BLUE** Weston

▲ **CBPD EXPLODED VIEW** Williams

"The helmets are from unused Ralph McQuarrie designs I found in a book [for *Return of the Jedi* in 1980; these sketches showed Imperial guards in black, with headgear influenced by armored samurai helmets]. They're not exact, but that was the takeoff point. I showed it to Chris, who took a break from the Caretakers to do the cop illustrations. But I just thought white and pale gray, as opposed to some heavy dark black or navy blue police officer. They looked right. And the helmet lights up." **Kaplan**

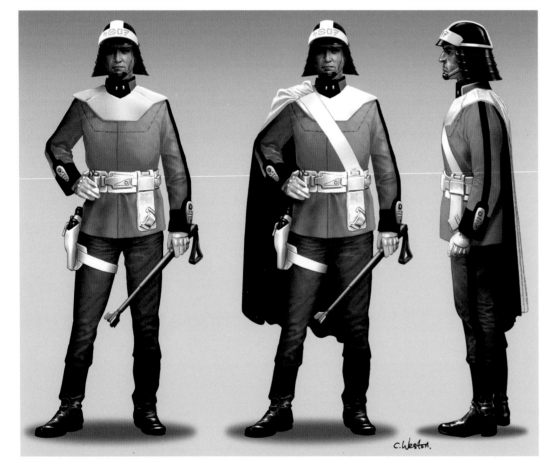

"From the first script I ever read, the casino always had that south of France, Monaco-and-Riviera feel. When you look at the policemen there, they're always impeccably dressed in gabardine uniforms—completely nonfunctional, but they look good. So the Canto Bight police have a lovely pale gray tunic and nice blue trousers, building toward that mid-European feel that some of the casino has, with very graphic white leather equipment. We had a nice fabric—like an oilskin but not shiny . . . more like a coated cape." **Crossman**

▶ **POLICE GUN VERSION 21** "As the Canto police are from a well-funded and opulent planet, prop master Jamie Wilkinson suggested we look at the most similar society in the classic trilogy, that being Cloud City/ Bespin. So the Cloud City guard weapons became our jumping-off point." **Savage**

▲ **POLICE SPEEDER PLANS & ELEVATIONS** Fangeaux

▲ **POLICE SPEEDER MAIN A IDLE** Booth and BLIND LTD.

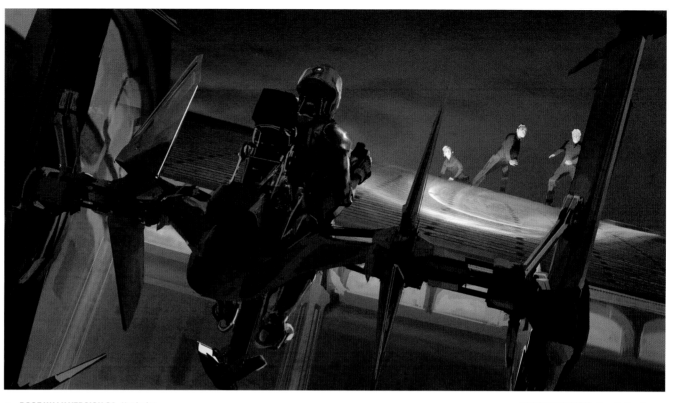

▲ **ROOF WALK VERSION 01** Kunitake

▼ **POLICE SPEEDERS** Fernández Castro

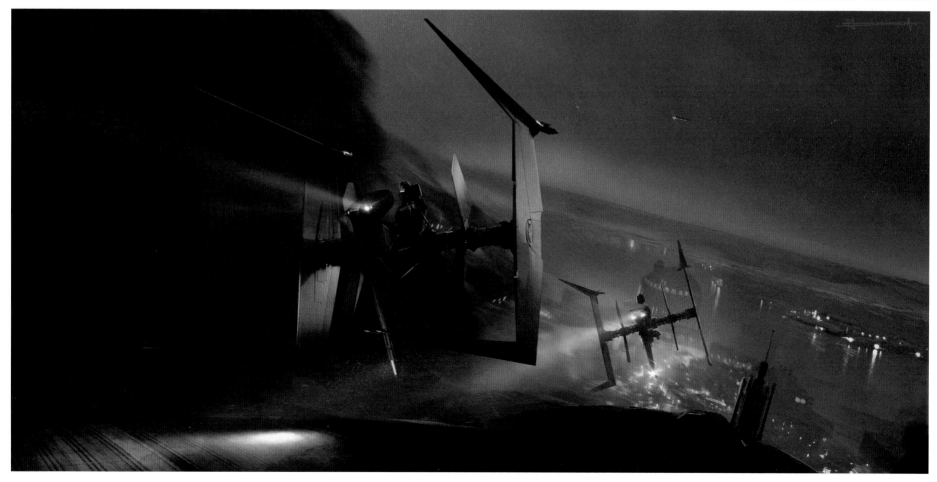

▲ **RACER MOUNT VERSION 01** Kunitake

▶ **HORSE HOUND VERSION 01** "The initial brief on the fathier was that it was a very strong, noble, and beautiful creature, but had been abused and overworked for the sport and entertainment of the patrons of Canto Bight. It needed to feel as if it had evolved for speed—like it was the fastest land animal in the galaxy. Early on, Rick Heinrichs had me reference the Akhal-Teke horse and the Ibizan Hound. The understanding was that the running gait that Rian wanted for them would ultimately inform which way the anatomy of the body would lean." **McBride**

▼ **RHINO GIRAFFE VERSION 05** McBride

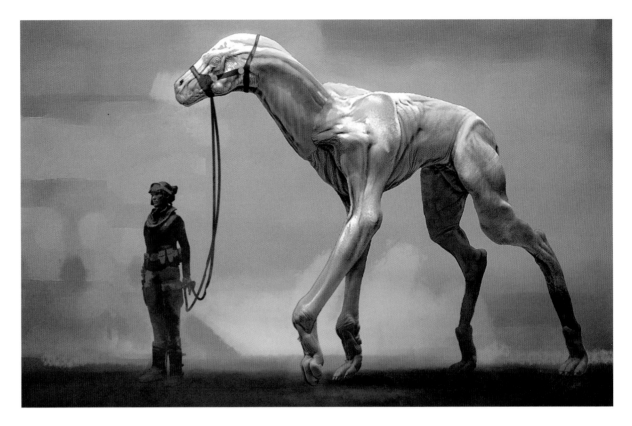

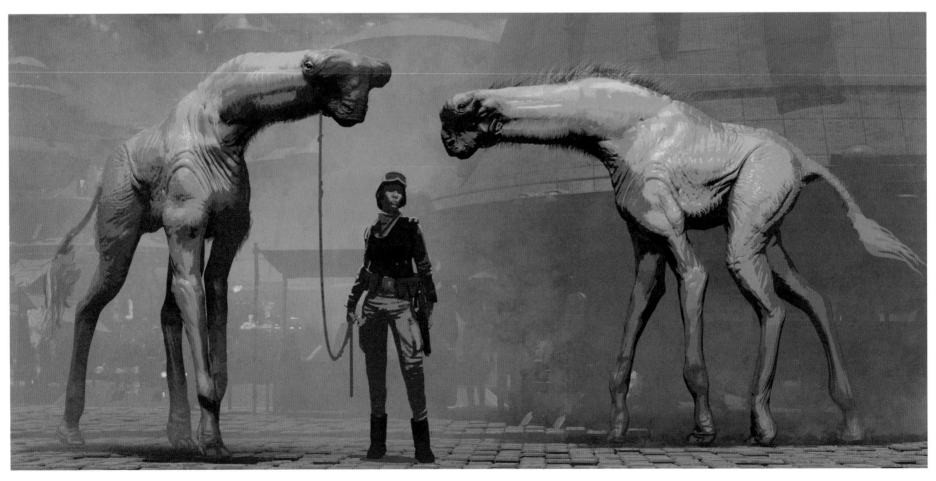

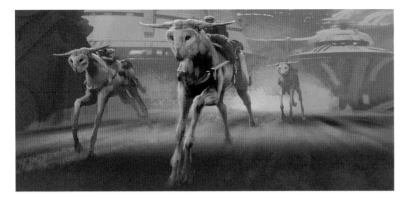

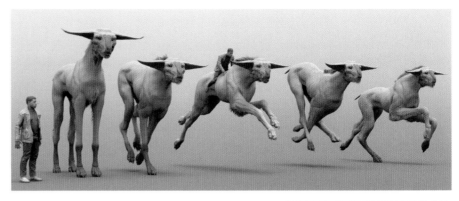

▲ **SNOW OWL VERSION 02** McBride

▲ **FATHIER 3D MODEL POSES GUIDE** McBride

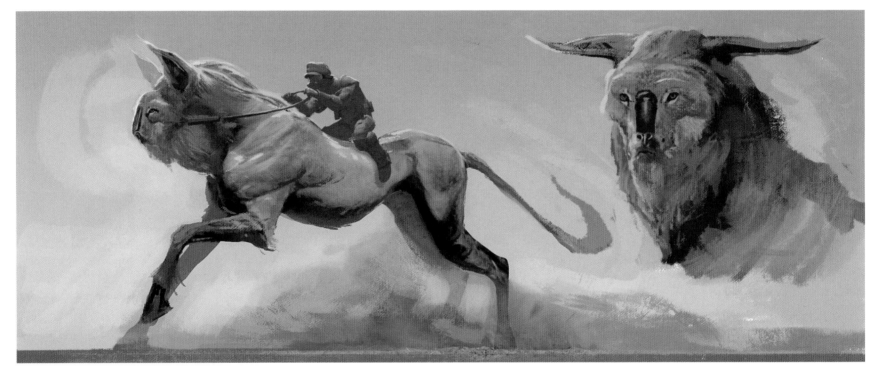

▲ **REVISED KOALA LION VERSION 02B** "I tried a combination of an owl and a lion with a long, dark nose like a koala, giving it elongated ears but very rigid and pointing out to the side. I thought it might be cool if the ears were almost control surfaces like airfoils on a Formula One racecar. As they were able to run at such high speeds, they had these strong, cartilaginous ears for stability. When they bank into a turn, you could see the ears shaking like an airplane wing fighting the air." McBride

▶ **HORSE HOUND CLOSE-UP VERSION 01** McBride

"Aaron McBride is a brilliant designer, and it ended up being Aaron who really keyed in and found, ultimately, the face of that creature. You realize you're asking so much, for the designer to do the work of evolution [*laughs*] in a few weeks. It's pretty amazing to create something that has these very abstract elements—wisdom and warmth—and actually put those into a face. Having the eyes both be forward instead of set on the side was a big first step." Johnson

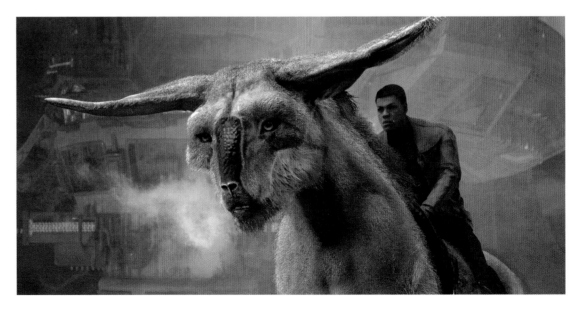

▲ **JOCKEY HELMETS VERSION 56** Zonjić

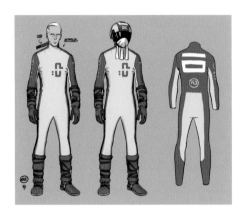

▲ **JOCKEYS VERSION 53** Zonjić

◄ **JOCKEY HELMETS VERSION 58** Zonjić

"The jockeys were all based on fitted ski and sports-
wear, like a retro sixties ski suit. Michael found
additional quilted and silky material from real-world
jockey outfits. Tonči and Rob had a go at drawing
jockey helmets. Tonči's designs were chosen, and
we made four styles of helmet." **Crossman**

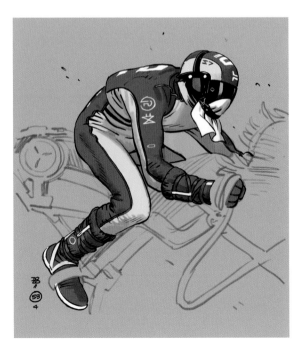

▲ **JOCKEYS VERSION 02** Zonjić

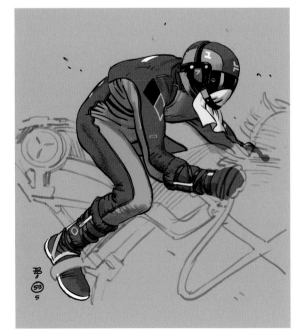

▲ **JOCKEYS VERSION 03** Zonjić

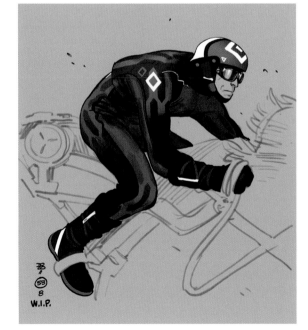

▲ **JOCKEYS VERSION 21** Zonjić

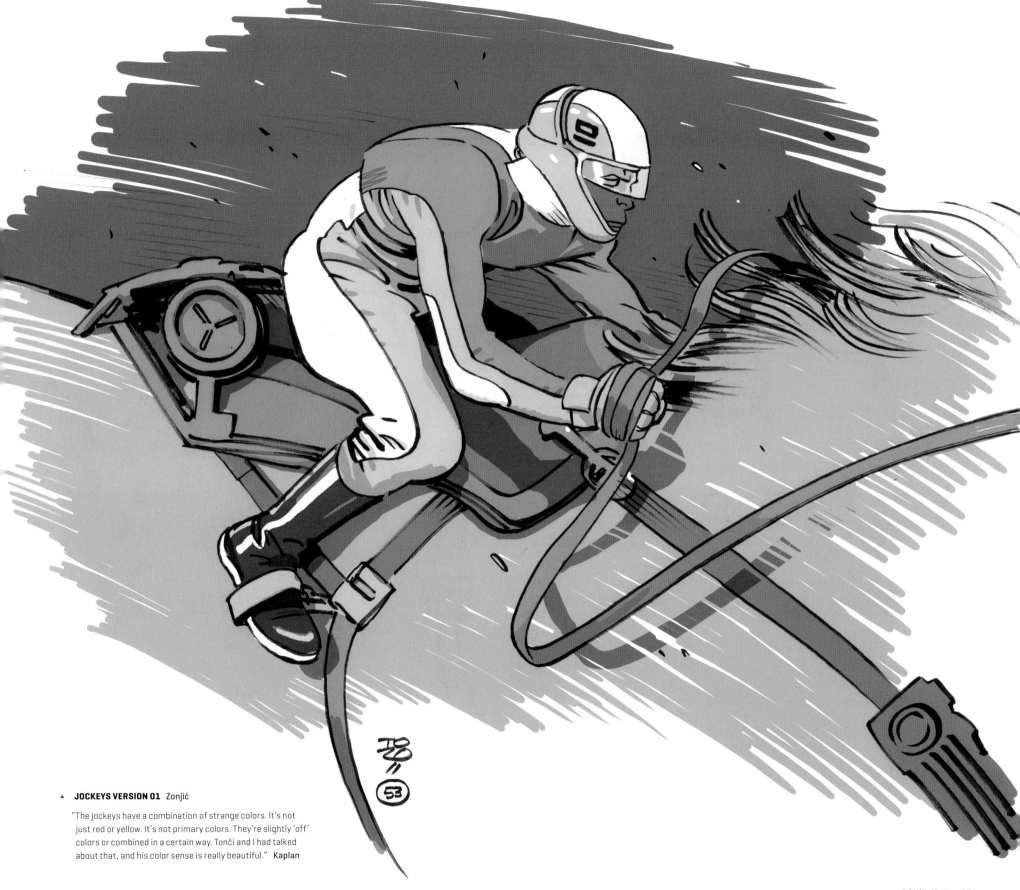

▲ **JOCKEYS VERSION 01** Zonjić

"The jockeys have a combination of strange colors. It's not just red or yellow. It's not primary colors. They're slightly 'off' colors or combined in a certain way. Tonči and I had talked about that, and his color sense is really beautiful." **Kaplan**

▲ **STABLES AND SUPPLY A1** Damaggio

▲ **STABLES AND SUPPLY PAN** Damaggio

▶ **STABLES VERSION 02** Damaggio

"Immediately after escaping the jail, we see the fathiers in their environment, riffing off of that because the fathiers are the ones who are truly in the dungeon, maligned, mistreated, and abused." **Heinrichs**

▼ **STABLES AND SUPPLY VERSION 10** Damaggio

"The instant you see the fathiers, you need to feel sympathy for them—to feel like you want to help them. It's a tough thing to communicate, design-wise." **Johnson**

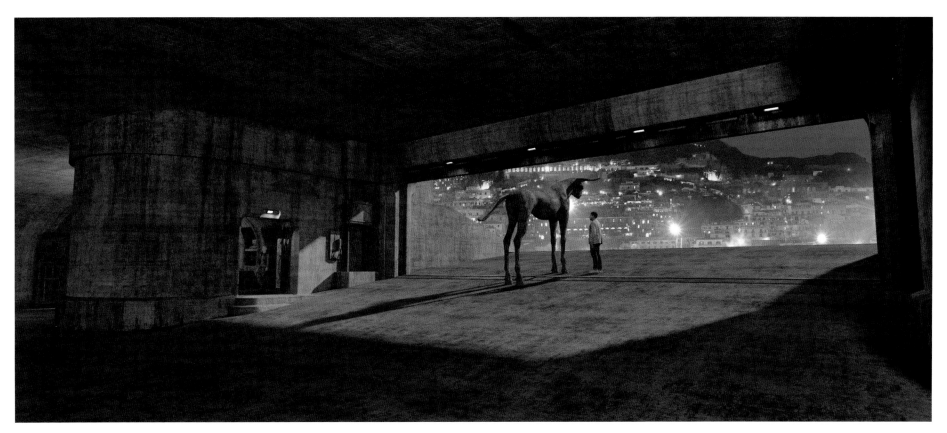

▲ **STABLES** Damaggio

▲ **KING 05 FOUR ARMS** "The stable master started out as a tic-tac man at the racecourse, hence the multiple arms. But his repulsive, boar-ish look really suited the cruel and callous nature of his final character. So in the sculpt and finish, we pushed the details. His eyes are swollen and piggy, with cataracts and shot with blood. Hairs sprout from boils, and his sores and pimples are blistering and pus-weeping." **Lunt Davies**

▲ **STABLE BOY 02** Zonjić

▲ **STABLE BOY 05** Zonjić

▲ **STABLE BOY 03** Zonjić

"You could always assume that, normally, stable boys get nice, characterful hand-me-downs from ex-jockeys: oversized riding garb. Tonči did a lovely set of kids, which Rian straight away picked four designs from. A lot of it is quilted riding garb, cast-aside clothing. You can just play around with the shapes and sizes on those kids." **Crossman**

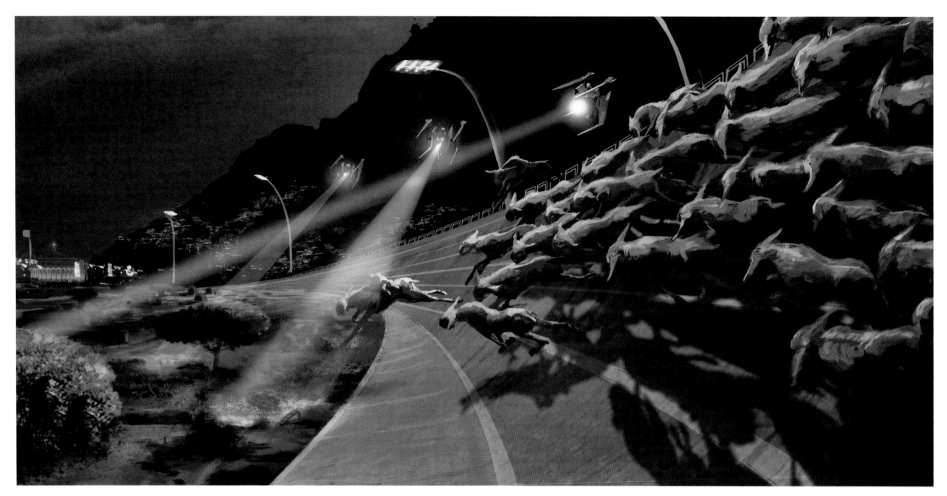

▲ **DIVERTED VERSION 01** Kunitake

▼ **STAMPEDE VERSION 02** Fernández Castro

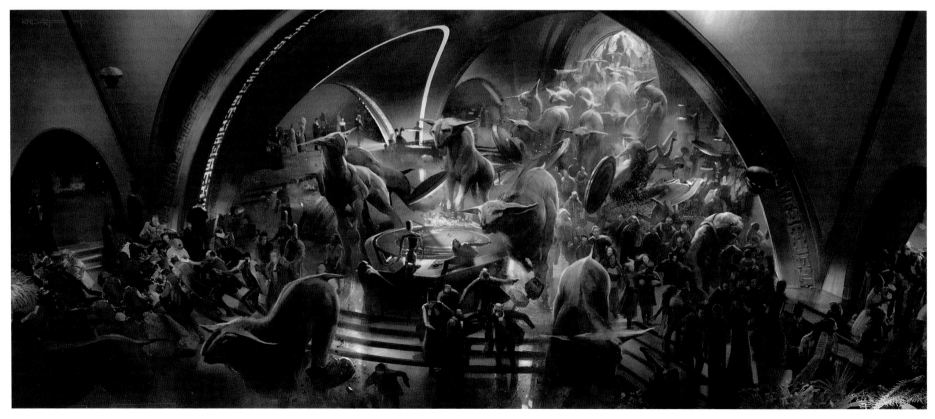

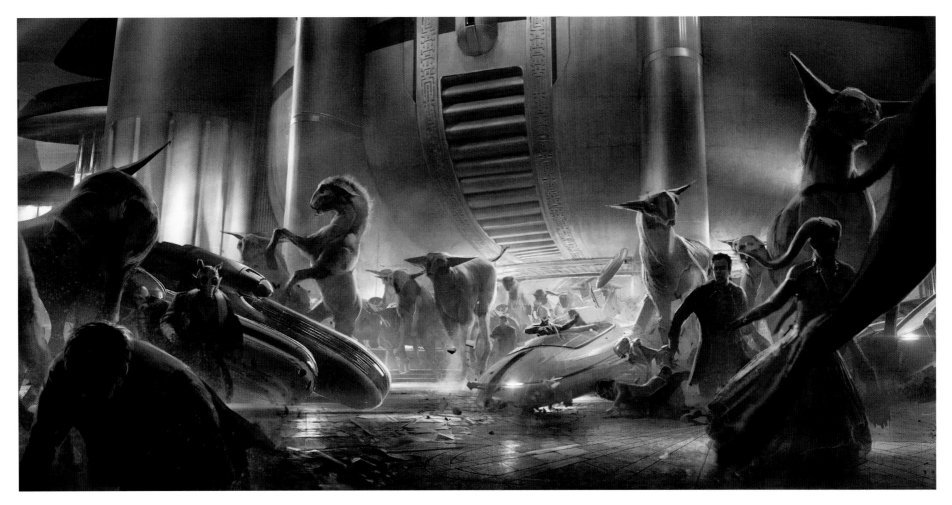

▲ **STAMPEDE EXTERIOR** Kim Frederiksen and Fernández Castro

"I've always admired this beautiful piece of McQuarrie artwork—a rolling-off, curved piece of Jabba's Palace roof architecture with this pattern in it from *The Illustrated Star Wars Universe* book. Rian didn't gravitate to it because he said, 'The casino is not stone. It's a luxury material.' So I started looking at the surfaces of aircraft, funnily enough: paneled but shiny and neat." **Jenkins**

▲ **STAMPEDE TIGHTER** Damaggio

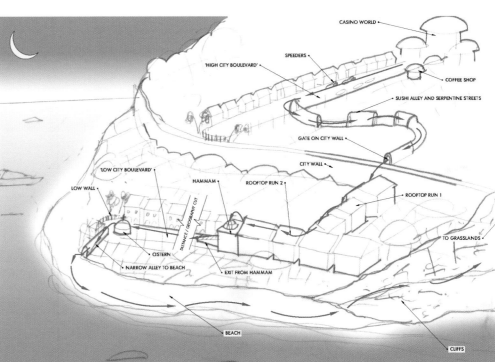

▲ **RODOLFO SCHEMATIC** Neal Callow

▼ **WRAITH VERSION 31** Fernández Castro

▲ **WINDOW** Damaggio

"Coming off the back of the casino, I was asked to play with the Canto Bight street. Instead of redressing the whole street, I came up with the big-pill door plugs you see and buttresses that roll off in the same stonework. When you're looking, in perspective, down a very tight street, you lose a lot of the modern-world elements because you are putting these gates down that obscure your view. The door plugs also ended up looking really *Star Wars*. So it all came together. Use what you have rather than replace it." **Jenkins**

◄ **KING 55** Manzella

▲ **CAFÉ VERSION 11** Browning

▼ **STAMPEDE ROOFTOPS** Horley

"The rooftop will be the real opportunity to get a sense of the *Star Wars* nature of the city. We're going to be putting more vaporators and stuff like that into it. Rian likes the old tiles—the idea that the fathiers are kicking off the tiles as they race along." **Heinrichs**

▲ **RECTOR'S PALACE VERSION 06** Brockbank

▲ **RECTOR'S PALACE ROOF VERSION 05A** Brockbank

"I love the idea of this hammam [Turkish bath]. The location is the rector's palace, right there in the middle of Dubrovnik. And this is the courtyard in the palace, open to the sky above. Right before we shot, they completely ripped up all of the stone flooring. That was a bummer. But I thought, 'Hey, wait a minute. There's a little *Star Wars* opportunity here.' We replaced the stone with palates, like the flooring on the *Falcon*, and we gave a gold veneer to it. Steam comes up through it now, so it actually feels very organic to the whole concept. Opportunities sometimes break your way." **Heinrichs**

"We interpreted this drawing as close as we could. For the big creature on the table, we went straight to sculpt because the design really caught the feeling of who this was. Then we took it a little further with Kiran Shah and Ali Sarebani, the two little masseurs on top.

"The shoot was in Dubrovnik, so we had to haul it out there. Lots of sweat, lots of water, lots of steam. The big creature and his table weighed just under a ton. And it was on a steel, vibrating base, which special effects had put in it. The request for this scene came a bit late in the day, but there was a really lovely flip side of not planning things too much, not being too precious about it." **Scanlan**

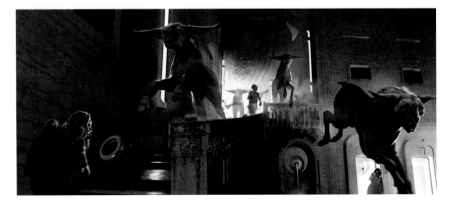

▲ **RECTOR'S PALACE VERSION 05** Brockbank

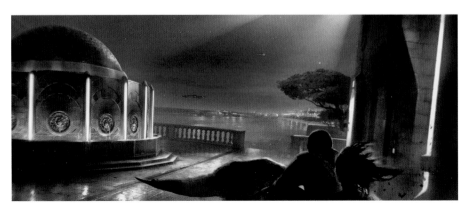

▲ **CISTERN VERSION 01** Fernández Castro

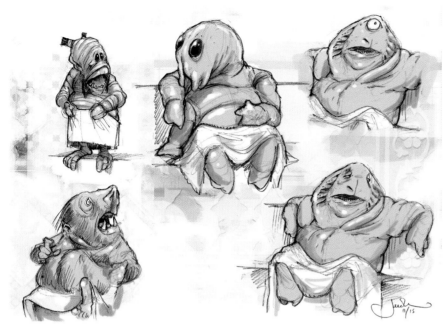

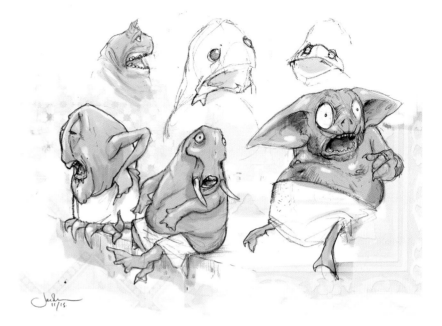

▲ **SAUNA 04** Lunt Davies

▲ **SAUNA 02** Lunt Davies

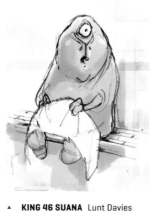

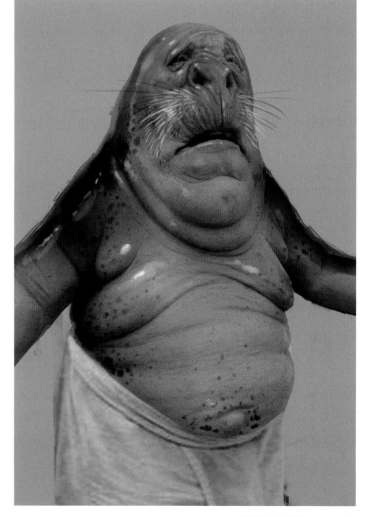

▲ **MASSEUR ALIEN 01** Lunt Davies

▲ **MASSEUR ALIEN 02** Lunt Davies

▲ **KING 46 SUANA** Lunt Davies

▲ **KING 69 COLOUR** Lunt Davies

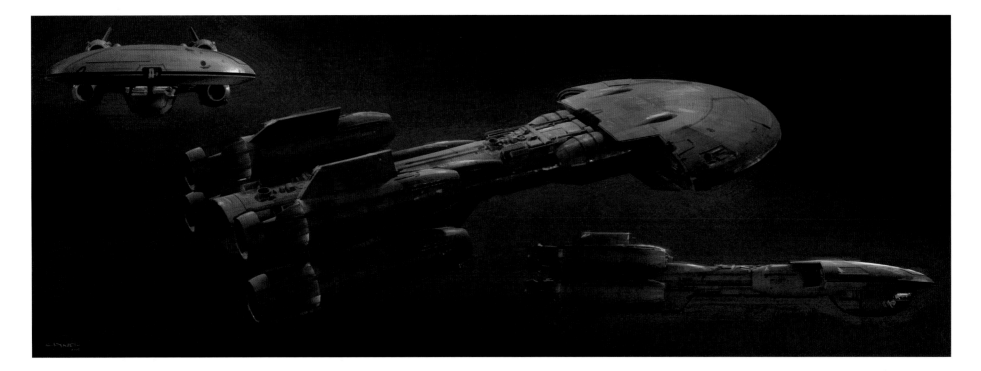

SLEEK SHIP VERSION 01 "Kevin and I threw a lot of sleek ship art out at Rian. The whole front area of this design is ripped right off of a Joe Johnston sketch that I found in the archive. Rian liked looking at old unused artwork. We try to do that as much as we can on these, just to feed back into all of that history." **Clyne**

▸ **CONCEPT SKETCH VERSION 01** Daniel Simon

"The 'sport' or 'sleek' ship was supposed to be sporty and fast, like a Bugatti or one of those high-end supercars. Affluent. The story element of it being stolen from Canto Bight was a part of the initial design briefing." **Clyne**

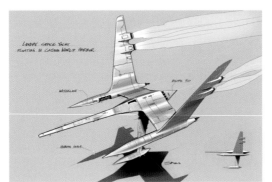

▲ **LUXURY CRUISER VERSION 01** "*Star Wars* ships are insanely hard to do. I did this mood board for Rian, talking about the Twin-Pod Cloud Car and how it's almost the only ship you see in classic *Star Wars* that's non-military, in its coloration and design. Initially, my versions were almost like buses. We had one a bit like a stagecoach. One was like a very eighties-retro square pyramid." **Jenkins**

◂ **LUX SHIP VERSION 01** "James was doing these very long, almost dragster-type things. I kind of went back to what I love about the seventies. I was thinking about James Bond and his beautiful white Lotus Turbo Esprit from *The Spy Who Loved Me*. Because our entire world is gray, I thought, 'Let's paint it a deep rose, almost like a burgundy red wine.' It's essentially a rocket ship meets a Lotus Turbo Esprit. The Lotus is why I put the spoiler on the back of that ship." **Jenkins**

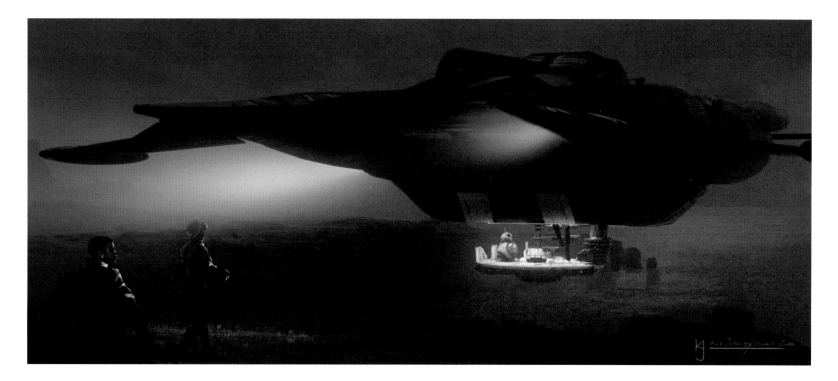

▲ **LUX SHIP ON EDGE VERSION 01** "We were wondering, 'How do we have a door on this ship?' We had it as a ramp and did a painting like that. But we thought, 'Well that's a bit . . . crap. What if it's like a staircase that pulls down, like when Indiana Jones falls back in *The Last Crusade*, down that rolling staircase in the castle?'" **Jenkins**

▶ **SLEEK SHIP LOUNGE** Fernández Castro

"Roberto Fernández Castro, who did a lot of the speeders on Canto Bight— beautiful elegant designs—took a pass at my layout. We had a lot of discussions of it feeling like a yacht, with the pilot up above and a reclining seating area down below. I wanted to harken back to the *Falcon* seating but bigger and lusher. There was a reference photo of this beautiful Italian gray-and-teal sofa. Rian pointed that out as something he liked. I wanted this blue to be gaudy but also a little approachable." **Clyne**

▼ **SLEEK SHIP INTERIOR VERSION 03** Clyne

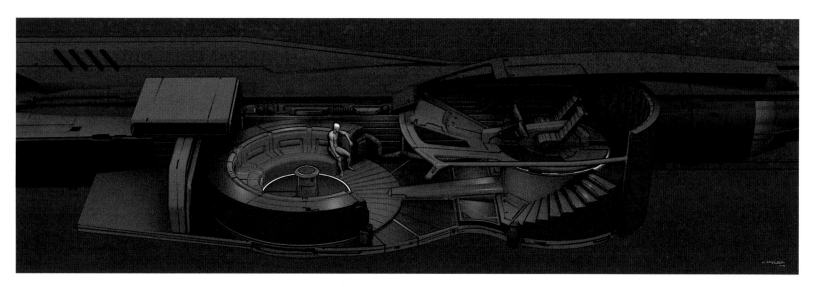

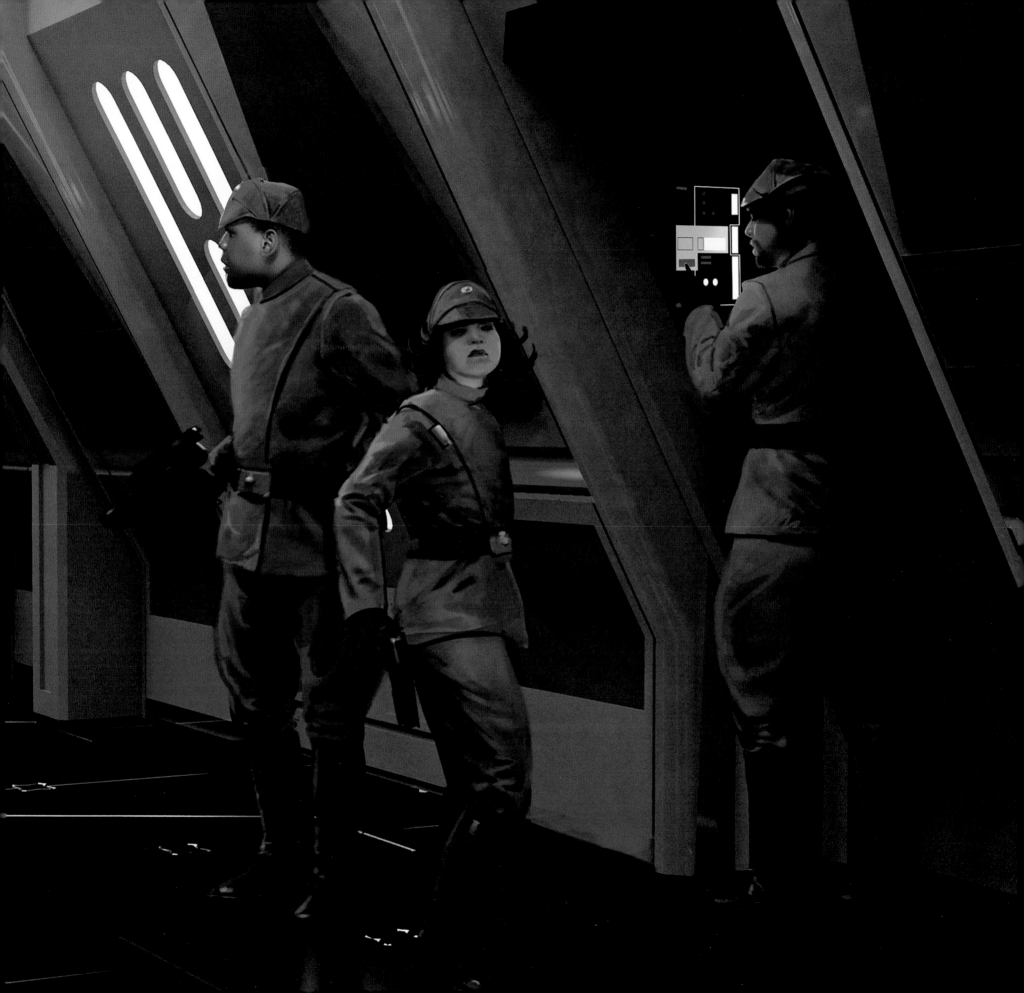

The Ball Stands Tall

As art director Todd Cherniawsky prepared the *Last Jedi* art department for its May 2015 shift from Burbank to Pinewood Studios outside of London, production designer Rick Heinrichs spent the final two weeks of March locking in crew housing in London and offices at Pinewood, meeting potential London-based crew, touring Industrial Light & Magic's Soho office and joining director Rian Johnson on a week-long scout of UK locations, the result of which narrowed down potential Ahch-To island shooting locations, discovered in a late-January reconnaissance scout, to Ireland.

In the final two months of the Burbank-based art department, Justin Sweet continued his island-design exploration, finalizing the basic concepts for the meditation ledge and mirror cave sequence, including the underwater dive. Rodolfo Damaggio contributed First Order and Resistance fleet illustrations; early Resistance cruiser bridge and bomber interior story beat sketches; fathier stable paintings; and initial Snoke throne room ideas, which Kevin Jenkins was also tackling. Tani Kunitake resumed his fathier chase paintings, including further refinement of the Canto Bight police speeder, as well as preliminary concepts for the Mega Destroyer laundry room and Crait ski speeder launch. In San Francisco, James Clyne focused primarily on the Mega Destroyer's massive hangar and Kylo Ren's TIE fighter. And in London, Kevin Jenkins received director-approval on his Resistance cruiser and Resistance transport vehicle designs, as well as his cruiser hangar concept.

April 17 through 19 saw Lucasfilm's *Star Wars* Celebration convention make its debut at the Anaheim Convention Center, a short walk from Disneyland Park. *Star Wars: The Force Awakens* and *Rogue One: A Star Wars Story* unveiled a hotly anticipated trailer and a teaser, respectively, at the fan gathering. The very next day, on April 20, Walt Disney Company chairman and chief executive officer Bob Iger, Walt Disney Studios chairman Alan Horn, Walt Disney Studios president Alan Bergman and Lucasfilm president Kathleen Kennedy visited the Burbank offices of the *Last Jedi* art department for a meeting and presentation by Rian Johnson, producer Ram Bergman, and Rick Heinrichs.

One week later, the *Last Jedi* art department's UK office officially opened, and soon concept artists Kim Frederiksen and James Carson, as well as storyboard artists Michael Jackson and Martin Asbury, would join the fray. By May 11, Johnson, Bergman, and Heinrichs would all relocate to London for the remainder of the film's production. Prior to his departure, Johnson met with actor Mark Hamill, returning to the role of Luke Skywalker, for a special weekend concept-art review at the Burbank office.

Johnson turned in his first draft [typically, the first revision beyond the rough draft] of *The Last Jedi*'s script, which remained relatively unchanged from the initial pitches and drafts almost a year earlier, on June 3. A few days later, the filmmakers embarked on a weeklong scout for a suitable shooting location for Canto Bight, including the walled Croatian city of Dubrovnik, which also stands in for the fictional King's Landing on HBO's *Game of Thrones* television series. "We were looking at palaces in India, as well as some eastern European locations that had an art deco or beaux arts look to them," Heinrichs recalls. "They never quite felt *Star Wars*. It just became clear: We're not going to go to an actual place and shoot it as it is. And that's when the idea of Dubrovnik came up. Yes, it's a medieval city, but it's a walled city; you could control it. It was a great blank canvas for us. And you will feel grounded in a real place—as opposed to other *Star Wars* cities like Cloud City or Coruscant—but with a lot of the shape-language of *Star Wars* added to it, like the wrap around piece that Ralph McQuarrie illustrated. That was the idea: to go to a place we could work with. But shooting an urban environment on location? That was the scary thing for us."

◄ **MAIN CORRIDORS VERSION 13** Catling

"In lieu of a casino dress, Rose's officer disguise became her reveal, because they are very form-fitting. And Kelly Marie Tran looks great in it. Also, we chose a color that would enhance her. We were limited to the First Order colors of gray, black, or teal. But we thought, 'Make her a higher-ranking officer than John Boyega and Benicio del Toro.' So she's in the teal." **Kaplan**

► **CYCLOPS VERSION 08** Lunt Davies

►► **MEGA DESTROYER EXHAUST PORT VERSION 01** Kunitake

▲ **EXHAUST PORT SKETCH** "These are a couple of drawings I did of the sleek ship going into the engines of the Mega Star Destroyer. I did them in magic marker because it was quicker to talk about them at the time." Jenkins

▶ **MEGA EXHAUST VERSION 02** Jenkins

▼ **MEGA EXHAUST VERSION 03** Jenkins

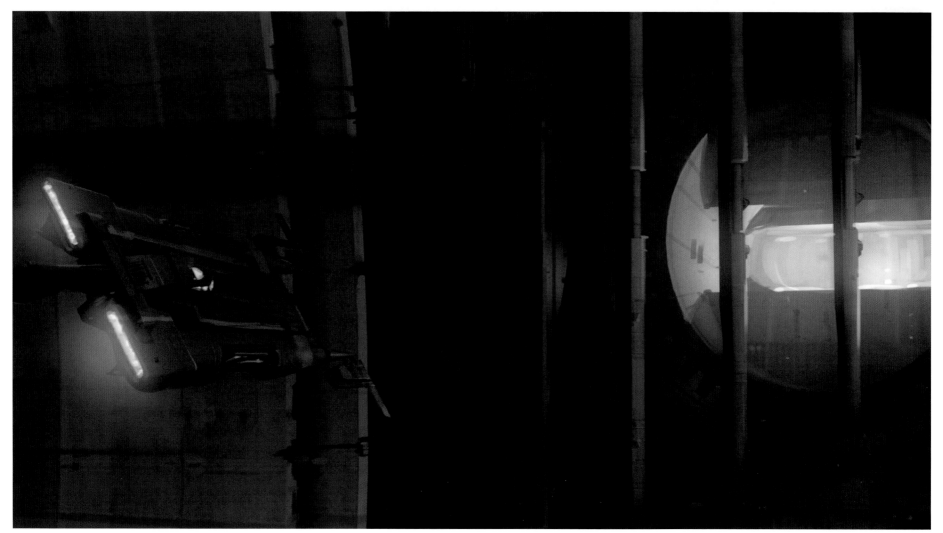

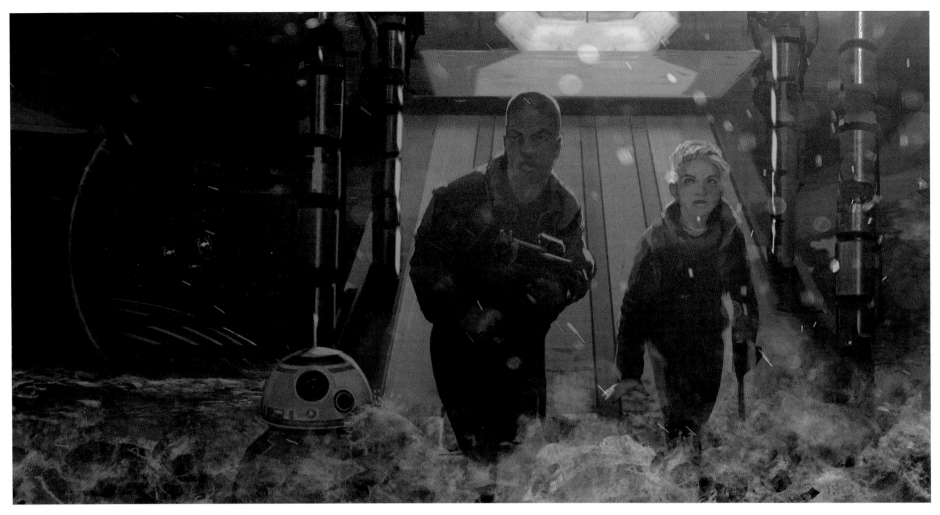

▲ **DUCT ENTRANCE VERSION 01** Kunitake

▲ **LAUNDRY VERSION 01** Kunitake

▲ **LAUNDRY ROOM VERSION 04** Kunitake

Several visual gags for the sequence where Finn, Rose, and BB-8 (prior to DJ's introduction to the story) sneak on board the Mega Destroyer were pitched in concept art form in early 2015. One had the trio follow a trail of lint piles down a cavernous tunnel until a trap door drops them into a massive tumble-dryer, exiting into the First Order laundry room.

▲ **IRON 03** Lunt Davies

▲ **LAUNDRY LANDING VERSION 01** Jenkins

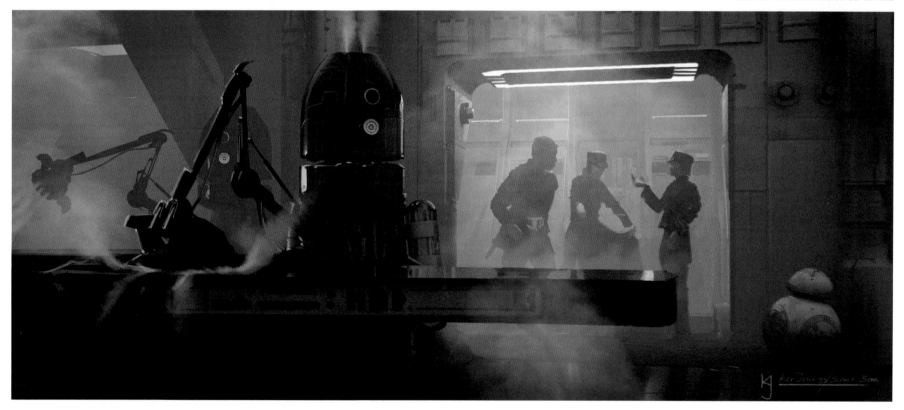

▲ **LAUNDRY LANDING VERSION 03** Jenkins

◄ **LAUNDRY GAG** Heinrichs

Another gag pitched in sketch form by Rick Heinrichs had Finn and Rose suddenly facing down a squadron of First Order stormtroopers, akin to Han Solo barreling through the Death Star corridors in *A New Hope*, only to realize that they were empty suits of armor hung from the ceiling on dry-cleaning racks.

▲ **ORIGINAL STORMTROOPER SKETCH** Kaplan

"As cool as the new helmets were, they felt a little friendly to me. They just missed that kind of menace and meanness—the essence of which is that skeletal grin. So I was over the moon when they showed me the tweak to the stormtrooper." **Johnson**

"We put these broken teeth in and changed the shape of the mouth a little bit. And there's a slight difference in the brow, but very a subtle one. I am all about small details and minutia. And the fact that such a subtle change to the stormtrooper meant a lot to Rian made me really like him that much more. I think, in a way, that note from Rian made my work better." **Kaplan**

"We actually used our *Rogue One* storm-trooper color, which has got a touch of gray in the plastic. *The Force Awakens* was the first time this material had been used for armor; the material has a slightly creamier feel when you look at it in real life. But on this film, we ran them with a tiny gray tint, which takes the white down slightly. We had to create eighty stormtrooper uniforms for this film. The ones from *The Force Awakens* had been practically destroyed." **Crossman**

▸ **COMMONS ELEVATOR VERSION 09** Catling

▲ **COMPARISON WITH EPISODE VII HELMET** Williams

▲ **COMPARISON WITH EPISODE VII HELMET SIDE** Williams

▲ **HELMET EXPLODED VIEW** Williams

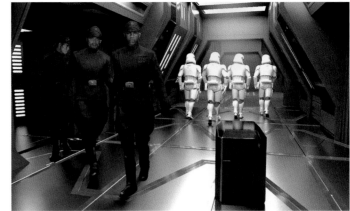

▲ **BB-8 BIN VERSION 01** "Rian's brief to Jamie Wilkinson and me was to design an object that could look like an Imperial trashcan but also, when turned upside down, could look equally like a rather innocuous Imperial droid." **Savage**

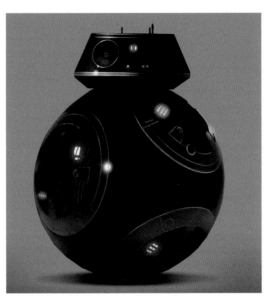

▲ **COMMONS ELEVATOR VERSION 06** Catling

"We had the worst time trying to keep our reflective floors from getting messed up by people walking on them. That was the bane of my existence for a long period of time. I kept explaining that the little boo-ties are not going to work if you walk off a set, walk around outside, and then come back. People were polishing the floor all day long." **Heinrichs**

"We concentrated on and hopefully were successful in giving the First Order BB unit a personality. That personality was ominous, as it should be. The idea was, 'How do you demonize BB-8?' [*Laughs*] It comes down to the face, designed by Luke Fisher. Jake Lunt did a brilliant job of grills and details on the body that give it a real Imperial feel. In the same way, we spent a lot of time with J.J., in the first round, getting BB-8's face to work—I think it was true of these designs as well." **Scanlan**

▼ **JESTER 02** Manzella

▲ **BB-8 IMPERIAL 01** Lunt Davies ▲ **BB-8 IMPERIAL 02** Lunt Davies ▲ **BB-HATE** Lunt Davies

MANZELLA

▲ **COMMONS AREA VERSION 04** Clyne

▲ **SEC DESK VERSION 03** Clyne

▶ **COMMONS AREA** Catling

"Rian's inspiration for the commons room came from Billy Wilder's *The Apartment*. There's a scene in that film where it's just rows and rows of desks; so here's this long bank of computer displays, which are essentially the pod or flower shape we see not only in *A New Hope* but also in *Jedi*. So again, not reinventing the wheel but paying homage and playing off of that." Clyne

▼ **MAP TABLE VERSION 04** "I looked at World War II map tables—how they were displayed. This map table is in the shape of the Imperial window mullion so you can actually lay them out almost like the window mullions of the Star Destroyer." Clyne

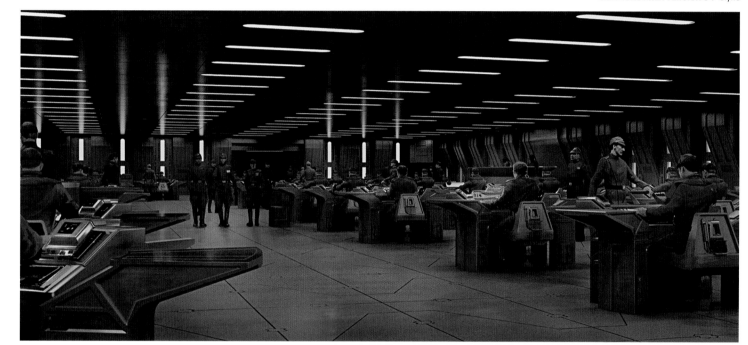

▲ **COMMONS AREA VERSION 04** Clyne

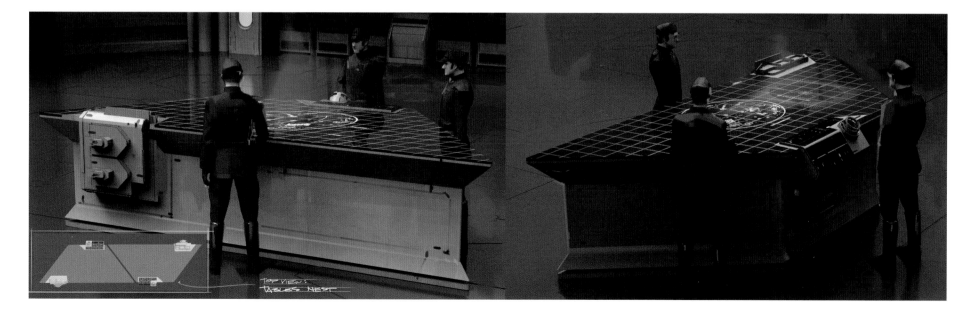

▲ **POWER CONVERTER HALL VERSION 05** Catling

▲ **TRACKING ROOM RUN-UP VERSION 01** Jenkins

▼ **MEGA CHASM VERSION 02** Jenkins

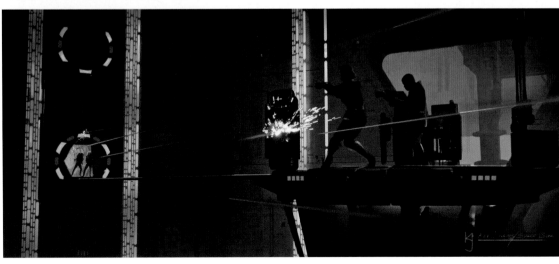

TOP SHOT
TRACKING
BACK
OVER
GENERATOR
ROOM
AND
TILTING
DOWN

CAMERA

FOLLOWING
CHAIN
REACTION
OF
EXPLOSIONS
AS THEY
OVERTAKE
FINN &
ROSE

CUT

CAMERA TRACKING WITH FINN & ROSE
SPARKING COILS STROBE IN F.G.

CUT

ANGLE ON
CHASM—
FINN &
ROSE RUN
OUT OF THE
SHOWER OF
SPARKS &
ONTO BEAM.

CUT

CLOSER
TWO-
SHOT
'OH GOD!'
CAM.
TILTS
DOWN
TO ..

CONTINUING SHOT

FEET
THEN
BACK UP
AGAIN
TO SEE ..

CONTINUING SHOT

▲ **MEGA DESTROYER SHOWDOWN PAGES 38 AND 40** Allcock, Asbury, and Kurt van der Basch

As conceived in initial drafts of the *Last Jedi* script, Finn and Rose dash down a Mega Star Destroyer's "power converter hallway," sparking with energy, after being discovered and fired upon by First Order stormtroopers. Barely escaping the exploding coils, the pair unwittingly runs full speed onto a six-inch-wide bridge over a typically gaping *Star Wars* chasm toward their destination: the tracking control computer preventing the Resistance from escaping. "I did the pictures and Rian loved them," Jenkins says. "But then he questioned himself because I went, 'Is this a bit on the nose?' 'No, no, this is great.' But Rian did come around to it being too on the nose."

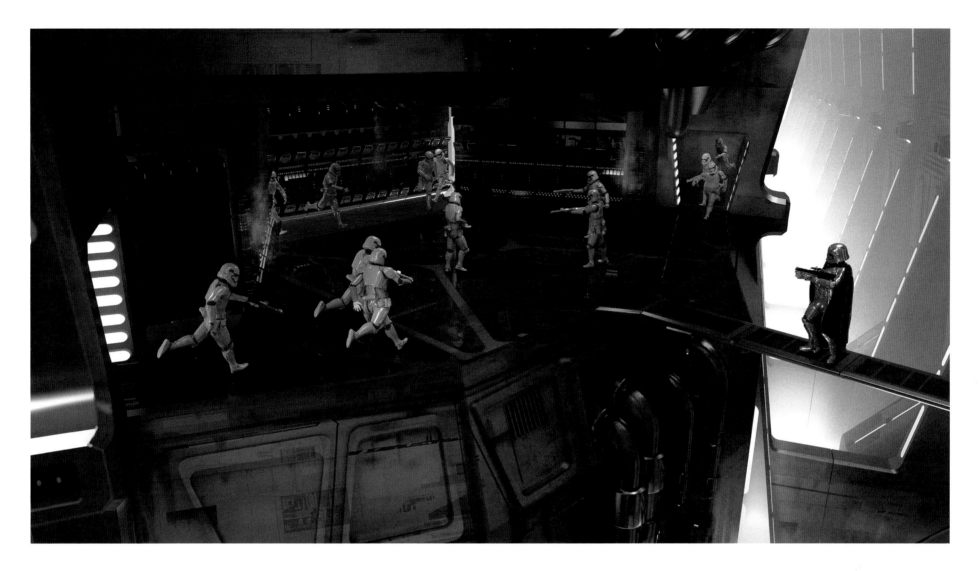

▲ **TRACKING ROOM VERSION 21**
Catling

▶ **SWITCHING ROOM VERSION 07**
"Rick came in and said, 'I still love the idea of them crossing a bridge.' We thought it gave them an opportunity to use the pit on E Stage at Pinewood. There's this beautiful shot in *Return of the Jedi* where the *Millennium Falcon* goes through this gated area as it heads toward the core of the Death Star. I essentially wanted to do a design riff on that. It is another chasm but it feels more mechanical—a machine room over a chasm. *Star Wars* has ridiculously pointless chasms, but they're so wonderful. It's so *Flash Gordon*, it's almost brilliant."
Jenkins

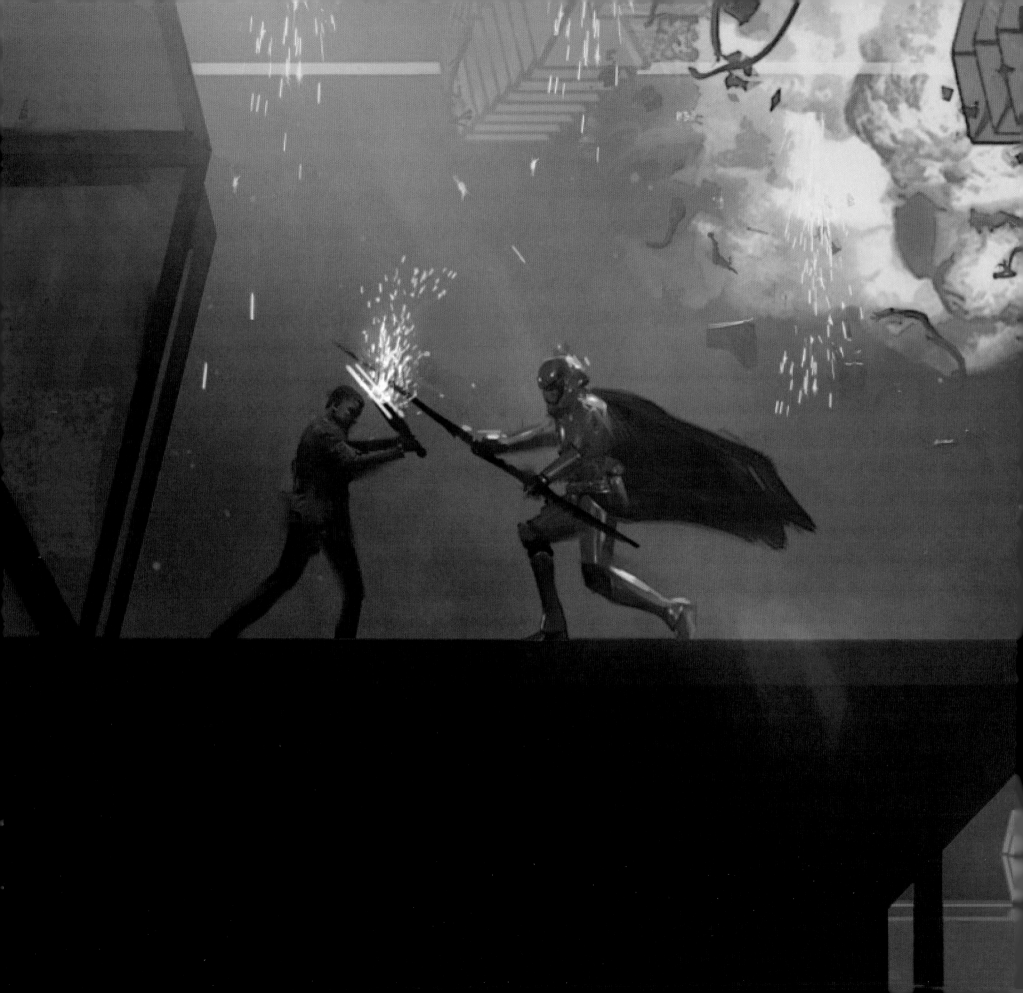

Phasma Unmasked

Fresh off of his costume department work on *Rogue One: A Star Wars Story*, concept artist Adam Brockbank joined the relocated *Last Jedi* art department on June 22, 2015. That same day, supervising art director Chris Lowe (*Captain America: The First Avenger, Skyfall, Into the Woods*) joined the production, reuniting with production designer Rick Heinrichs, who had previously collaborated with Lowe on *Captain America: The First Avenger*, directed by *Star Wars* legend Joe Johnston, as well as Tim Burton's *Dark Shadows*. "This could be the biggest movie I've ever worked on," Heinrichs says. "Chris Lowe and I talked about this a lot since Chris has also done a lot of huge films, including the last few James Bonds. The other big films that would maybe compete with this were the *Pirates of the Caribbean* films. I did *Pirates II* and *III* at the same time. I thought that was a lot to ask of me [*laughs*]. And this is just one film. I'm glad it's just one film, because it takes a while to recharge your batteries."

Also returning to *Star Wars* just two weeks later were *The Force Awakens* costume designer Michael Kaplan (*Blade Runner, Fight Club, Star Trek* [2009]) and *Rogue One* co–costume designer David Crossman (*Saving Private Ryan, Harry Potter and the Goblet of Fire, Lincoln*), once again serving as costume supervisor under Kaplan. Crossman remembers, "Yes, costume work on *The Last Jedi* did start just as *Rogue One* was about to start shooting in early August. There was a complete crossover, and it was a stressful summer! We knew on *The Last Jedi* that we were going to do this big casino sequence. Even in June and July, it felt like time was running low until January, when we were slated to shoot.

"There wasn't that much of a run-up, particularly since we were going to be short of concept artists— Glyn Dillon was tied up as costume designer on *Rogue One*, and unable to do *The Last Jedi*," Crossman continues. "So then we started looking for other concept artists. Frankly, most people in the UK were tied up on *Rogue One*.

"I was talking to Glyn about it every day, and Glyn knew Tonči Zonjić. They'd met online and had been discussing their various comic-book projects. Glyn said, 'Well, there's this guy, but he's in Canada.' We talked to Tonči on the phone and started making arrangements. Tonči came to us in August and stayed a good length of time, contributing to most of the major parts of the film. Jock (the pen name of Mark Simpson) was another comics artists and another recommendation from Glyn. Jock had just gotten off a plane, so we grabbed him at the airport. He came in the next day and started work. By then, we were under pressure. We needed at least three concept artists to get going with things.

"Rick Heinrichs then suggested this guy, Chris Weston, whom he'd worked with. Chris was about to take another job, funnily enough in Canada, so he would have swapped with Tonči. We cajoled him out of it: 'Look, it's *Star Wars*. C'mon.' And Chris did some amazing illustrations, some really intricate, detailed stuff that knocked us out. It became apparent that Chris could do some of the creature work as well. His Caretaker illustrations could be the material for a book of its own.

"Then, to help us to do more fashion or costume plates, rather than illustrations of characters, we got a young guy called Robert Rowley. Samantha Keeble, our assistant designer, said, 'I know this guy.' So we put him on a trial as a junior. But as the months went by, he got better and better. By the time the job finished, he'd really come a long way.

"So those were our four, in the end. It was really good bunch. We're lucky. The concept artists you know will always suggest good people," Crossman concludes.

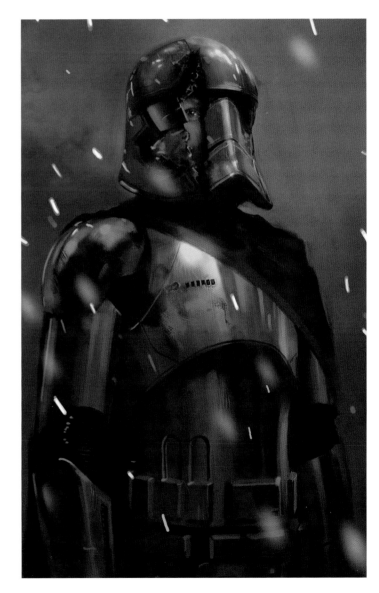

"We did a version of Phasma where some of the eyepiece still remains: a ring you can see her eye through. And Rian said, 'No, no.' He wanted it more open. He wanted to see the femininity a bit more clearly." **Crossman**

"I got a note from Rian showing that he wanted a big, open split. And I said, 'I'd rather take the helmet off entirely. We're showing too much. If we're going to do it, it needs to be mysterious.' So I put aluminum foil in the big gash in the helmet and closed it up. You just saw this eye. It was beautiful, and he really liked that. She has piercing blue eyes, too, which is unexpected." **Kaplan**

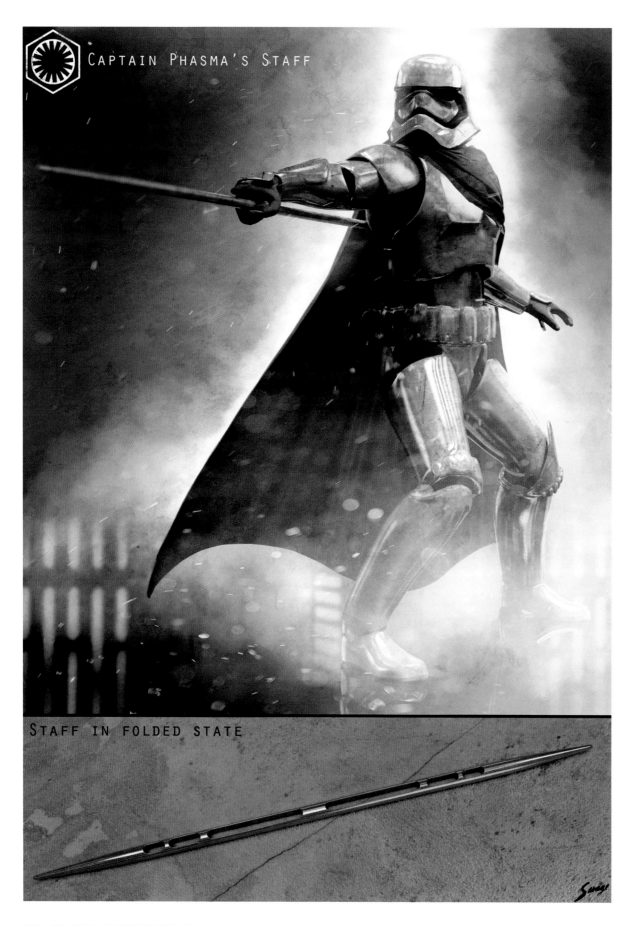

Captain Phasma's Staff

STAFF IN FOLDED STATE

Savage

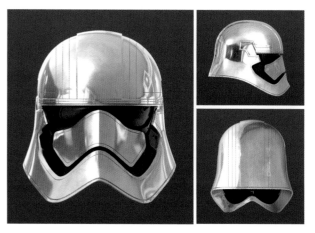

▲ **PHASMA 146** Williams ▼ **PHASMA 145** Williams

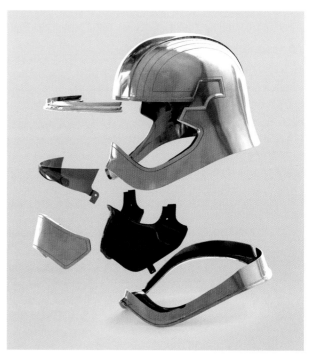

◄ **PHASMA STAFF VERSION 02** "Rian was after a very clean, simple design for her staff, with the same chrome finish as her armor. We added a few very simple, Imperial-style pill-shaped holes so if there was ever a situation when it was back-lit, you would glimpse that classic *Empire* lighting state." Savage

"Phasma wasn't even supposed to be in *The Force Awakens*; it was a design for Kylo Ren that I had hanging up in the design room even after J.J. said, 'I want him totally different. He's not leading the stormtroopers as one of them.' I guess it hung there long enough that I got attached to it. Then Kathy walked in one day and said, 'What is that? That has to be in the movie!' So J.J. not only created a character to wear it but he cast Gwendolyn Christie to play her." Kaplan

"On *The Force Awakens*, we had four or five days to make Phasma. It was a complete panic. So this time, we made her a new suit, with tweaks to improve the legs, the fit, and the length of her arm pieces. The helmet was re-chromed, so it shows less distress. She's much cleaner and shinier, which gives visual effects a complete nightmare, but retains her field cape and things like that." Crossman

LASER AXE VERSION 29 Savage

"Once we get toward the end of the film, there are two executioner troopers that have slightly different paintwork. We had to do it quite quickly, as Rian came up with the idea at the end of the week and we filmed it the following Monday. There's only so much you can do with them. And it's quite tricky adding paintwork to stormtroopers and making it look believable." Crossman

▼ LASER AXE VERSION 37 "Both Rian and Rick Heinrichs wanted a stormtrooper weapon that was clearly an axe but also clearly in the *Star Wars*, First Order universe. Our first passes on the design incorporated a very terrestrial vernacular while keeping it in the classic, black-and-white trooper color scheme. We found what worked on paper looked far too medieval when the prop was realized as a physical, 3-D object. This led to a rethink and a far less earthly looking weapon." Savage

▲ LASER AXE VERSION 35 Savage

▲ LASER AXE VERSION 10 Savage

▼ LASER AXE VERSION 12 Savage

▼ LASER AXE VERSION 36 Savage

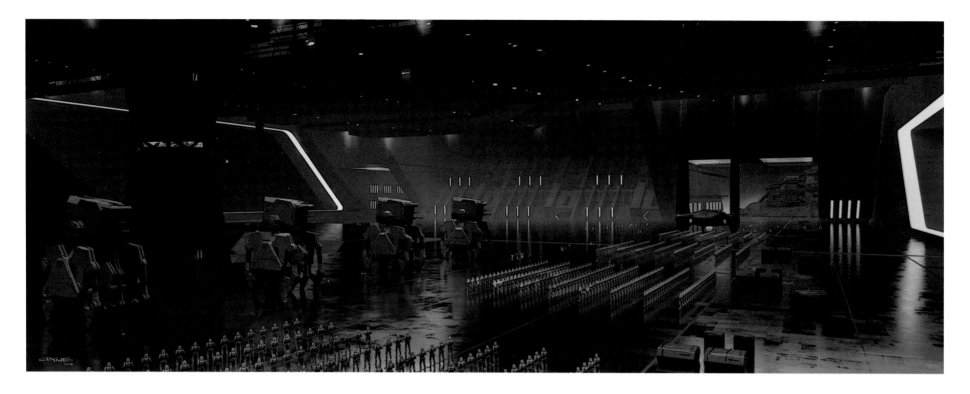

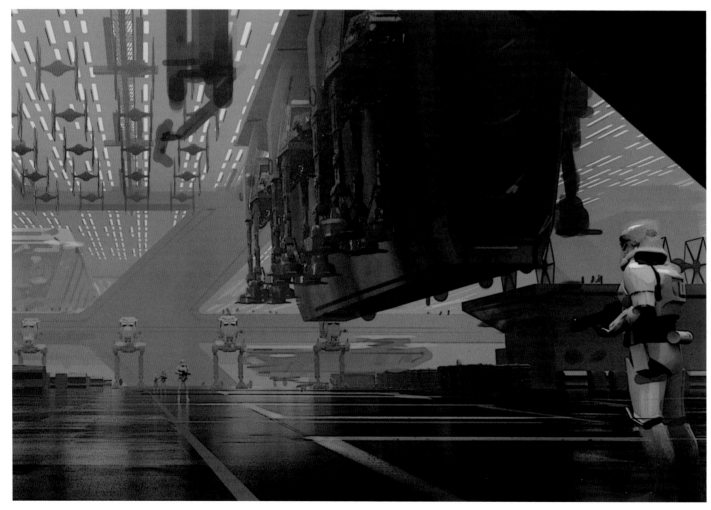

HANGAR VERSION 07 "The First Order hangar started fairly early. At the time, Kevin was working on that big wing design, which I love. How do we not only up the hangar in scale, but also bring something new to the table? So along with multiple levels, what if we had multiple apertures? Big, going on forever . . . I kept on saying, 'It's the Costco of hangars.' They're so big, they have their own control towers within the hangar. You can see the old Rick Heinrichs design for the First Order battering ram seen on Crait back there, which would be a fun little moment. Every new image I showed Rian, he was like, 'Bigger. Bigger. More levels.' The challenge is to really develop a space that feels massive without losing the humanity, the human scale. I always tried to have a stormtrooper in the foreground, on ground level, in a lot of the shots." Clyne

HANGAR VERSION 13 "One idea was introducing these big heavy-hauler vehicles that you might drop AT-AT walkers into. We always wondered, 'How do they get down there?' So maybe they get there in these big, breadbox vehicles." Clyne

▲ **GANTRY VERSION 02** Damaggio

"The scout walker became a part of the film based on discussions about what kind of vehicles we see in the hangar. We'd obviously have First Order vehicles. But what if there are still relics from the Empire? They're not going to just throw them out. They're going to reuse them, maybe upgrade them a bit. So I just started populating my images with everything." **Clyne**

▶ ▶ **AT-ST BB-8 HANGAR SEQUENCE VERSION 02** "I think Rian, Ram, and I were just walking back from lunch at Pinewood. BB-8 somehow gets into a walker and starts shooting up the place, which is great. But we wouldn't really see him in there. And I just threw out this idea: Maybe the First Order is retrofitting old walkers, and one of the heads is off. And Rian's like, 'Yeah, essentially BB-8 is given legs!' He laughed, and I said, 'I'll go back to my computer and start hacking something out. I put these little arms on him [laughs], which is almost cartoony. But it seems to fit." **Clyne**

▲ **BB-8 WALKER VERSION 01** Heinrichs

▲ **AT-ST ARMS SKETCH 03** Lunt Davies

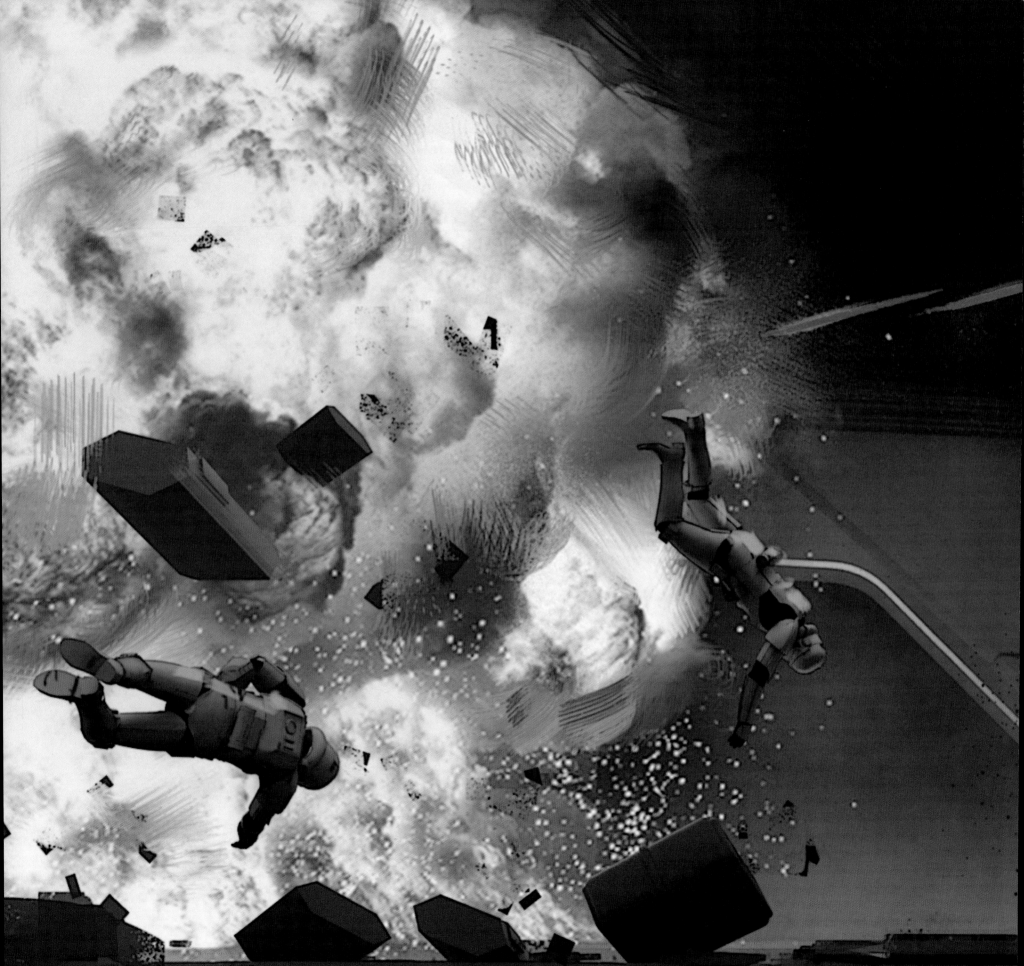

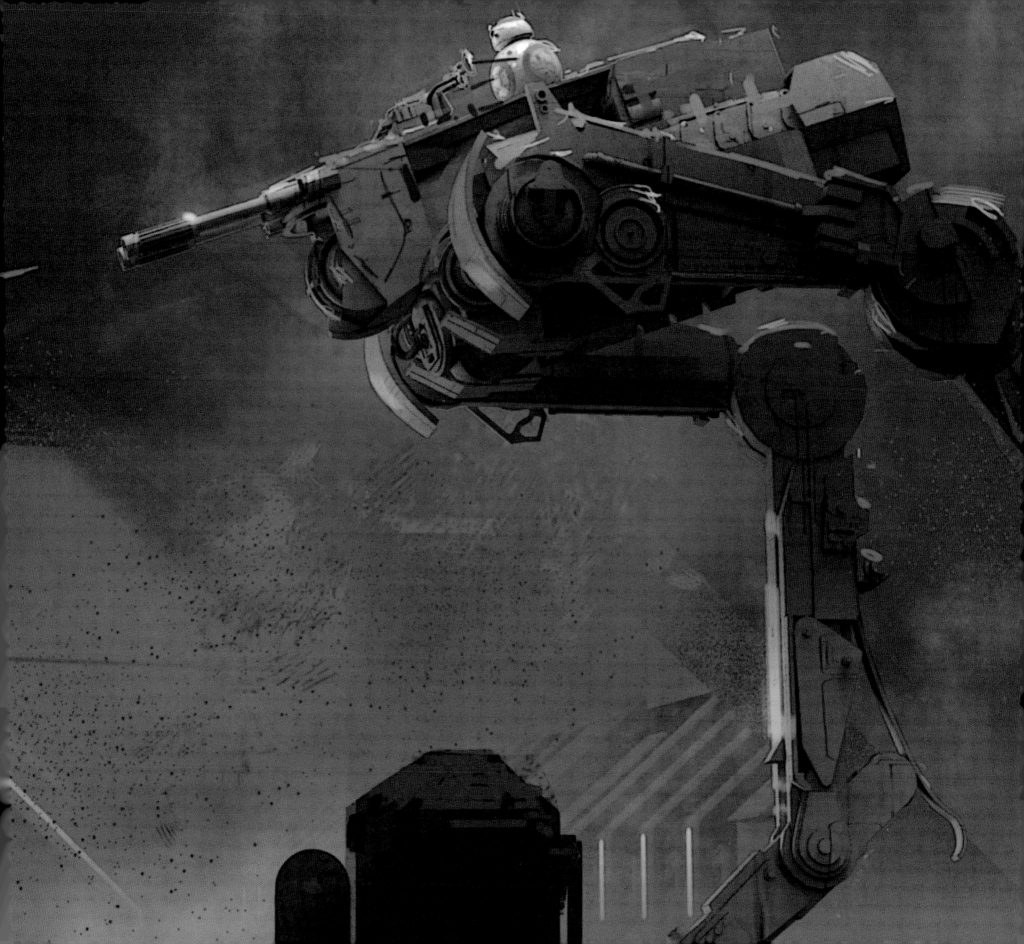

▲ **SMALL SHUTTLE VERSION 01** Clyne

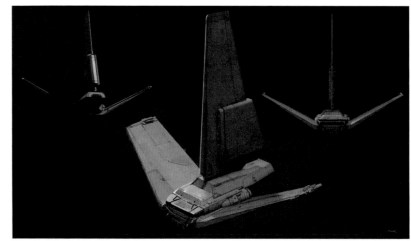

▲ **SMALL SHUTTLE VERSION 04** Clyne

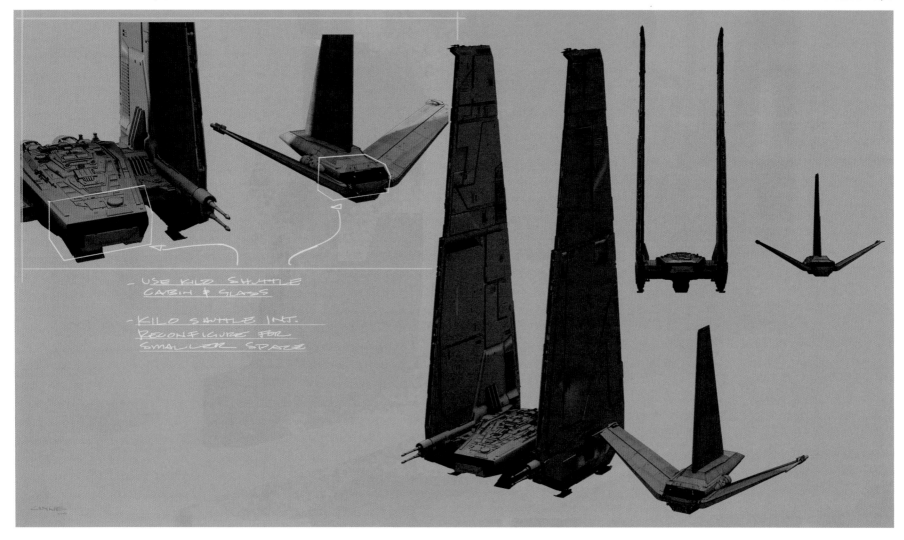

▲ **SMALL SHUTTLE SCALE CHART 03** "The stolen shuttle was a mini-version of Kylo's shuttle. But also there was a discussion with Rick Heinrichs along the lines of, 'Can we use or reuse or redress the interior cockpit of Kylo's shuttle, playing with that same layout, the same scale, and apply that to a smaller shuttle?' It's Hollywood; you can get away with a little. The inside is going to seem somewhat big. But when you're in the ballpark, nobody will know the difference, especially if it's redressed." **Clyne**

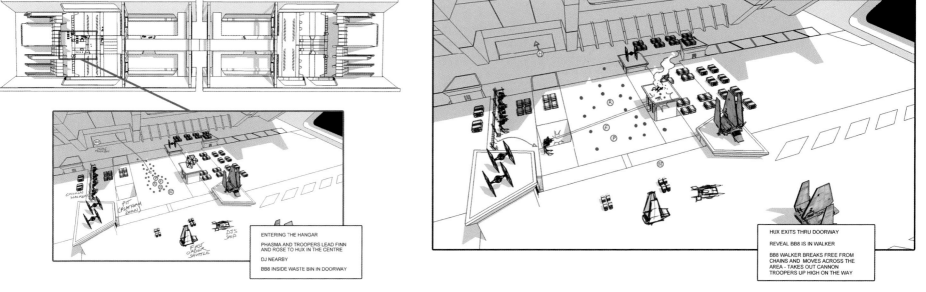

ENTERING THE HANGAR

PHASMA AND TROOPERS LEAD FINN AND ROSE TO HUX IN THE CENTRE

DJ NEARBY

BB8 INSIDE WASTE BIN IN DOORWAY

▲ **HANGAR BEATS ROUGH LAYOUT PAGE 01** Allcock

HUX EXITS THRU DOORWAY

REVEAL BB8 IS IN WALKER

BB8 WALKER BREAKS FREE FROM CHAINS AND MOVES ACROSS THE AREA - TAKES OUT CANNON TROOPERS UP HIGH ON THE WAY

▲ **HANGAR BEATS ROUGH LAYOUT PAGE 06** Allcock

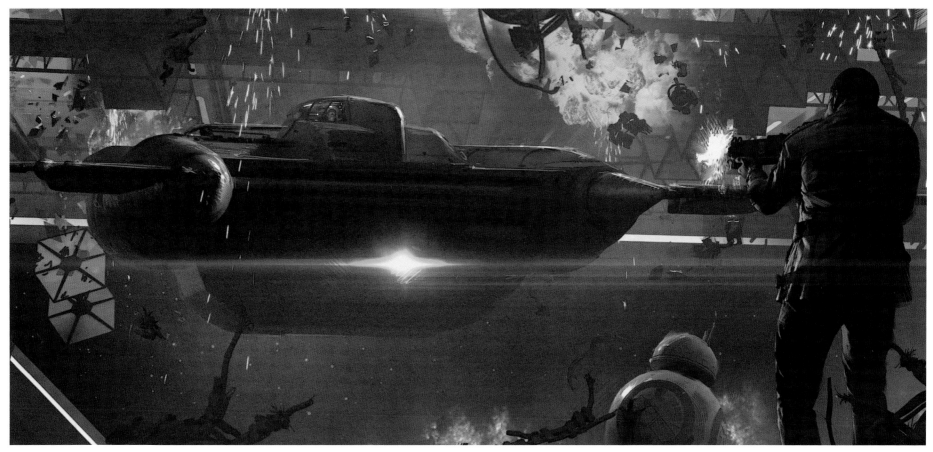

▲ **SLEEK SHIP VERSION 02** Clyne

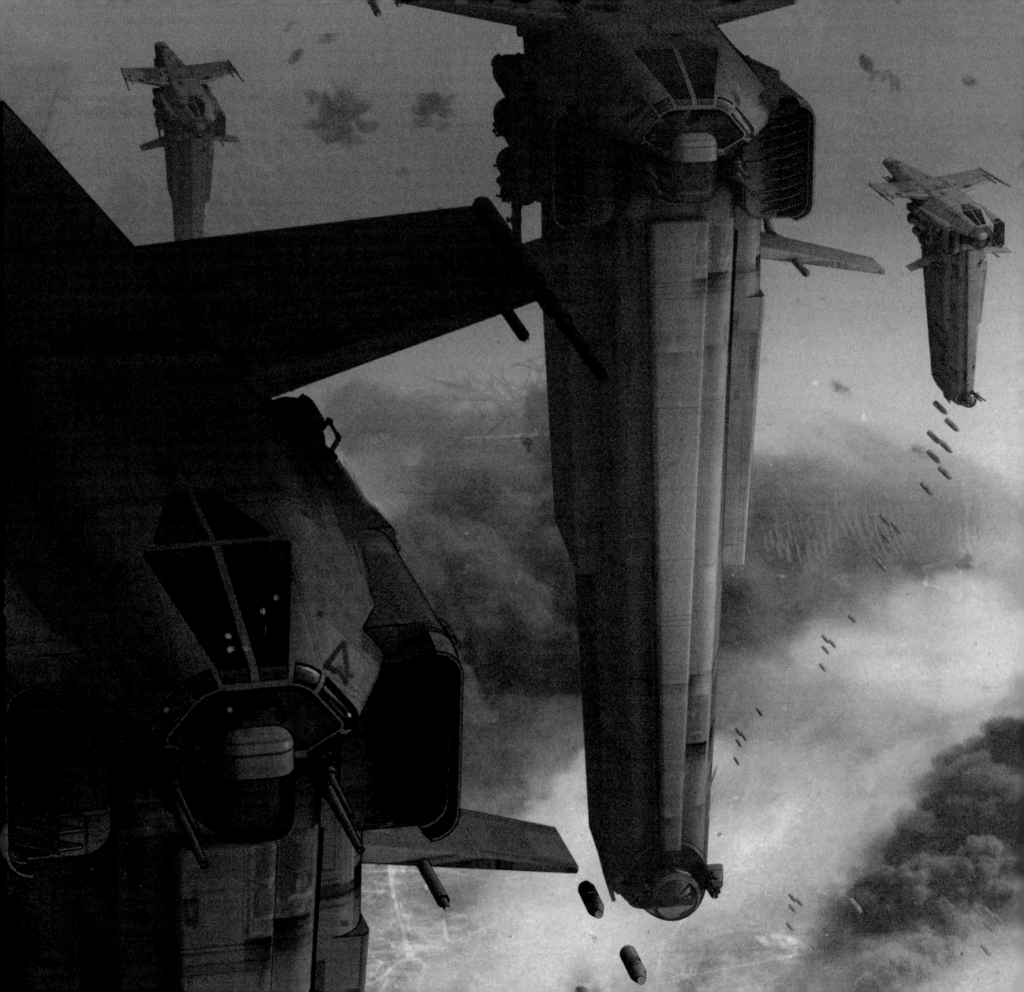

Poe Dameron and the Virtue of Not Fighting

Also returning to *The Last Jedi* full time starting July 20, 2015 was Neal Scanlan (*Babe, The Golden Compass, Prometheus*) and his creature effects team, including *The Force Awakens* and *Rogue One* creature concept artists Jake Lunt Davies, Luke Fisher, Ivan Manzella, and Martin Rezard. "My four main guys and I felt that maybe it was time to expand our team a little bit," Scanlan recalls. "And we came across a guy who, purely by chance, just happened to be visiting the studio. His name was Tim Napper. I met him in a coffee shop, gave him a little brief, and said, 'Tim, come back in a week and we'll see what you come up with.' And he went away full of enthusiasm and came back with some tremendous ideas. So he joined us.

"Tim's graphic style was very different than the present concept team—very abstracted. Some of his drawings were, quite frankly, off the wall," Scanlan continues. "And it charged everybody else, because Rian chose a lot of Tim's designs. That dynamic helped fuel the thought, 'Let's break out of preconceptions of what these characters might look like,' because, within the relatively safe territory of a desert or creature bar location, we could fall back on the established *Star Wars* world—on Ralph McQuarrie, and on all that's come before us."

One week later, *The Force Awakens* and *Rogue One* prop master Jamie Wilkinson (*The Dark Knight, Alice in Wonderland* [2010], *Skyfall*) also started on *The Last Jedi*, with the bulk of prop design work being handled by concept artists Matthew Savage, Nick Ainsworth, and Chris Rosewarne. And on July 29, Rian Johnson turned in the second draft of his *The Last Jedi* script.

With the commencement of *Rogue One* principal photography on August 3, the clock started ticking for the entire *Last Jedi* team. Only five short months remained before they would be in the same boat, with *Rogue One* and *The Last Jedi* effectively shooting back-to-back at Pinewood Studios. Late-August scouts cemented the final seaside Ireland locations that would stand in for Skellig Michael: Malin Head, Brow Head, Loop Head, Sybil Head, Dingle, Dunmore Head, and Mizen Head. "We scouted up and down the west coast of Ireland, all the way up into those fingers that go out into the sea and all the way down," Johnson remembers. "It was tricky because we would get out of the van at some of the most spectacular scenery that you'd ever seen in your life, just jaw-dropping, and we'd take one look and say, 'Nope, that's not going to work' and turn around [*laughs*]. We were looking for specific locations that you could buy as being part of Skellig."

Following a two-week round of costume, hair, and makeup tests, and rehearsal with actors Mark Hamill and Daisy Ridley, *Star Wars* returned to Skellig Michael from September 15 through 17 for a three-day *Last Jedi* preshoot helmed by director Rian Johnson. The shoot covered aerial photography of the island, shots for the Force montage, the "sea saddle" where Luke Skywalker and Rey first meet, and any shots involving the 618 stone steps that the sixth-century Catholic monks of Saint Fionán monastery would descend each morning to fish for their breakfast. A week later, *Rogue One*'s main unit was in Iceland to shoot Director Krennic's arrival on Lah'mu for the opening sequence of that film.

Back at Pinewood Studios, the three production art departments scrambled to prepare for the start of *The Last Jedi*'s principal photography on January 25. The highest priority designs were the Resistance bomber interior, including costumes for Paige and the bomber crew; Leia's chambers, including the medical droid, C-3PO, and costumes for Finn and Rose; both Resistance cruiser bridges, including costumes for Leia, Poe, Vice Admiral Holdo; creature work on C'ai Threnalli and the Resistance BB units; and the First Order Dreadnought bridge, all slated to be shot within the first month. Looming just on the horizon was the massive Canto Bight casino sequence, which would test every department on the show.

With all of the new roles cast by the end of November, Rian Johnson submitted his third draft of *The Last Jedi*'s script on December 11, quickly followed on December 16 by the European premiere of J.J. Abrams's *Star Wars: The Force Awakens* across three London theaters: the Empire, Odeon, and Vue. Three days later, after a week-long location shoot in the Maldives, Gareth Edward's *Rogue One: A Star Wars Story* wrapped principal photography. Only five weeks remained until *The Last Jedi* was scheduled to roll camera, three of which would be eaten up by the end-of-year holiday hiatus.

BB-8 HEAD Lunt Davies

X-WING ENGINE VERSION 03 "We wanted the fifth engine on the back of Poe's fighter to look like it was jerry-rigged—like he built a quick engine and hot-rodded it into the back of the vehicle with three clamps." Jenkins

POE ATTACK VERSION 01 "The Dreadnought had a few changes. It started off just as the standard Star Destroyer until Rian saw it and said, 'No, it's flat.' 'What do you mean?' He said, 'I just need a flat surface to fly over.' And that's all he said for quite a long time. But it just looked really weird: a flat top Star Destroyer. It looked un-designed." Jenkins

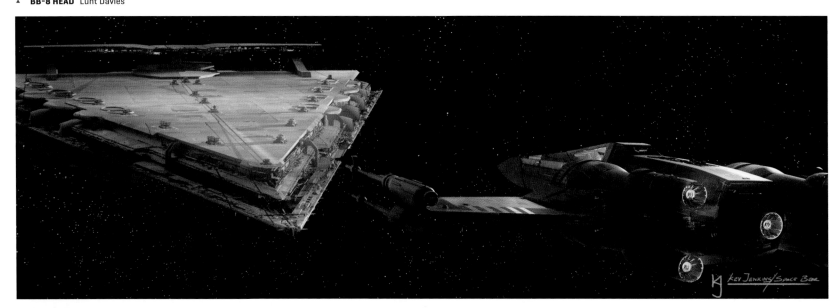

DREADNOUGHT NARROW TOWERS VERSION 04 Julian Gauthier

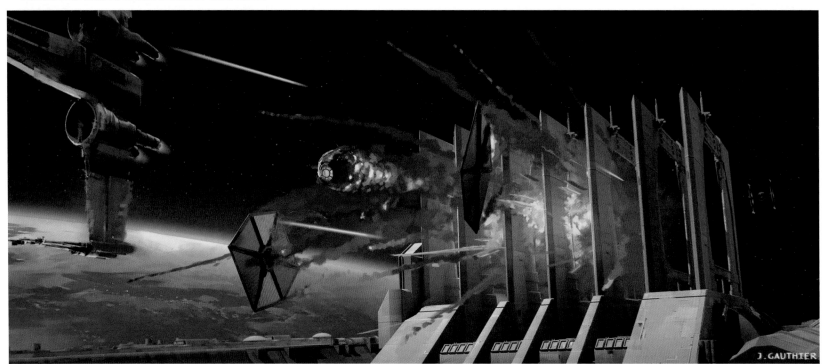

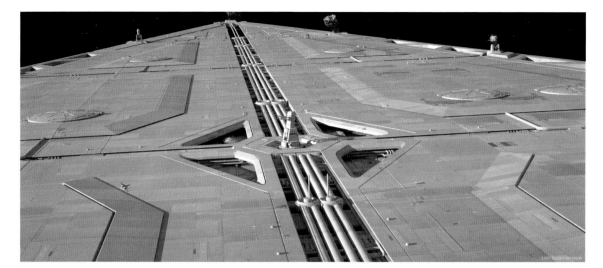

▲ **CANADY DREADNOUGHT VERSION 28** Luis Guggenberger ▼ **DREADNOUGHT VERSION 05** Jenkins ▲ **CANNON SHOT 2** Booth and BLIND LTD.

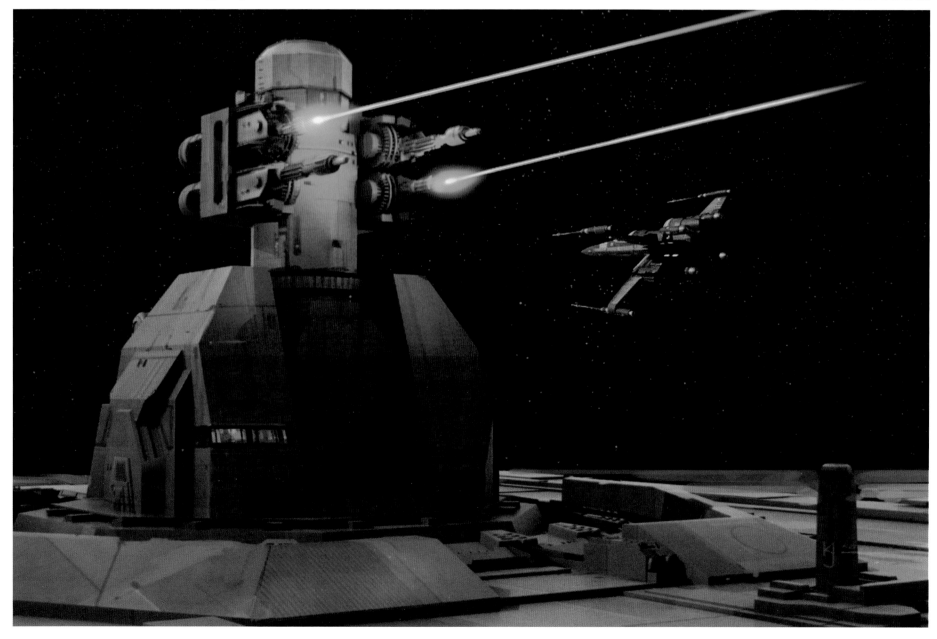

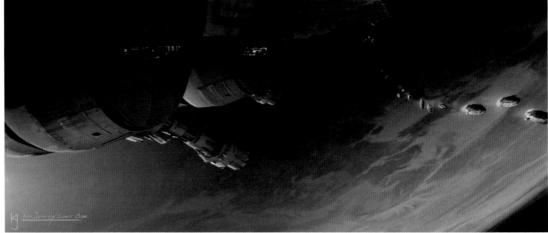

▲ **DESTROYER TANKER SKETCH** Jenkins

▲ **DREADNOUGHT GUNS VERSION 01** Jenkins

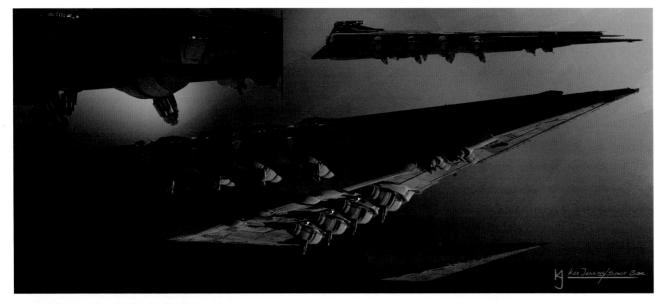

In the first few drafts of Rian Johnson's script, the Resistance bombing run, led by Poe Dameron in his X-wing starfighter, was executed over First Order officer Captain Canady's flat-top "fuel tanker" Star Destroyer, prior to the craft's reimagining as a Dreadnought. And the action did not yet take place over the evacuation of D'Qar, the Resistance's home base in *The Force Awakens*, and therefore, did not link up as closely as events on the island with the conclusion of *The Force Awakens*. "But after the rewrite, Rian had two requirements: one still being the flattop, because he wanted the sequence of Poe taking out the guns on his own, to show his bravado, " Jenkins says. "And two: he also wanted guns underneath that turn around like a clock face, aligning in a very simple way with D'Qar and preparing to fire."

▼ **DREADNOUGHT FROM LIGHTSPEED VERSION 01** "I wanted the bridge to be a big airfoil, almost like a *Miami Vice* speedboat, purely because I wanted to have the bridge away from the main deck of the ship. I figured nobody really lives or works in the main deck, apart from in-the-deck gunners. So everyone else on the Dreadnought is in the airfoil deck on the back, this big long strip." Jenkins

▲ **DREADNOUGHT BARREL BOTTOM VERSION 01** Jenkins

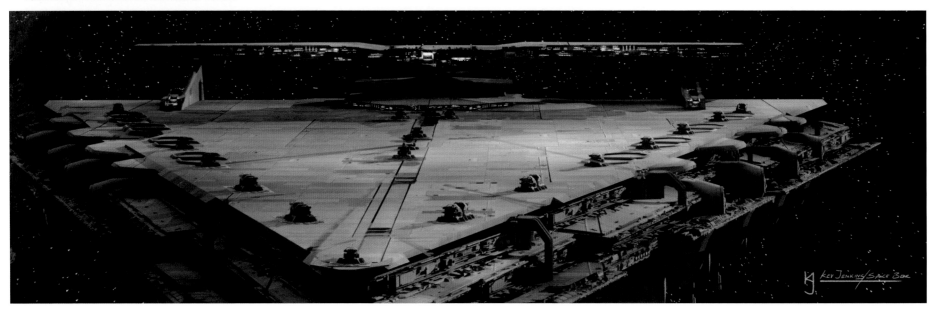

▲ **FLAT-TOP TURBOLASERS VERSION 02** "Rian wanted the guns to be slow and awkward. But I do want to bring back the windows with troops inside of them—anything that gives you that *Star Wars* scale, which they did so well in the past: that little man in front of a big thing or placed within it. It's very seventies, having a little window with someone in there, doing something." Jenkins

▸ **CANADY DESTROYER BRIDGE VERSION 07** Catling

Captain Canady's submarine-like Dreadnought bridge was a redress of Hux's Star Destroyer bridge, filmed ten days apart in the first month of principal photography on *The Last Jedi*.

▾ **DREADNOUGHT GUN VERSION 03** Jenkins

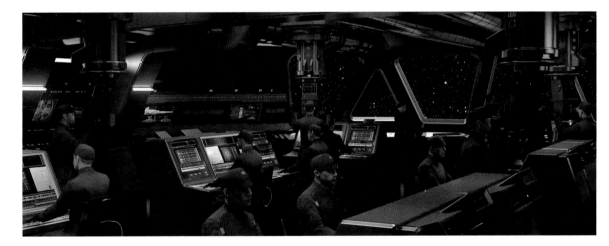

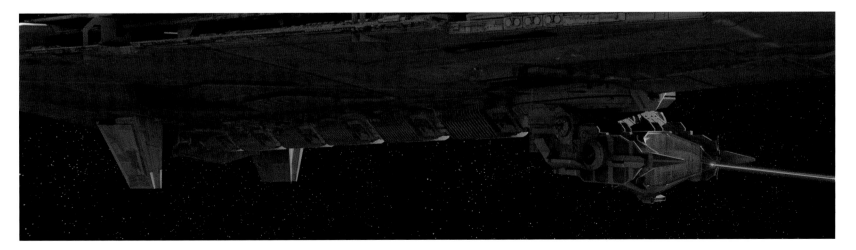

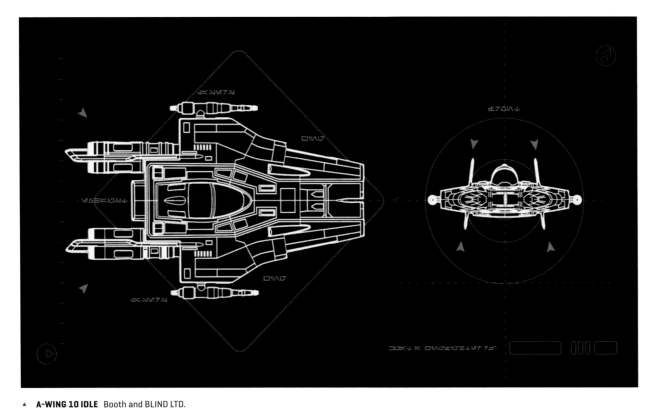

▲ **A-WING 10 IDLE** Booth and BLIND LTD.

▲ **A-WING PAINT VERSION 02** Jenkins

▲ **A-WING PAINT VERSION 03** Jenkins and Heinrichs

▲ **OTHER A-WING VERSION 06** Jenkins and Heinrichs

▲ **A-WING PAINT VERSION 07** Jenkins

▶ **TALLIE A-WING VERSION 08** "For the paint jobs on the A-wings, I did the big blue striped one, riffing off of the A-wing that Ralph McQuarrie designed. We didn't want to do the same exact design, but my paintjob, that big stripe, is a tribute to the seventies-ness that Ralph brought to the whole thing." Jenkins

▸ **BOMBER OUTER WEAR B4** Jock

▾ **BOMBER HELMET C** Jock

"Whenever I am talking about helmets with
Michael, we'll look back at what's gone
before. Jock and I were looking at some
really small sketches from *Return of the
Jedi* that had the feel of a Rebel bomber.
Tonči added an upper layer to the helmet,
and that was refined down. Rian wanted a
kind of oxygen mask and was very keen to
have it wrapped in rough fabric. You always
step back to Vietnam, so I bought some
original American oxygen masks, which
we then cast and readapted so it all clips
very nicely into this Rebel helmet. Then
we attached some older pipes from six-
ties German gas masks, which gives it an
instant age and character." **Crossman**

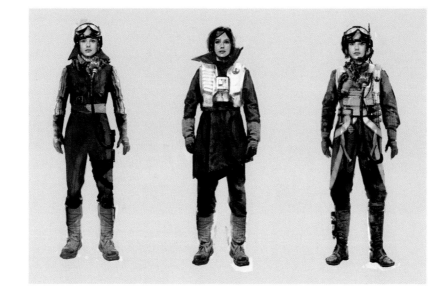

GEAR

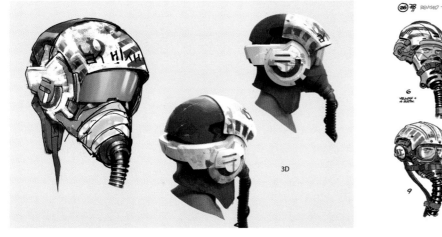

3D

REVISED — SECOND PASS

▴ **BOMBER FLIGHT SUIT D** Jock

"We took the X-wing pilot life jacket and added some
leg harnesses. You've got more of a yellowy-green
version of the X-wing suit and another Rebel patch
sewed onto the arm—one of the touches Michael
wanted to add. The bombers are probably my favorite
costume in *Star Wars*." **Crossman**

◂ **BOMBER HELMET IDEAS REVISION 2C** Zonjić

▾ **BALL TURRET VERSION 02** Clyne

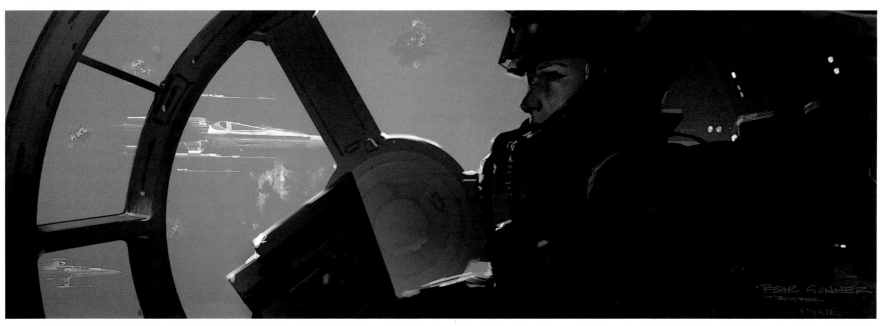

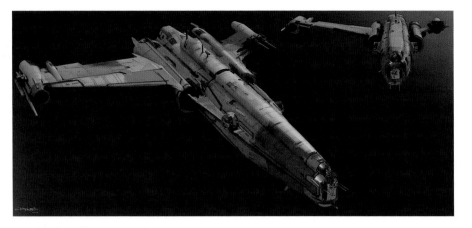

▲ **BOMBER 01** Clyne

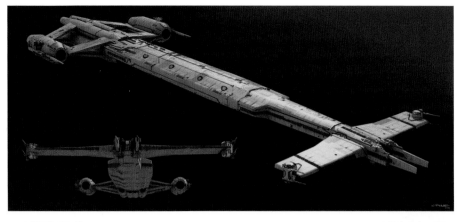

▲ **BOMBER 05** Clyne

▼ **BOMBER 10** Clyne

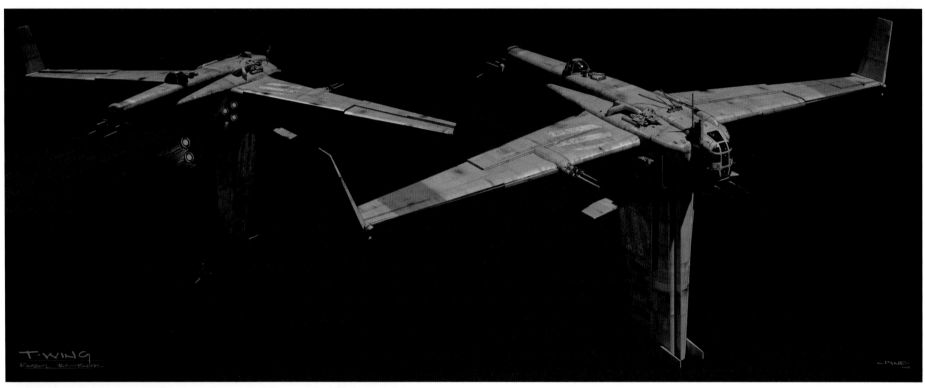

▼ **BOMBER 08** Clyne

"I didn't realize that Rian would structure some of *The Last Jedi* around this unique new *Star Wars* ship: a big Avro Lancaster, B-52 kind of bomber. The idea is a testament to Rian understanding George's influences from Vietnam and World War II—both the historical events and the movies made about them. Any time I tried to design it where it was heavily armed, armored, and full of guns, Rian would back off on it.

"It started with a more traditional fuselage—long, more like big World War II bombers. Then I proposed this idea [Bomber 10] to Rian and Rick: 'What if we play with the notion of what it means to be a bomber—from a horizontal thing to a totally vertical thing?' Harkening back to what's been done before, some of the initial aesthetic was the B-wing and the Medical Frigate." **Clyne**

"Initially, when I was writing the bombing run, I had the B-52 in my head—this horizontal tube with the bombs in it. When James came up with the idea of the vertical clip, I rewrote the action scene. Instead, we could have this vertical element, which meant somebody could fall down into it. It just opened up all of these other possibilities. James was also going off of a cue of mine: 'I don't want these things to be maneuverable. I want them to be like big, pregnant cows.' So he came up with, 'What if we extend the belly down so it's this huge, weighty thing?' The temptation is always there to make ships sleek and cool looking. The notion of working against that was intruiging: 'No, these things are big, floating beasts that the nimble fighters have to protect.'" **Johnson**

▲ **BOMBING RUN ROUGH** Heinrichs

▲ **T-WING BOMBER VERSION 10** Clyne

DETAIL

▲ **RESISTANCE BOMBER FRONT VERSION 19** Guggenberger

▼ **BOMBER LINEUP VERSION 25** Clyne

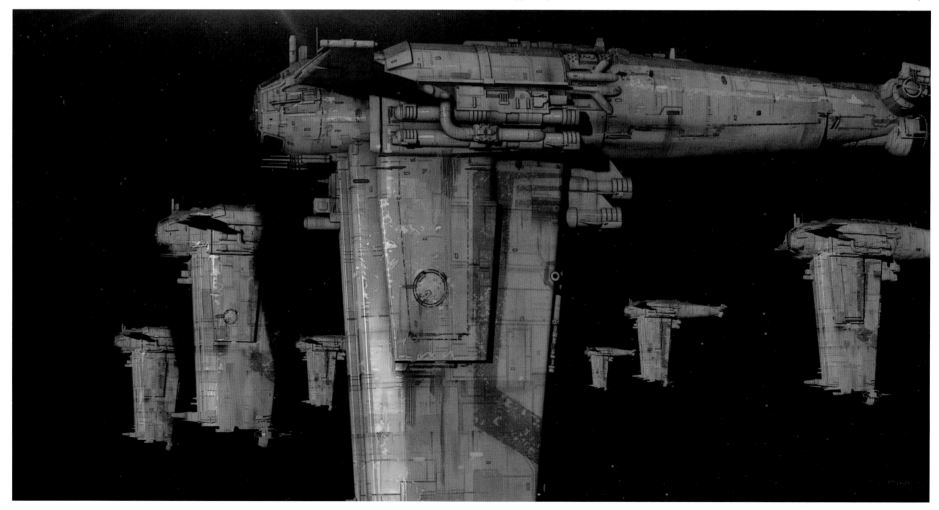

▲ **BOMBER RUN FLAT VERSION 01** Jenkins

▼ **BOMB RUN VERSION 03** Jenkins

▶ **T-WING BOMBER FUSELAGE VERSION 03** "This was a great note from Kevin: 'Look at the ribs from the Blockade Runner.' I riffed off of that. Instead of traditional ribs, I gave it a little more *Star Wars*-ness. That was a big influence—the Blockade Runner—and going even further back, the genesis of the *Falcon*. Rian loves the big, clunky controls. They're not technology-driven; they're story-driven." **Clyne**

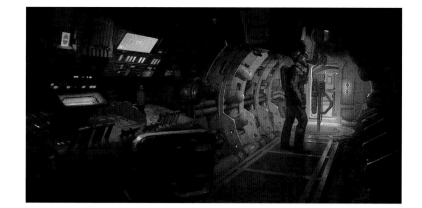

HI
SNOKE

HAN
SAYS
HI

▲ **MAGNA BOMBS** Kitisakkul

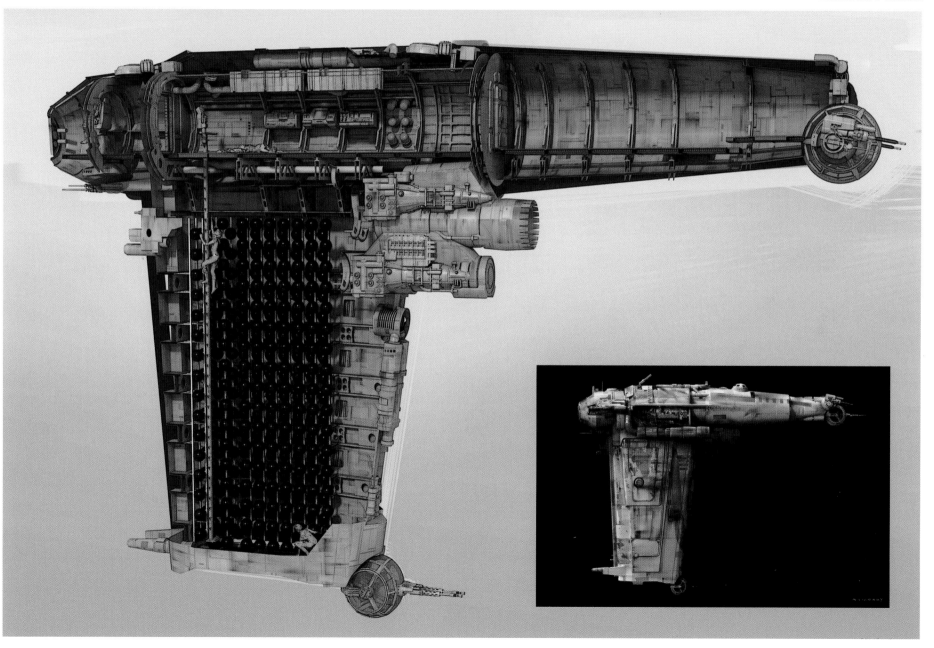

▲ **INTERIOR VERSION 05** Clyne

▲ Inset **RESISTANCE BOMBER B4** Timothy Rodriguez

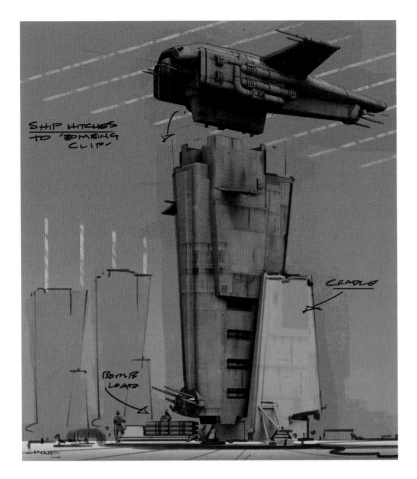

SHIP HITCHES
TO 'BOMBING
CLIP'

CRADLE

BOMB
LOAD

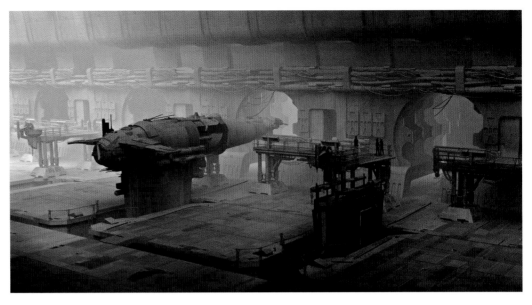

T-WING BOMBER 12 "Here was the idea pitched: The bombs all come vertically out of a clip, almost like the magazine of a gun. I thought Rian was going to say, 'This is stupid,' but he totally embraced it. Then the team had discussions about how to make it work. I was even thinking on the level of what would make a great toy. You could have a handle on the back of it with a trigger. You could drop bombs out of it by squeezing the trigger [*laughs*]." **Clyne**

RESISTANCE BOMBER HANGAR VERSION 03 "The idea was: The bombers go into keyholes in the wall, then the ships load up with clips coming out from the floor, slotting into the bomber. In the rewrite, Rian had to lose it. It wasn't necessary for the story, and I appreciate that. It's a practical, military, almost ludicrous solution, if you think about it. In *Star Wars*, I always describe it as 'analog.' You manually load things, you manually turn things. You're not in a digital, computer-based world." **Jenkins**

BOMBER HANGAR VERSION 01 Jenkins

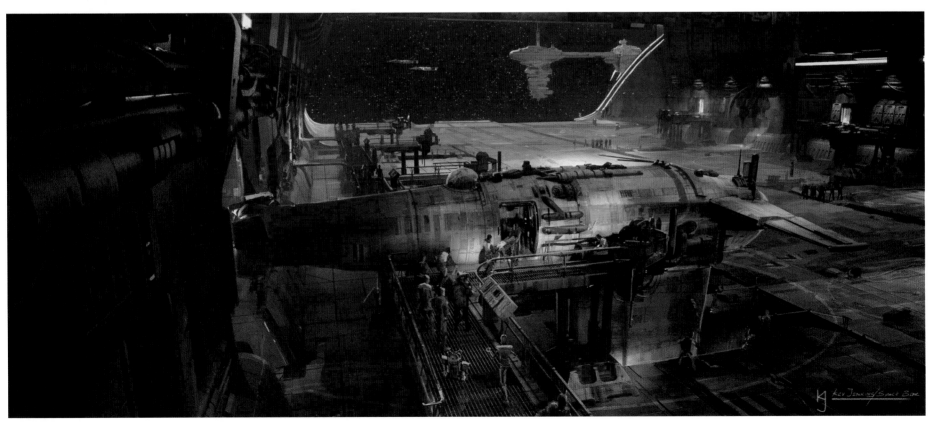

In the initial drafts of Rian Johnson's *The Last Jedi* script, a masked tail gunner aboard Cobalt Bomber is revealed to be Finn, fully healed from his Kylo Ren–inflicted wounds and a member of the Resistance fighter squadron. As in the finished film, Paige dies after the bombs are released, but in initial drafts, Finn is with her, bearing witness to her sacrifice. Paige's dying gesture in Finn's arms leaves a bloody handprint on his heart, mirroring the bloody handprint on Finn's stormtrooper helmet in *The Force Awakens*. "Ultimately, I found I couldn't pay it off," Johnson realized. "If Finn witnessed Paige's death and didn't know that she was Rose's sister, that meant there would have to be a big scene after he found out. If he did know Paige was Rose's sister, there would either have to be a big 'I saw your sister die' scene, which I didn't want to write and the movie would have to come to a full stop to do—or he would be an asshole because he would never tell her [*laughs*]. So ultimately, it felt really right as a setup, but I realized there was no wood to burn, in terms of a payoff."

▼ PAYLOAD VERSION 05 Damaggio

"In earlier drawings, the bombs looked more like conventional World War II bombs. It was Rian's idea to have these reflective spheres, which are so much more *Star Wars* than a traditional bomb. From those early discussions, the bomber evolved more like a set than it did a vehicle. The ladder in the bomber clip eventually went down the middle. That was a Rian decision, and he makes the most of it: The bombs all fall around Paige." **Clyne**

▲ **BOMBER 05** Clyne

▼ **BOMBER CROSS SECTION 01** Clyne

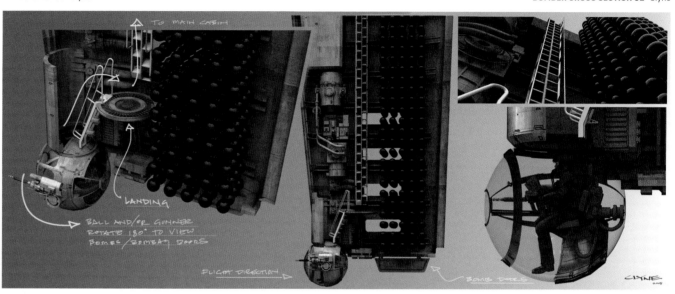

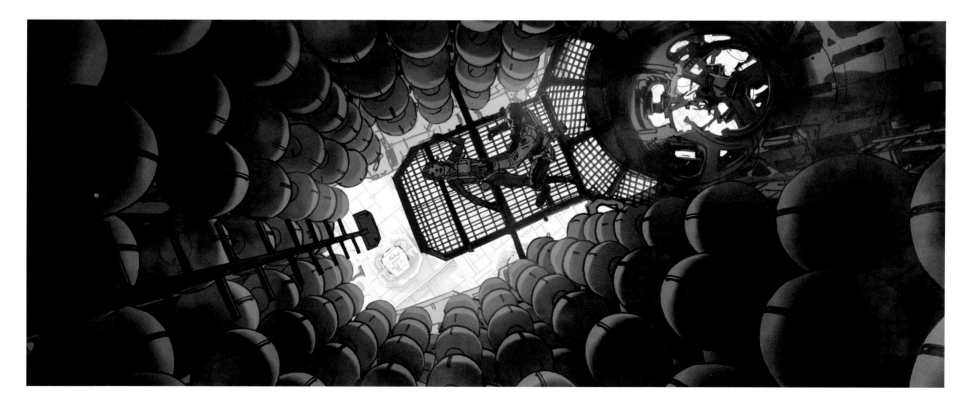

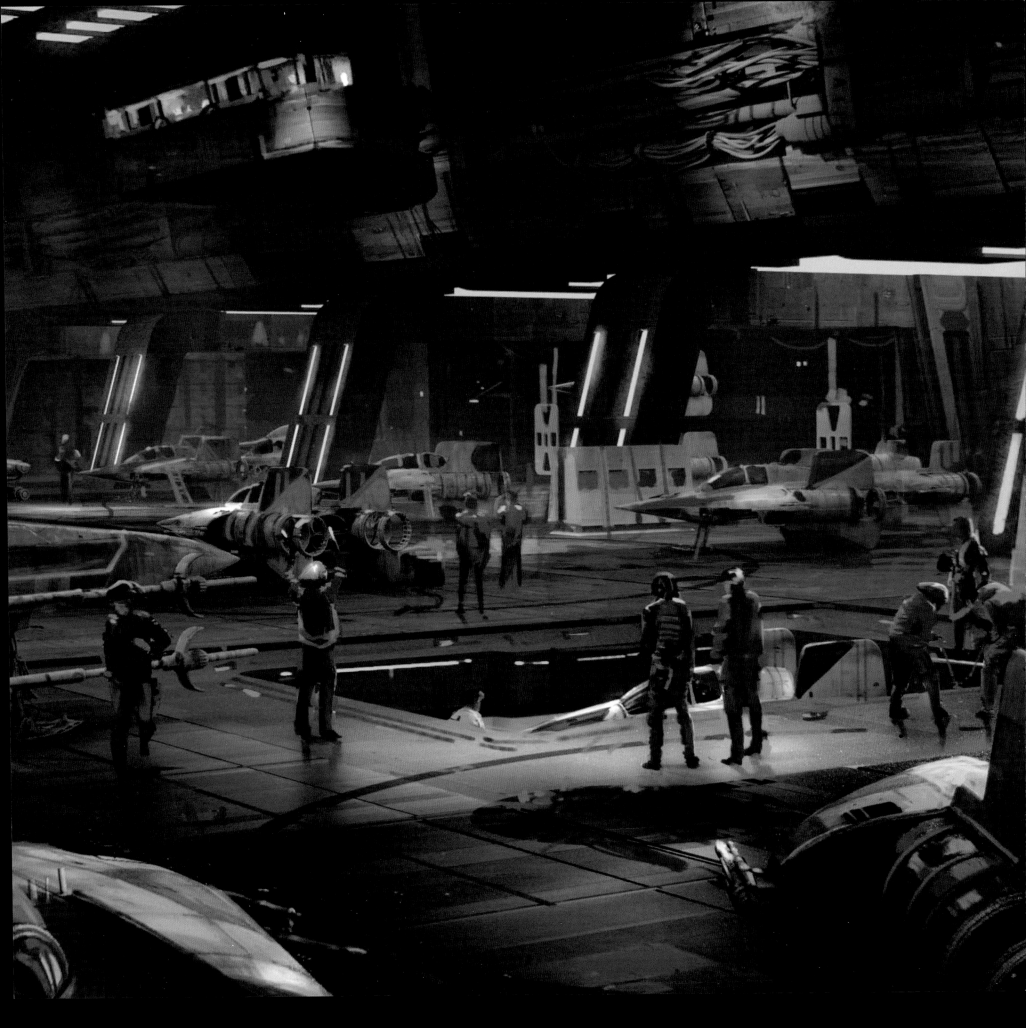

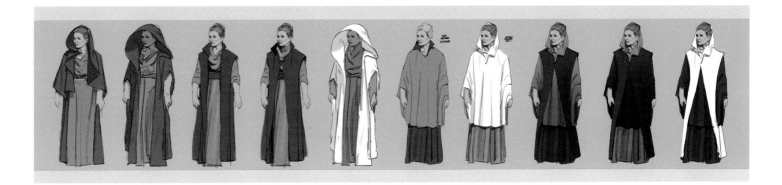

The Unsinkable Leia Organa

Over the 2015 holiday break, screenwriter/director Rian Johnson made several shifts to *The Last Jedi*'s story, most notably removing Finn from the opening bombing run; altering that sequence to occur during the evacuation of the Resistance base at D'Qar; having Luke and Rey briefly duel before she leaves the island; and adding the *Rashômon*-esque Jedi academy flashback sequence, with the first draft of the shooting script [the version Johnson would actually shoot the film against] arriving on February 1, 2016. On January 20, Lucasfilm announced that *The Last Jedi*'s release date would be pushed back from May 26 to December 15, 2017.

The start of principal photography also shifted, and was now slated to begin three weeks later, on February 15. "I had longer to prep this than I've ever had on a movie," Rick Heinrichs says. "Fourteen months, and we used every bit of it. We had every stage at Pinewood, a stage at Longcross Studios, a location outside of Longcross, locations in Ireland, a few second unit locations in Iceland—and we used the Bond [007] Stage, the largest stage in London. We had to manage all of those stages and how the shoot was going to unfold."

By February 8, the remaining cast, including Carrie Fisher, Adam Driver, Mark Hamill, Oscar Issac, and Domhnall Gleeson, assembled at Pinewood Studios for two days of hair, makeup, and wardrobe camera tests on the Resistance cruiser bridge, followed by rehearsal for the imminent bridge and bomber interior scenes on February 10. Preshoots for those two sets, plus the interior of the *Millennium Falcon* with Rey, Luke Skywalker, and R2-D2 kicked off *The Last Jedi*'s shoot on February 11 and 12.

The same day that *The Last Jedi*'s principal photography officially began on Pinewood's Stage B—home to Leia's chambers and the Mega Destroyer observation room—Lucasfilm announced the cast, including *Star Wars* newcomers Benicio del Toro, Laura Dern, and Kelly Marie Tran, and released a short production-announcement video, showing Rian Johnson, Daisy Ridley, and Mark Hamill shooting on Skellig Michael back in mid-September 2015.

The next three weeks saw shoots on a wide variety of Pinewood stages and sets. Sharing space with the bomber fuselage, the Resistance cruiser bridge was constructed on D Stage. General Hux's Star Destroyer bridge, quickly redressed as the Dreadnought bridge, was shot on S Stage. The bomber "clip" set was housed on Q Stage. A Stage was reserved for the temporary cruiser bridge set and Kylo's chambers and shuttle interiors were found on F Stage. Dwarfing them all was the massive casino interior set on 007 Stage, shot March 7 and 8.

The splinter unit traveled to Dubrovnik, Croatia, for Canto Bight city-street shoots from March 9 to 17, with Rian Johnson joining them for the rooftop, yacht, and steamroom scenes on March 12 and 13. "It was basically very elaborate plate work, stunts and effects, elements for the chase," Johnson recalls. "But none of our cast was there. I had visited Dubrovnik before, as a tourist. It's one of the most beautiful cities on the planet. To have free run of it for a couple of days was amazing."

The remainder of March and April saw the production back in England at Pinewood Studios, broken up by three days at nearby Longcross Film Studios for casino exterior and Jedi library tree shoots from March 31 to April 4. The Canto Bight jail; mirror cave; night scenes in the island village; Caretaker village; Resistance fighter hangar; library interior; sleek ship interiors; and Mega Destroyer commons and bridge sequences were all shot before the end of April. Rick Heinrichs remembers, "We had a brilliant relationship with first AD [assistant director] Jamie Christopher. He would push his schedule mandates, and we would push back with our physical-construction mandates. We had to tell Jamie from the beginning, 'If you guys don't make your days, our little house of cards here is going to get blown away, because we're not going to be able to turn things around in time for you.' So Rian was very disciplined about making the days. And that's how we chugged through it. Everybody stayed on top of it."

Design work in the three *Last Jedi* art departments focused on whatever designs remained for the back half of the shoot. Of pressing importance were the new Resistance-cruiser medical room for Finn's introduction in the bacta suit; the Crait base interiors, including the crystal foxes and mine tunnels they run through; Snoke's throne room, with its complicated stunt and motion-capture rigs; and the newly-envisioned flashback in Kylo's temple chambers.

▲ **LEIA VERSION 03** Zonjić

◄ **FIGHTER HANGAR VERSION 01** Jenkins

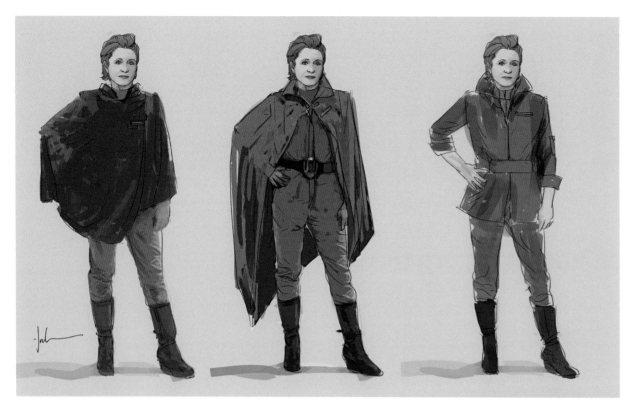

▼ **LEIA WEAR LINE B** Jock

▲ **LEIA OUTER WEAR COMP A** Jock

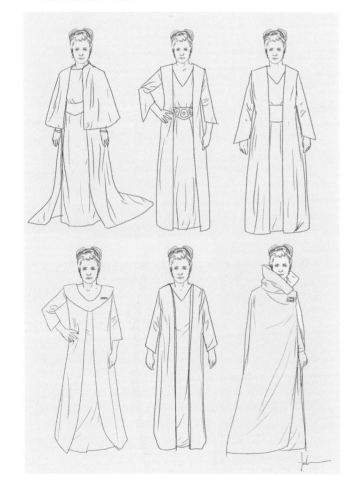

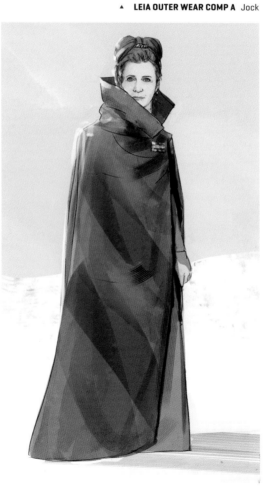

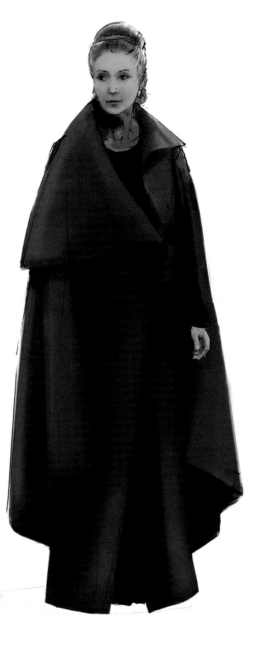

▲ **LEIA 2** Rowley

"I wanted Carrie to look fabulous again. So let's do dramatic lines. Let's do gorgeous coats. One of the few specific visual ideas I gave was that big *Blade Runner*-like coat with the huge collar that blocked the bottom half of her face. I didn't want her to have to be buttoned-down and practical. I wanted her to look badass." Johnson

◄ **LEIA WEAR DRESS K** Jock

"Rian wanted Leia to be a little more queenly or authoritative looking. And I wanted something that would frame her, some kind of regal robe without it being too busy—just big graphic shapes like capes. As a takeoff point, I'd seen pictures of Queen Elizabeth wearing these capes on the Scottish moors. I wouldn't say the outfit on the bridge is an evening fabric, but it does have a shine to it and the shape is quite beautiful—a nice silhouette." Kaplan

▲ **BRIDGE WIP** Damaggio

▼ **COMMAND BRIDGE VERSION 03** Damaggio

▲ **COMMAND BRIDGE VERSION 02** Damaggio

"The cruiser-bridge sets are absolutely inspired by the *Home One* from *Jedi*, but with our own spin on it. Riffing off of the shape of that Calamari cruiser, the bridge is in a dominant position on top of it. The temporary bridge is in an inferior position below it. You can see that the main bridge has windows angled up, and when you get to the temp bridge, it's the opposite." **Heinrichs**

◄ **HOLOGRAM TABLE REVAMP** Grant

"Senior art director Mark Harris is the spiritual descendant of Harry Lange. Mark's got the kit with the tape, the little turn dials and knobs. There's a point at which we send Mark into the set to do the 'Harry Lange-uage,' as he would call it." **Heinrichs**

▸ **FLEET LOSS 5 GONE** Booth and BLIND LTD.

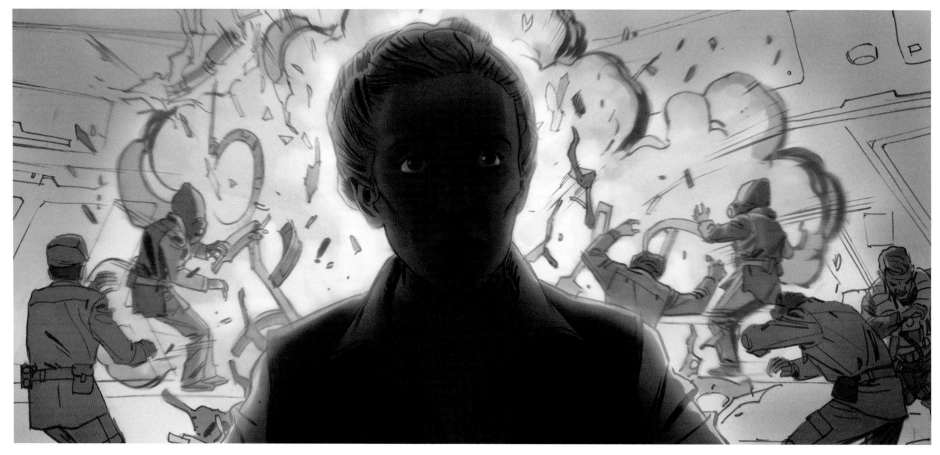

▲ **LEIA** Damaggio and Heinrichs

▼ **BRIDGE DAMAGE VERSION 01** Damaggio and Heinrichs

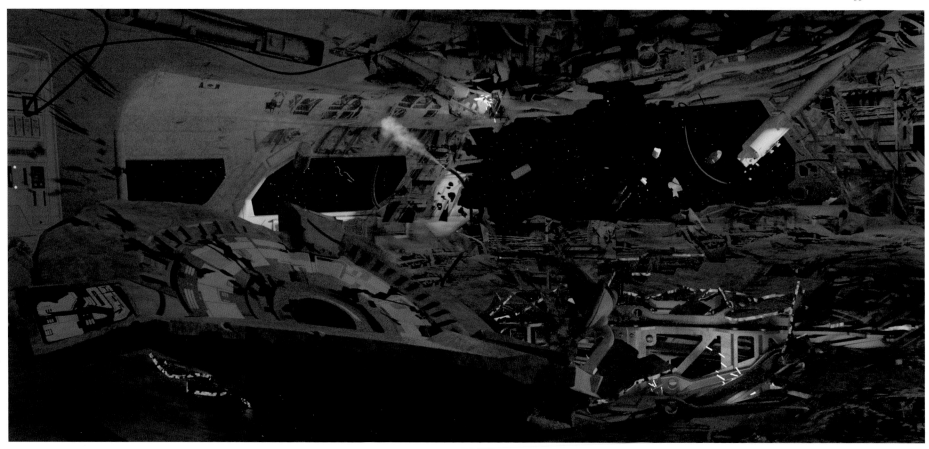

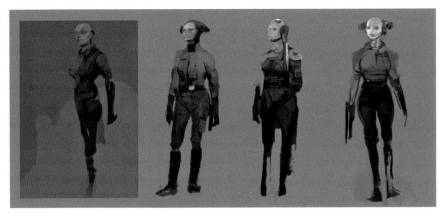

▲ **GENERAL HARD-ASS VERSION 04** Sweet

▼ **REBEL COMMANDER** Weston

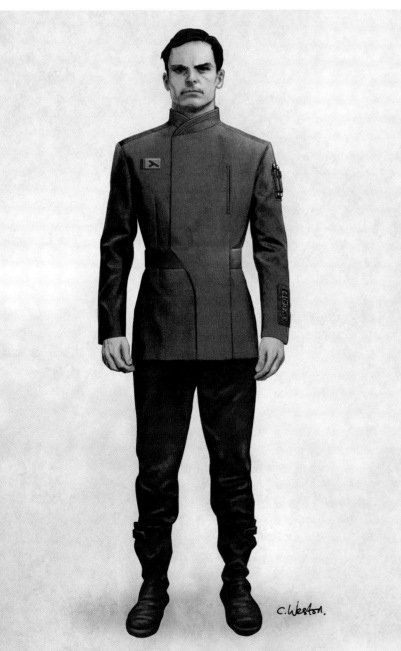

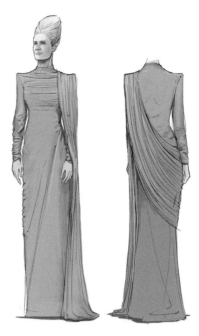

▲ **HOLDO ALT 5** Rowley

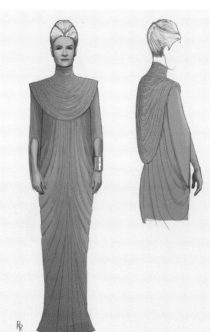

▲ **OFFICER DRESS** Rowley

"I just assumed Holdo was going to be in an officer's uniform. I knew she would look great because Laura Dern has amazing posture and a great figure. Then Rian said, 'No, I want her in something much more feminine, some kind of a gown, something that feels different from everyone else.' He used the word 'balletic,' and she does have that kind of posture. He wanted to see her body language. He wanted her to look a little flirtatious in some of the scenes with Poe, yet he wanted her to look dignified. She has a comb in her hair. It's like a halo." **Kaplan**

▲ **HOLDO FINAL** Rowley

"I just wanted something very feminine and very unexpected for Holdo, playing away from what you would expect: an iron gray, locked-down general coming in to butt heads with Poe. And so everything about the costume was, 'Let's make it beautiful.' Laura's build is gorgeous and statu-esque and slender. So playing to that felt like the way to go. I was calling Holdo 'Hard-ass.' [*Laughs*] That's true. Ironically, that was exactly the thing that I was trying to play against, in terms of the visual element." **Johnson**

THE UNSINKABLE LEIA ORGANA **203**

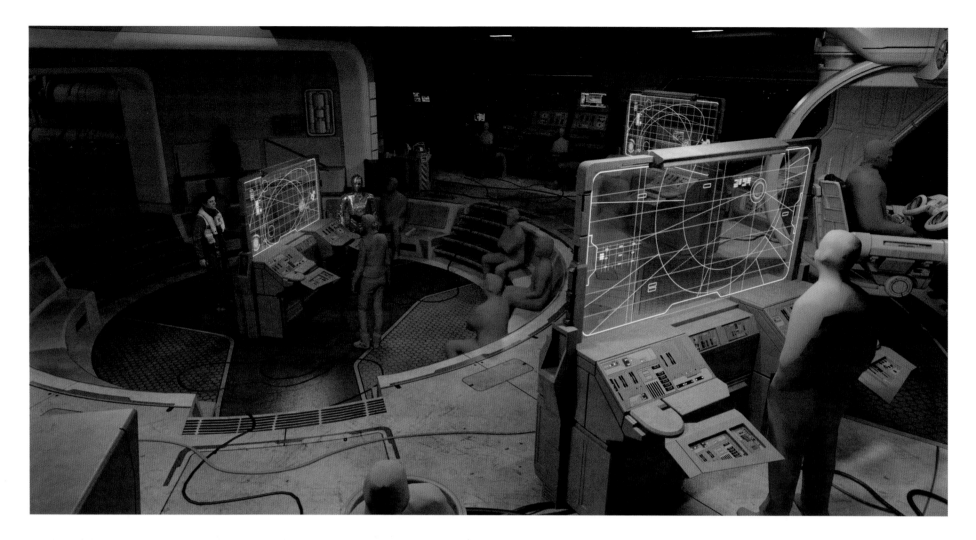

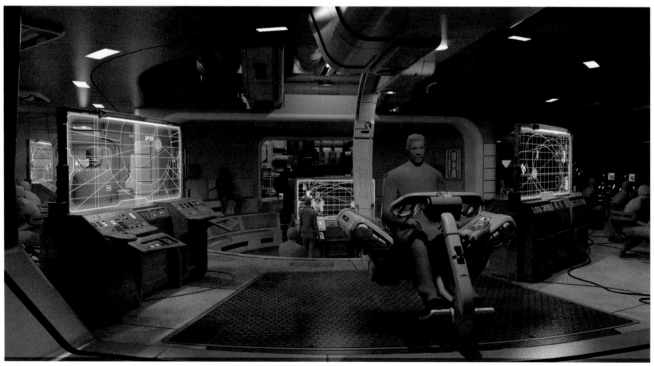

▲ **TEMP BRIDGE VERSION 05** Damaggio

◄ **TEMP BRIDGE VERSION 03** Damaggio

"The temporary bridge is in the underbelly of the ship, like the under-levels of the Resistance cruiser where we meet Rose. In the reverse shot, there's an engine room with all of these pipes and gack. It's a much more industrial space compared to the high-tech main bridge. So it had a nice contrast. This chair is a little bit of a departure that still refers back to Ackbar's *Home One*." Heinrichs

▼ **TEMP BRIDGE CHAIR VERSION 60** Damaggio

▲ **REBEL BB DROID 06** Lunt Davies

▲ **REBEL BB DROID 08** Lunt Davies

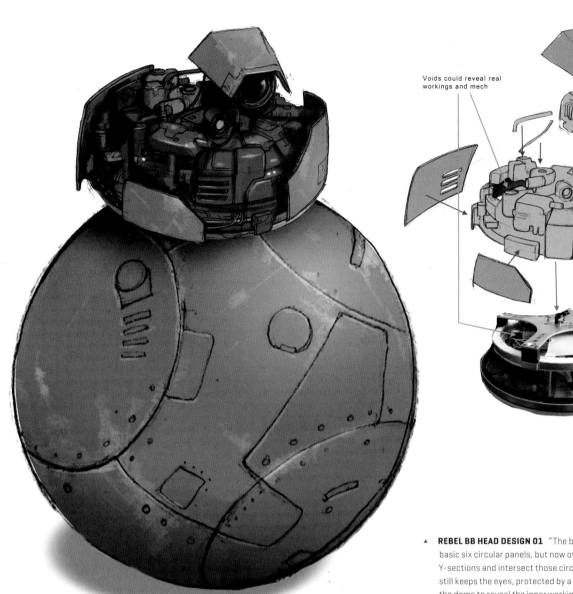

Voids could reveal real workings and mech

▲ **REBEL BB HEAD DESIGN 01** "The ball body still has the basic six circular panels, but now other panels break up the Y-sections and intersect those circular panels. The head still keeps the eyes, protected by a cowling, but breaks up the dome to reveal the inner workings." **Lunt Davies**

"BB-8 had become such a little star in his own right. Surely he is not alone. So the thought was that there would be, dare I say, 'dumber' versions of BB-8 that go about their tasks—military and utilitarian looking. Their bodies were very easy to do. Their faces took quite a lot of iteration. We built several mock-up versions in plasticard and cardboard, and stuck them on top of balls. Rian would come in and go, 'Yeah, what about this? What about that?'

"Unlike Artoo, it's not actually the graphic that tells BB-8's personality. It's his face. You can completely repaint BB-8 and think you are still looking at BB-8. So the head became the issue. How do you change where the focus is, where the eyes are, where the personality is? You have to take BB-8 out of the BB unit and create this less emotive, more simplistic or utilitarian version." **Scanlan**

▶ **REBEL BB UNITS 02** Manzella

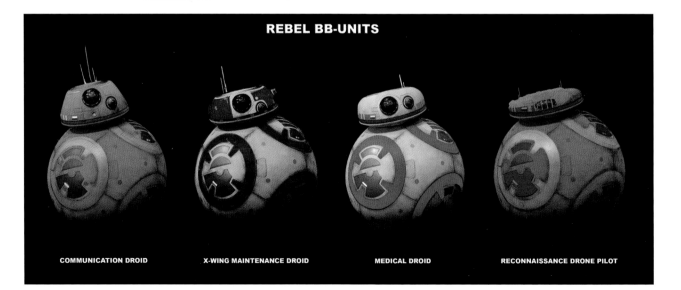

REBEL BB-UNITS

COMMUNICATION DROID X-WING MAINTENANCE DROID MEDICAL DROID RECONNAISSANCE DRONE PILOT

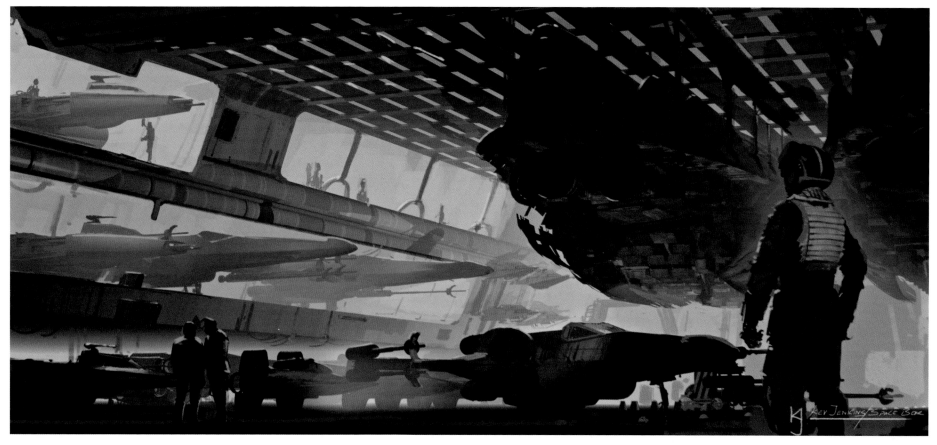

▲ **RESISTANCE CRUISER HANGAR VERSION 03** Jenkins

▼ **FIGHTER HANGAR VERSION 01** Jenkins

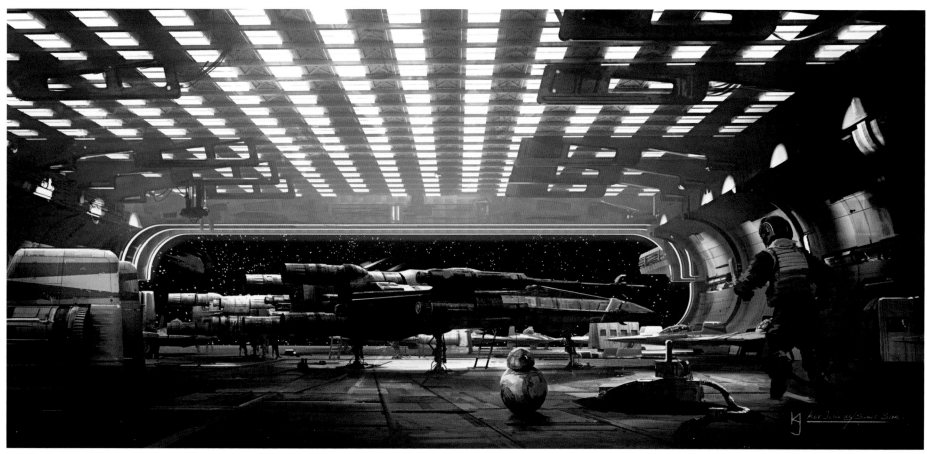

"That same idea of turning the First Order hangar wall into the Starkiller oscillator on *The Force Awakens* worked great for us. So we started with the Resistance cruiser hallways on Q Stage, and then it became the transport hangar. Then it became the medical frigate hallways and hangars. And then, finally, it was the fighter hangar. We were able to reuse hallways and walls, and turn things around for all of those. We were just barely able to wipe that stuff out of Q Stage and turn it into Snoke's throne room."
Heinrichs

▶ **KYLO ATTACKS FIGHTER HANGAR VERSION 01** Jenkins

▼ **FIGHTER HANGAR EXPLOSION VERSION 01**
"The fighter hangar is deliberately curved at the sides, not only because of its lovely retro seventies aesthetic, but Rian said, 'I want it small and low, so it can contain the blast.' And I thought, 'What better way to funnel the blast toward Poe than by rounding off the walls?'" Jenkins

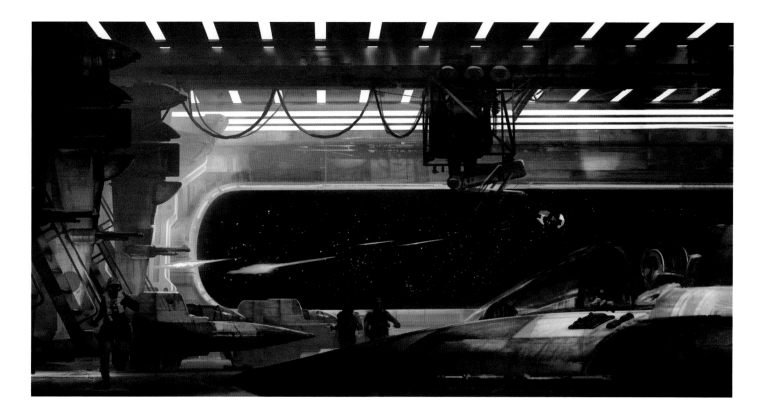

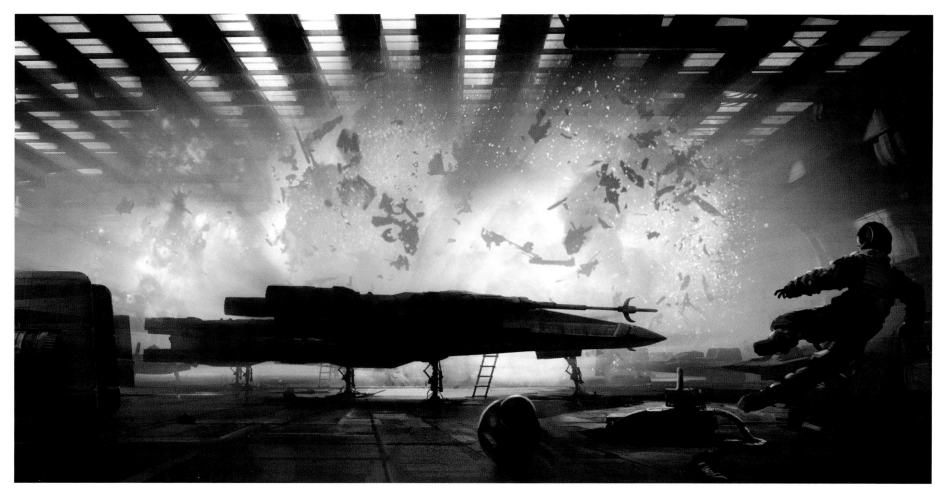

▲ **REBEL TRANSPORT VERSION 02** Clyne

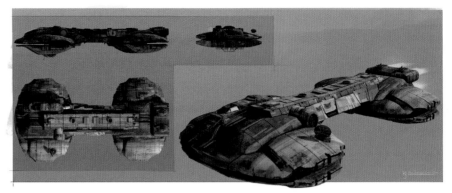

▲ **MID-SIZE TROOP TRANSPORT VERSION 01** Jenkins

▲ **REBEL TRANSPORT VERSION 03** "I was first up to do the Resistance troop transport. Fairly straightforward; I wanted to do this split: one side is the pilot, one side is the gunner. It got pretty far. And then we realized Rian wanted something a little more defenseless, a little more standardized." **Clyne**

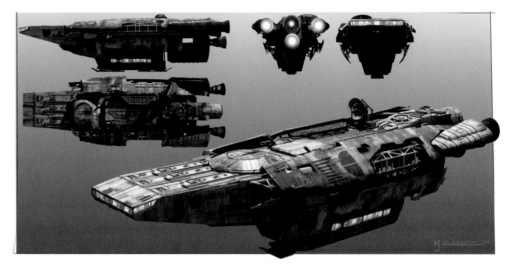

▲ **RESISTANCE TRANSPORT VERSION 02** Jenkins ▼ **RESISTANCE TRANSPORT ESCAPE VERSION 01** Jenkins

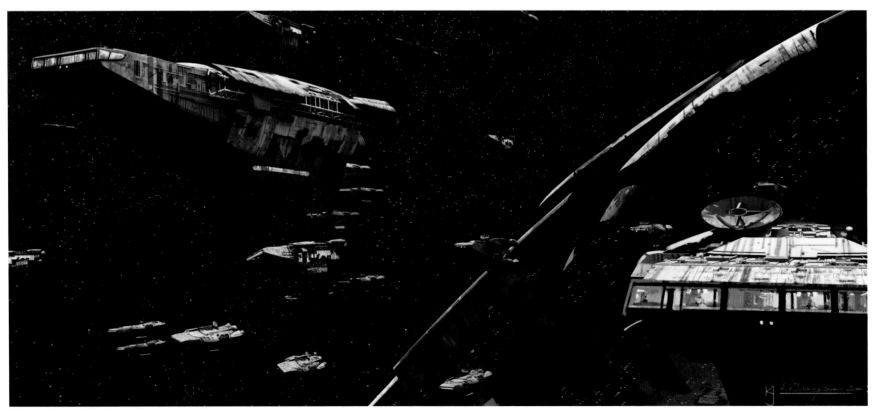

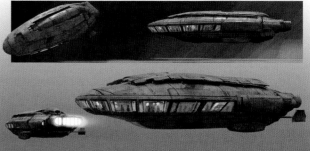

▲ **RESISTANCE TRANSPORT VERSION 03** Jenkins

▲ **TRANSPORT SKETCH** Rian walked by after a meeting, and we said, 'What about this?' He said, 'It's too fussy. I need windows. It's a bus.' And that magic-marker sketch was it. Rian approved it, and that's what we built. It's that simple. I colored it up, but it was one version from saying, 'I need windows.'" Jenkins

▶ **TRANSPORT HANGAR VERSION 05** "Nothing was designed for design's sake in any of the paintings. It was all thought through. This is for the rebels, so it's knackered, it's worn down. It doesn't really fit very well. It's soft, it's round, it's armored, it's falling apart. It's gray, green, oranges, yellows. Flipping that to the First Order: It's navy blues and cold colors and angular Brutalism." Jenkins

▼ **TRANSPORT HANGAR VERSION 02** Jenkins

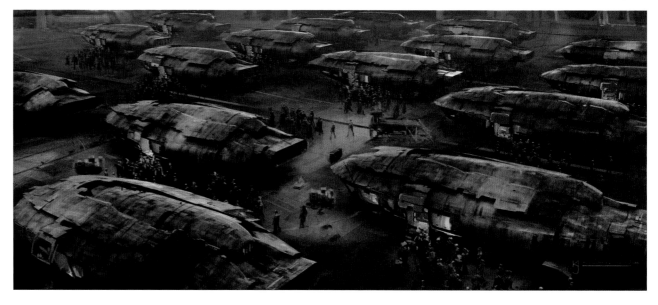

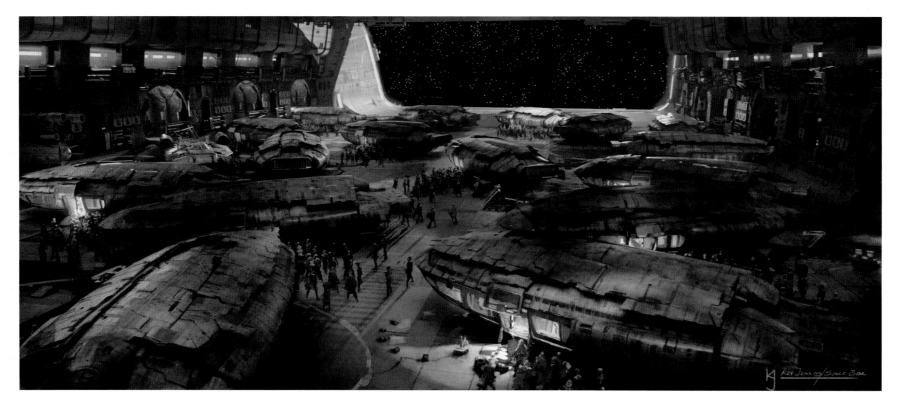

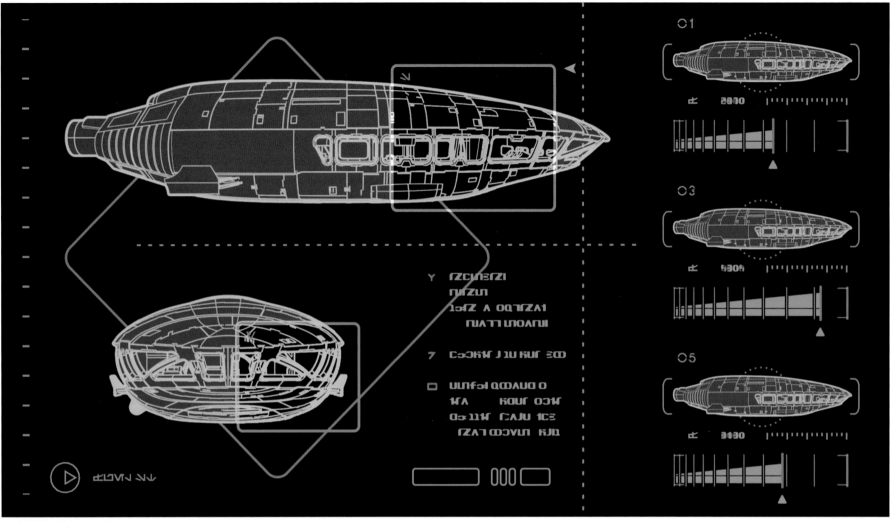

▲ **TRANSPORTER REFUEL LEFT VERSION 01** Booth and BLIND LTD.

▼ **RESISTANCE TRANSPORT INTERIOR VERSION 04** Jenkins

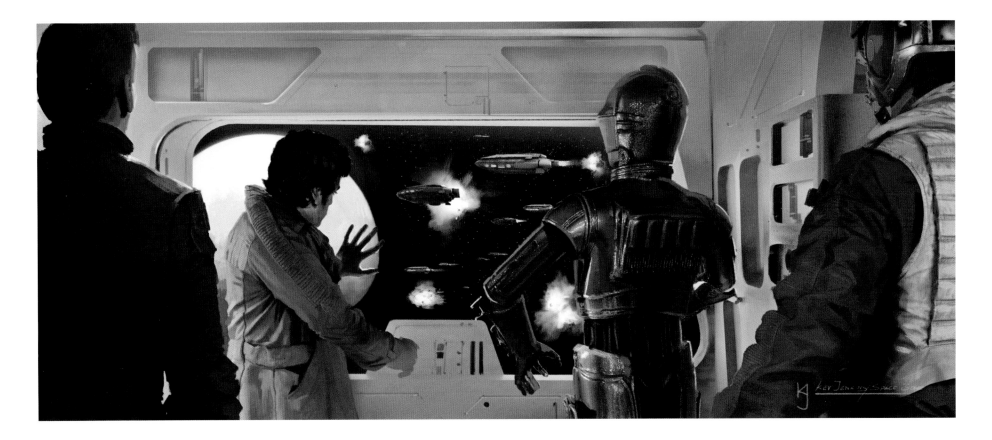

RESISTANCE TRANSPORT CRAIT VERSION 03 "A lot of the original *Star Wars* art directors, like Harry Lange, worked on *2001*. So I took a lot of inspiration from *2001*—that seventies, plastic vac-formed look. When I started making up the inside, I wanted to bring back the *Star Wars* padding and then go into that seventies rounded-off look. I think about it in this abstract way: The company that made the armored turtleback transports from *Jedi* also made these buses. They were made at the same time by the same company. You try to not go abstractly new in the design but more, 'We only have twenty arms suppliers. Why wouldn't they have something similar?'" **Jenkins**

"We had to approach the transports as an interior/exterior set. Creating the framing for it so it could be used for both was a huge challenge. So it ended up being a completely built ship that you could shoot from the interior and the exterior. We sliced it in half and used both halves on 007 Stage as transports inside the Crait mine interior." **Heinrichs**

▶ **RESISTANCE TRANSPORT CRAIT VERSION 02** "You've got this gung-ho star-pilot trapped on a bus, watching everything fall apart all around him. At the time, I thought, 'Poe should look sad.' But looking back on it now, it's more than that. He's losing everything in that moment." **Jenkins**

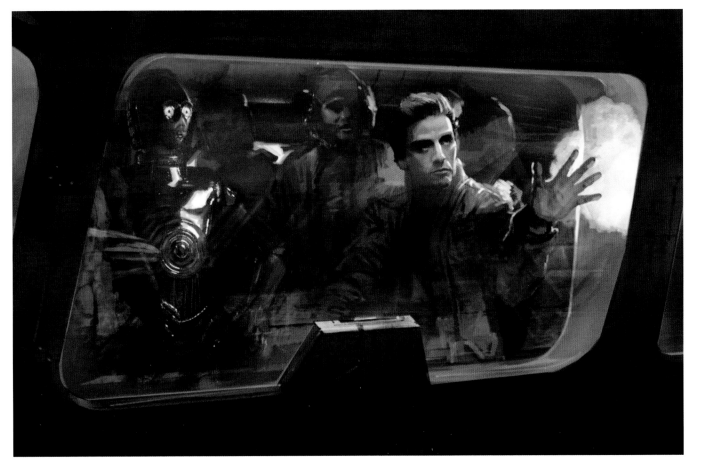

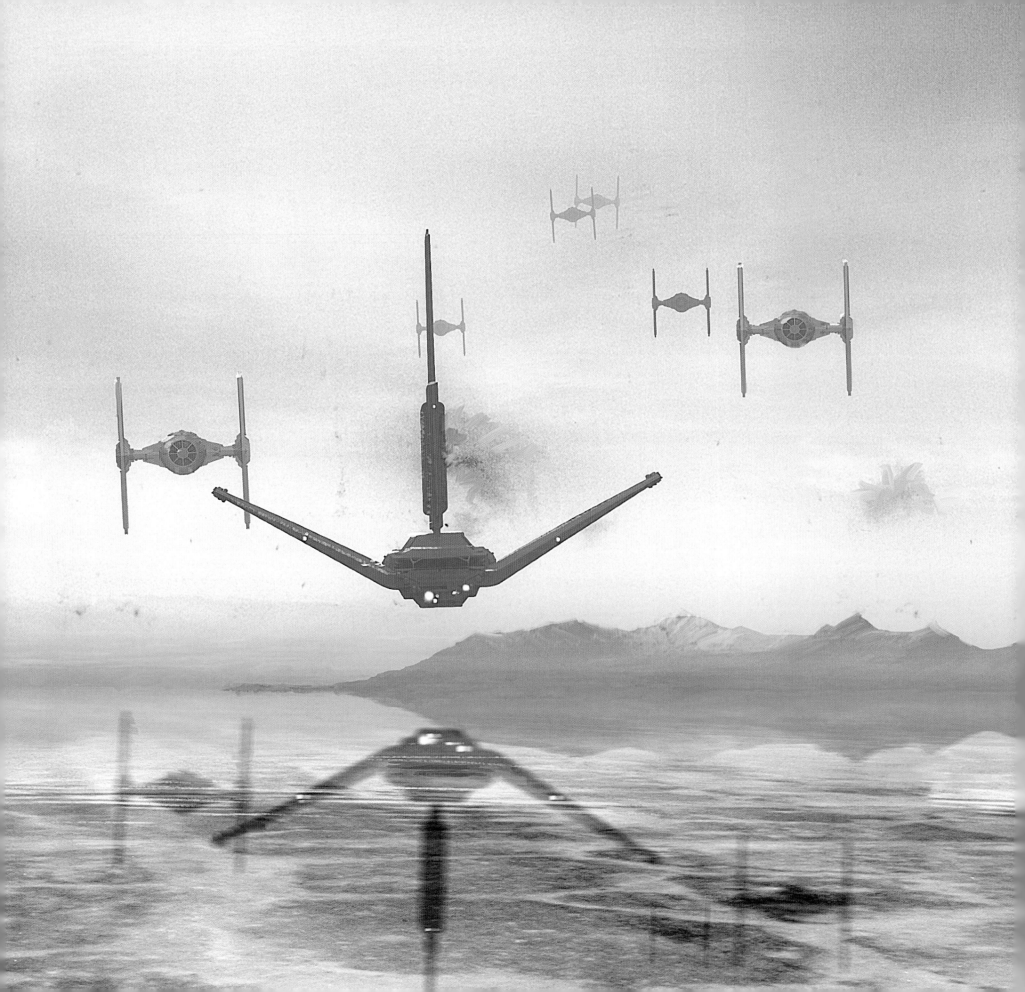

A Line in the Salt

Principal photography for *The Last Jedi* resumed at Pinewood Studios in May 2016 with a day on both R and C Stage for DJ's stolen sleek ship staircase and lounge, respectively. Pinewood's "paddock tank," the outdoor site of Domhnall Gleeson's Starkiller Base speech in *The Force Awakens* almost two years prior, hosted the Crait battle trench for an additional two days. *Rogue One: A Star Wars Story* director Gareth Edwards, *Last Jedi* art director Kevin Jenkins, key second AD Matthew Sharp as Sergeant "Salty" Sharp, creature performers Brian Herring and Dave Chapman of BB-8 fame, senior creature animatronics designer Joshua Lee, and creature electronics design and development supervisor Matthew Denton all appeared as Resistance soldiers in the trench. "I kept asking, 'When am I going to get to cameo in the movie?'" recalls Jenkins. "And Ram said, 'What do you want to do?' 'I want to get blown up looking at those walkers I've designed [*laughs*].'"

May 12 marked the start of the two-week Ireland location shoot, with a travel day to Malin Head for three days of shooting Rey running to the Caretaker village, the *Millennium Falcon* landing pad beside a partial build of the ship, and Luke Skywalker's approach to the library tree, eventually cut together with the library tree itself shot at Longcross Studios a month earlier. The Ireland shoot continued for a day at Brow Head for the fishing sequence before shifting three hours north to Sybil Head and Dingle for five days with the transplanted Jedi huts. Following a day at nearby Dunmore Head for the sea-cow scenes, the Ireland shoot wrapped on May 25.

Back at Pinewood Studios, the island temple interior set on the R.A., or Richard Attenborough Stage awaited the main unit's return on May 31 through June 2. The fathier stables and flashback to Luke's temple were the final scenes shot at Longcross from June 3 to 7. Meanwhile, construction manager Stephan Bohan's crew scrambled to strike the thrice-used Resistance hangar on Pinewood's Q Stage and build Supreme Leader Snoke's complex throne room set in its place, from the ground up. The library interior set on B Stage and First Order hangar set on D stage were also demolished to make room for *Rogue One* reshoot sets, slated to begin filming on June 8.

The throne room sequence, with its stunt rigs for the Praetorian Guards and motion-capture rig for Snoke actor Andy Serkis, was scheduled to shoot for an entire week, from June 13 to June 17,

quickly followed by the last major set on the show, the Resistance's Crait base on Pinewood's immense 007 Stage. *The Last Jedi*'s main unit wrapped on June 25 after completing two days shooting the Crait boulder cave on R.A. Stage and the Crait crevasse on the far side of the mountain in the north backlot.

Over the next four weeks, a reduced *Last Jedi* main unit and the splinter unit shot whatever odds and ends remained in the production schedule, on primarily smaller sets. These included the Crait ski speeder, Resistance X-wing and fathier gimbal shots, the *Millennium Falcon* escape-pod bay, and cockpit and turret and green screen work for the mirror cave. "There were a lot of sets," says Johnson. "And it's also just more fun to shoot on sets. It probably wasn't more fun for Rick and Chris Lowe, our art director, who were tasked with fitting a hundred and sixty-seven sets into our schedule and in a limited amount of space."

Star Wars: The Last Jedi officially wrapped production on July 29 after three days shooting aerial and plate photography, as well as Resistance extras, on the Salar de Uyuni salt flats of southwestern Bolivia—the largest salt flat in the world, standing in for the battlefields of Crait. Rian Johnson, producer Ram Bergman, and a small editorial crew relocated to a hidden office suite in the Frank G. Wells building on Burbank's Walt Disney Studios lot to begin the long process of assembling the film.

In Industrial Light & Magic's London offices, Kevin Jenkins and fellow art director Jason Horley led a team of concept artists including Julian Gauthier, Luis Guggenberger, and Timothy Rodriguez, finalizing designs for ILM's digital effects work on the film. Some *Last Jedi* shots were delivered to ILM London for early-look development during production. But larger shot turnovers from Johnson's editorial team to VFX supervisor Ben Morris's team didn't begin until November. Prior to the 2016 holiday break, 3-D vehicle models also began construction at ILM, with the intention of finishing all models by April 2017.

On December 16, 2016, Gareth Edwards's *Rogue One: A Star Wars Story* was theatrically released to critical and fan acclaim, becoming the highest grossing film of 2016, the second highest-grossing *Star Wars* film behind *The Force Awakens*, and, by January 22, only the twenty-eighth film in history to gross over a billion dollars worldwide.

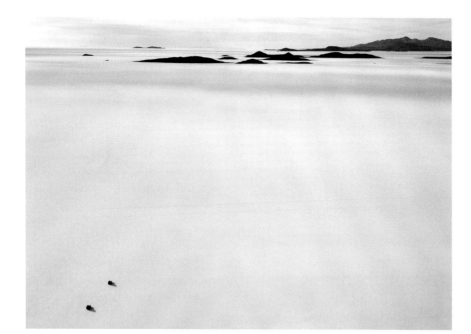

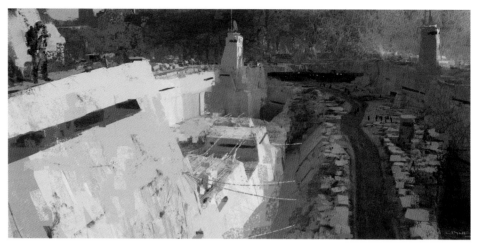

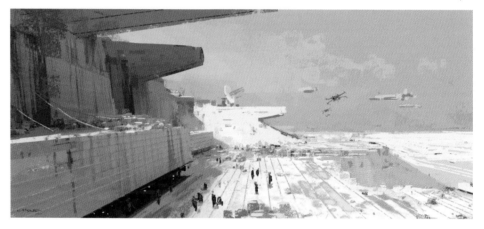

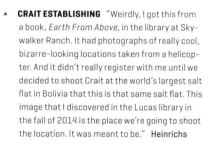

▲ **CRAIT ESTABLISHING** "Weirdly, I got this from a book, *Earth From Above*, in the library at Skywalker Ranch. It had photographs of really cool, bizarre-looking locations taken from a helicopter. And it didn't really register with me until we decided to shoot Crait at the world's largest salt flat in Bolivia that this is that same salt flat. This image that I discovered in the Lucas library in the fall of 2014 is the place we're going to shoot the location. It was meant to be." **Heinrichs**

"The base developed slowly. The earliest idea was, 'Okay, it's some kind of base that's behind some big armored door.' I kept pushing it toward the simplest visual embodiment of that idea. Instead of a front structure that has a door element, I was like, 'Nope, what if it's just a big rock wall with a big-ass door that looks like a shield?' Because the door is shielding them: big dumb idea. [*Laughs*] And I kept focusing it toward making that big dumb idea feel as real as possible." **Johnson**

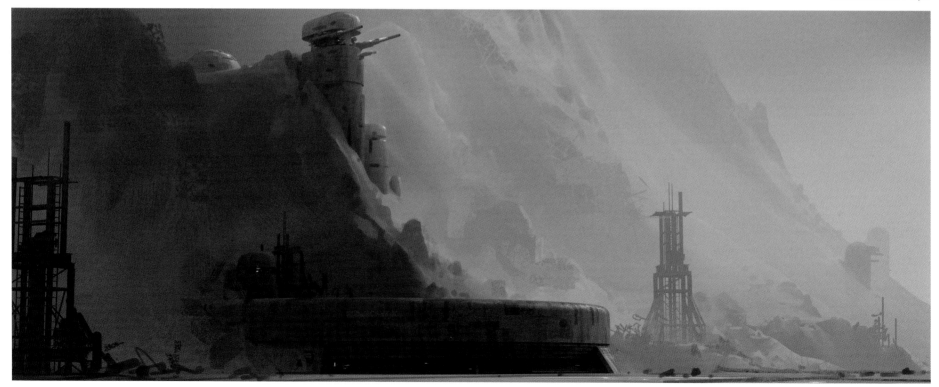

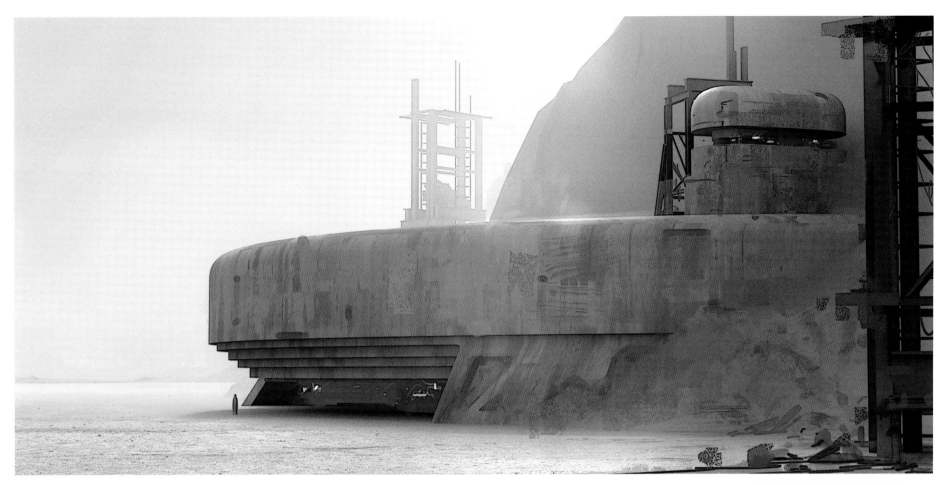

▲ **REBEL BUNKER VERSION 02** Clyne

▼ **INTERIOR CRAIT MINE VERSION 07** Fangeaux

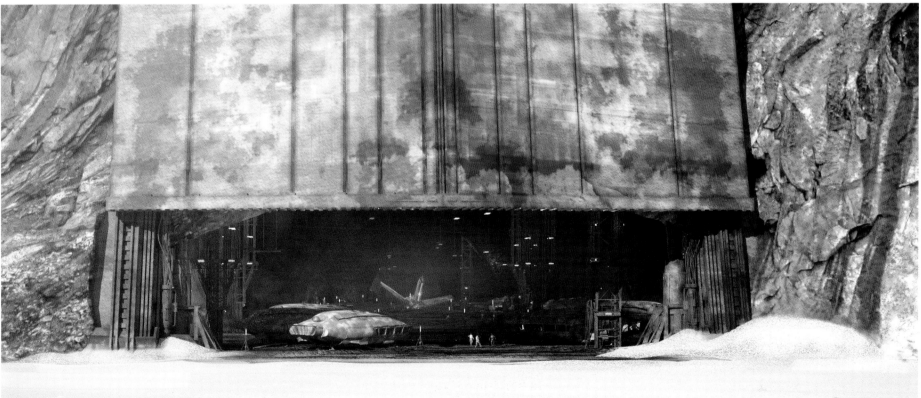

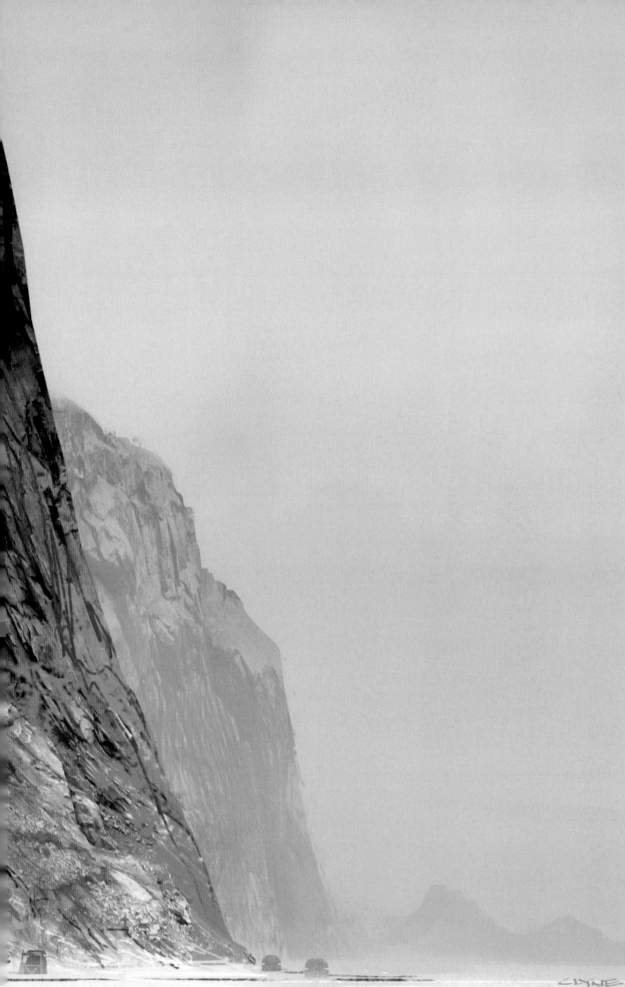

▲ **MINE BASE ENTRANCE SKETCHBOOK VERSION 02** Clyne

▲ **MINE ENTRANCE** Heinrichs

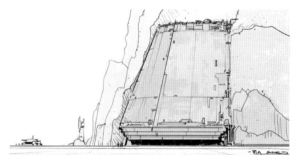

▲ **REBEL BUNKER SKETCH VERSION 04** Clyne

"I think Rian was well into writing at this point when he started to talk about a vertical massive shield. I thought, 'Maybe it's like layers of an onion. It all steps and drops down.' This was the first sketch that Rian was like, 'That's it. That's what it should feel like.' It was almost a throwaway. I almost didn't send it to him. It's pretty close to the final design." Clyne

◀ **MINE ENTRANCE ESTABLISHING VERSION 02** "This was really art-directed by Rian, to the point of having these slots on either end of the door. It was just this big, singular piece of metal dropping down. Anytime I got fussy with it, it got some pushback. A bit of the architecture from earlier sketches was retained, and I always liked the idea of a McQuarrie-style slit opening. But eventually, the story needed the whole door moving up and down." Clyne

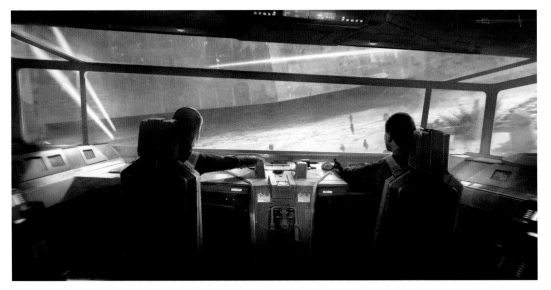

▲ **SHUTTLE COCKPIT INTERIOR VERSION 02** Fernández Castro

▲ **SHIP CRASHING THROUGH DOOR VERSION 01** Engstrom

DOOR CLOSING

SHUTTLE CRASH LANDS UNDER DOOR, JUST BEFORE IT CLOSES

▲ **CRAIT ORDER OF BATTLE MINE PAGE 2** Allcock

"We built quite a bit of the crashed shuttle. And Chris Corbould's special effects team has it running in and dragging through, coming a halt at the end. It was another one of those mandates from the director: Do as much in-camera as possible. And we actually ended up doing it. That scene played out beautifully." **Heinrichs**

▼ **HANDS UP VERSION 02** Fernández Castro

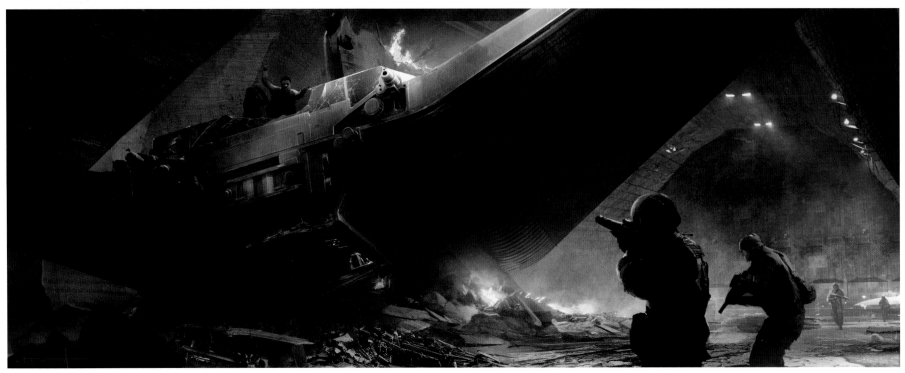

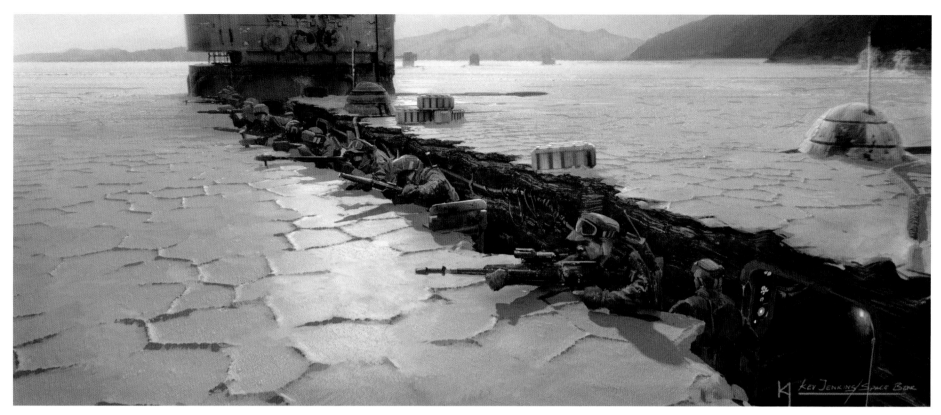

▲ **CRAIT TRENCHES VERSION 03** Jenkins

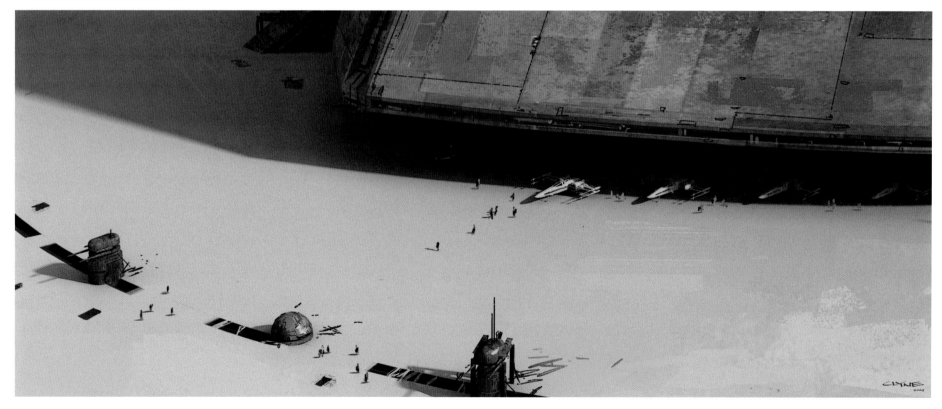

▲ **THIRD ACT BATTLE 01** "There was a lot of talk about where the gunnery and trenches are laid out: What's the proportion, how small are they, how large are they, how forward of the shield are they. Because at this point, it was in 3-D. Rick and Rian were getting a little more specific, even in these early stages of scale and layout." **Clyne**

▲ **ROUND GUN TURRET VERSION 03** Jenkins

▲ **CRAIT TURRET VERSION 01** "James Clyne had done some turrets, and I was moving down the path to finish them off. I liked the idea of hanging the guns off of the side of the main turret. When you think about proper war—World War I, World War II—not everything looked the same. I also like the idea of people in the turrets, looking out across. James had done a slot for that." Jenkins

▶ **THIRD ACT BATTLE VERSION 03** Clyne and Heinrichs

▼ **CRAIT TRENCHES VERSION 01** "The Crait trench and turrets is one of those designs where the actual concept models—the MODO [3D modelling software] file—ends up being the drafting for the set. I'm not making concept-art pieces. I'm almost planning sets. As you can see from the final set, they're incredibly faithful to the 3-D models I made." Jenkins

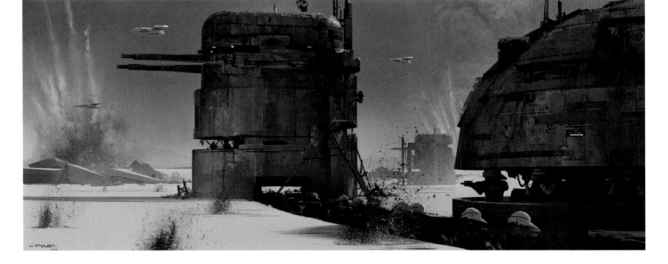

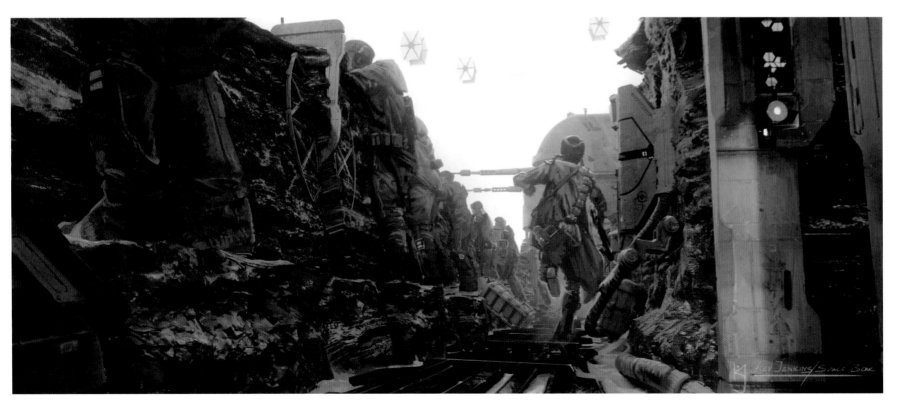

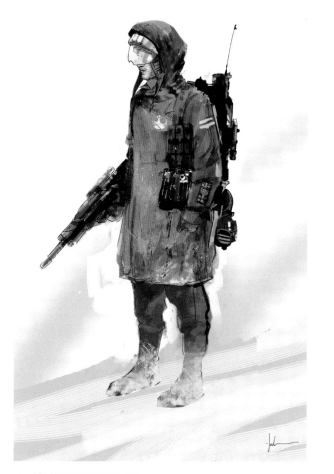

▲ **REBELS PONCHO A7B** Jock

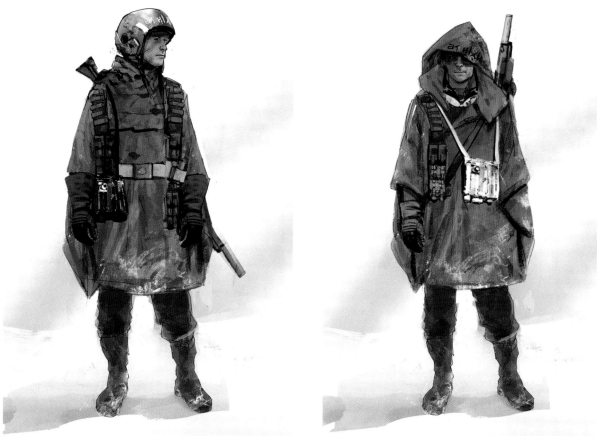

▲ **REBELS PONCHO FRONT B2** Jock

▲ **REBELS PONCHO FRONT C** Jock

"For the shots along the trench in Crait, you see a lot more of the rebel army look: the helmets, smocks, hoods—a sort of proto-commando look with ammunition pouches on their chests. We're hoping it doesn't look too *Rogue One*, because we actually had Gareth Edwards as a guest rebel. He looked and went, 'Well, this is *Rogue One*.' We're like, 'No, it's not.' [*Laughs*] I think that sort of thing works, whichever period of rebel you're doing." **Crossman**

"We deliberately brought more knitwear jumpers in. We withdrew some of the woolier elements of *The Force Awakens* and put virtually all of them into high boots and cotton trousers. And we took away the leg wraps but kept the mixture of hats we had done in the previous film." **Crossman**

"The soldiers on Crait have additional parkas and ponchos, since we didn't see that kind of warfare in *The Force Awakens*. I would say it was bouncing off of a World War I-inspired look. But *Star Wars* always took bits and pieces from World War I, World War II, and samurai movies. There's so much you can do with those elements and keep it *Star Wars*. If you bring in too many new elements, it starts to become something from another film. I also always wanted the film to be rooted in the period when *A New Hope* was released. So you'll notice all of the rebels' hair has a seventies feeling about it." **Kaplan**

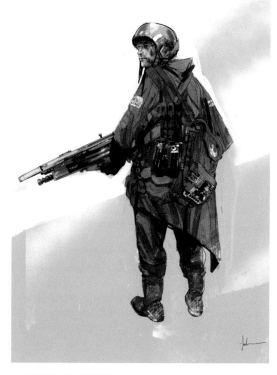

▲ **REBELS PONCHO BACK J** Jock

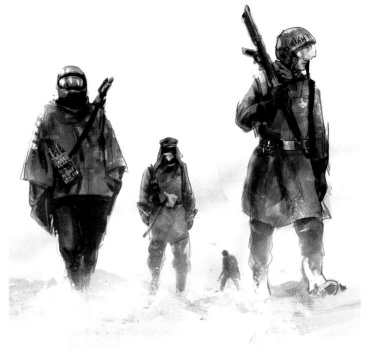

▲ **REBELS GROUP** Jock

▲ **TURBINE REDRESS VERSION 01** Ainsworth

▲ **REBEL BUNKER SKETCH VERSION 01**

"We started to play with the base interior fairly early on. Those early sketches were little vignettes. It was more of a working world then, more similar to Hoth, where you had all of your rebels in action, running back and forth. It eventually became almost this Haunted Mansion, with the Resistance showing up in this dark, cavernous place. What came out of the process is that there's a lot more history to it than just being an old mine. These vignettes were inspired by Ralph McQuarrie and his little sketches, the Hoth sketches, trying to get into the rebel mindset." Clyne

▼ **REBEL BUNKER VERSION 01** "I had this idea of it being more like the Pantheon in Rome, with a circular window on the ceiling that let this natural light through." Clyne

▲ **REBEL BUNKER SKETCH VERSION 03** Clyne

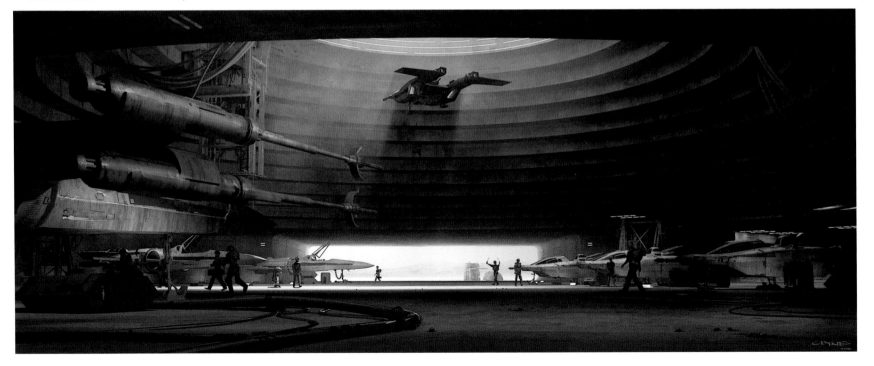

MINE ENTRANCE ESTABLISHING VERION 01

"First and foremost, the rebels and Empire do have distinct personalities. The Empire and First Order, going forward, look very orderly, and their military was tight. The rebels were on the run most of the time; they were in hiding. They had to deal not only with the environment they were in, but the potential of having to leave. They were gypsies. So what is that gypsy aesthetic?" Clyne

DOOR VIEW VERSION 01 Engstrom

CRAIT DOOR VERSION 06 Fangeaux

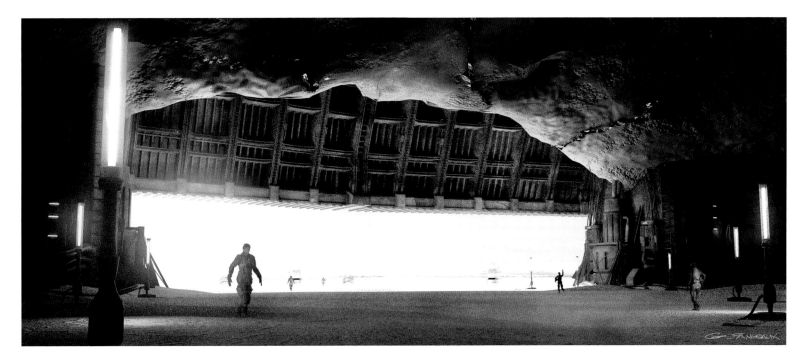

▲ **MINE BASE CONTROL COMS** Booth and BLIND LTD.

▲ **PERISCOPE** Ainsworth

▲ **MINE BASE CONTROL VERSION 01** Rosewarne

▲ **WINDOW VERSION 02** Engstrom ▼ **ONE SCREEN ONLY VERSION 07** Engstrom and Heinrichs

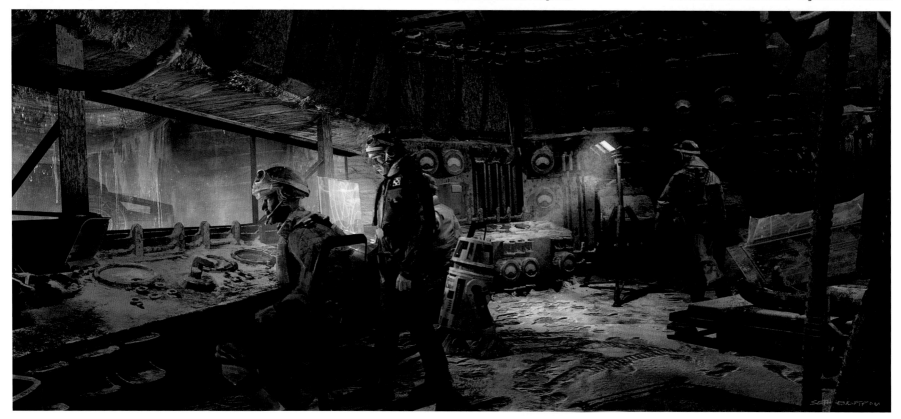

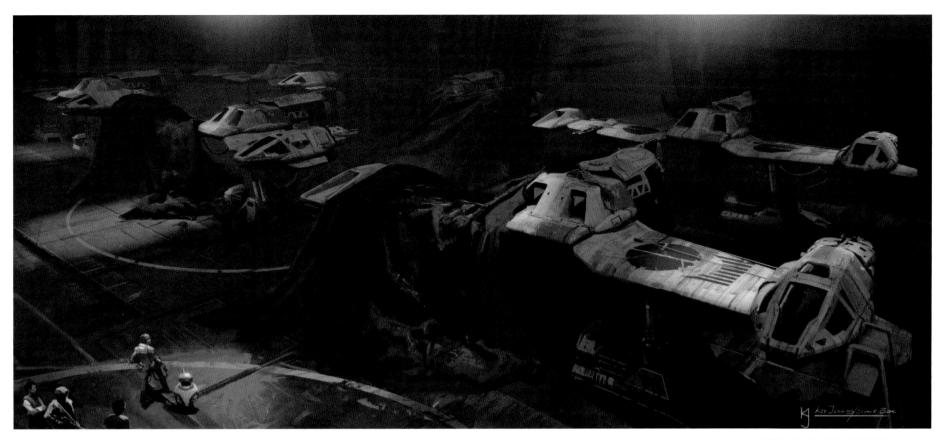

▲ **RESISTANCE HANGAR VERSION 01** Jenkins

▼ **LAUNCH TUBE REVERSE VERSION 02** Jenkins

"We talked about the ski speeders being absolute rust-buckets. They've been under cover, left around for years." **Jenkins**

"When they fire out from the launch tubes and the 'doggie-door,' as Rian calls it, and fly down, we thought, 'Wouldn't it be cool if they don't fly very well?' But when they engage the mono-ski, they bite in and really go for it. As we were developing the vehicle, all of those things added some personality." **Jenkins**

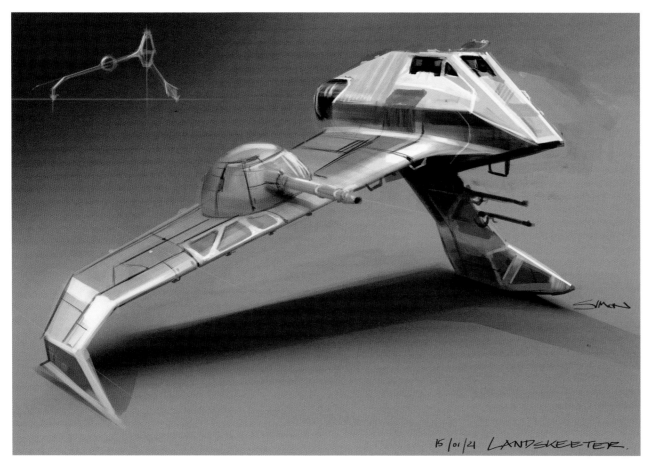

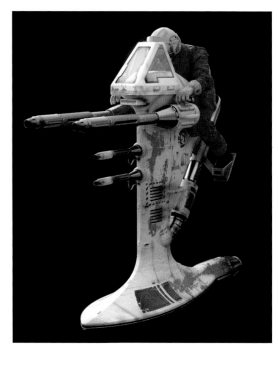

▲ **SKI SPEEDERS RENDER FRONT VERSION 01** Simon

▼ **SKI PAINT OUT POE VERSION 02** "It's a heap of crap, basically. It's not even meant for fighting, but they have to use it. And that's the yin-and-yang thing: these stupid, insanely flimsy, falling-apart rusty, thirty-year-old God-knows-what-they-ares going up against this First Order army." Jenkins

▲ **SKI SPEEDERS CONCEPT VERSION 02** Simon

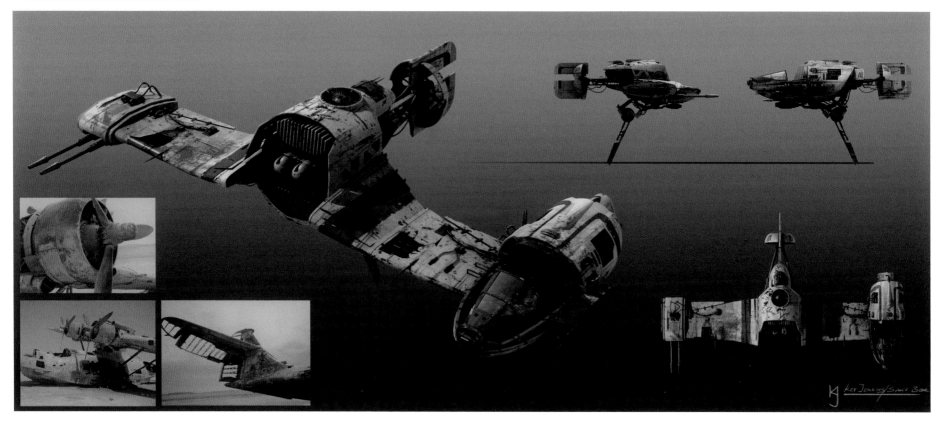

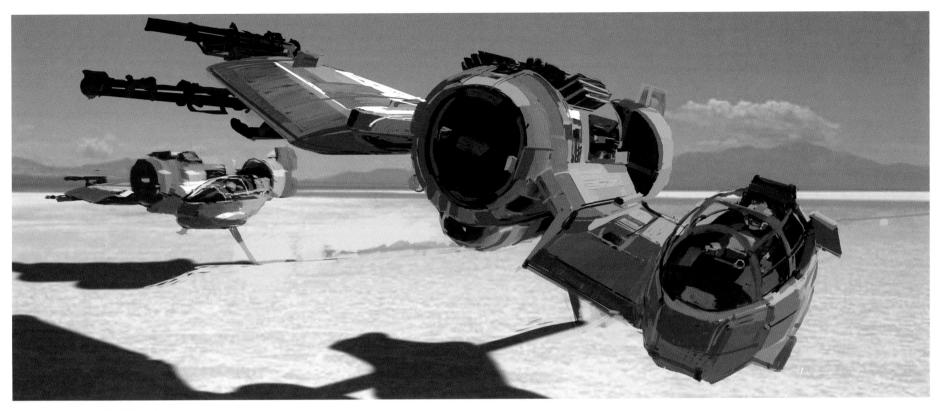

▲ **LANDSKEETER VERSION 2B** Kunitake

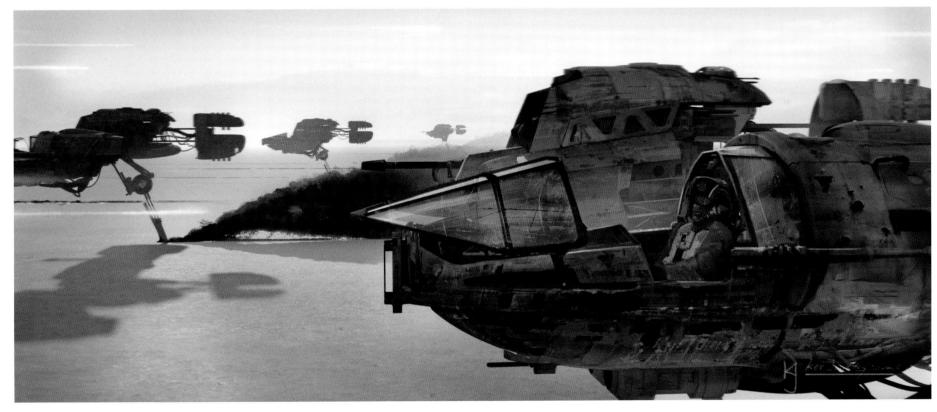

▲ **SKIFF ASSAULT VERSION 02** "I always talked about the ski speeder with Rian as having a hawk-like shape when you see it from the side, so it's almost pointing and jutting forward—quite an aggressive shape. The other thing were talked about at the time were Florida Everglades swamp boats. The tail is like that." Jenkins

▶ ▶ **SKIFF WALKER VERSION 02** "I originally had a pilot on one end and a gunner on the other. And his wonderful way, Rian said, 'There's already one pilot. I don't need a gunner. But the design's cool. Keep going.' Even at that early stage, he had that battle planned out—the ski speeders needing only one pilot." Jenkins

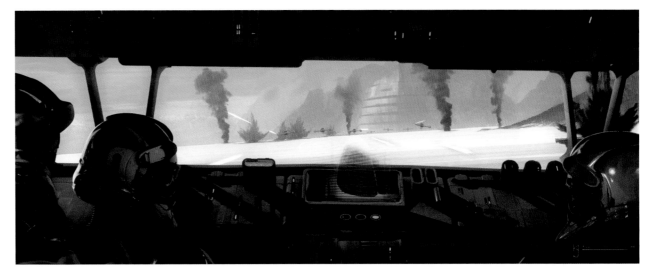

▲ **WALKER ATTACK VERSION 01** Jenkins

▲ **GORILLA HEAD SKETCH** "The head took quite
a few versions. The things I remember Rian
really liking were the mandibles that droop
down either side of the face, that the guns
are within, and the aggressive eyebrow. It's a
literal gorilla, modeled up in armor." Jenkins

▸ **GORILLA WALKER VERSION 01** "To sell the
new walker's scale, I wanted to pair it with the
original walkers. Now, they're the scouts for
the gorillas. These hugely powerful things in
The Empire Strikes Back are deliberately little
puppy dogs running alongside and protected
by the big gorillas." Jenkins

▾ **GORILLA WALKER VERSION 03** "I thought,
'What would the Germans have done in World
War II? They would have just made a bigger
tank.' That's what they and the Russians did.
I only did a couple of line drawings, sketched
out roughly, from the side and a couple of
cockpits. So I went on holiday and modeled it
by the pool. I said to Rian that it was a further
iteration on the walker: bigger, heavier, like a
Panzer tank." Jenkins

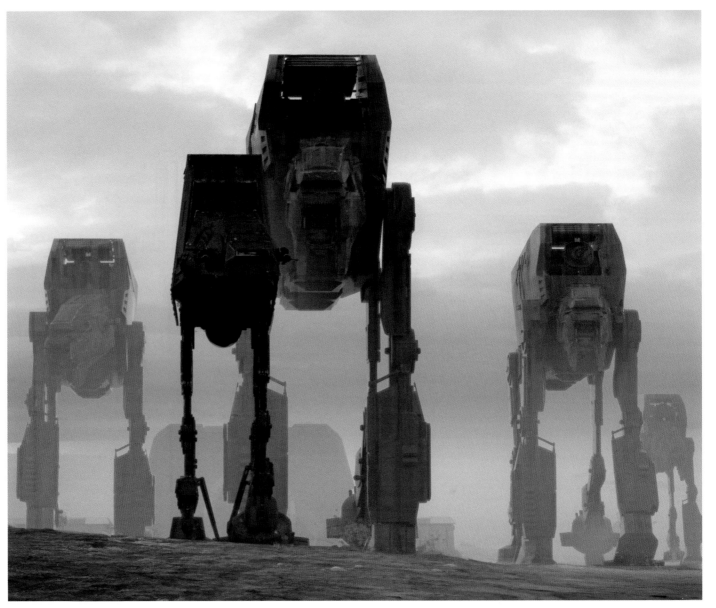

GERMAN NAVAL GUN

LIFTS TO CREATE 2nd ROW

▲ **MULTI-LEG WALKER 1** Clyne

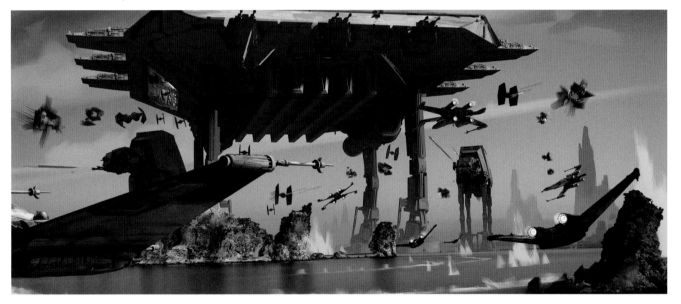

▲ **SMALL WALKER 05** "I did one that was like a scout walker, an iteration off of the big multiple leg walkers." **Clyne**

◄ **MONO LAKE ATTACK 01A** "There was some early thought of Mono Lake—the water being mirrored, almost like glass. Then I thought it would be cool if the ships skim across it and create these little wakes. But I think it quickly turned to the idea of a salt flat." **Clyne**

▼ **MULTI-LEG WALKER VERSION 03** "In *Empire*, everyone wanted to know, 'How did the walkers get down there?' So I came up with this idea that the First Order drops one massive walker down that would then drop all of the smaller walkers, the aircraft carrier of walkers. It would have little bays where TIE fighters could pour out of it. It's like the hive of our worker bees. It comes to a certain point and stops. It's just sitting back there in the fog." **Clyne**

FRONT

▲ **WALKER SKETCHES** Clyne

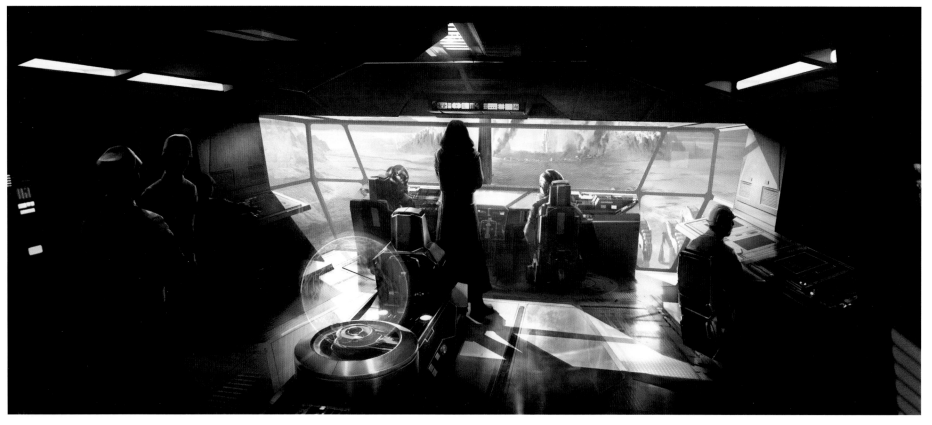

▲ **KYLO SHUTTLE INTERIOR VERSION 22** Fernández Castro ▼ **KYLO SHUTTLE INTERIOR VERSION 21** Fernández Castro

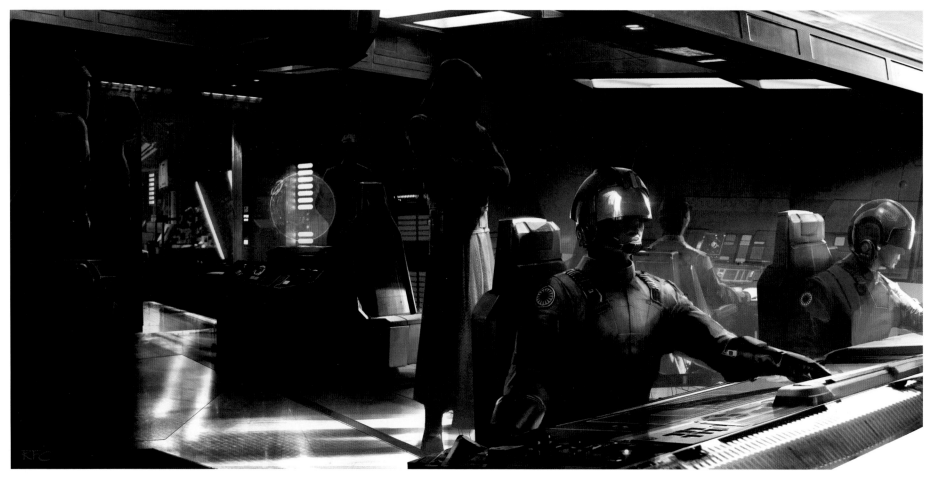

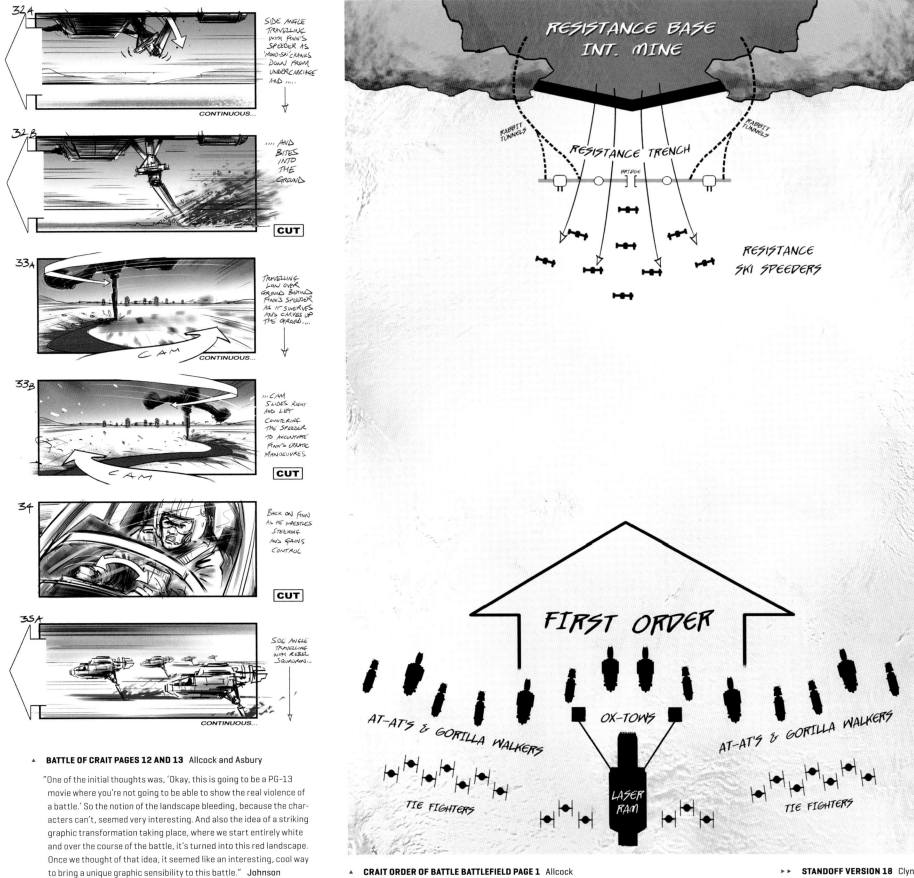

32A SIDE ANGLE TRAVELLING WITH FINN'S SPEEDER AS 'MONO-SKI' CRANKS DOWN FROM UNDERCARRIAGE AND

CONTINUOUS...

32B AND BITES INTO THE GROUND

CUT

33A TRAVELLING LOW OVER GROUND BEHIND FINN'S SPEEDER AS IT SWERVES AND CARVES UP THE GROUND,...

CAM CONTINUOUS...

33B ,..CAM SLIDES RIGHT AND LEFT COUNTERING THE SPEEDER TO ACCENTUATE FINN'S ERRATIC MANOEUVRES

CAM CUT

34 BACK ON FINN AS HE WRESTLES STEERING AND GAINS CONTROL

CUT

35A SIDE ANGLE TRAVELLING WITH REBEL SQUADRON...

CONTINUOUS...

▲ **BATTLE OF CRAIT PAGES 12 AND 13** Allcock and Asbury

"One of the initial thoughts was, 'Okay, this is going to be a PG-13 movie where you're not going to be able to show the real violence of a battle.' So the notion of the landscape bleeding, because the characters can't, seemed very interesting. And also the idea of a striking graphic transformation taking place, where we start entirely white and over the course of the battle, it's turned into this red landscape. Once we thought of that idea, it seemed like an interesting, cool way to bring a unique graphic sensibility to this battle." Johnson

RESISTANCE BASE INT. MINE

RABBIT TUNNELS

RESISTANCE TRENCH

RABBIT TUNNELS

BRIDGE

RESISTANCE SKI SPEEDERS

FIRST ORDER

AT-AT'S & GORILLA WALKERS

OX-TOWS

AT-AT'S & GORILLA WALKERS

LASER RAM

TIE FIGHTERS

TIE FIGHTERS

▲ **CRAIT ORDER OF BATTLE BATTLEFIELD PAGE 1** Allcock ▶▶ **STANDOFF VERSION 18** Clyne

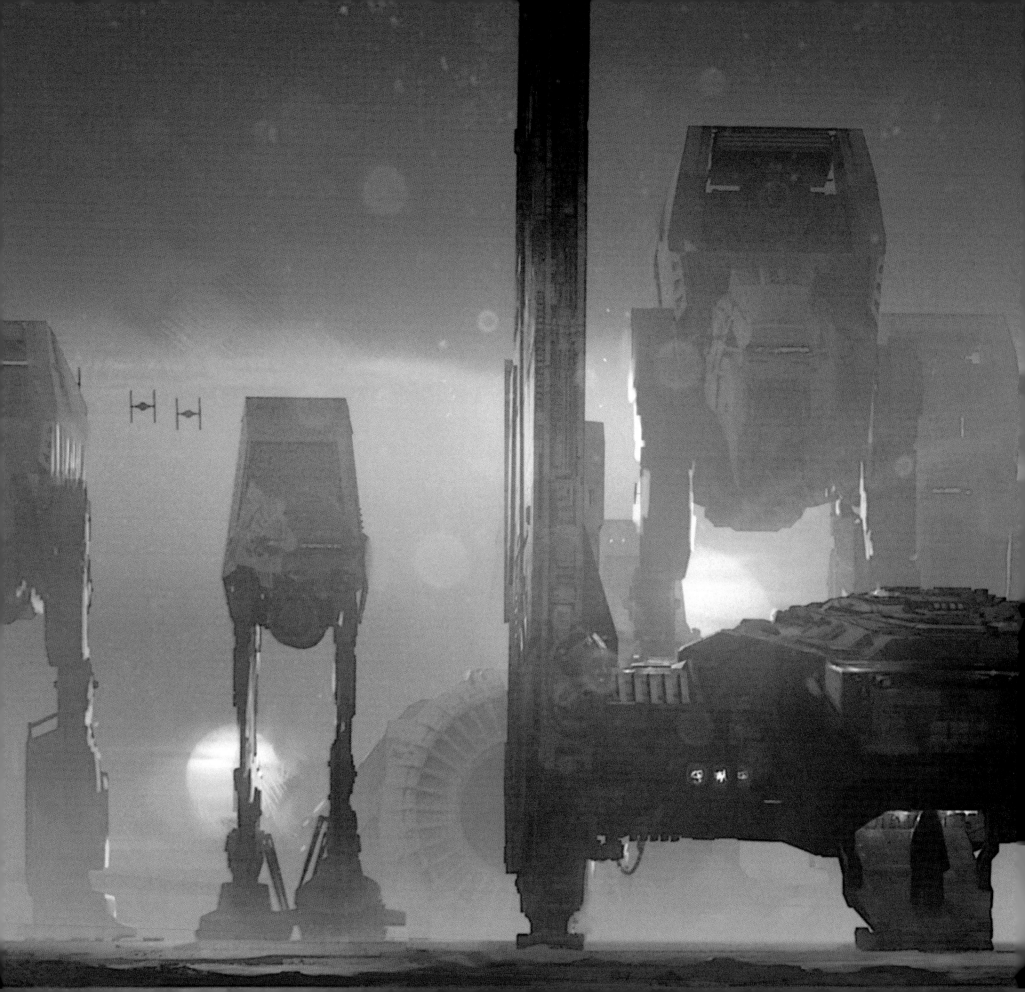

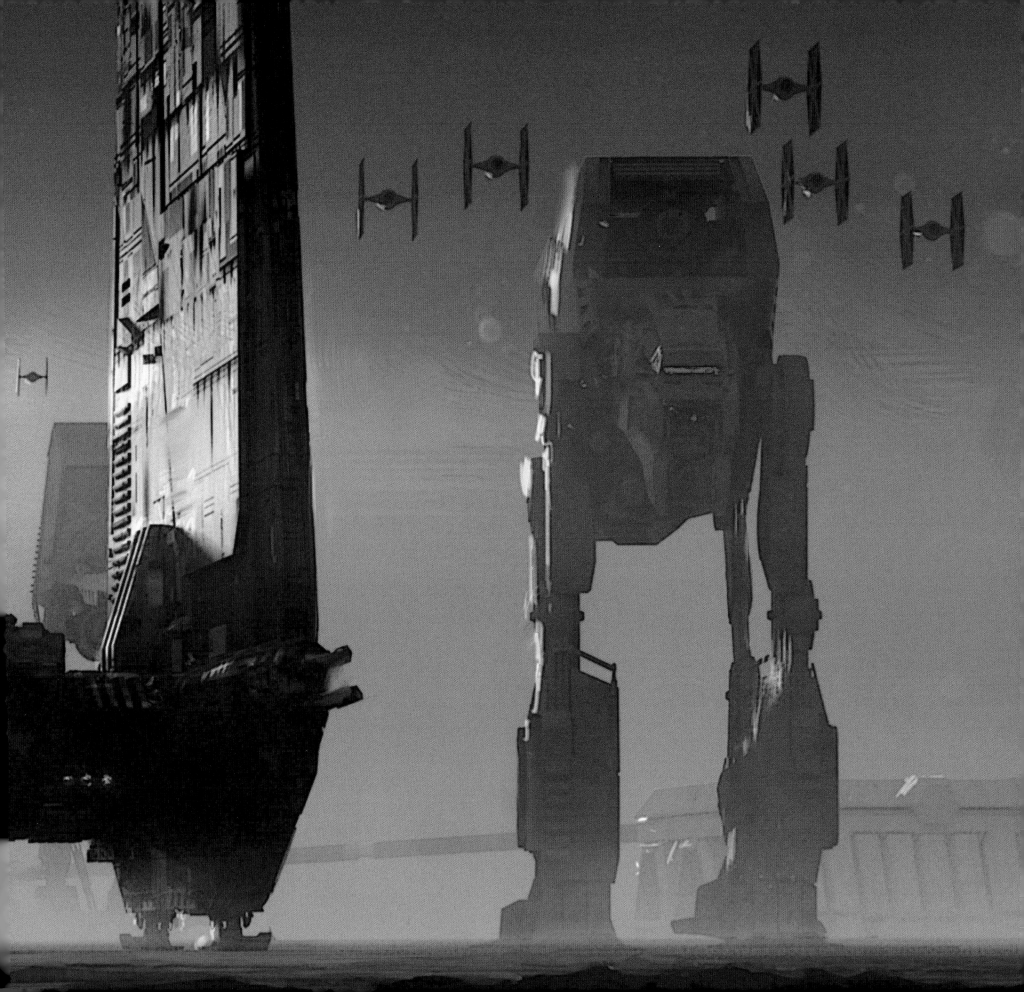

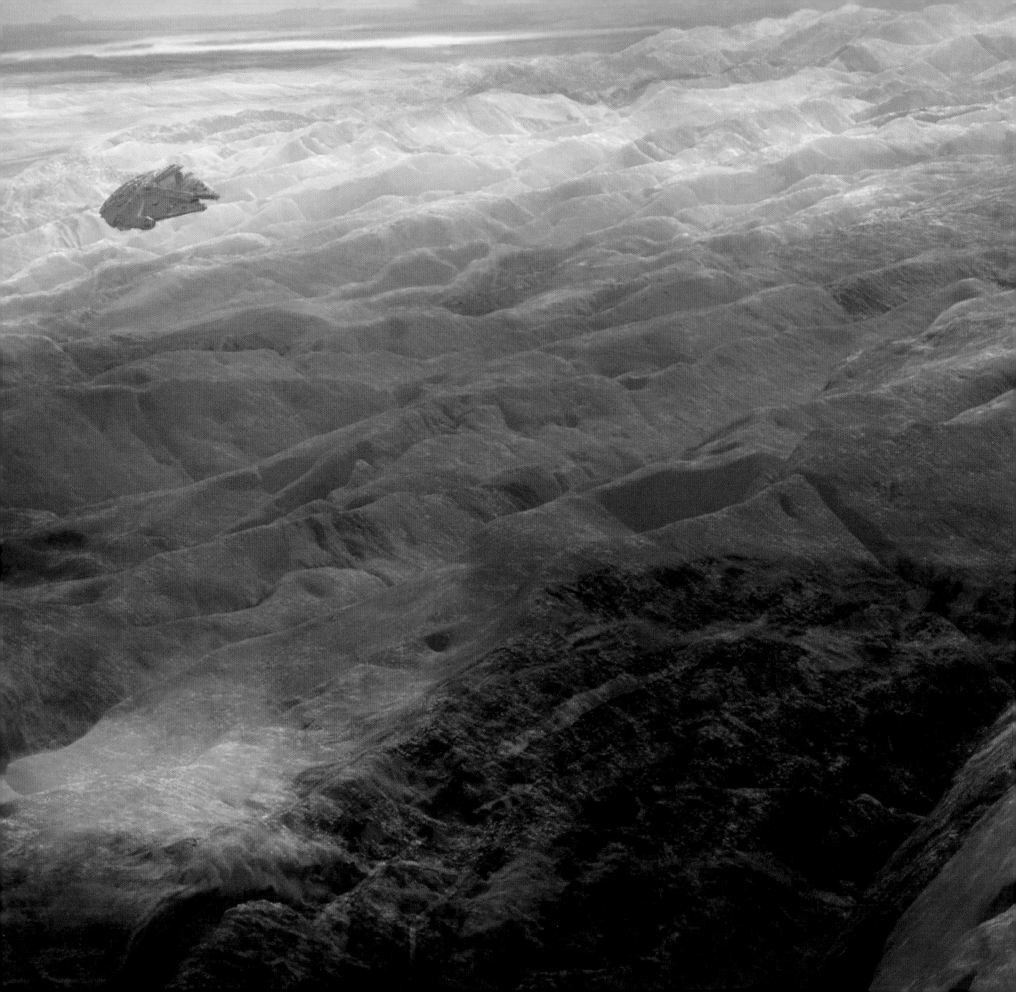

Binary Sunset

ILM London VFX supervisor Ben Morris and team resumed their work in the New Year, finalizing their first shots for *The Last Jedi* in January 2017, apace to finish every shot in the film by June, well in advance of the film's December 15, 2017 release date. The London-based ILM art department continued to support them, anticipating serving in that role until at least April.

On January 23, 2017 the official title for *The Last Jedi* was unveiled to the world—the same title first seen on Rian Johnson's rough draft of the script submitted March 4, 2015.

"The truth is, once we started getting into the work, the most surreal thing was how un-surreal it was, how natural and fun it felt," Johnson says. "And that's a testament to everybody I worked on this whole thing with, but specifically with the designers and their crews. Everybody was so good at what they did. It was just the A-Team, from top to bottom. But beyond that, they all loved what they were doing. They all just love *Star Wars*. And as weird as this sounds, considering what we're doing, the vibe was never, 'Let's recreate and idolize the past.' The vibe was always, 'We all know this world in our bones from growing up with it. But let's make something new and exciting in it.' That was something that we all shared, and we all very naturally felt. So it was surreal, but it also was like slipping into a pair of comfortable shoes."

Summarizing his experience on *The Last Jedi*, costume designer Michael Kaplan says, "Rian is the nicest person in the world. It's too good to be true. First J.J., and now Rian? I've been totally spoiled." Creature creative supervisor Neal Scanlan reflects, "We're waving goodbye to the legacy that is the original films and prequels, even to *The Force Awakens*. Rian is taking this film to a place that I hope the fans adore and is as successful as any other place that we've been. But it's definitely a place that we haven't been before. And that's liberating, isn't it—because where does *Star Wars* go from here? What a fantastic way to say, 'Goodbye.' And 'Let's go somewhere else.' It was really amazing to do it with him."

"I don't think I'll ever understand the experience I had on *The Last Jedi* until I'm a long way past it," says art director Kevin Jenkins. "The confidence that Rian allowed me to have . . . at times, he almost let me play. Knowing that Rian so wanted to make this film like it's still the eighties—to make an emotional *Star Wars* film—I've never tried so hard to key everything into that, to never give up on a design. To have Rian say on so many of the designs, 'I want it just like the artwork.' It's so incredibly rewarding."

Art director James Clyne agrees, "This project was so much fun. I got to work with Kevin again. I got to work with Rian and see someone else's perspective on *Star Wars*. And I got to work with Rick Heinrichs. *The Last Jedi* has the potential to be one of the best *Star Wars* movies, and I really feel so fortunate to have had the opportunity to work on this."

"What I get out of all of the *Star Wars* movies is George's interest in making sure the idea comes across," says production designer Rick Heinrichs. "That's what I love about it. He is interested in ideas. And the journey to figure out what those things are is very reductive, 'It doesn't look like that.' Until you start to feel, 'Yeah, it kind of looks like that.' It was brilliant that he teamed up with Ralph McQuarrie so early on, not just because of his technical skills, but because he was able to go on that journey and realize that if you've only got one correct drawing in one hundred, you damn-well better start drawing all the wrong ones so you can get to the right ones [*laughs*]. J.J. has reenergized the spirit of the original films, and we're now able to take that to the next place because it's living again."

"As kids, we opened up that *Star Wars* action figure, and it became part of our creative play," remembers Johnson. "In one way, we are looking to the past and trying to capture what it is that Lucas and McQuarrie and all those designers created that inspired us. On the other hand, we know what inspired us, because we were inspired by it when we were six years old [*laughs*]. At the end of the day, it's not the documents in the archives. It's not the old drawings. It's not the old treatments. It's not old interviews. It's not research. The only research that really matters is reaching back to when you were six and thinking, 'What were the things that made *Star Wars* feel real then—that inspired me, personally?' And then following your heart with those things."

▲ **FOXY EARLY** Napper

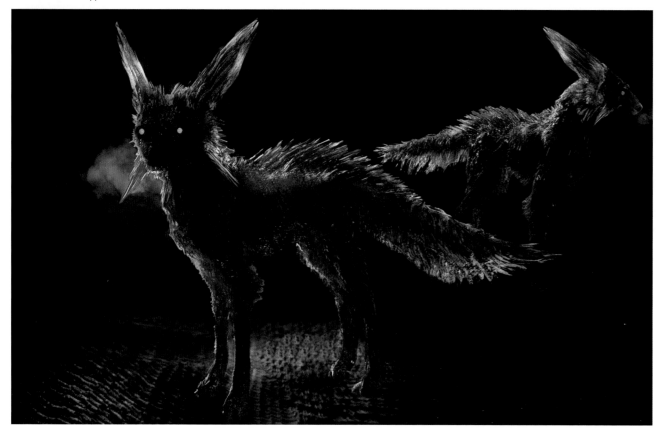

▲ **SHARD FOX** Sweet

"We had two images of this beautiful female fox that we found on the Internet. To me, they had all of the emotion that Rian was wanting from this. And they became the guides for creature effects animatronic designer Louise Day and her team. They almost were like building in LEGO. We sculpted the fox as an under-shape, and then Lou went in and chose ten thousand crystals, something in that region. There were only ten different-sized crystals. It was almost like flower arranging.

"We looked at making the lips clear and crystalline, and the teeth clear and crystalline. And all of that took away from the soul of the animal. You believe this has blood running through it because the tongue and mouth interior are real in color and in texture. So you begin to get this juxtaposition, this metamorphosis of two things: a living thing and this crystalline coat. I think it's an adorable design." Scanlan

◄ **SHARD FOX BACKLIT VERSION 05** "Justin Sweet and I did some explorations, and I played with whether or not there was an organic, mammal-type core in the crystal. Were the crystal shards an accumulated growth in underlying fur? Or was it crystal, through and through? I also played with clarity and iridescence to the crystals." McBride

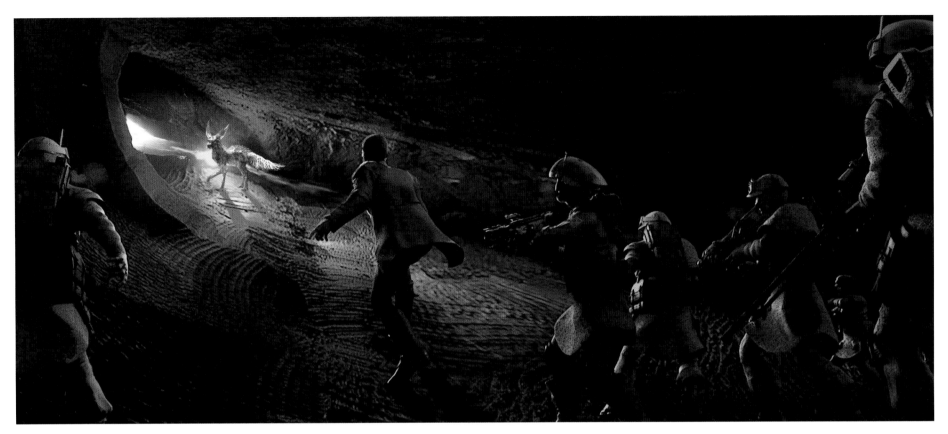

▲ **FINN FOLLOWING SHARD FOXES VERSION 03** McBride

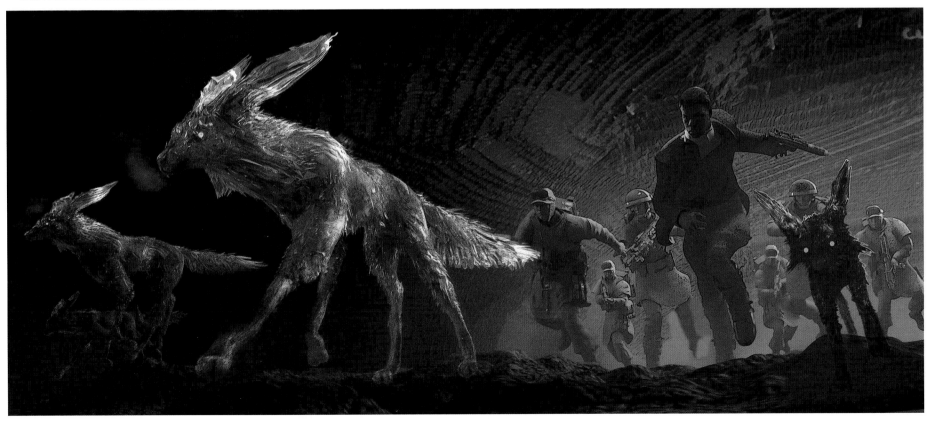

▲ **FINN FOLLOWING SHARD FOXES VERSION 02B** "I did a few illustrations of the foxes leading the rebels out of darkness, to show how their bodies refracted the light of the escape route and thus led the rebels to it." McBride

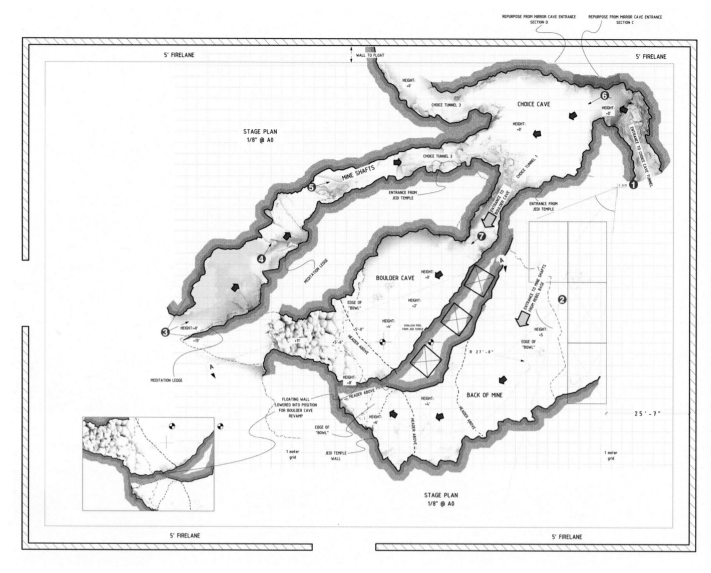

▲ **MINE FISSURE R.A. STAGE LAYOUT 2**
Frederiksen

◀ **BOULDER CAVE VERSION 15** Borrelli

"One of our 'brilliant' ideas was to turn the
rock set around. The rock set is initially
the mirror cave on the island. Using as
much of it as possible, we turned that
into the Jedi temple. And then the temple
became the back of the Crait mine, with
tunnels and boulders and all of that. What
it allowed us to do was efficiently turn
things around. These are not cheap things
to build in the first place. So if there was
any way to amortize the cost of building it,
we did so." Heinrichs

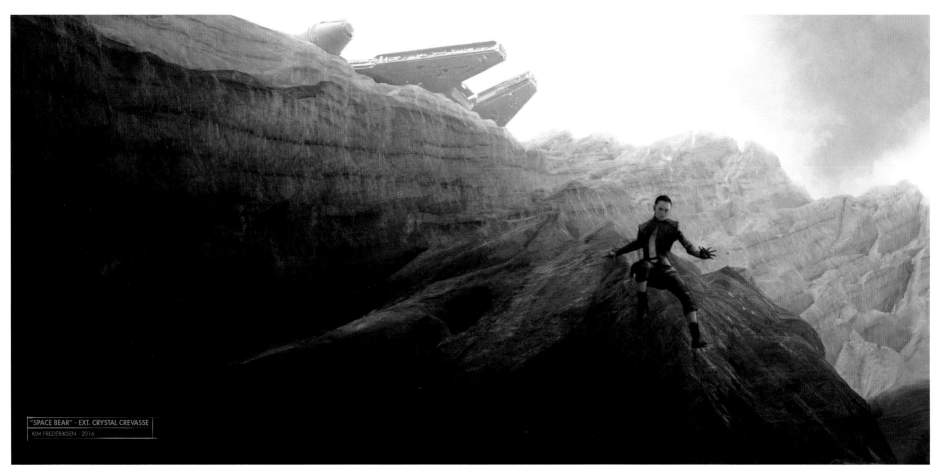

▲ **CRYSTAL CREVASSE PAGE 55** Frederiksen

▼ **CRYSTAL CREVASSE PAGE 59** Frederiksen

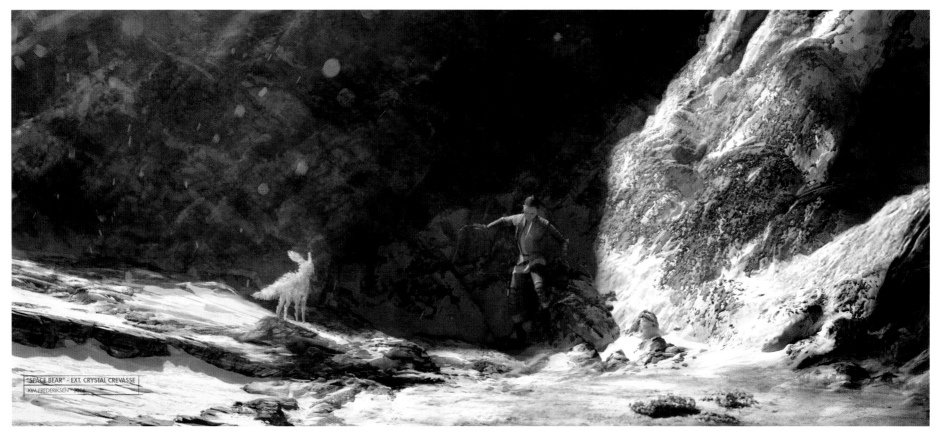

x55

x130

▲ **CRYSTAL CREVASSE BOULDER SCULPT PAGE 154** Frederiksen

"The crevasse was on the backlot here at Pinewood, a totally separate set. We were able to reuse our boulders from the cave set and put them into the crevasse [*laughs*]. You always look for those opportunities. And Chris Corbould figured out a rig so the boulders could all be floating there. Then Rey waves her hand, and they all zoom out. It looked really good." **Heinrichs**

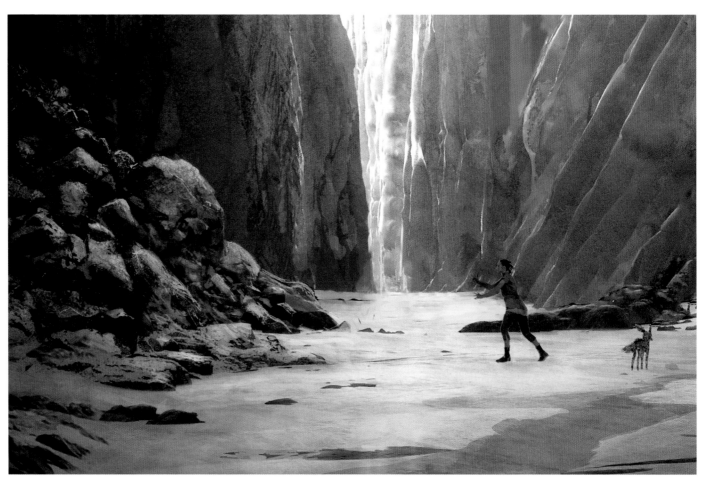

▲ **CRYSTAL CREVASSE PAGE 59** Frederiksen and Carson

▼ **CRYSTAL CREVASSE PAGE 48** Frederiksen and Carson

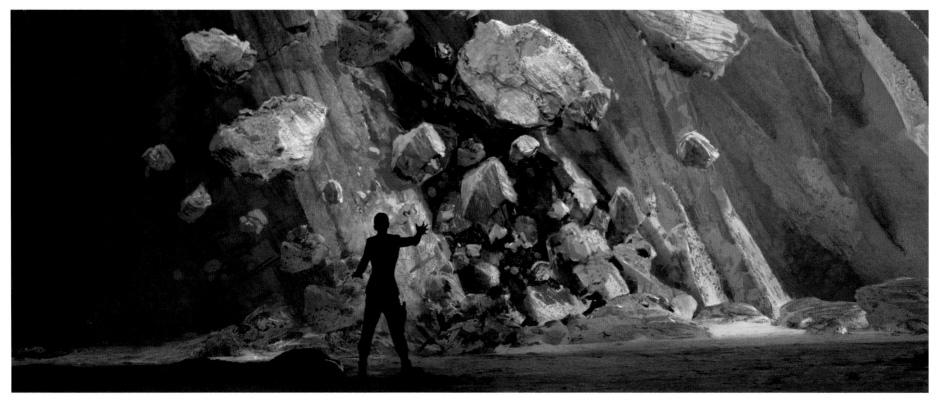

▲ **MINERAL SPEEDER CRASHED LAYOUT VERSION 02** Fangeaux

▸ **THIRD ACT BATTLE 05** "I thought, 'What if they were just in a big crater?' A big bomb went off and created this massive crater. It creates this beautiful graphic but it also forms this kind of arena. At the time, someone said this that it reminded them of the Japanese flag, the rising sun, a symbol, harkening back to Kurosawa." **Clyne**

▲ **MINE BLASTER DOOR VERSION 01** Fernández Castro and Heinrichs

▸▸ **LUKE ON LEDGE SUNSET VERSION 11** Engstrom

INDEX

FOR LUCASFILM LTD.

Senior Editor Frank Parisi
Creative Editor Michael Siglain
Art Director Troy Alders
Asset Group Newell Todd and Erik Sanchez
Story Group Pablo Hidalgo, Matt Martin, and Rayne Roberts

FOR ABRAMS

Senior Editor Eric Klopfer
Designer Liam Flanagan
Managing Editor Gabriel Levinson
Production Manager Denise LaCongo

Pages 250–51
STABLES VERSION 04
Brockbank

Page 255
STABLE BOYS GROUP SHOT
Zonjić

Page 256
STABLES VERSION 01A
Brockbank

Case
TURRET SLALOM VERSION 01
Jenkins

Library of Congress Control Number: 2017943326

ISBN: 978-1-4197-2705-4

Printed and bound in the United States

10 9 8 7 6 5 4 3 2 1

Abrams books are available at special discounts when
purchased in quantity for premiums and promotions as
well as fundraising or educational use. Special editions
can also be created to specification. For details, contact
specialsales@abramsbooks.com or the address below.

ABRAMS The Art of Books
195 Broadway, New York, NY 10007
abramsbooks.com

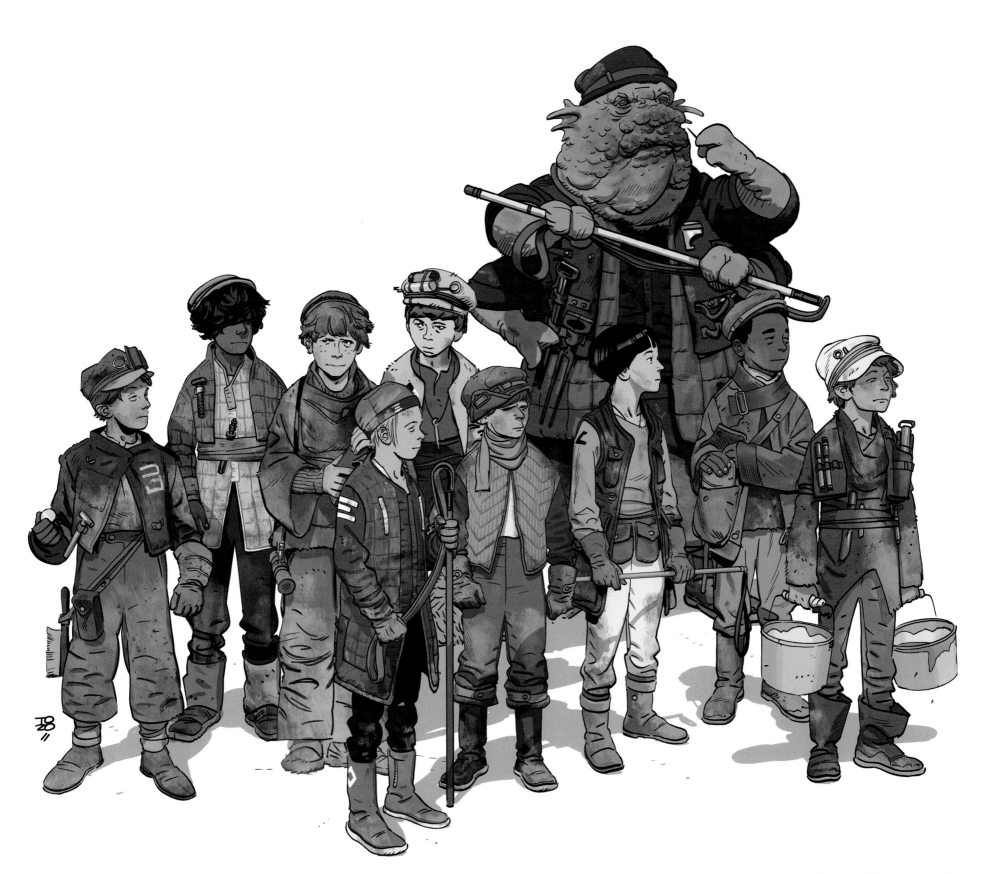